The Works of Joseph Légaré

1795-1855

The Works of Joseph Légaré

1795-1855

Catalogue raisonné by John R. Porter, Assistant Curator of Early Canadian Art, The National Gallery of Canada

with the collaboration of Nicole Cloutier, Jean Trudel

The National Gallery of Canada, National Museums of Canada, Ottawa 1978

Version originale en français

English translation
© The National Gallery of Canada
for the Corporation of the
National Museums of Canada
Ottawa 1978

ISBN 0-88884-358-5

PRINTED IN CANADA

Obtainable from your local bookstore
or
National Museums of Canada
Mail Order
Ottawa, Canada K1A 0M8

Frontispiece:
Self-Portrait c. 1825 (detail)
cat. no. 7

Contents

ITINERARY

The National Gallery of Canada, Ottawa
22 September–29 October 1978

Art Gallery of Ontario, Toronto
25 November 1978–7 January 1979

Montreal Museum of Fine Arts
1 February–15 March 1979

Musée du Québec, Quebec
12 April–20 May 1979

LENDERS TO THE EXHIBITION

Art Gallery of Ontario, Toronto

Monastère des Augustines de
l'Hôpital-General, Quebec

Monastère des Ursulines, Quebec

Montreal Museum of Fine Arts

Musée du Québec, Quebec

Musée historique de Vaudreuil

Mr Louis Painchaud, Sherbrooke

Résidence des pères Jésuites, Quebec

Séminaire de Québec, Quebec

Wellington County Museum, Fergus

Private collections

Foreword

Little known up to now, the Quebec painter Joseph Légaré (1795-1855) played a very important role in the development of Canadian painting in the first half of the nineteenth century. His many and varied works are particularly remarkable for their innovative treatment of landscape, historical subjects, and contemporary life. An innovator, Légaré led a very active political and social life, constantly taking a stance on each of the great questions of his day. He also opened the first public gallery in Quebec City - in Canada for that matter - in 1833. An expert and tireless collector, Légaré worked all his life to encourage a taste for the fine arts among his fellow-citizens.

Because we were convinced of Légaré's importance, this project was set afoot in the autumn of 1972 by Jean Trudel, then Curator of Traditional Canadian Art at the National Gallery of Canada and myself, then Assistant Curator of Traditional Canadian Art. Simultaneously with the preparation of the travelling exhibition *The Calvary at Oka* (1974), I began a systematic inventory of Légaré's work and the documentation on his life and work. During my leave of absence from the Gallery, from October 1975 on, Nicole Cloutier was hired on a year's contract to sustain the research. Miss Cloutier was especially involved in exploring newspaper accounts and notorial archives. Once back at the Gallery, I picked up where Miss Cloutier left off, completed files on each of the works, and began with Mr Trudel the selection for the exhibition. Mr Trudel, before his appointment as Director of the Montreal Museum of Fine Arts in June 1977, had the time to write about thirty catalogue entries, while at the same time buying several works and arranging their restoration by the Restoration and Conservation Laboratory of the National Gallery. With Mr Trudel's departure for Montreal, I assumed full responsibility for the writing of the catalogue. For the technical aspects of the organization of the exhibition I have benefited greatly from the assistance of Robert Derome, Acting Curator of Traditional Canadian Art, from June 1977 on.

The introduction to this *catalogue raisonné* is a concentrated study on the life of Joseph Légaré. There are no notes or references as the introduction is based on the monograph *The Life of Joseph Légaré,* to be published in the fall of 1979, which will be fully documented.

J.R.P.

Preface

Joseph Légaré, painter, art-collector and thinker, can be seen as a prime figure in the evolution of Canadian painting in the first half of the nineteenth century.

Jean Trudel, now Director of the Montreal Museum of Fine Arts, began this project over five years ago when he was the National Gallery of Canada's Curator of Traditional Canadian Art. John R. Porter, Assistant Curator in the same department, continued the research and brought it to fruition. Robert Derome, now Acting Curator of Traditional Canadian Art, has assisted as co-organizer of the exhibition. And Nicole Cloutier contributed (on contract) to explore archival sources.

Their enthusiasm, careful scholarship and largeness of historical vision have made possible not only this *catalogue raisonné* of Légaré's painting, but also a discursive introduction to Légaré in his historical environment published in the National Gallery of Canada's popular *Journal* series. These will be followed by a larger study, in monograph form and with a fuller scholarly apparatus, that will treat Légaré in the context of the political and social culture of his times. The single fact that he opened the first public art gallery in Canada, in 1833 at Quebec City, has implications for all of Canada's cultural history.

Ottawa will share this experience of an early nineteenth century intellectual and aesthetic pioneer with the Art Gallery of Ontario in Toronto, the Montreal Museum of Fine Arts and the Musée du Québec. The National Gallery of Canada warmly thanks all the institutions and individuals who have lent works to the exhibition. In particular, we acknowledge our appreciation of the Séminaire de Québec, which has lent thirty-four works, and the Musée du Québec, which has lent fourteen, for their generous participation.

Hsio-Yen Shih
Director
The National Gallery of Canada

Acknowledgements

We would like to thank all those who have contributed, directly or indirectly, to this catalogue, be it in giving us access to their collection or in letting us consult documents in their possession. We would in particular like to thank the artist's descendants, especially Brother Jérôme Légaré of Chicoutimi, for their valuable conversation. We must also thank our colleagues at the National Gallery of Canada for careful advice and generous support. Finally we are grateful for a wide variety of services rendered us by Sister Marcelle Boucher o.s.u., Sister Lucie Vachon a.m.j., Mrs Pauline Séguin, Monsignor Albertus Martin, Bishop of Nicolet, Father Adrien Pouliot s.j., Abbé Honorius Provost, and by J. Russell Harper, Laurier Lacroix, Jean-Pierre Paré, Pierre Savard, Claude Thibault, and Peter Winkworth.

J.R.P.
N.C.
J.T.

Joseph Légaré

(1795-1855)

In his sensitivity to new ideas and involvement in the events of his time, the Quebec painter Joseph Légaré (1795-1855) holds an exceptional place in the history of early Canadian art. Ever faithful to his principles and convictions, he displayed a life-long concern for the welfare of his fellow-citizens and for the moral and material improvement of his native land. A respected figure, Légaré was a forerunner and pioneer in the area of the promotion of the fine arts. Moreover, his artistic contribution is inseparable from his many social, political, and cultural activities. Everything in his life showed him generous and many-talented, and in many respects, a very innovative man.

Eldest son in a family of six children, Joseph Légaré was born in Quebec City on 10 March 1795. At the time of his birth his father, also called Joseph (1766-1855), was a cobbler in Saint-Jean Street. Légaré's mother, born Louise Routier (c. 1773-1860), was illiterate. Her husband, however, assured their social status by his success as a business man. Around 1815, fortified by extra income from the loans he made and properties he rented out, the elder Légaré had become a relatively wealthy man.

The young Joseph Légaré studied for three years at the Séminaire de Québec; various documents attest to his reaching the *sixième* level (roughly equivalent to the tenth grade) in 1810-1811. Up till then having achieved only mediocre results, it seems he discontinued his studies, in July 1811. Less than a year later, on 19 May 1812, he apprenticed himself to Moses Pierce (fl. 1806-1848). The painter-varnisher profession Pierce practised consisted mostly of carriage-painting (coats of arms and so on), sign-painting, and interior decoration, as well as the various kinds of gilding. The profession may from time to time also have involved some restoration of pictures, but it did not really include the actual painting of canvases. Légaré's apprenticeship to Pierce was likely brief: the latter must have left Quebec when the United States declared war on Britain in July of 1812.

Whatever the case, Légaré, as a painter-varnisher, engaged an apprentice - one Henry Dolsealwhite - only five years later in 1817. He may also at this time have assumed an active role in the restoration of the Desjardins collection. In 1819 he took another apprentice, Antoine Plamondon (1804-1895), but by this time he had become a full-fledged painter and had undertaken commissions to make large-scale copies of religious paintings. The oldest of his known works date from the following year.

On 21 April 1818 Légaré married one Geneviève Damien (c. 1800-1874), also of Quebec City. Soon after his marriage (as he would later confide to a collector, toward the end of his life), he refused an offer the Governor made to send him to Italy to perfect his skills. (He would never, in fact, get to Europe.) Geneviève Légaré produced twelve children during their marriage, only five of whom survived. The Légaré family spent the rest of their life together on Saint-Angèle Street in Quebec City's upper town, successively occupying two houses there. The artist eventually came to own three income-producing houses in the same street - and another on Saint-Jean Street. He was also the Seigneur of part of the Saint-Francis seigneury at Sainte-Foy between 1827 and 1841. In other words, he was fairly well off. He died at Quebec, on 21 June 1855, after a full life.

THE CITIZEN OF QUEBEC

Since its siege and capture by Wolfe in 1759, and especially after the loss of the American Colonies, Quebec City had been the administrative, political, economic, military, social, and religious capital of British North America. In 1830, Quebec was still the most populous city in Lower Canada. Though the vast majority of its inhabitants were French-speaking Roman Catholics, Quebec was nevertheless dominated by the small group of English-speaking Protestants who controlled its commercial and administrative life. In fact, the city had a small French élite among whom figured the painter Joseph Légaré.

It seems to have been about the time of the great cholera epidemic of 1832 that Légaré first began to take an active interest in the city and its citizens. He was at that time on the Quebec City Board of Health and member of a relief committee for disease-stricken and needy families. A year after the incorporation of the city, he was elected to city council where he represented the Palais ward. He occupied this position until 1836, actively participating in council meetings and in several committees. Named a grand juror at the criminal assizes in 1835 Légaré was one of those to suggest improvements in a prison system already notoriously deficient. A year later, and according to the act of 1832 incorporating the city, municipal administration became the responsibility of the justices of the peace - among them Légaré. Stripped of his position in 1837, five days before his arrest as a *patriote*, Légaré was more or less inactive on the municipal scene until 1840 when he opposed municipal taxation on the grounds that the city council that imposed it was non-elective.

In 1842 Légaré was one of the founding members of the Quebec City chapter of the Saint-Jean-Baptiste Society, an association whose goals were the promotion of French-Canadian unity, the increase of their self-awareness, the preservation of the "French-Canadian nation" (*la nationalité franco-canadienne*) and the furtherance of the industrial and social interests of the country in general, and of Quebec City in particular. Légaré was vice-chairman of the first section of this society from 1842 to 1847. He was also a believer in temperance as a means of better exercising his freedom. Légaré also took an interest in educational matters: he was an exponent of child education and adult nightschools and favoured the Frères des Écoles chrétiennes and the setting up of public libraries. Like many of his colleagues Légaré wanted "to educate the people and bring them to the level of those with whom they live so that they may compete on more equitable terms." He was as well a member of the Quebec City Education Society between 1841 and 1849 and also (1843) of a committee for the creation of an "association whose aim was the dissemination of useful knowledge among the mercantile classes." In 1845, moreover, Légaré supported the founding of a Mechanics' Institute at Quebec City, a society whose purpose was "securing for the working classes an inexpensive means of self-education, especially in areas related to each man's trade or profession."

In 1844 Légaré conducted a successful fund-raising drive for his friend Napoléon Aubin, proprietor of the newspapers *Le Castor* and *Le Fantasque,* after Aubin's printing shop burnt down. Rebuilt, the shop would burn down again in June of 1845 in the fire in the Saint-Jean quarter that followed only a month after the one in the Saint-Roch quarter. These devastating fires gave Légaré yet another occasion to demonstrate his civic spirit. He took an active part in a number of meetings of the Fire Relief Committee and was nominated chairman of the committee of policy holders of the Canada Fire Insurance Company. Légaré also participated in various charity drives: that of 1846 for the fire victims in St John's, Newfoundland; that of 1847 for famine relief in Scotland and Ireland; and finally that of 1852 for fire victims of the conflagration of 8-9 July in Montreal.

Légaré was justice of the peace in Quebec City more or less continuously between 1843 and 1852, member of the Board of Health between 1847 and 1849, usher of the church of Notre-Dame de Québec between 1846 and 1848, and grand juror between 1843 and 1846. In 1849 he once again demanded changes in the prison system and denounced the inadequacies of the city jail - considered a real school for crime. Also, in 1849, he chaired a committee recommending amendments to the city's act of incorporation; in particular the committee demanded proportional representation, a voting age of 21, election of mayors by all electors, and restrictions on muncipal taxation. Alert to the commercial advantages of railroads since 1845, Légaré was one of their most enthusiastic promoters between 1849 and 1852.

His municipal concerns led naturally to nationalistic ones, touching the future of his homeland. Despite many defeats and delays he maintained his fighting spirit and unshakable determination.

THE NATIONALIST

In 1791 the British Parliament voted the *Constitutional Act* into effect; the *Act* complemented the *Quebec Act* of 1774. While the *Constitutional Act* maintained the French civil law and religious liberties, it divided Canada into two provinces, Upper and Lower Canada. Lower Canada had a majority population of Francophones and was being governed according to the Custom of Paris (*Coutume de Paris*). The *Constitutional Act* gave the two new provinces their first parliamentary governments, identical political institutions: the Legislative Assembly had from then on shared with the old Legislative Council the voting into effect of laws - under the authority of the Governor. In 1792 this political system had been completed by the promulgation of an ordinance that established an Executive Council nominated by the Crown. That the Executive Council was responsible not to the Assembly but rather to the Imperial Parliament would be at the root of political struggles that would last over half a century.

The first debates in the new Assembly were marked by a fundamental division between French- and English-speaking Canadians in Quebec. English-Canadians, aware they were a minority, quickly allied themselves with the Governor, the real source of power, and with his ministers in the Legislative and Executive Councils. As early as 1805

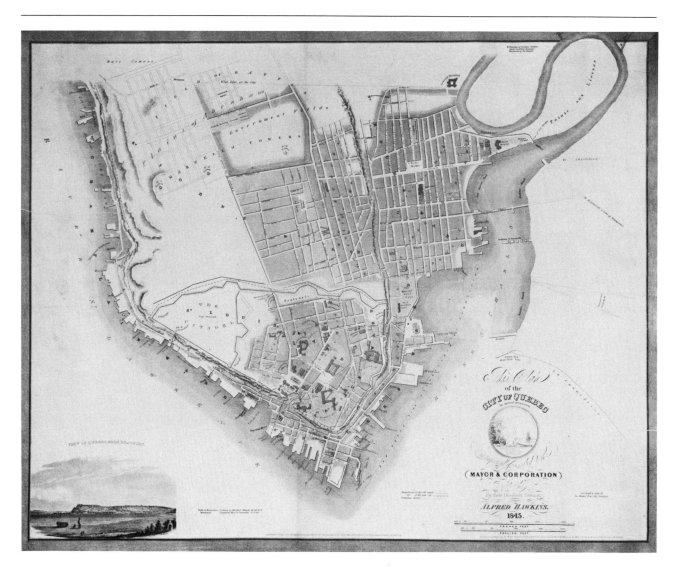

1. Alfred Hawkins, *Plan of Quebec City*, January 1845, 50 x 64.3 cm, Public Archives of Canada, Ottawa

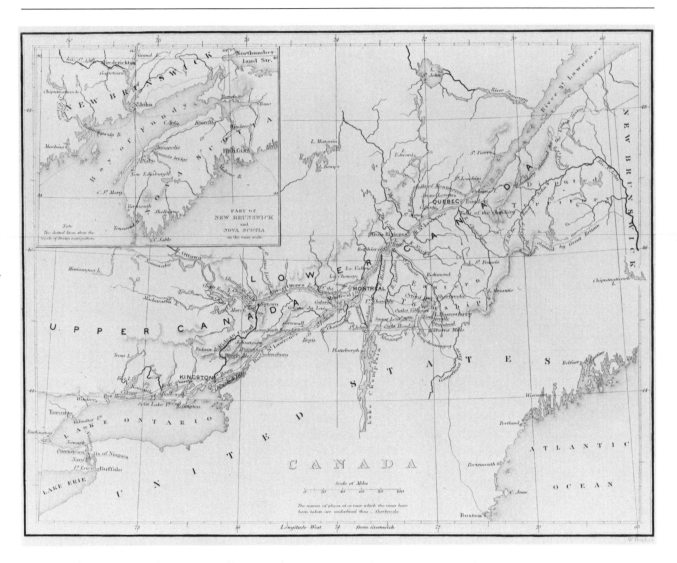

2. *Canada,* map drawn from N.P. Willis, *Canadian Scenery* (London: 1842), VOL. 1, facing p. 1,
Public Archives of Canada, Ottawa

they had founded *The Quebec Mercury* as a platform for their opinion - a gesture countered in the following year by the founding of *Le Canadien.*

In the first quarter of the nineteenth century Lower Canada underwent profound economic changes: its agricultural problems bit by bit generated ideological ones. The opposed interests of English-speaking merchants and French-speaking professional classes led to more and more entrenched and irreconcilable positions. While, on the one hand, the merchants demanded brand-new economic structures, a union of the two Canadas, and the abolition of the Custom of Paris, the Francophones, on the other hand, remained attached to traditional structures, were opposed to Union, and demanded more political power.

After the election of 1827, the Governor and Executive Council refused to ratify the almost unanimous choice of Louis-Joseph Papineau, leader of the popular party, as speaker of the Assembly. The Assembly refused in turn to reconsider its decision, and the Governor prorogued the session. Lower Canada expressed its indignation in a monster petition complaining of the Legislative Council and its injustices, of conflicts of interest of magistrates, of irregularities in fiscal expenditure, of obstacles to public education, and of the inept management of Crown Lands. Joseph Légaré was a member of the Quebec district committee of petitioners. From this point on he showed his intense admiration of, and boundless loyalty to Papineau and his political principles.

In 1833 Légaré took part in a "state of the nation" meeting, was a member of a committee that drafted an address to the Crown, the tenor of which recalled the petition of 1827-1828. A year later, in 1834, Légaré was one of those who circulated a second petition, this time in favour of the Ninety-Two Resolutions. In the new petition Papineau made a frontal attack on Britain's colonial policy, denouncing administration by Governors and the partisanship of judges, demanding control of fiscal expenditures and an elective Legislative Council. By 1836 Papineau had become more and more radical in attitude and refused assent to supply bills. Papineau kept the Assembly with him in this, despite the defection of a small group of representatives who espoused the moderate views expressed in *Le Canadien.* On this occasion Légaré led a delegation to Papineau to express moral support for him and those *patriote* deputies who had remained loyal to him. The moderate René-Édouard Caron saw in this deputation an overt criticism of himself and resigned. Légaré came very close to putting himself forward as a candidate in the by-election that followed upon Caron's resignation.

By 1837 the divorce between radicals and moderates was complete, and the situation had become very unstable. On 6 March 1837 the British Colonial Secretary of the time, Lord Russell, put before the Imperial Parliament ten resolutions, one of which authorized the Governor to use public funds without the prior assent of the Assembly. This action lit the fuse that exploded in the Rebellions of 1837-1838. During this crisis, Légaré was himself involved in all the activities of the *patriotes* in Quebec City. He became one of the directors of the reformist newspaper *Le Libéral,* in opposition to the moderate *Le Canadien* run at that time by Étienne Parent. Member of the "Permanent

Committee for the City and District of Quebec," Légaré also, it seems, supported the uprisings in the Montreal area and wished to see set up a group of "Sons of Freedom" in Quebec City itself. Arrested and jailed on 13 November 1837, he was released on his own recognizance five days later. He was accused of "forming the design of opposing the Government by force and by violence." In 1838, his trial was set, then postponed, and finally never took place.

After the rebellion and the tabling of the *Durham Report* the Imperial Parliament passed the *Act of Union* in 1840; it came into effect the following year. This new piece of legislation irritated French-Canadians in several of its provisions: Lower Canada was under-represented in the new Union relative to Upper Canada; elected representatives still had no control over fiscal expenditure; Lower Canada had jointly to assume the considerable debt of Upper Canada; and English would henceforth be the only official language of the land.

Légaré vigorously opposed Union at Quebec City and, at the elections supported the Anti-Unionists. From 1841 on he was a member of a committee for political exiles. In 1842, he was one of a committee that drafted an address to the new Governor, Sir Charles Bagot, in which decisions of Bagot's predecessor were criticized. (Légaré would later praise Bagot for his just and impartial rule.) In the election of 1844 Légaré supported his friend P.-J.-O. Chaveau, a Liberal candidate. Chaveau was elected. In 1845 he supported Chaveau again, as well as others of the Liberal minority in the Assembly.

In 1847, Légaré was named vice-chairman of the "Constitutional Committee for Reform and Progress." This political association was chaired by René-Édouard Caron and in November 1847 published an anti-government manifesto denouncing the former Governor, Lord Metcalfe, and government corruption. Extending its support to the minority party, the manifesto demanded responsible government, electoral reform, implementation of the terms of the *Act of Union*. economic reforms, loans to fire-victims at Quebec City, and a better education system. The elections of 1847 were distinguished by Papineau's return after a long exile to political life and by the victory of the reformists.

In 1848, one of the two representatives for Quebec City was named to the bench and a by-election was announced to fill the vacancy left by his resignation. Liberal ranks were divided when two candidates put their names forward: the merchant F.-X. Méthot and Joseph Légaré. Légaré had the support of *Le Canadien*, at that time under the direction of Napoléon Aubin, while Méthot had the support of the *Journal de Québec*, which belonged to Joseph-Édouard Cauchon, representative for Montmorency County. Throughout the campaign that followed, Cauchon would insist, in an insidious way, on Légaré's connections with Papineau - to whom Cauchon ascribed violence and a refusal of responsible government. In fact, Légaré supported the reformists now in power without at the same time foreswearing his loyalty to Papineau. After a hard-fought campaign Légaré succeeded in obtaining a majority of the French-Canadian vote, but was defeated all the same since Méthot had not only Cauchon's support but that of *The Quebec Mercury* and the Tories. Some

months later Légaré would demand electoral reform on the grounds that the existing system did not allow the registration of voters from the outlying areas of the city.

On 25 April 1849, a new Governor, Lord Elgin, arrived at the Union Parliament at Montreal to give Royal Assent to a bill compensating losses suffered by people in Lower Canada during the Rebellion of 1837-1838. Malcontent English-speaking Tories set fire to the Parliament buildings and its library. Légaré expressed his indignation at a large public meeting at Quebec City. He became member of a committee that drafted an address to Lord Elgin and was one of the delegation presenting it to the Governor. Lord Elgin, who was much admired by French-Canadians for his conciliatory stance, was Governor still in 1848 when responsible government was granted and when French was made one of the official languages of the Assembly.

The granting of responsible government caused a realignment of political parties. A certain number of reformists turned to radicalism (*rougisme*) and demanded universal suffrage, proportional representation, an elective Legislative Council, and fiscal restraint. In 1849, Papineau founded a party committed to separation from the British Empire and annexation to the United States. Once again Légaré followed his political idol, and it was as a radical annexationist that he stood against Jean Chabot (new commissioner for Public Works) at by-elections at Quebec City in January 1850. The campaign resulted in yet another resounding defeat for Légaré: subjected once more to Cauchon's demagogic attacks and gathering little support, Légaré was beaten by a wide margin. *The Quebec Mercury,* however, while not endorsing Légaré's political principles, praised his frankness, his impartiality, and his progressiveness and condemned the dishonest tactics of Chabot.

In the general election of 1851 Légaré supported Cauchon's adversary in Montmorency Riding. Though Cauchon was re-elected, Légaré had the satisfaction of seeing Cauchon's two protégés in Quebec City go down to defeat. The following year he sent a committee's congratulations to Papineau upon the latter's re-election in the riding of Two Mountains.

During the period 1848-1849 Légaré was one of those who promoted the settlement by French-Canadians of the Eastern Townships to offset the weakening of seignorial holdings there, to combat famine, and to counter emigration to the United States. In the same vein he would speak four years later, in 1853, for the outright abolition of seignorial tenure - which occurred in the following year.

In the general election of 1854 Légaré supported the Liberal reform candidates for the city and riding of Quebec, all of whom were returned. One of them, Légaré's friend Chauveau, shortly afterward joined the government benches. On Chauveau's recommendation Légaré was appointed to the Legislative Council on 8 February 1855, just a few months before his death.

THE CONNOISSEUR

Légaré's political engagement on the municipal and provincial levels did not prevent his playing an essential role in the cultural life of his time. From the retrospect of over a century his activities as a collector and propagandist for art reveal him to have been not just a pioneer but also

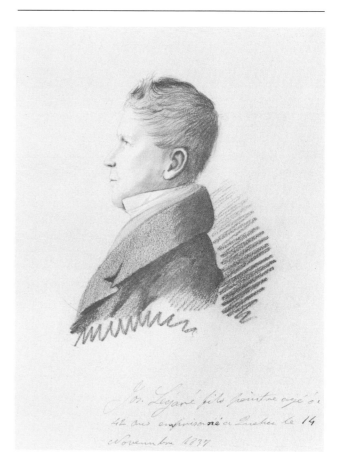

3. Jean-Joseph Girouard (1795-1855),
Jos. Légaré the Younger, Painter at the Age of 42 jailed at Quebec City 14 November 1837, photograph of drawing, Jean-Joseph Girouard Collection,
Public Archives of Canada, Ottawa

one of the very first of our connoisseurs.

After the suppression of monastic orders during the French Revolution, the French State confiscated many paintings and other works of art between 1793 and 1795; the latter languished for some time thereafter in various warehouses. In 1803, the Abbé Philippe-Jean-Louis Desjardins (1753-1833) was able to acquire more than a hundred of these paintings cheaply and in circumstances that remain obscure. He wanted somehow to enhance the churches of Lower Canada in which he had served between 1793 and 1802, but he did not get around to shipping the works off until 1816. In the spring of 1817, however, the first consignment arrived in Quebec City *via* the United States - the second not arriving until 1820. The paintings were unpacked, mounted and framed (occasionally even restored) and exhibited for sale in the Hôtel-Dieu by Desjardin's brother Abbé Louis-Joseph (1766-1848) from 1817 on.

This "Desjardins Collection," it seems, had a great influence on Légaré's career. Légaré in fact succeeded in buying some thirty of the works on sale, most with religious subjects. To accomplish this he may well have used a loan of £125 granted by his father in July 1819. Whatever the case, it was these thirty works or so that were to form the nucleus of his collection of European paintings. Hereafter, Légaré would seize every opportunity to augment it, exchanging copies he had made for originals, buying works from foreign missions at very low prices, or convincing heirs of a collector to sell him a coveted painting.

The majority of Légaré's subsequent acquisitions, however, came through Johan Christopher Reiffenstein and G.D. Balzaretti, two merchants at Quebec. Reiffenstein, cultivated and a dilettante, imported many paintings and engravings from Europe from 1816-1817 on. His imports were sometimes impressive: in an auction of 1823, for example, he displayed no less than 118 paintings, secular as well as religious in subject, and no doubt Légaré took advantage of such an opportunity to enrich his personal collection. As the years went by in fact Légaré seems to have acquired about thirty paintings from Reiffenstein alone. His dealings with Balzaretti are less well known but they were doubtless eased by the common cause they had made in politics.

From at least 1829 (and without doubt before) until 1832 inclusive, Légaré's collection was on public display at the Union Hotel in Quebec City, in rooms lent by the Government to the Literary and Historical Society of Quebec. This organization had been founded in 1824 for the advancement of literature, science, and the arts and received a Royal Charter in 1831. It included among its members Joseph Bouchette, Reverend George Bourne, Sir John Caldwell, Archibald Campbell, Abbé Jérôme Demers (1774-1853), the historian François-Xavier Garneau, Etienne Parent, James Smillie (1807-1885), Reverend Daniel Wilkie, and, of course, Joseph Légaré. In 1833, in fact, Légaré was appointed chairman of the arts section of the Society and thereafter earned praise in a speech by Reverend Wilkie. It is possible that political differences of opinion led to Légaré's resignation several years later.

In 1833, meanwhile, Légaré had built himself a new house in Saint-Angèle Street. At last he had spacious lodgings and put his paintings and engravings on display, inviting the general public to view them from November of that year. His initiative drew the attention of the newspapers of the city who praised his good taste, perserverance, and patriotism. It also drew congratulations from the Governor, Lord Aylmer, well known as a knowledgeable patron of the arts.

Five years later, in June, Légaré and Thomas Amiot, a lawyer, opened The Quebec Gallery of Painting on the upper floors of a building Amiot had just erected on the north side of the market square in the upper town. The great exhibition hall was lit by a domed ceiling, while a telescope and *camera obscura* were also available to visitors. (The view from the roof was much praised.) The papers reported that the collection consisted of more than a hundred paintings - most belonging to Légaré. They published the checklist adding further praise of Légaré and Amiot. The new establishment soon furnished a reason for further important acquisitions.

The importance of the Gallery for the self-perfection of artists was emphasized at the time. The master paintings, it was said, constituted excellent models for artists both for their technical variety and for their diversity of genre. Called a "temple of the fine arts" the Gallery welcomed, in 1838, musical concerts and a school of drawing and painting run by Henry D. Thielcke (*fl.* 1832-1866). Also in 1838, Légaré and Amiot exhibited "landscape views," and a year later, a portrait of Queen Victoria by the American Thomas Sully, as well as a large miniature by Guiseppe Fassio (*c.* 1810-1851).

The understanding that seems to have existed between Légaré and Amiot lasted until 1836 when Légaré sold Amiot half his collection, composed at that time of 134 paintings. In October 1838 Amiot promised Légaré to go to Europe or elsewhere to sell part of their common collection. We know Amiot did thereafter find buyers for at least four paintings. He must thereafter have experienced serious financial reverses, for, in debt to Légaré, Amiot in March 1840 made over the paintings remaining in his possession. It is likely that the Quebec Gallery of Painting closed its doors in 1840, after just missing destruction by fire.

In the same year, Quebec City welcomed the Frenchman Alexandre Vattemare (1796-1864) whose project for an institute won Légaré's support. An "original" to say the very least, Vattemare created an international system for the exchange of duplicate holdings in the arts, natural sciences, literary and scientific works. After his visits first to Montreal and then to Quebec City Vattemare expanded his exchange system to include a grandiose project for an institute. The institute was expected to gather together already extant associations - in the case of Quebec City this included the Literary and Historical Society, the Mechanics' Institute, and the Quebec City Library. On the occasion of the great farewell meeting of 2 March 1841, Vattemare noted that the desired society should "comprise library, natural science museum, art museum, collection of objects of general interest, painting and drawing academy, lecture hall, and public education classrooms - finally all that could help the development of genius, taste, and

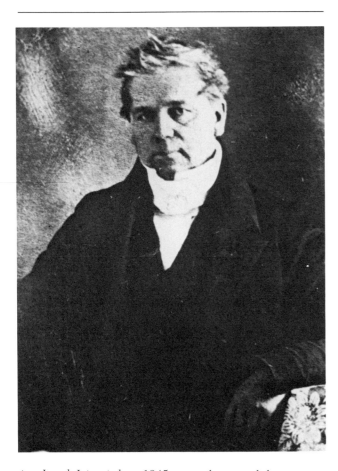

4. *Joseph Légaré about 1845*, copy photograph by J.E. Livernois from an old daguerreotype, Archives nationales du Québec, Quebec City

intelligence." A committee was set up to work for the creation of a Vattemare Institute. The membership included the architect Thomas Baillairgé (1791-1859), the historian François-Xavier Garneau, Archibald Campbell, and P.-J.-O. Chauveau, as well as the painters Joseph Légaré and Antoine Plamondon. Their high hopes, and Vattemare's, unfortunately came to nothing - unanimity vanishing as quickly after Vattemare's *departure* as it had appeared after his *arrival*.

All the same, certain of the ideas Vattemare put forward had some influence in the formulation of a project for a national gallery at Quebec City in 1845. On 20 February eleven citizens - among whom were Légaré, Aubin, Campbell, and Judge Édouard Bacquet - signed a letter to the chairman of the City Council requesting that councillors take advantage of the vacancies in certain government buildings to found a national gallery. They drew to the Council's attention the fact that "few cities on this continent [have] more precious paintings, old engravings, than one could gather together here." In the committee's eyes "one quickly realizes the pleasure and utility [of the projected institutions] that would inculcate a taste for the fine arts and facilitate their teaching to the young." The letter had no result, but three years later Légaré exhibited temporarily certain paintings from his collection - and some of his own work - in one of the halls of the Legislative Assembly in Quebec City. A reader of *Le Canadien* - while Aubin was still publisher - blamed the government for neglecting to furnish chambers sufficiently spacious for the whole of Légaré's collection. In the same year a new proposal was made for a national gallery - and Légaré was probably involved - but it was to suffer the same fate as the first in 1853.

In 1851 Légaré carried out considerable rebuilding to a new property at the corner of Saint-Angèle and Sainte-Hélène Streets (the latter the present-day McMahon). On the upper floor he created a vast vaulted gallery lit by a great light-well. The following year, he published a catalogue of his collection and admitted the public free of charge. In September, he received Lord Elgin as a visitor and Elgin displayed great satisfaction with what he saw.

At the time of the Governor's visit the *Journal de Québec* emphasized both the marked interest of outsiders and the almost total indifference of Quebeckers to Légaré's gallery. It seems in fact that Légaré's many initiatives to diffuse and develop a taste for the fine arts among his fellow-citizens and compatriots did not produce the results he counted on. With the exception of a certain local élite - including men such as Aubin, Bacquet, Campbell, Chauveau, and Wilkie - Légaré's clientele comprised transient foreigners, especially British. This accords well with the fact that the catalogue published by Légaré in 1852 was in English only.

After Légaré's death his collection of paintings and engravings remained the property of his widow until 1874 when it was acquired almost in its entirety by Laval University, an institution controlled by the Séminaire de Québec. This collection, upon examination, reveals Légaré's limitations. Never having travelled to Europe, Légaré the autodidact had to build his collection according to his own lights, basing it only on those paintings that reached Quebec City in his own lifetime. Even given these limitations, the high quality of several works compels us to admit he had a remarkable flair as a connoisseur.

Légaré's expert opinion was often solicited in his lifetime, particularly for inventories of estates. This occurred, for example, in 1853, when he made the inventory of the important collection of Judge Bacquet, with whom Légaré jointly owned some paintings. Toward the end of his life he was three times member of selection committees for industrial exhibitions held at Quebec City and which included works of art. In 1854, Légaré was even on the provincial committee planning representation at the universal exhibition to be held in Paris the following year.

In 1879, nearly twenty-five years after Légaré's death, Chauveau remembered well his friend the connoisseur: "How many agreeable hours," Chauveau was to write, "did I pass amidst his paintings, works he brought out and showed me, which, to put it mildly, were stacked about in small storage cupboards ...! When, later, I had the pleasure of visiting the great galleries of Europe, more than once the memory of these happy hours, the knowledgeable remarks I heard him make, came back to enlighten and guide me on my too-rapid tour."

THE ARTIST

Légaré's distinct interest in European master paintings had, to a certain extent, an influence on his own work from the very first years of his artistic career. Responding to the needs of parish churches and religious orders, Légaré supplied a great number of copies of religious works from Europe - some thirty of which we know from the period 1820-1825. Several originals of these were from the Desjardins collection. While such copying brought in income, it was also a form of education and a means of refining technique. Throughout his career Légaré would interest himself in painting copies, sacred and profane in subject. On occasion he would even use his talent as a copyist, borrowing certain elements from European sources to furnish his own compositions.

As a master-painter Légaré had three apprentices: Antoine Plamondon (between 1819 and 1825); a certain Jean Langlois (between 1825 and 1826); and possibly Thomas Valin (c. 1810-1857), from 1827. Doubtless these pupils helped Légaré in his copying. In 1829, Légaré took advantage of the exhibition at Quebec City of a portrait of George IV to make a copy (see cat. no. 25). This last was praised by Governor Kempt and the artist Lieutenant-Colonel James Patterson Cockburn (1779-1847) and was acquired by the Legislative Council. The artist would repeat the experiment the following year with a portrait of George III, but was not so successful (see cat. no. 13). Légaré, however, recognized the curiosity and interest excited by these portraits and exploited them for some inexpensive self-promotion to attract new clients. The venture would be repeated in 1839 with a portrait of the young Queen Victoria (see cat. no. 40).

Some years earlier, in 1828, Légaré had won an honorary medal from the Society for the Encouragement of Arts and Sciences in Canada at Quebec City for an original painting *The Massacre of the Hurons by the Iroquois* (see cat. no. 12). Despite its evident weaknesses, this work demonstrates Légaré's determination to diversify his work. The

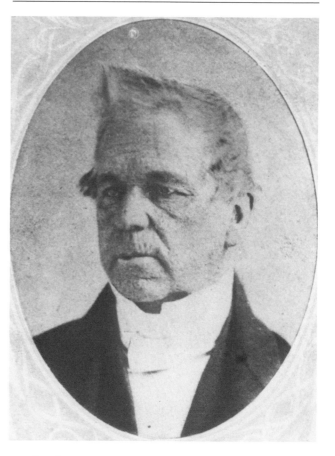

5. *Joseph Légaré Late in Life*, anonymous photograph from an old daguerreotype, Archives nationales du Québec, Quebec City

award he won certainly encouraged him to persist in this intention. After the joint venture of the decoration of the new Theatre Royal at Quebec in 1832 (see cat. no. 252), Légaré's career took a decisive turn a year later. In 1833, as well as chairing the arts section of the Literary and Historical Society of Quebec and opening his own collection to the general public, Légaré designed the first seal of the city of Quebec (see cat. no. 253), painted the masthead of *Le Canadien* (see cat. no. 22), and was for the first time referred to as a History Painter. As well, he published advertisements in which he said he was ready to do "landscape views" on commission for which offer he was praised by the author of a long article in *The Quebec Gazette*. The journalist was happy to see the artist doing something other than religious paintings and noted with pleasure that Légaré would devote a good part of his energies to painting the finest landscapes of his own land. In fact Légaré's first experiments in the genre went back to the 1820s – when he also did his first portraits.

From 1833 on Légaré's career became more and more complex and his artistic production more varied. His audacities followed cautious retrogressions, and vice versa. The artist seemed not to neglect any aspect of his talent. From then on his artistic development was inseparable from other social, political, and cultural concerns. Certain of his interests led him to exhibit in Montreal in 1842 and 1848, and at Quebec in 1843, 1845, and 1848. His winning of two first prizes at the Quebec City Industrial Exhibition a year before his death was a modest crowning of an artistic career that had been particularly intense and innovative.

There are many facets to Légaré's work. As well as occasionally working in the areas related to his first-ever *métier* of painter-varnisher (bronzing, gilding, statue-painting, restoration), Légaré painted religious subjects, portraits, landscapes, contemporary scenes, historical subjects and so on. The work of such an "image-hunter" is hardly easy to summarize. It raises, for example, questions about his working methods.

Though one may note from time to time real differences of quality between certain versions of the same subject, Légaré was nevertheless an excellent copyist. Certain religious works in fact bear eloquent witness to his undoubted mastery. Légaré seems also to have taken particular care in copying secular works in his collection and the large-format portraits of British sovereigns exhibited at Quebec during his lifetime - though in the latter case his flair for self-promotion was a not-irrelevant factor.

Relatively few of Légaré's portraits have come down to us. Copies excepted, the majority were intended for his family circle or his social or cultural entourage. Unlike many of his contemporaries he did not devote himself to portraiture, but he did produce a few portraits - like that of Josephte Ourné - of a remarkable concentration and strength (see cat. no. 56).

It was in his landscapes that Légaré showed real innovation. The first *native* Canadian landscape-painter, he inherited from British topographical painters a pronounced taste for waterfalls, rivers, forests, country homes, certain cityscapes, and generally speaking certain "picturesque" views. He was aware of Cockburn from at least 1829 on. We know that Légaré, like British artists, was skilled in the use of the *camera lucida* and able to find the most interesting points of view. He was praised by a journalist in 1847 for having succeeded, on natural talent alone, "in bringing to life on canvas the lovely and fertile countryside of Canada, its peaceful farms, taken *in flagrante delicto* amidst a too-prolonged rest, the blue waters of its rivers, its green and sombre forests, its picturesque waterfalls." The recent discovery of several oil-on-paper sketches by Légaré permits a confirmation of these comments.

Légaré also took an interest in everything touching the life of his times. Several of his works find roots in his socio-political concerns: the seal of the city of Quebec, the masthead of *Le Canadien*, his religious or political banners (see cat. nos 254-258), his paintings of temperance monuments (see cat. nos 231-232), and the paintings devoted to the cholera plague of 1832 (see cat. no. 19), the landslide of 1841 (see cat. no. 44), and the great fires of 1845 (see cat. nos 69-73). Other allegorical paintings have a more marked political connotation, like *Landscape with Wolfe Memorial* (see cat. no. 42) or *Election Scene at Château-Richer* (see cat. no. 78). One could also qualify many works of the artist from the point of view of his commitments.

Finally Légaré painted a certain number of notable history paintings. Though this category is difficult to define, it seems fair to say that it would include works like *First Monastery of the Ursulines at Quebec* (see cat. no. 41), *Memorials of the Jesuits of New France* (see cat. no. 52), *The Martyrdom of Brothers Brébeuf and Lalement* (see cat. no. 53), *The Battle of Sainte-Foy* (see cat. no. 81), and a number of works showing the customs of North American Indians. The latter subject, especially after 1840, seemed to have interested Légaré and those that have come down to us are sometimes concentrated and evocative, sometimes even full of real "finds" and true audacities - as for example the series painted between 1840 and 1844. These works illustrate perfectly the concept of the "barbarous savage," and of the "noble savage." In this indecisiveness, Légaré was at one with his contemporaries, in particular his historian friend, F.-X. Garneau.

Légaré's overall achievement stands in striking contrast to that of his most prolific contemporaries like Roy-Audy (1778-c. 1848), Antoine Plamondon, and Théophile Hamel (1817-1870): it goes far beyond the religious painting and portraits, the chief concern of these fellow-artists. Légaré's work, in its variety and daring, often even went beyond the taste of the clientele of the age. Thanks only to his relative facility could Légaré paint as he pleased without constant reference to saleability. A forerunner, a new breed of artist, he did not always find a market for many of his works. Certainly he sold several religious works to parish churches and religious orders - most notably in commissions for history paintings from the Jesuits and Ursulines - but his landscapes were all but rejected by his fellow-countrymen, as other of his works were, because of his political opinions. With the exception of such supporters as Campbell, Chauveau, the Jourdain brothers, Abbé Raimbault or Jacques Viger, Légaré's most appreciative clientele were, as newspapers of the day often emphasized, foreigners. Many works acquired by this transient population, in fact, have never afterward been traced. What, for example, became of the landscape series sold by Légaré to a lady from Liverpool? The disappearance of such works is all the more regrettable because the few we have discovered abroad are among his finest.

Throughout his life Légaré maintained excellent relations with the art world in Quebec. He knew well Plamondon, Valin, François Baillairgé (1759-1830), Cockburn, Fassio, Thielcke, R.C. Todd (1809-c. 1865), Somerville (*fl.* 1839-1856), and many others. Towards the end of his life his new gallery was a special meeting place for artists and amateurs of painting in the city. After his death a large proportion of his work remained in the hands of his widow before passing, with most of the rest of his collection, to Laval University in 1874. Several works of his were lost or destroyed. A number of those that survived are in poor condition. This last has been one of the major obstacles to the organization of the present exhibition - for which several have indeed been restored.

Légaré the man, and his work, have been underestimated for a long time - neglected, even forgotten. A real "one-man-band," however, he was a respected and esteemed citizen, a loyal and sincere patriot, a remarkable connoisseur, and an innovative artist firmly rooted in his time and its faithful mirror.

John R. Porter

Chronology

This chronology is restricted to the artistic life of Légaré.

1795 Birth of the younger Joseph Légaré at Québec, 10 March

1808 Student at the Séminaire de Québec, Quebec City, until 1811

1812 Apprenticed to the painter-varnisher Moses Pierce

1817 Henry Dolsealwhite, apprenticed to Légaré, painter-varnisher
Works on the restoration of some of the paintings in the Desjardins Collection

1818 Married Geneviève Damien
Turned down an offer, shortly after his marriage, to go and study in Italy

1819 Antoine Plamondon, apprenticed to Légaré, master-painter

1820 First known religious paintings

1825 Jean Langlois, apprenticed to Légaré, master-painter
Sold nine religious paintings to the Hôpital-Général de Québec

1827 (?) Thomas Valin, apprenticed to Légaré

1828 Won an honorary medal from The Society for the Encouragement of Arts and Sciences in Canada for his painting *The Massacre of the Hurons by the Iroquois* (cat. no. 12)

1829 Exhibits his collection of paintings at The Literary and Historical Society of Quebec at the Union Building
Made a copy of the portrait of George IV by Wheatley (cat. no. 25). His painting is purchased for the Chamber of the Legislative Council and earns the praise of Governor James Kempt and Lieutenant-Colonel James Patterson Cockburn

1830 Makes a copy of the portrait of George III by Reynolds (cat. no. 13)

1831 A founding member of The Literary and Historical Society of Quebec at the time the society was granted a royal charter

1832 Contributes to the decorating of the Theatre Royal at Quebec
Cholera at Quebec City (cat. no. 19)

1833 Chairman of the Arts Section of The Literary and Historical Society of Quebec
Le Canadien (cat. no. 22)
Opened his collection to public view and received a visit from the Governor, Lord Aylmer
Designed the first seal of the city of Quebec

1836 Executed his largest known work *The Crucifixion* for the Church of Saint-Patrice at Quebec
Sold half of his collection to the lawyer Thomas Amiot

1838 With Amiot, opened the Quebec Gallery of Painting.
Offered for sale "Landscapes"
The painter Thielcke gave painting and drawing classes at the Picture Gallery

1839 Copied the portrait of Queen Victoria by Sully (cat. no. 40)
The artist Fassio exhibited a large miniature at the Quebec Gallery

1840 Amiot ceded his part of the collection of paintings to Légaré
Sold some oils-on-paper to Jacques Viger
Used the *camera lucida*

1841 Supported the project for an Institute Vattemare at Quebec City

1842 Executes the main banner for the Saint-Jean-Baptiste Society of Quebec City
Exhibited paintings in the salon of Mrs Saint-Julien, at Montreal

1843 Exhibited paintings at the Mechanics' Institute in Quebec City
Executed four banners for the sections of the Saint-Jean-Baptiste Society of Quebec City
Memorials of the Jesuits of New France (cat. no. 52)

1844 *The Engagement of an Indian Girl* (cat. no. 57) and *The Despair of an Indian Woman* (cat. no. 59)

1845 Exhibited paintings at the Mechanics' Institute, Quebec City
Proposed a scheme for a national gallery at Quebec
Paints a series of works of the fires of the Saint-Jean quarter and Saint-Roch quarter

1848 Exhibits works at Montreal, then at Quebec in a room of the Legislative Assembly, some works offered in a lottery

1849 Executes a banner for the Frères des Écoles chrétiennes

1850 Member of a committee to organize an industrial exhibition at Quebec
Rented an apartment to the painter R.C. Todd

c. 1851 *Election Scene at Château-Richer* (cat. no. 78)

1852 Published a catalogue to his collection of paintings. His new picture gallery became the meeting place of local artists and enthusiasts of painting at Quebec

1853 Evaluates the estate of the judge Édouard Bacquet with whom he shared ownership in some paintings

1853-54 Rented an apartment to the painter Martin Somerville

1854 Wins two first prizes at the Lower Canada Provincial Agricultural and Industrial Exhibition - one probably for *The Battle of Sainte-Foy* (cat. no. 81)
Designs the funeral wagon used to transport the remains of the Heroes of 1760
Member of the provincial committee for the world exhibition at Paris in 1855

1855 Dies at Quebec on June 21

1874 The Séminaire de Québec (Laval University) acquired almost the whole of Légaré's collection of pictures and several works by Légaré himself

Catalogue Raisonné

NOTE

In the catalogue entries, the Bibliography is not limited solely to writings that refer to the particular painting. The Bibliography includes all references (sources, printed matter, visual documents etc.) related to the content of the work and to events directly or indirectly related to the realization of the work. In sum, the section includes all references used in writing the catalogue entry. We have opted for this approach because of the rich content of many of the works and because much of the information used is unpublished.

In dimensions, height precedes width. Quotations of English texts are reproduced exactly from the original; translations are indicated (trans.).

The entire catalogue was written by John R. Porter with the exception of the following entries by Jean Trudel: 2, 3, 4, 9, 10, 11, 12, 15, 22, 26, 40, 41, 42, 43, 44, 52, 53, 55, 56, 59, 60, 69, 70, 71, 72, 73, 74, 78, 81.

ABBREVIATIONS

ACSV	Archives des Clercs de Saint-Viateur, Montreal
AHGQ	Archives de l'Hôpital-Général de Québec (communauté)
AJQ	Archives judiciaires de Québec
AMUQ	Archives du monastère des Ursulines de Québec
AMUTR	Archives du monastère des Ursulines de Trois-Rivières
ANQ-Q	Archives nationales du Québec, Quebec
ANQ-TR	Archives nationales du Québec, Trois-Rivières
A.P.	Archives paroissiales
ASJCF	Archives de la Société de Jésus, province du Canada français, Saint-Jérôme
ASQ	Archives du Séminaire de Québec
AVQ	Archives de la ville de Québec
DBC	Dictionary of Canadian Biography
IBC	Inventaire des biens culturels du Québec (formerly the Inventaire des oeuvres d'art, Fonds Gérard Morisset et inventaire provisoire), Quebec
RHAF	Revue d'histoire de l'Amérique française
SQ*	Séminaire de Québec
SSJB	Société Saint-Jean-Baptiste
LU*	Laval University, Quebec

Author's note

Laval University was founded in 1852 by the Séminaire de Québec, and until the early 1970s the Superior of the Séminaire was officially the Rector of the University. In the beginning, the University was located in buildings adjacent to the Séminaire de Québec. It was not until about the beginning of the 1940s that Laval University began slowly to establish itself on the campus at Sainte-Foy. The Musée du Séminaire de Québec is today situated in the buildings where the University was originally, still a part of the Séminaire de Québec. The museum has for a long time been known as the Musée de l'Université de Laval.

Exhibited Works

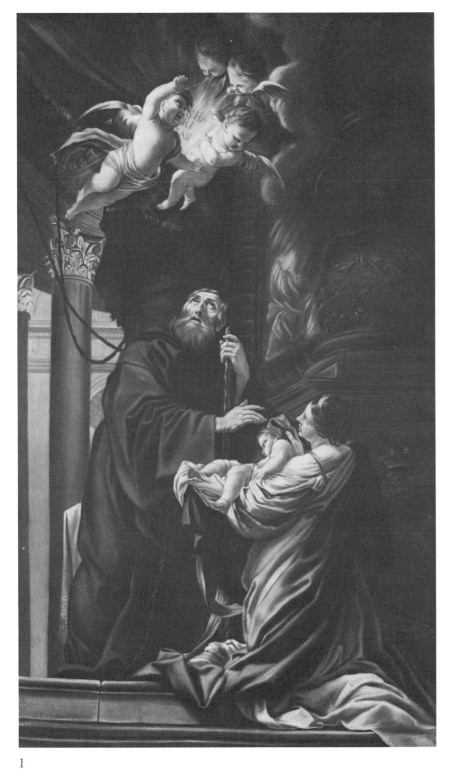

1

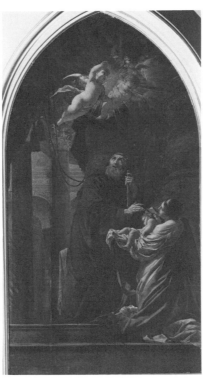

1a Simon Vouet, *Saint Francis of Paola Raising his Sister's Child from the Dead,* First half seventeenth century, Oil on canvas, 1.8 x 3.0 m, Église de Saint-Henri de Lévis

1 *Saint Francis of Paola Raising his Sister's Child from the Dead* c. 1821
Oil on canvas, 2.92 x 1.73 m

Inscription: Signed l.l., *J. LÉGARÉ.*

Provenance: Church of Saint-Augustin, Portneuf, 1836; Grand Séminaire de Québec, Sainte-Foy, 1961; National Gallery of Canada, 1976 (18619).

Bibliography: IBC, Joseph Légaré and Saint-Augustin files; Béchard (1885), p. 198; J.-E. Roy, vol. 2 (1898), p. 208; East (1934), p. 5; Morisset, "La collection Desjardins - À Saint-Henri-de-Lauzon" (1934), pp. 320-321; Réau, Book III, vol. 1, pp. 535-537.

It was in 1817 that the religious paintings of the Desjardins Collection, originally belonging to churches in France, were exhibited and put up for sale at the Hôtel-Dieu in Quebec. Between 1820 and 1824, the parish of Saint-Henri in Lévis acquired seven of these paintings, including *Saint Francis of Paola Raising his Sister's Child from the Dead* (which arrived in Quebec in 1817) by Simon Vouet, and *Saint Philip Baptising the Eunuch of Queen Candace* (which arrived in Quebec in 1820) by a still unidentified master (see cat. no. 2). In 1836, the parish of Saint-Augustin bought two pictures of the same size from Joseph Légaré which were copies of these two works kept at Saint-Henri. Légaré was paid £15 each for the pictures. Both are signed, but only the *Saint Philip* is dated: 1821. Therefore, the pictures probably were still at the Hôtel-Dieu when Légaré made these copies, which he kept until 1836 before finding a buyer.

When restoration work began on the church of Saint-Augustin in 1961, it was decided to transfer most of the religious pictures to the Grand Séminaire de Québec for storage, and this was carried out in the summer of 1962. In 1975, as the Grand Séminaire was to be used for other purposes, several of the paintings were offered for sale to the National Gallery of Canada, which subsequently acquired the *Saint Francis of Paola* and the *Saint Philip*, in 1976. The former work was restored in 1976; the latter work was restored the following year.

Saint Francis of Paola (1416-1507) was the founder of the Order of Minims, Franciscans or reformed Minor Brothers (see cat. no. 5). Very quickly his miracles earned him a reputation as a healer. His motto was *Charitas* or *Humilitas.* After the suppression of the monastic orders at the time of the French Revolution, a painting by Simon Vouet entitled *Saint Francis of Paola Raising his Sister's Child from the Dead* was seized by the state and passed through different hands before being acquired by the Abbé P.J.L. Desjardins. This picture, whose subject is unique in the iconography of the saint, was engraved by Jean Boulanger in 1655. This painting was probably one of those executed by Vouet for the church of the Minims at Place Royale in Paris in the first half of the seventeenth century. In 1878, several years after its acquisition by the parish of Saint-Henri, the painting was enlarged so that it would better suit the neo-Gothic style of the new parish church.

In Légaré's copy, Saint Francis is shown clad in the full

frock of his order. Leaning on a stick, he stretches out his right hand towards the dead child presented him by his kneeling sister. The saint has a long beard and lifts his eyes to heaven towards a group of angels encircling his radiant motto. Having had difficulty in deciphering the motto on Vouet's picture, Légaré painted the inscription as *SHA/RI/TAS* instead of *CHA/RI/TAS*. The scene takes place near an altar surmounted by a picture framed by imposing wreathed columns and the background is an architectural setting. Légaré's copy is remarkable for its faithfulness to Vouet's original.

There exists another copy of this picture, also by Légaré. Painted at an unknown date, for the church of Ancienne-Lorette, the painting now belongs to the Musée du Québec (see cat. no. 136). This signed version is far less finished than the Saint-Augustin painting. Its execution is less careful, even rough. It should also be noted that Légaré, in his visual way, borrowed elements from Vouet's picture for four other religious compositions. At Châteauguay, he painted a *Virgin Mary Consoling the Afflicted* in which the figure of Saint Francis's sister holding her child may be seen (see cat. no. 125); the same figure appears in *The Virgin Mary Mediating for the Christians*, a work belonging to Mr Jean Soucy of Quebec City (see cat. no. 124). In a picture painted for the church of Saint-Gilles about 1854, he borrowed the figure of Saint Francis to represent the patron saint of the parish (see cat. no. 141). In this picture the holy anchorite is in a forest beside a doe which had given him her milk, and he lifts his right hand over the head of a kneeling man. Two of the angels that dominate Vouet's composition are to be found in *The Annunciation* that Légaré painted for the church of Ancienne-Lorette and which is now in the Musée du Québec (see cat. no. 87).

National Gallery of Canada, Ottawa

2 Saint Philip Baptizing the Eunuch of Queen Candace 1821
Oil on canvas, 2.91 x 1.72 m

Inscription: Signed and dated l.l. *J. LÉGARÉ P-XIT/1821.*

Provenance: Church of Saint-Augustin, Portneuf, 1836; Grand Séminaire de Québec, Sainte-Foy, 1961; National Gallery of Canada, 1976 (18615).

Bibliography: IBC, Joseph Légaré and Saint-Augustin files; Béchard (1885), p. 198; J.-E. Roy, vol. 2 (1898), p. 206; East (1934), p. 5; Morisset, "Joseph Légaré copiste [à l'Ancienne-Lorette]" (1934); Morisset, "La collection Desjardins - À Saint-Henri-de-Lauzon" (1934), pp. 325-326; Réau, Book III, vol. 3 (1958), pp. 1069-1071.

For the history of this painting see text of cat. no. 1.

The painting represents Saint Philip, one of the first seven deacons of the Church of Jerusalem, baptising a black eunuch, the Queen of Ethiopia's chamberlain. This is the best-known episode in the life of the saint. On the

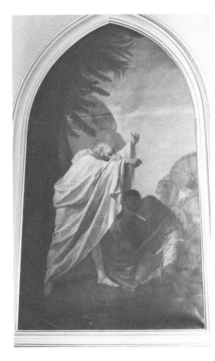

2a Anonymous, *Saint Phillip Baptising the Eunuch of Queen Candace*, Seventeenth century, Oil on canvas, 1.8 x 3.0 m, Église de Saint-Henri de Lévis

2b Detail: Joseph Légaré's signature from cat. no. 2

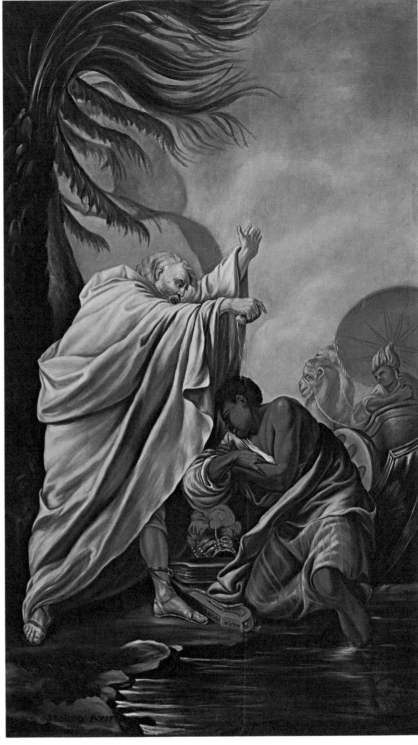

2

road from Jerusalem to Gaza, the two met, and the chamberlain asked the saint to ride with him in his chariot; the saint explained the prophecy of Isaiah: "Neither let the eunuch say, Behold, I am a dry tree." As a result of Saint Philip's explanations, the eunuch asked to be baptised.

In the painting, Saint Philip is pouring water onto the head of the eunuch kneeling before him. Between them lies the feathered helmet of the eunuch, placed on a book (perhaps the text of Isaiah's prophecies), and an object that is hard to identify. Behind the saint rises a palm tree, while in the eunuch's chariot, drawn by camels, the driver watches the scene. Légaré's painting is very faithful to the original which still belongs to the church of Saint-Henri in Lévis.

Légaré made another copy of the Saint-Henri painting. Smaller in size, it is signed at lower left, but is not dated. The painting belonged to the church of Ancienne-Lorette but was sold in 1973 to the Musée du Québec (see cat. no. 160). From the stylistic point of view, the Musée du Québec version is slightly different from that of the National Gallery, in that it is less precisely executed, as if the painter no longer had the model in front of him while painting. No document to date, however, enables us to date the Musée du Québec version, nor say when it was acquired by the parish of Ancienne-Lorette.

Finally, there exists a another copy of the Saint-Henri painting that can be attributed to Joseph Légaré. Now in the presbytery of the church of Châteauguay, it formerly (before 1961) hung in the church (see cat. no. 159). In its present state of preservation, we are prevented from making a useful comparison with the two other known versions. Nor do we know when it was acquired by the parish of Châteauguay, but the attribution to Légaré is possible.

National Gallery of Canada, Ottawa

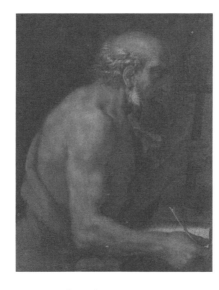

3a Attributed to Francesco Mazzuola Parmegiano, *Saint Jerome,* Oil on canvas, 78.7 x 63.5 cm, Musée du Séminaire de Québec, Quebec

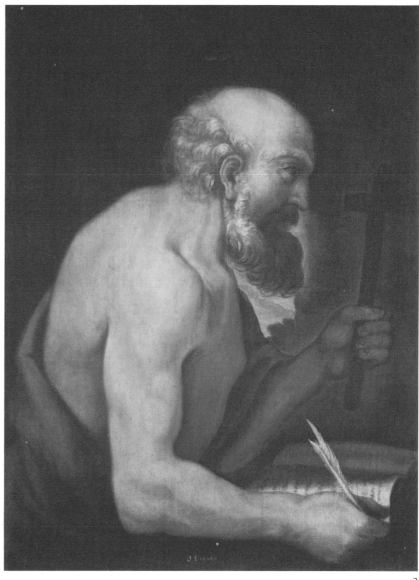

3

3 *Saint Jerome* c. 1821
Oil on canvas, 81.3 x 59.7 cm

Inscription: Signed l.c., *J. LÉGARÉ.*

Provenance: Church of Saint-Charles, Charlesbourg, 1822; private collection, 1975.

Exhibition: 1971, March, Quebec, Musée du Québec, *Charlesbourg, atelier d'art traditionel.*

Bibliography: ASQ, *Séminaire 12,* no. 41(1874), p. 5, no. 201; IBC, Joseph Légaré file; Laval University Catalogues (SQ) (1908), pp. 103-105, no. 165; Morisset, "La peinture au Canada français" (1934), p. 93; Harper (1970), p. 194; Noppen & Porter (1972), p. 54.

At a churchwardens' meeting in the parish of Saint-Charles of Charlesbourg in 1821, it was agreed that "Sieur Légaré, painter, should be given the Saint Jerome that is in the church, in exchange for a copy of the same, or for another painting of the same size." Until 1974, there was

a painting in the church of Charlesbourg representing Saint Jerome and signed by Joseph Légaré - a fact that indicates that the exchange did take place in 1821, or shortly afterwards. Moreover, a European painting of the same size and representing the same subject is still in the collections of the Séminaire de Québec. This last picture may quite possibly have been acquired by the Seminary in 1874 at the sale of Joseph Légaré's collection of paintings.

In 1822, the account books of Charlesbourg parish mention a payment of £2.10.0. for "pictures." This may have been a payment to Légaré for the *Saint Jerome* and for another picture, *Ecce Homo* (see cat. no. 4), of the same size, which also belonged to Charlesbourg. The two works were sold by the parish in 1974. The *Saint Jerome* was acquired that same year by a private collector who had it restored in Montreal in 1975.

In 1908, James Purves Carter attributed the original picture copied by Joseph Légaré to the Italian painter Francesco Mazzuola Parmegiano (1504-1540). The saint, one of the four great doctors of the Roman Church, is depicted in a kind of grotto through which a landscape can be seen. He holds a crucifix in his left hand and a pen in his right hand. An open book lies before him. Perhaps he is in the process of writing the life of Saint Paul the Hermit, or translating the Holy Scriptures. In his copy, Légaré kept very close to the original painting to which he tried to be as faithful as possible.

It is very probable that the exchange of pictures was requested by Légaré who saw the chance to add this work, at very little cost to himself, to the collection of European works he must have owned by that time. As for the Charlesbourg parishioners, they were undoubtedly quite pleased to see a picture in good condition replace an old canvas showing the ravages of time.

Private Collection

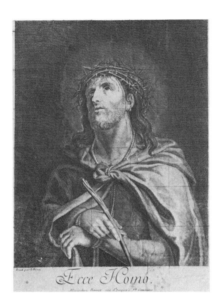

4a *Ecce Homo,* Anonymous engraving after a work by Charles le Brun, 23.0 x 18.4 cm, Archives du Séminaire de Québec, Quebec

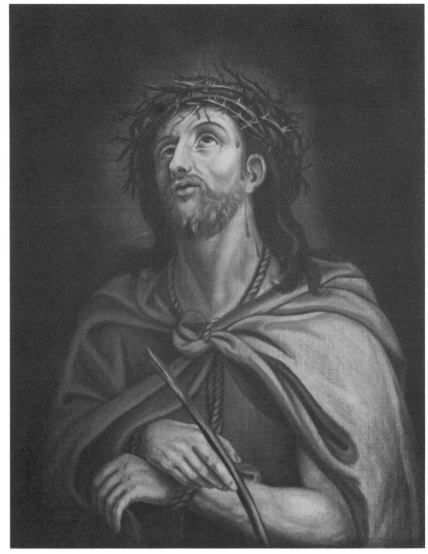

4

4 Ecce Homo c. 1821
Oil on canvas, 81.3 x 63.5 cm

Provenance: Church of Saint-Charles, Charlesbourg, 1822; private collection, 1975.

Bibliography: ASQ, Portfolio 80-G; ASQ, Séminaire 12, no. 41 (1874); IBC, Légaré and Charlesbourg files; Morisset, "La peinture au Canada français" (1934), p. 93; Harper (1970), p. 194; Noppen & Porter (1972), p. 54.

In 1821 the parish of Charlesbourg agreed to exchange with Joseph Légaré a European painting representing Saint Jerome for a copy or another picture of the same size. In 1822 the same parish made a payment of £2.10.0. for "pictures." The *Ecce Homo* which remained in Charlesbourg until 1974 is the same size as the *Saint Jerome* (see cat. no. 3) signed by Légaré, which also belonged to the church. The payment may well have been made to Légaré for the two paintings.

Légaré's *Ecce Homo* was sold in 1974. It was acquired in 1975 by its present owner, who had it restored in

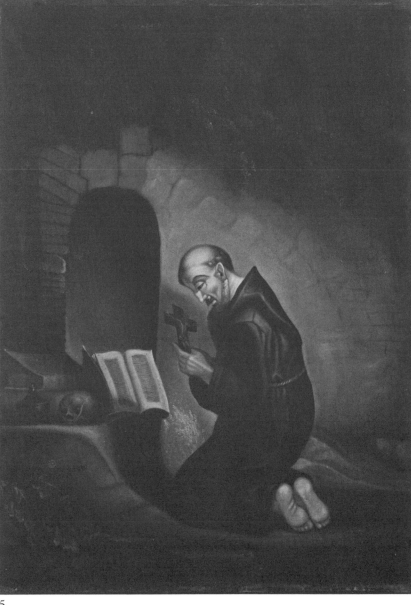

5

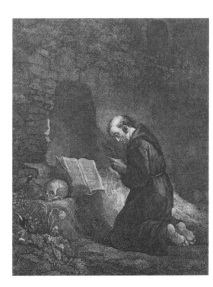

5a H. Guttenberg, *Saint Francis*,
Engraving after a work by Rembrandt
(1606-1669), 20.5 x 16.2 cm,
Archives du Séminaire de Québec,
Quebec

Montreal the following year.

In the Archives of the Séminaire de Québec, Portfolio 80-G contains a French engraving of a painting by Charles Le Brun (1619-1690) and entitled *Ecce Homo*. This engraving is squared off and was used as a model for the painting formerly at Charlesbourg. Légaré is known to have collected not only European paintings but also engravings, and these engravings were acquired by the Séminaire de Québec in 1874. That of the *Ecce Homo* confirms the attribution of the painting to Légaré.

Private Collection

5 *Saint Francis of Paola at Prayer* 1824
Oil on canvas, 120.6 x 88.3 cm

Inscription: signed and dated l.l., *J. LÉGARÉ/Pxt/1824*; *verso*, top of mount (half erased), *J. LÉGARÉ*, on canvas *bis*, *J. LÉGARÉ*.

Provenance: Monastère des Augustines de l'Hôpital-Général de Québec, 1824 (P-23).

Bibliography: AHGQ, Annales, Book III (1794-1843), p. 210; AHGQ, Journal de la Dépense et de la Recette (1827-1843), 8 & 12 Oct. 1825; AHGQ, Livre de comptes (1825-1861), year 1824-1825; AHGQ, Notes diverses (1686-1866), pp. 134-135; ASQ, Portfolio 100-G and section H of Portfolio 129-G; IBC, Hôpital-Général file; *Journal de Québec* (16 May 1871), p. 1; Lemoine (1872), p. 22; *Monseigneur de Saint-Vallier et l'Hôpital-Général de Québec* (1882), p. 503; Beaudet (1890), p. 163; Morisset, "La peinture au Canada français" (1934), p. 92; Morisset, "Joseph Légaré, copiste à l'Hôpital-Général de Québec" (1935), p. 2; Marteau de Langle de Cary *et al.* (1963), *passim*; Réau, Book III, vol. 1, *passim*; Gerson (1968), p. 252 (no. 97).

To complete the decoration of their newly restored chapel, the nuns of the Hôpital-Général de Québec bought nine paintings from Joseph Légaré in 1825. One of them, *Saint Francis of Paola at Prayer*, was hung in the gallery of the chapel. It had been painted the previous year. It now adorns the wall of one of the corridors of the Hôpital-Général. It was restored at the National Gallery of Canada in 1978.

At the time the nuns acquired this painting, it was entitled *Saint Antoine de Padoue (Saint Anthony of Padua)*. This title has remained with the painting ever since, although Lemoine, in 1871-1872, identified it as Saint Jerome. In an article devoted to the works of Légaré at the Hôpital-Général, published in 1935, Gérard Morisset accepted both titles, leaving the choice between *Saint Antoine l'Ermite (Saint Anthony the Hermit)* and *Saint Jerome* to the reader.

Légaré himself seems to have shown some hesitation about the identification of the holy hermit represented in this painting belonging to the Hôpital-Général. Thus, when he was painting another version of this work at the same time for the parish of Ancienne-Lorette (see cat. no.

135), he added stigmata to the saint's hands and feet - which transformed him into a Saint Francis of Assisi. Research into the artist's probable sources enabled us to solve the iconographic problem posed by the painting at the Hôpital-Général. It will be remembered that Légaré's collection of engravings was acquired by the Séminaire de Québec in 1874. It is now divided up into a number of portfolios (*cartables*) in the custody of the archives of that institution. In Portfolio 129-G, there is an engraving entitled *SAINT FRANCOIS (Saint Francis)*, after a work by Rembrandt. There are several versions of this painting by Rembrandt, one of which, entitled *Saint Francis at Prayer* and dated 1637, belongs to the Gallery of Fine Arts in Columbus, Ohio. It is obviously the source of Légaré's painting. Portfolio 100-G contains a variant of this engraving which is entitled *Saint François de Paule (Saint Francis of Paola)*. It is therefore this saint who is most probably represented in the picture belonging to the Hôpital-Général de Québec.

Francis of Paola (1416-1508) was born in Calabria. When he was thirteen, his parents, to fulfill a vow, placed him for a year with the Franciscans. On his return home, wishing to withdraw from the world, Francis carved out a cavern for himself in a rock. There he slept on stones, ate grass, and prayed. He was only nineteen years of age when he received disciples who built themselves cells near to his. To ensure constant humility in his followers, he gave them the name of Minims - Order of reformed Franciscans - and took the word *Charitas* for his motto.

This brief biography well suits the kneeling saint, depicted in profile, in the painting at the Hôpital-Général. With long beard and bare feet, he wears a hooded sackcloth cassock and holds a crucifix in his hands. Before him, on a rock serving as a table, lies an open prayer-book, and to one side can be seen a skull, symbol of the spirit of humility he tried hard to acquire. In the background, to the left, the arched door of a cave stands out, and a similar opening is suggested higher up on the right side.

The *Saint Francis of Paola at Prayer* of the Hôpital-Général de Québec is by no means free of clumsiness or stiffness. In spite of his efforts, Légaré has not succeeded in rendering all the effects of light present in the small engraving. Nevertheless, his picture is not entirely without interest. The books, the skull, the inkpot (?), and the flowering plant in the foreground constitute quite an attractive still-life.

Monastère des Augustines de l'Hôpital-Général de Québec, Quebec

6 *The Death of Saint Francis Xavier* 1824
Oil on canvas, 121.3 x 88.3 cm

Inscription: signed and dated l.l. *Jos LÉGARÉ/PXT 1824.*

Provenance: Monastère des Augustines de l'Hôpital-Général de Québec, 1825 (P-24).

Bibliography: AHGQ, *Actes capitulaires,* Book II (1821-

6

28

1858), p. 8; AHGQ, Annales, Book III (1794-1843), p. 210; AHGQ, Journal de la Dépense et de la Recette (1827-1843), 8 & 12 Oct. 1825, & 10 Feb. 1826; AHGQ, Livre de comptes (1825-1861), year 1824-1825; AHGQ, Notes diverses (1686-1866), pp. 134-135; IBC, Louis Dulongpré and Hôpital-Général de Québec files; *Journal de Quebec* (16 May 1871), p. 1; Lemoine (1872), p. 22; *Monseigneur de Saint-Vallier et l'Hôpital-Général de Québec* (1882), p. 503; Beaudet (1890), p. 163; Morisset, "La peinture au Canada français (1934), p. 92; Morisset, "Joseph Légaré, copiste à l'Hôpital-Général de Québec" (1935), p. 2; Réau, Book III, vol. 1, pp. 538-540; Marteau de Langle de Cary *et al.* (1963), pp. 143-143; Csatkai (1969), pp. 293-301.

To complete the decoration of their newly restored chapel, the nuns of the Hôpital-Général de Québec bought nine paintings from Joseph Légaré in 1825. One of them, *The Death of Saint Francis Xavier*, was hung in the gallery of the chapel along with the *Saint Francis of Paola at Prayer* (see cat. no. 5). It had been painted the previous year. It now adorns the wall of one of the corridors of the Hôpital-Général. It was restored at the National Gallery of Canada in 1978.

This picture seems to have greatly pleased the nuns, for they bought another, smaller version on 10 February 1826 (see cat. no. 137). On 4 February of that year, Mgr Panet, Bishop of Quebec, had authorized Abbé Laurent-Thomas Bédard to celebrate a novena in honour of Saint Francis Xavier in the chapel of the institution. Devotion to this saint was very popular at that time, as witnessed by the numerous representations that have come down to us.

Francis Xavier was born in 1506 at Xavier Castle in Navarre. He was to become the greatest saint of the Jesuit Order after Ignatius of Loyola. Taking with him only his crucifix and his rosary, Saint Francis left Europe for India in 1540. He later extended his missionary activities to Japan. Haunted by the idea of converting China, he set out again in 1552. Struck down by fever as he was nearing his destination, he was abandoned by the Portuguese on the island of Sancian. There he died in a hut made of branches, clutching to his heart the crucifix that Saint Ignatius of Loyola had given him.

It is this last episode that Légaré has depicted in his painting. The saint is lying on a shaggy skin laid on the rocks. His eyes are turned towards heaven. He is clad in a cassock and his feet are bare; his rosary lies by his side. In the upper right-hand corner of the painting, through the structure of the hut, two angels watch the scene, one of them pointing heavenwards with his left hand. Lower down, between the island of Sancian and the steep cliffs of China, a sailing vessel can be seen, toward which row the occupants of a skiff who have just abandoned the dying saint.

In addition to the small version acquired by the Hôpital-Général de Québec in 1826, three other paintings representing the death of Saint Francis Xavier may be attributed to Légaré. They are in the churches of Ancienne-Lorette, Sainte-Croix, and Vaudreuil (see cat. nos 138-140). These works show obvious stylistic similarities with the large version at the Hôpital-Général. Gérard Morisset attributed the Sainte-Croix and

7

Vaudreuil versions to Louis Dulongpré (1754-1843), believing them to be identical to a painting by this artist that had been acquired by Notre-Dame Church in Montreal about 1807. However, this latter painting differs from the others in its composition, in several of its elements, and in its style.

To paint his different versions of the death of Saint Francis Xavier, Légaré probably copied an engraving or a painting that we have unfortunately not been able to trace.

Monastère des Augustines de l'Hôpital-Général de Québec, Quebec

7 Self-Portrait c. 1825
Oil on canvas, 76.5 x 61.3 cm

Provenance: Mrs Charles Narcisse Hamel (née Célina Légaré; Marie-Thérèse Hamel; Mrs Edmire Painchaud; Louis Painchaud, Sherbrooke.

This excellent portrait has always remained in the artist's family. His daughter Célina, who married the lawyer Charles-Narcisse Hamel in 1865, left it to her daughter Marie-Thérèse. The latter, in her turn, left it to her eldest daughter, Mrs Edmire Painchaud, the mother of the present owner, Mr Louis Painchaud, of Sherbrooke.

In this self-portrait, Légaré must have been about thirty. He has pictured himself in profile, dressed in a dark suit of the period contrasting with the whiteness of his collar and jabot. He looks the viewer straight in the eye and his features have a determined air. The pendant of this straightforward portrait (cat. no. 8) depicts the artist's wife. Both were restored at the National Gallery of Canada in 1978.

Louis Painchaud, Sherbrooke

8 Madame Joseph Légaré c. 1825
Oil on canvas, 76.2 x 60.8 cm

Provenance: See cat. no. 7.

Bibliography: ANQ, Registre d'état civil de la paroisse Notre-Dame de Québec, 3 May 1800.

The portrait *Madame Joseph Légaré* is the pendant to that of her husband (cat. no. 7) and its provenance is the same.

Daughter of a sailor, Geneviève Damien was born at Quebec City, 3 May 1800. On 21 April 1818, she married Joseph Légaré, a young Quebec artist. She bore him twelve children, seven of whom were to die in early childhood. She died 24 February 1874, nineteen years after the death of her husband.

The artist has shown his wife sitting in an armchair, the straight back of which can be seen to the left of the picture. She looks melancholy. She is pretty in spite of a rather large nose. Her hair is soberly dressed and she wears

8

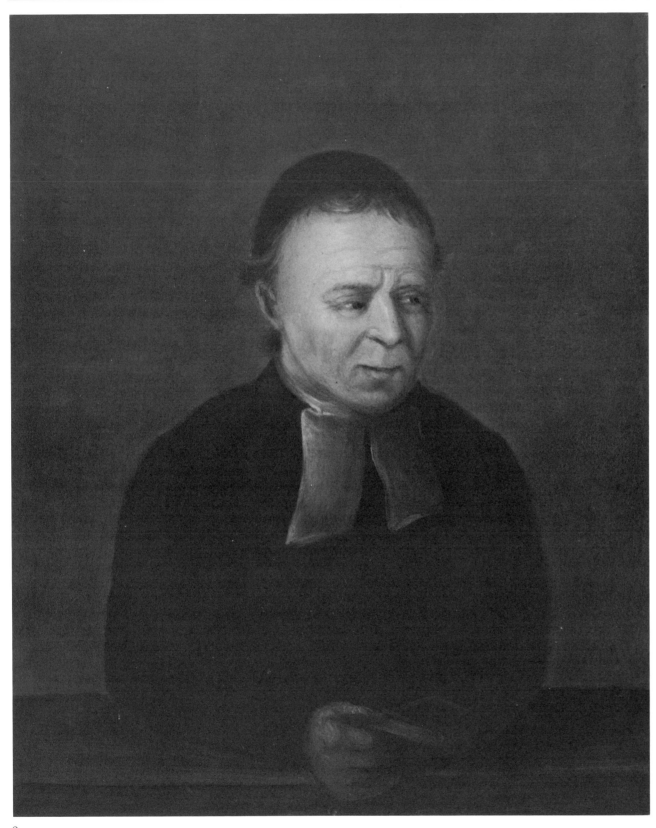

9

delicate earrings and her dress is very simple; a thin veil encircles her throat and modestly hides the bareness of her *décolleté*. She holds an open fan somewhat stiffly in her right hand.

Louis Painchaud, Sherbrooke

9 Brother Louis, Recollect c. 1825
Oil on cardboard, 22.9 x 19.1 cm

Provenance: Légaré's Quebec Gallery of Paintings; Séminaire de Québec, Quebec City, 1874 (Archives, Portfolio 159-G, p. 80B).

Bibliography: See cat. no. 15 for biographical sources; also, ASQ, *Séminaire 12*, no. 41 (1874).

This work was acquired in 1874 by the Séminaire de Québec at the sale of Joseph Légaré's collection of paintings. In the manuscript catalogue of this collection, lots 290, 291, and 292 are each described as "Batch of oil sketches." This work was perhaps one of them. During research for the Joseph Légaré exhibition, John R. Porter examined Portfolio 159-G and came to the conclusion that several of the oil sketches it contained could well be attributed to Légaré.

Comparison of this portrait with the full-length portrait of Brother Louis Martinet, called "Bonami, Recollect," also at the Séminaire de Québec, reveals the sitter's identity (see cat. no. 15). The brother is wearing his indoor dress consisting of the calotte, which was typical of him, and bands worn with his black cassock. He is seated, leaning on what may possibly be a table or desk, and holds a small book in his right hand. His face is younger than in the full-length portrait. His hair has not yet turned white and he does not sport side-whiskers, but the resemblance is unquestionable.

This portrait of Brother Louis is certainly earlier than the full-length portrait and was painted while he was still teaching in his house on Saint-Vallier street, about 1825. It was probably Brother Louis teaching that Légaré wanted to depict here. The good brother taught for over thirty years at a time when schools were far from numerous in Quebec City.

Séminaire de Québec, Quebec

10 Quebec Viewed from Sainte-Pétronille Point, Île d'Orléans c. 1826
Oil and gouache on paper, 30.5 x 49.5 cm

Inscription: verso, Québec vu de la pointe de Sainte-Pétronille, I.O. (Québec viewed from Sainte-Pétronille Point, Île d'Orléans).

Provenance: Légaré's Quebec Gallery of Paintings; Séminaire de Québec, Quebec City, 1874 (Archives,

10

Portfolio 159-G, p. 53).

Bibliography: ASQ, *Séminaire 12,* no. 41 (1874).

This sketch was acquired by the Séminaire de Québec at the 1874 sale of Joseph Légaré's collection of paintings. In the handwritten catalogue of this collection, lots 290, 291, and 292 are each described as "Batch of oil sketches." This work was perhaps one of them. During research in preparation for the Joseph Légaré exhibition, John R. Porter examined Portfolio 159-G and came to the conclusion that several of the oil sketches that it contained could be attributed to Légaré.

This possibility was confirmed when it was discovered that the sketch *Quebec Viewed from Sainte-Pétronille Point, Île d'Orléans* had been used in the painting *Edmund Kean Reciting before the Hurons* in the collection of the Montreal Museum of Fine Arts (see cat. no. 11).

Probably painted from life, this sketch shows the Indian encampment on the north-west point of the Île d'Orléans, with Quebec City in the background. The work is executed with great assurance, and although Légaré attaches no great importance to details, he tries to convey the atmosphere and colouring of the landscape. His only intention in this sketch is to make a landscape study.

Séminaire de Québec, Quebec

11 *Edmund Kean Reciting before the Hurons* c. 1826
Oil on canvas, 53.3 x 92.4 cm

Provenance: Légaré's Quebec Gallery of Paintings; Séminaire de Québec, Quebec City, 1874; antique dealer Gilbert, Quebec City, 1957; Jean-Paul Lemieux, Quebec City; Gérard O. Beaulieu, Montreal; Montreal Museum of Fine Arts (Horlsey and Annie Townsend Bequest), 1961 (961.1293).

Exhibitions: 1964, 20 Apr.-21 May, Montreal, Montreal Museum of Fine Arts, JAMM *Perspective in Painting;* 1966, 7 Nov.-11 Dec., Montreal, Maison du Calvet, *Collection of Paintings and Old Furniture from French Canada;* 1967, 9 June-30 July, Montreal Museum of Fine Arts, *The Painter and the New World,* repr. cat. no. 218; 1971, April-June, Binghampton, N.Y., Robertson Centre for the Arts, *A Festival of Canada.*

Bibliography: Le Canadien (21 Sept. 1831), p. 2; *La Gazette du Québec* (9 October 1826), pp. 1-2; *The Quebec Mercury* (29 July 1826) p. 370, (5 Aug.) p. 383, (2 Sept.) p. 431, (5 Sept.) p. 439, (9 Sept.) p. 445, (12 Sept.) p. 452, (19 Sept.) p. 466, (23 Sept.) p. 470, (3 Oct.) p. 490, (7 Oct.) p. 498, (10 Oct.) p. 505, (17 Oct.) pp. 517-518; ASQ, *Séminaire 12,* no. 41(1874); Laval University Catalogues after 1933 (SQ), no. 623; Roy (1946), pp. 223-224; Playfair (1950), pp. 196-211, 236-275; Dufebvre (1955), pp. 19-22; Harper (1966), p. 81; Malavoy, n.d. Giroux (1972), p. 3; Burger (1974), pp. 123-126, 326-328.

In September 1825, after some tumultuous and unhappy love affairs, the famous English actor Edmund Kean (1787-1833) left England for a tour of the United States, where he had already played with some success. Hoping to mend both his reputation and his fortune, Kean performed in New York, Boston (where his appearance caused a riot), Philadelphia, Charleston, Baltimore, and in various other cities. The American public, very much aware of his misadventures, did not give him the welcome he had hoped for. On 31 July 1826, however, Edmund Kean opened at Montreal's Theatre Royal, which belonged to John Molson and had been open for less than a year. In sharp contrast to his treatment in the United States, he received a triumphal reception in Montreal.

In Quebec City, the arrival of "the greatest actor of the century" was impatiently awaited, and prepared for by the newspapers who published his biography. Performances of *Richard III* and *Othello* were billed at the Royal Circus. Kean arrived in Quebec on 4 September 1826 and gave his first performance of *Richard III* that same evening. He played very successfully in several other plays but, alleging the mediocrity of the supporting actors, refused to play Hamlet on the last night, 4 October. He merely gave extracts from Thomas Otway's *Venice Preserved.* After the performance, the infuriated audience caused considerable material damage.

On 5 October, Edmund Kean met four Huron chiefs and gave to each a medal made by a goldsmith called Smillie. In return, he was received into the Huron tribe under the name of Adanieouidet (or Alanienouidet) and was apparently given the Huron costume and arms. After leaving Quebec City, Kean travelled to New York and from thence to England, in December 1826. Both in New York and London, it amused him to wear his Huron costume and he was so proud of his Indian name that he had it engraved on the back of his visiting card. In London he had his portrait painted in Huron costume and had the result engraved.

Joseph Légaré's painting depicts the meeting of the actor with the Hurons. The subject of this picture was identified in April 1961, by the historian Edgar Andrew Collard, who then gave it the title of *Edmund Kean Reciting before the Indians at Quebec.* This painting had probably been acquired by the Séminaire de Québec in 1874 at the sale of Joseph Légaré's collection of pictures. It was only in 1933, in the catalogue manuscript of the Laval University collection that it was listed under no. 623 as "anonymous" with the title of *Indian Village.* This picture was exchanged by the Musée du Séminaire de Québec with the antique dealer Gilbert, on 17 June, 1957, and thence passed into the collections of the artist Jean-Paul Lemieux and Gérard O. Beaulieu, before being acquired by the Montreal Museum of Fine Arts in 1961.

In Légaré's painting, the meeting between the Hurons and Edmund Kean fills the lower right-hand corner of a landscape. Standing on a mound, dressed in a frock coat in the European manner, the figure presumed to be the famous actor gesticulates, surrounded by a group of attentive Indians. Another European stands near Kean, but lower down. To the left in the picture, there are two groups of three conical tents. Other Indians can be seen near the farthest tents. One of them runs towards Kean's audience while four other draw a canoe up the beach. In the background, the outline of Cape Diamond and the Citadel, the Saint Charles estuary and, to the right, the

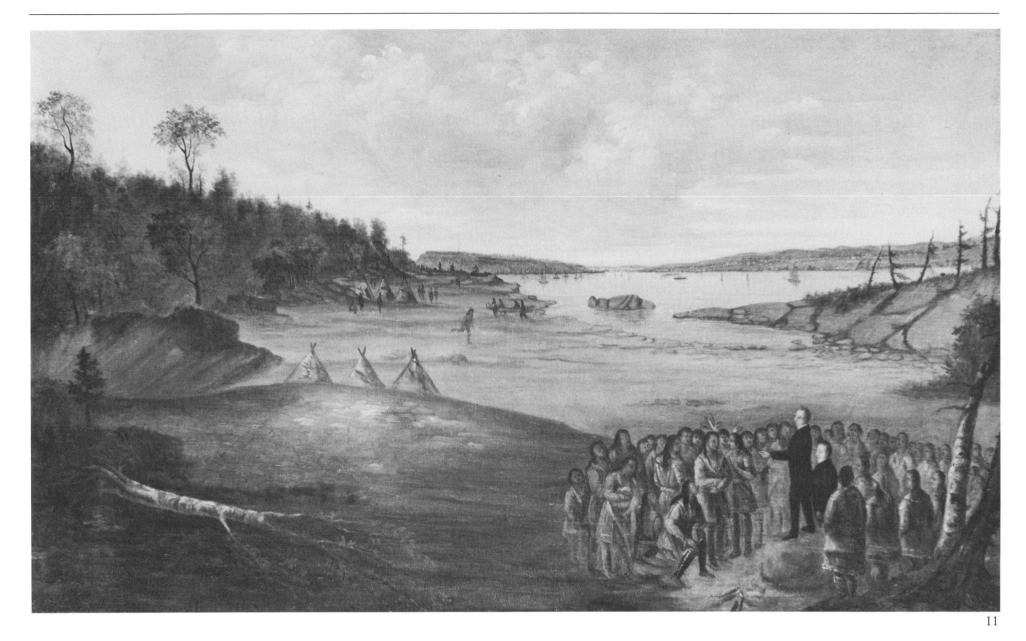

Côte de Beaupré shore can be seen clearly. Sailing boats and a steamship sail on the Saint Lawrence river. Kean and the Hurons are neither at the village of Jeune Lorette (see cat. no. 47), nor at Quebec City, or Lévis, but at the Huron encampment which was, at the time, established on the north-west point of the Île d'Orléans.

To paint this picture, Légaré used an oil and gouache sketch on paper, now in the Archives of the Séminaire de Québec, which he had probably done on the spot (see cat. no. 10). The landscape shown is exactly the same as that of this painting. Légaré was much more careful than usual in his use of detail in the painting and added certain elements such as a tent, an uprooted tree, and the boats on the river to strengthen the composition. The landscape becomes somewhat like a set for a play taking place before our eyes.

The composition of the painting is rather weak. The uprooted tree in the lower left-hand corner merely fills a gap - unless it has some symbolic meaning which now escapes us. The figures are not painted with as much ease and skill as those in the painting *Cholera in Quebec City* (see cat. no. 19), for example. The two trees in the lower right-hand corner do not have the strength of those appearing in the sketch. It is an early example of Légaré's historical pictures and cannot date much later than Kean's visit to Quebec City.

What remains to be discovered is what prompted Légaré to paint this subject of an entirely Canadian interest. Légaré had certainly attended Kean's theatrical performances and followed the numerous newspaper accounts concerning the actor's North American tour. The event he chose to paint, however, is that of the meeting between two civilizations, between the Indians (commonly called "savages" at the time) and an illustrious representative of European culture. It was the idea of this meeting that fascinated Légaré. He pictured it in a setting with Quebec City dominated by the Citadel in the background, surrounded by a forest of ships' masts, in sharp contrast to the Huron encampment and the canoe drawn up on the beach. For Edmund Kean, the Hurons were an object of curiosity and what struck him was "the nobility of their bearing" and "the natural dignity of their manners." As

for the Hurons, they were probably just as impressed by Kean's attitude and by his oratorical talent. It is this mutual respect that Légaré has depicted in his painting.

Montreal Museum of Fine Arts, Montreal

12 Massacre of Hurons by the Iroquois c. 1828
Oil on canvas, 62.9 x 83.8 cm

Inscription: formerly *verso* on a piece of newsprint, *334, bataille des sauvages - Légaré* (334, Indian battle - Légaré).

Provenance: Légaré's Quebec Gallery of Paintings; Séminaire de Québec, Quebec City, 1874; antique dealer Gilbert, Quebec City, 1957; Musée du Québec, Quebec City, 1957 (A 57 204 P).

Exhibitions: 1958, 17 Jan.-22 Feb., Paris, Grands magasins du Louvre, *Les arts au Canada français*; 1959, 12 July-23

Aug. and 3-23 Sept., Vancouver and Winnipeg, Vancouver Art Gallery and Winnipeg Art Gallery, *The Arts in French Canada*, cat. no. 171, repr.; 1960-1961, Dec.-Jan. and Feb., Mexico City and Guadalajara; 1966, 13-19 June, Toronto (exhibition organized for French Week in Toronto by the National Gallery of Canada).

Bibliography: La Bibliothèque canadienne (June 1827) pp. 39-40, (Oct. 1827) pp. 192-194, (Mar. 1828) pp. 158-159, (Mar. 1829) pp. 158-159, (July 1829) p. 23; *The Quebec Mercury* (23 Oct. 1827) p. 536; AJQ, Register of the Notary Public Jean-Baptiste Delâge (6 Dec. 1872), no. 2921; ASQ, *Séminaire 12*, no. 41 (1874), p. 6, no. 235; Laval University Catalogues (SQ) (n.d. I) p. 4, no. 141, (1880) p. 12, no. 12, (n.d. IV) p. 31, no. 14 (n.d. V) p. 31, no. 14, (n.d. VI) p. 31, no. 14, (1889) p. 31, no.14, (1893, in French) p. 32, no. 14, (1893, in English) p. 31, no. 14, (1894) p. 29, (1898) p. 32, no. 16, (1901) p. 21, no. 144, (1903) p. 30, no. 24, (1905) p. 32, no. 24 (1906) p. 45, no. 55, (1908) p. 87, no. 255, (1909) p. 50, no. 255, (1913) p. 62, no. 334, (1923) p. 71, no. 334, (1933) p. 80, no. 226; Charlevoix (1844), vol. I, book VII, pp. 283-300; Lemoine (1876), p. 366, no. 141; Hopkins (1898), vol. IV, p. 355; Bellerive (1925), p. 16; Colgate (1943), p. 109; Morisset, *La peinture traditionnelle* (1960), p. 98; Harper (1966), p. 82; Cauchon (1968), p. 2; Tremblay (1972), pp. 41-42, 59; Lord (1974), p. 49; Porter, *La société québécoise* (1977), pp. 16-17, repr.

In 1827 the Society for the Encouragement of Arts and Sciences in Canada was founded at Quebec City. Its aim was "to encourage the budding genius of this country." In October of that same year, the society advertised a competition in the newspapers which would "encourage praiseworthy emulation among studious and educated youth, by crowning the efforts of genius, and appreciating its useful talents, so as to take under its protection all that can contribute to the progress of the arts and sciences" (trans.). The society promised a medal as the prize to the successful candidates. Candidates had until 1 March 1828 to submit their works, and the third section of the Literary Class was thus defined: "An oil painting the design and composition of which will be of the author's invention."

Meeting at the Hotel Malhiot in Quebec City on 6 March 1828, the Society held a ceremony to distribute its medals. There was no first prize medal for painting, but an honorary medal was awarded to Joseph Légaré: "A similar medal [honorary medal] was awarded to Mr. A.J. LÉGARÉ, of Quebec City, for the original design of an oil painting representing the barbarous character of savage fighting between the Hurons and Iroquois." This medal is still in the collection of the Musée du Séminaire de Québec. On the *recto*, it bears the following inscription: *JOS. LEGARE, FOR AN OIL PAINTING OF INDIAN WARFARE. HONORARY. QUEBEC MARCH 1828.* On the *verso*: *SOCIETY FOR THE ENCOURAGEMENT OF ARTS AND SCIENCES IN CANADA. FOUNDED 1827.* Another competition was held in March 1829 by this society, which in the summer of that same year amalgamated with the Literary and Historical Society of Quebec.

Légaré's picture was therefore painted between October 1827 and March 1828 to enable him to take part

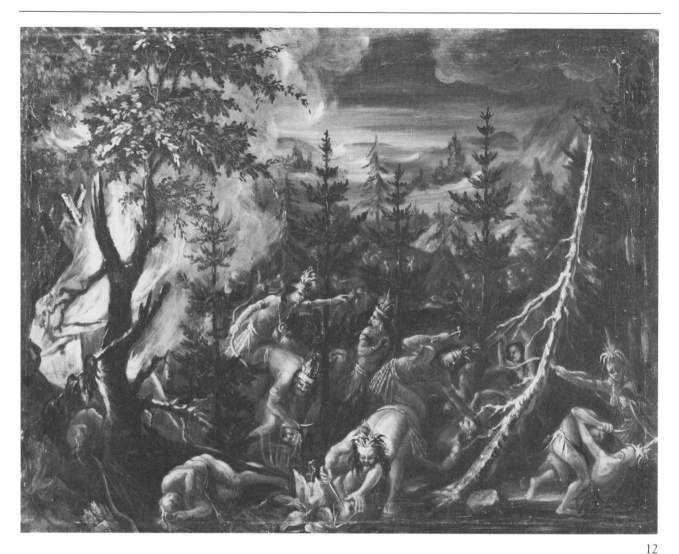

12

in the competition, and it remained in his collection until it was sold to the Séminaire de Québec in 1874. It was then inventoried under the title *Indian Battle*. It appeared in 1876 in Lemoine's book, *Quebec Past and Present*, under the title *Battle between Indians*. The various catalogues of Laval University mention it under the following titles: *Bataille entre Sauvages, Une scène de guerre indienne, An Indian war scene, Battle of Indians, Bataille de Sauvages, An Indian Battle.* In 1957, the painting *The Massacre of the Hurons by the Iroquois* was exchanged by the Séminaire de Québec with the antique dealer Gilbert of Quebec City who immediately sold it to the Musée du Québec. It was restored at the National Gallery of Canada in 1978.

Charlevoix, in his *Histoire et description générale de la Nouvelle-France* (Paris, 1774) of which Légaré had a copy in his library as well as *Mœurs des sauvages* (Paris, 1724) by Lafiteau, described the various battles that took place about 1649 between Iroquois and Hurons, and which ended in the latter's defeat. This was probably the literary source from which Légaré took the idea for his historical painting.

The scene, lit by a burning wigwam to the left, represents a bloody massacre in a forest. A group of Indians clad in loincloths, their heads encircled with feathered headbands, are massacring and scalping another group of Indians, several of whom are already lying on the ground while others are still resisting. The chief of the attackers seems to be the figure in the background, left of centre, who, holding a bow in his right hand, makes an imperious gesture with his left arm. Round his neck - like the figure standing on the extreme right - he wears a medal similar to those distributed to the Indians under English rule.

The picture as a whole is clumsy in the extreme. The composition is confused, with no sight-lines. The background, with the landscape, has no depth. The figures are awkwardly painted. A bow and quiver can be seen on the ground in the left foreground, cut off by the bottom of the canvas. The whole work suggests that it was one of Légaré's first attempts to paint a subject of his own invention without copying a European painting. From this point of view, a comparison could be made between *The Massacre of the Hurons by the Iroquois* and *Edmund Kean Reciting before the Hurons* (see cat. no. 11), painted a few years earlier.

If the Society for the Encouragement of Arts and Sciences only awarded Légaré an honorary medal for his painting and not a first prize, it was probably because of the treatment of this picture. The subject, however, was new in Canadian painting and Légaré's originality merited encouragement. It was certainly this kind of encouragement that led Légaré to paint his most original works.

Musée du Québec, Quebec

13 *George III* 1830
Oil on canvas, 2.49 x 1.6 m

Provenance: Légaré's Quebec Gallery of Paintings; Séminaire de Québec, Quebec City, 1874.

Bibliography: The Quebec Mercury (27 Feb. 1830) p. 113, (6 May 1845) p. 2, (31 Aug. 1852) p. 2; AJQ, Register of the Notary Public Jean-Baptiste Delâge (6 Dec. 1872), no. 2921; ASQ, *Séminaire 12*, no. 41 (1874), p. 6 (no. 259); IBC, Musée de l'Université de Laval file; Laval University Catalogues (SQ) (n.d. I) p. 2, (n.d. II) p. 1, no. 2, (n.d. III) p. 6, no. 54, (n.d. V, in MS) p. 30, (1894) p. 28, no. 2, (1898) p. 30, no. 2, (1901) p. 21, no. 142, (1903) p. 15, no. 54, (1905) p. 15, no. 54, (1906) p. 20, no. 54, (1908) p. 87, no. 54, (1909) p. 21, no. 54, (1913) p. 56, no. 289, (1923) p. 65, no. 289, (1933) p. 43, no. 184; Lemoine (1876), p. 363; Bellerive (1925), p. 17; Colgate (1943), p. 109; Harper (1966), p. 81; Harper (1970), p. 194; Cauchon (1971), p. 92; Reid (1973), p. 48; Lord (1974), p. 54.

In 1829 Légaré made a copy of a painting representing King George IV of England (see cat. nos 25, 186), and the Parliament of Lower Canada purchased it for the Legislative Council chamber. After this success, the artist once more tried his luck by copying a portrait of the late George III, a work by the English painter Joshua Reynolds (1723-1792) which hung in a room of the old Château Saint-Louis, the governor's residence - the painter Jean-Baptiste Roy-Audy also made a copy of the *George III* in 1830. Légaré hoped that his copy would eventually join his *George IV* in the Legislative Council, as we learn from an item in *The Quebec Mercury* of 27 February 1830:

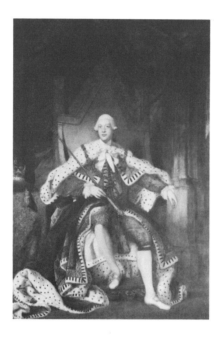

> Mr. Légaré, whose success in copying Sir Thomas Lawrence's coronation portrait of His Present Majesty, we had lately pleasure of noticing, has just finished a copy of that of the late King, by Sir Joshua Reynolds, which ornaments one of the state apartments in the Old Chateau. It is intended as a companion to the first picture, and is an equally happy effort of our Canadian artist's talent. It has we learn been purchased by the Legislative Council.

13a Joshua Reynolds, *George III* 1779, 2.7 x 1.8 m, Royal Academy of Arts, London

In spite of the newspaper editor's affirmation at the end of his account, Légaré's *George III* was not purchased by the government. Indeed, this copy is listed among the paintings of an exhibition held at the Institut des Artisans de Québec in 1845. Légaré's probable model, an original painting by Reynolds depicting George III, was also included in the same exhibition. Légaré's painting was acquired by the Séminaire de Québec in 1874 (lot no. 259). It is subsequently mentioned in several Laval University catalogues (SQ). Until 1906, most of these catalogues identify it under the title of *Guillaume IV* (*William IV* in the English catalogues). In the 1906 catalogue, at item no. 50, the title *Guillaume IV* has been crossed out by hand and replaced by that of *George III*. It is under this corrected title that the painting can henceforth be traced in the catalogues published in 1908, 1909, 1913, 1923, and 1933.

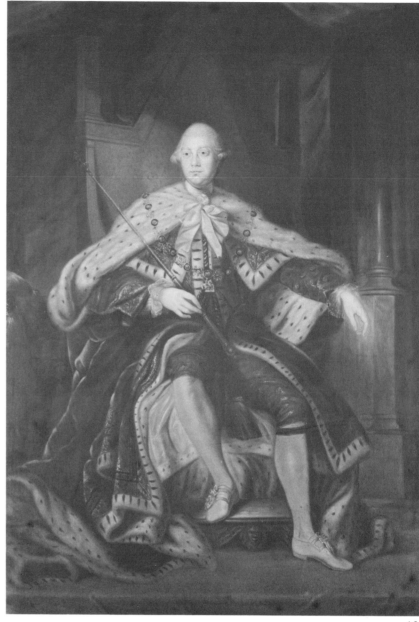

13

14

Contrary to Bellerive's opinion, and that of several art historians who accepted Bellerive's conclusion, Légaré's work is not a copy of a painting by Allan Ramsay (1713-1784) but rather of a work by Reynolds, who is known to have made several replicas of his *George III*. In Quebec City, there was a copy at the Château Saint-Louis and another in the Assembly Chamber, the latter as a pendant to a portrait of Queen Charlotte. These versions were unfortunately lost in fires, but Reynolds's original is still in existence. It dates from 1779 and is at the Royal Academy in London, together with the original of the portrait of Queen Charlotte.

In Légaré's painting, King George III (1738-1820) is depicted at about the age of 40. He is seated on the royal throne, looking to the right. Dressed in rich ceremonial robes and an ermine cape, he wears the insignia of the Order of the Garter and holds the sceptre. The darker background of the painting shows an architectural setting interrupted by draperies. This large painting is a good illustration of the skill Légaré had by now acquired as a copyist.

In his library, the artist possessed books on George III. He was therefore doubly interested in this man who reigned with difficulty for sixty years, was deeply marked by the loss of the American colonies, and who finally succumbed to a form of madness in 1810.

Séminaire de Québec, Quebec

14 *Madame Charles-Maxime De Foy* c. 1830
Oil on canvas, 76.4 x 62.2 cm

Provenance: Mrs Pierre Duhamel, Deschambault, Quebec; Louis Carrier, Montreal; Musée du Québec, Quebec City, 1954 (A 54 31 P).

Exhibition: 1959, Ottawa & Quebec City, National Gallery of Canada and Musée du Québec, *Canadian Portraits of the Eighteenth and Nineteenth Centuries*, cat. no. 11 repr.

Bibliography: ANQ-Q, Registre d'état civil de la paroisse de Notre-Dame de Québec, 7 Sept. 1798; Signaÿ, *Recensement de la ville de Québec en 1818*, p. 229; Bellerive, (1925), p. 17; Morisset, *La peinture traditionnelle* (1960), p. 97.

Before its acquisition by the Musée du Québec this painting belonged first to Mrs Pierre Duhamel, a descendant of Légaré, and then to Mr Louis Carrier of Montreal.

Née Louise Légaré, Madame Charles-Maxime De Foy was one of the artist's younger sisters. She was born at Quebec 6 September 1798 and baptized the next day. She married the notary De Foy of Quebec City on 1 May 1827. Joseph Légaré had frequent business dealings with the latter from 1825 onwards.

Turned three-quarters toward the right in the painting, Madame De Foy stares straight at the onlooker. Her features are rather severe. Her hair is dressed in a very elaborate fashion and threaded with a muslin band. Her rich green dress is adorned with bows. Her *décolleté* is veiled

by a skillfully-painted transparent material. It is a portrait that well conveys the artist's mastery. It was restored in 1954 along with its pendant, a portrait of Charles-Maxime De Foy which does not appear in this exhibition (see cat. no. 182).

Musée du Québec, Quebec

15 *The Recollect Brother Louis, called "Bonami"*
 c. 1830
Oil on paper laid down on panel, 31.7 x 22.2 cm

Inscription: at bottom on wood, *FRÈRE LOUIS, DERNIER RECOLLET/DÉCÉDÉ À QUÉBEC LE 9 AOÛT 1848, INHUMÉ DANS LE SANCTUAIRE DE L'ÉGLISE DE ST. ROCH* (Brother Louis, last of the Recollects/laid to rest in the sanctuary of the Church of Saint-Roch).

Provenance: Légaré's Quebec Gallery of Paintings; Séminaire de Québec, Quebec City, 1874.

Exhibitions: 1952, Quebec City, Musée du Québec, *The Arts in French Canada*, cat. no. 72; 1965, Ottawa, National Gallery of Canada, Quebec City, Musée du Québec, *Treasures of Quebec*, cat. no. 24; 1974, Quebec City, Musée du Quebec, *The Diocese of Quebec 1674-1974*, cat. no. 57.

Bibliography: AHGQ, "Différents papiers" (correspondence), no. 92 (Mgr Arthur Maheux, "Panégyrique en mémoire du Frère Louis dit Bonami," 1938); ASQ, *Séminaire 12*, no. 41 (1874), p. 7 (nos 290-292); IBC, Légaré and Musée de l'Université Laval files; Laval University Catalogues (SQ) (1880) p. 11, no. 7, (n.d. IV) p. 30, no. 7, (n.d. V) p. 30, no. 7, (1889) p. 30, no. 7, (1893, in French) p. 30, no. 7, (1893, in English) p. 30 no. 7, (1894) p. 28, no. 7, (1898) p. 30. no. 7, (1901) p. 29, no. 5, (after 1933) no. 338; Trudelle (1898), *passim*; (anon.), *Le Frère Louis* (1901), pp. 206, 267; Douville (1903), vol. I, pp. 30, 34, 38-39 and vol. II (supplement 1937), p. 3; Morisset, *Peintres et tableaux* vol. II (1937), pp. 75-76; Jobin, *Le Frère Louis Bonami* (1951), p. 21; Morisset, *La peinture traditionnelle* (1960), p. 97; Harper (1966), repr. p. 81.

Louis Martinet, called Bonami, Recollect, was born in Montreal on 5 December 1764. He entered the Franciscan Order of Recollects in Quebec City as a brother. Their monastery then stood on the site of the present Palais de Justice. The Recollects first arrived in Quebec in 1615, and the Hôpital-Général de Québec now occupies their first monastery, enlarged and rebuilt (see cat. no. 28). The building of their second monastery, in the upper town, was begun in 1693. In addition to various ministeries, the Recollects provided shelter and care for old monks. At the capitulation of New France, they were tolerated by the English government but were forbidden to recruit new priests. On 6 September 1796, their monastery in the upper town of Quebec City burned to the ground. The community then probably only consisted of two priests and about fifteen brothers, including Brother Louis. The

15

16

his right hand on his old man's stick, returned a gracious salute with his left hand, together with a pleasant smile. People were glad to meet him.

If Légaré chose to paint the portrait of Brother Louis, this was not merely because he was such a well-known figure in Quebec City, but because he was a living reminder of the past. Moreover, he painted a second portrait of Brother Louis, a half-length, which is also in this exhibition (see cat. no. 9).

Séminaire de Québec, Quebec

16 *Bridge on the Chaudière River* c. 1831
Graphite and oil on paper, 37.5 x 52.7 cm

Inscription: Verso, l.r., *St-Nicolas, ce pont est maintenant tombé* (Saint Nicolas - this bridge has now collapsed).

Provenance: Légaré's Quebec Gallery of Paintings; Séminaire de Québec, Quebec City, 1874 (Archives, Portfolio 159-G, p. 10).

Bibliography: Le Canadien (16 July 1831), p. 2; ASQ, *Séminaire 12*, no. 41 (1874), p. 4 (no. 148); IBC, "R.B." and Séminaire de Québec/Archives files; J.-E. Roy, vol. 5 (1904), pp. 451-454.

This oil on paper was acquired by the Séminaire de Québec at the 1874 sale of Joseph Légaré's collection of pictures. In the manuscript catalogue of this collection, the work listed as no. 148 under the title *Pont sur la rivière Chaudière* (*Bridge on the Chaudière River*). Gérard Morisset wrongly attributed it to an English painter visiting Quebec City about 1846, whose initials he took to be "R.B." (see cat. nos 10 and 21). This work was restored at the National Gallery of Canada in 1976. *Verso* there are two hastily executed drawings, apparently depicting a pillared building surrounded by trees. The paper bears a watermark of 1821.

The Chaudière River flows into the Saint Lawrence about five kilometres upstream from the old seigneurial manor of John Caldwell (see cat. no. 43). In 1818, the government of Lower Canada had given a certain William Davidson permission to build a bridge over this river between the Pointe-Lévis and the village of Saint-Nicolas. Ten years later, since the bridge had still not been built and the need for it became increasingly urgent, the inhabitants of the surrounding counties asked the government to take over the construction of the bridge. A committee, set up to decide the place where it would span the river, decided in 1830 to build the bridge near the mouth of the river at a place called "the great basin." The river was forty-seven metres wide at this point and the hills around it sheltered the basin from high winds. An engraving by William Henry Bartlett, published in 1848 (N.P. Willis, *Canadian Scenery*), gives a good picture of the general lie of the land.

François Normand of Three Rivers and Édouard Normand, a Quebec City carpenter, were given the

English government took the opportunity of seizing their possessions, and the Bishop of Quebec, Mgr Hubert, decreed the secularization of the members of the community.

The community of the Quebec Recollects was then dispersed. As the bishop had left the monks free to wear the Franciscan habit if they so wished, Brother Louis decided to go on doing so. He took up residence in the Faubourg Saint-Roch, on Saint-Vallier street, where he lived for fifty-two years near the Hôpital-Général. He soon became a legendary figure in the city. He taught school in his house until about 1825, and from that time on made communion bread for the various churches in Quebec City and the surrounding neighbourhood. When he died on 9 August 1848, however, Brother Louis was not the last of the Recollects. His death was followed in November of that same year, in Montreal, by that of Brother Paul, and then in March 1849, by that of Brother Marc of Saint-Thomas de Montmagny.

Joseph Légaré's oil sketch was probably acquired by the Séminaire de Québec at the 1874 sale of the painter's collection of pictures. The manuscript catalogue of this collection refers to batches of oil sketches. Brother Louis's portrait is mentioned in the various catalogues of paintings of the Séminaire de Québec (or of Laval University) from 1880 to 1901. It finally reappears in the handwritten addendum to the 1933 catalogue.

Légaré has depicted Brother Louis walking in an inde-terminate landscape - perhaps the Saint-Charles river valley, with the Laurentians in the background. In the lower left-hand corner, lilies grow, probably symbolizing the purity and chastity of this monk still bound by his vows. This was perhaps also an allusion to the flower and vegetable garden that Brother Louis tended at his home and which he ran as a small business. His reputation as a gardener was considerable, and his flowers were much sought after in Quebec City.

Brother Louis wears the Recollect dress that he had adopted for outdoor use. This consisted of a black cloth cassock with a hood. A black cloth coat, with its collar fitting under the hood, completed the outfit. His belt was a cord to which the brother tied a large-beaded rosary. He always wore a skullcap on his head and never went out without his silver-headed walking stick.

Charles Trudelle, who knew Brother Louis from 1835 until the time of his death, described him as follows (trans.):

> He was a venerable old man and venerated by all, not only because of the habit he wore, which recalled the country's first missionaries, but because of his virtues and the fine crown of white hair that stood out around the skullcap that covered his head. Everyone greeted this good Brother Louis with respect, with his sallow and swarthy complexion, his bright, black eyes, his spiritual and intelligent look, who, always leaning

17

Oil and gouache on paper, 34.9 x 46.0 cm

Inscription: Verso u.r., *Résidence de M. Panet, Petite-Rivière/(Saint Charles)* (Home of M. Panet, Little Saint Charles River); again on *verso* l.r., *Résidence de M. Panet/Petite Rivière* (Home of M. Panet/Little (Saint Charles) River).

Provenance: Légaré's Quebec Gallery of Paintings; Séminaire de Québec, Quebec City, 1874 (Archives, Portfolio 159-G, p. 11).

Bibliography: ANQ-Q, Register of Notary Public Charles-Maxime De Foy (27 Aug. 1830), no. 1372; ASQ, *Séminaire 12,* no. 41 (1874), p. 7 (nos 290-292); IBC, "R.B." and Séminaire de Québec files; Lemoine (1865), p. 130.

This oil sketch was acquired by the Séminaire de Québec at the 1874 sale of Légaré's collection of pictures. In the manuscript catalogue of this collection, lots 290, 291, and 292 are each described as "batch of oil sketches." This work was perhaps one of them. Gérard Morisset wrongly attributed it to an English painter visiting Quebec City about 1846 and whose initials he took to be R.B. (see cat. nos 10 and 21). This work was restored at the National Gallery of Canada in 1976.

About 1830, several leading Quebec citizens were attracted to the countryside bordering the Saint Charles River near the Scott Bridge. It was a peaceful and healthy spot to which they could retire with their families. Two of them, lawyer Philippe Panet (1791-1855) and his brother Louis (1794-1884), a Quebec notary, bought adjoining lots on the north bank of the Saint Charles. In 1830, they began building houses on their respective properties. On 27 August, Philippe Panet signed a contract for this purpose with François Fortin, a master mason of Quebec City. The contract described the future residence as follows (trans.):

The said main building shall consist of
1. A three-storied house, twenty-two feet in width by fifty feet in depth including the two ends which will be five-foot projections of semi-hexagonal form in each of which there will be nine openings and two on the long sides.

2. Two wings joining the main building, which will be only two stories in height and each twenty feet wide by forty feet in depth.

The contract specified that the second and third stories would be eleven feet in height and that the ceiling of the third storey would be vaulted and arched. In addition, there were to be seven chimneys in this sumptuous residence. It is interesting to note that the architecture of Philippe Panet's house was inspired by that of Italian villas he had seen during a trip to Naples. Légaré had known Panet at least since 1828 when the two were on the Quebec district committee of petitioners.

As depicted by Légaré, Panet's residence corresponds closely to the description in the contract. It is shown in

contract to build the bridge. Originally estimated at £1949.15.0d., the cost of the work soon started to mount. The contractors, in fact, had great difficulty in completing their work. The collapse of an arch alone involved the additional expenditure of £500. The work was finally completed during the summer of 1831 and on 11 July, the new bridge was officially opened. *Le Canadien* describes the event in the following terms (trans.):

Last Monday, the superb bridge built over the river Chaudière was opened for carriages to pass, and Lady Aylmer crossed it first, with D. Daly, Equerry, and her carriage was followed by that of Lord Aylmer, accompanied by Sir John Caldwell, the seigneur of the locality. This is a very audacious piece of architecture, and the first of its kind in the whole of British North America. The plan was the work of M. Wickstead, one of the commissioners, and its execution was entrusted to M.M. Normand, both already well-known locally for their genius in architectural matters. We should add that everyone who has visted this bridge is very satisfied with it.

In 1852, as the bridge had deteriorated and become dangerous, the government ordered its demolition.

Légaré's composition highlights the variety of the

architectural lines of the bridge. It is a fairly simple structure with a single arch resting on massive abutments built firmly into the cliffs. The bridge largely fills the left-hand side of the work; on the right bank of the river, its structure disappears into thick forest. The irregular platform of a quay parallel to the river occupies the foreground of the work. Masts of several small boats anchored alongside can be seen over its edge, and there are several logs arranged crosswise on the left-hand side.

The interest of this work lies not so much in its tiered composition as in the effects of light to be found in it. Beneath a pinkish sky, the river shows a fine range of greens that underline the orange hue of the piers. Moreover, the cheerful tones of the forest offset the flatter colours of the quay. As for the subject of the painting, this certainly shows the artist's interest in one of the remarkable technical achievements of his time, but also the marked contrast existing between this feat and the wildness of the surrounding country.

Séminaire de Québec, Quebec

17 Country House of Philippe Panet on the Little Saint Charles River *c.* 1831

18

the background and to the right side of the work. It is surrounded by numerous pine trees which accounted for the name by which the place was known: *Le Bocage* (The Grove). To the right of the house, behind a screen of trees, is an outbuilding mentioned in the contract. It was probably a place where tools for the upkeep of the house and garden were kept. Some men can be seen working in front of the house, while one, coming from the river, follows a path to the shed.

A large, fenced-off wood hides the house from the view of passers-by crossing the Scott Bridge. The latter spans the Saint Charles river in the left part of the work. Its roadway, with parapets on either side, rests on heavy piers. Further to the left, the gates of a neighbouring property, that of Louis Panet, can be seen. In the foreground, cows drink lazily in the shallow waters of the river under the watchful eye of a man and his dog.

In this work, Légaré is not just interested in painting a rich country residence. He is also anxious to show the surrounding countryside and the peaceful life there.

Séminaire de Québec, Quebec

18 Baie Saint-Paul
Oil on paper, 36.8 x 55.9 cm

Provenance: Légaré's Quebec Gallery of Paintings; Séminaire de Québec, Quebec City, 1874 (Archives,

Portfolio 159-G, p. 56A).

Bibliography: ASQ, *Séminaire 12*, no. 41 (1874), p. 3 (no. 93); IBC, "R.B." and Séminaire de Québec/Archives files; Bouchette (1831), see entry "Côte de Beaupré" for "The Parish of Baie St Paul."

This oil on paper was acquired by the Séminaire de Québec at the 1874 sale of Joseph Légaré's collection of pictures. In the manuscript catalogue of this collection, this work appears under item no. 93 as *Vue de la Baie St. Paul (View of Baie Saint-Paul).* Gérard Morisset, who tried in vain to identify the subject of this work, wrongly attributed it to an English painter visiting Quebec about 1846 whose initials he took to be R.B. (see cat. nos 10 and 21). This work was restored at the National Gallery of Canada in 1976.

The parish of Baie Saint-Paul is situated at about 90 kilometres to the north-east of Quebec City. Surveyor Joseph Bouchette described it in 1831 in the following terms:

> In St. Paul's Bay, and along the river du Gouffre, the settlements are girted by a lofty range of mountains, stretching N. from the St. Lawrence and enclosing a valley about 13 m. in length and from 1 to 1½ m. in breadth, the greatest part of which is numerously inhabited and very well cultivated, notwithstanding the land is in many places very rocky and uneven: several spots on the sides of the hills, being difficult

of access from their elevated and precipitous situation, are tilled by manual labour and are extremely fertile in grain of most kinds. On this tract the houses of the inhabitants are nearly all of stone, very well built and whitewashed on the outside, which greatly adds to the gaiety of the general prospect of the settlement, as well as to the neatness of their individual appearance. Several small streams descend from the mountains, and after meandering through the valley fall into the Rivière du Gouffre, turning in their way several saw and corn-mills. The main road passes at the foot of the bounding heights to the extremity of the cultivated land in Côte St. Urbain, and on each side presents many neat and interesting farms and settlements in a very improved state.

Légaré's work corresponds perfectly with Bouchette's description. From one of the heights surrounding Baie Saint-Paul, we have a general view of the valley in which the Rivière du Gouffre meanders, in the left part of the painting. In the background, across the Saint Lawrence, the Île-aux-Coudres can be plainly seen. Fences subdivide the valley into long strips of cultivated fields. Farmhouses and their outbuildings are dotted here and there. In the foreground stretch the calm, dark waters of a river basin in which trees and thickets are reflected.

In this work, Légaré is successful in portraying the rural tranquillity of one of the pretty villages that bordered the Saint Lawrence in his day. His landscape is remarkable for its perspective effect and the atmospheric quality of the light.

Séminaire de Québec, Quebec

19 Cholera at Quebec City c. 1832
Oil on canvas, 82.2 x 111.4 cm

Provenance: Légaré's Quebec Gallery of Paintings; Séminaire de Québec, Quebec City, 1874; antique dealer Gilbert, Quebec City, 1957; William P. Wolfe, Montreal, 1957; National Gallery of Canada, Ottawa, 1959 (7157).

Bibliography: Le Canadien (21 May 1832) p. 16, (6 July 1832) p. 3, (9 July 1832) p. 2, (12 Sept. 1832) pp. 2-3; *The Quebec Mercury* (10 Mar. 1832) p. 3, (21 Apr. 1832) p. 1, (7 July 1832) p. 2; ASQ, Portfolio 160-G, p. 9; ASQ, *Séminaire 12*, no. 41 (1874), p. 7 (no. 267); Laval University Catalogues (SQ) (1913) p. 63, no. 350, (1923) p. 72, no. 350, (1933) p. 81, no. 242, (after 1933) no. 509; Bellerive (1925), p. 15; (anon.) *Les peintures de Légaré sur Québec* (1926), p. 432; Roy (1931), pp. 253-258; Robson (1932), p. 20; Colgate (1943), p. 108; Hubbard (1963), p. 56; Hubbard (1964), p. 56; Wade (1966), pp. 161-162; Drolet (1967), pp. 70-71; Cauchon (1968), p. 2; Harper (1970), p. 194; Harper (1971), p. 8; Giroux (1972), pp. 1-12, repr. in col. (detail); Tremblay (1972), pp. 57-60, 120, 163, repr. in col.; Reid (1973), pp. 48-49; Vézina (1974), p. 49; Lord (1974), pp. 49-53, repr. in col.; Vézina (1975), pp. 53-54; Godsell (1976), p. 46.

19

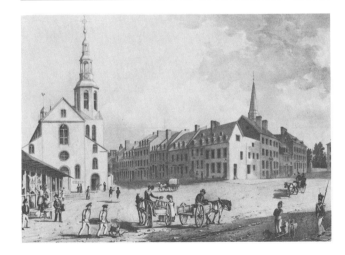

19a W. Walton, *View of the Marketplace and Catholic Church, Taken from the Barracks, Fabrique Street (Quebec City, Lower Canada)*, 1832, Engraving after a watercolour by Robert Auchmety Sproule, 26.5 x 37.6 cm, Archives du Séminaire de Québec, Quebec

growing poverty and unemployment in England, Scotland, and Ireland. For poor immigrants, travelling conditions from England to Canada were deplorable. They were crowded together in the insalubrious holds of boats used for transporting wood from Canada to England. Upon their arrival, most of the immigrants were penniless, ill, and became a burden on public relief. Thus, the terrible Asian cholera epidemic, which broke out in 1832, was brought by immigrants. It rapidly spread along the Saint Lawrence, taking its toll indiscriminately of both newcomers and the local population.

In Quebec City, 3,292 deaths were recorded (1,084 only being recent arrivals) between 8 June and 1 September. The whole town was disturbed by the epidemic. The newspapers were full of heart-breaking stories, disquieting statistics, and health tips concerning the dread disease. An impressive number of Quebeckers fled to the country. Churches were closed and business activities seriously curtailed. A new cholera epidemic broke out two years later. Though shorter in duration, it nonetheless claimed 2,519 victims in Quebec City.

From 8 March 1832 onwards, Joseph Légaré was a member of the Quebec Board of Health and took part in its meetings. The Governor appointed him a member of the new Board on 16 May. One of the tasks of this organization was to establish an efficient quarantine system in the town, the suburbs, and the surrounding district. At the beginning of July, at the height of the epidemic, a welfare committee was set up to bring help to afflicted and needy families. Légaré's father was a member of this committee. Several days later, the artist joined the committee and, with two other people, undertook to raise funds in the Palais quarter. In 1834, he took an active part with his father at a public meeting destined to bring pressure to bear on the government so that it would take proper steps to prevent the recurrence of new epidemics in future. He thus prolonged his task, assumed since 1833, for the Quebec City Council as a member of the health committee.

As an artist, Joseph Légaré was also very much aware of the ravages caused by the cholera. His picture doubtless depicts an episode during the first epidemic, that of 1832, and the most deadly. The scene takes place at night. In the background of the painting, amid threatening clouds, a full moon stands out, palely illuminating the market place of Quebec's upper town. From left to right can be seen the market building, the front of Notre-Dame Cathedral, the row of houses on Buade Street, and lastly, the houses on Desjardins Street, with the steeple of the Anglican cathedral towering above, and seen in perspective as far as the corner of Sainte-Anne Street. The market place is marked out by fumigating fires lighted in front of the houses and the cathedral - a health measure of the day.

For the architectural setting of his painting, Légaré copied an engraving entitled *View of the Market Place and Catholic Church Taken from the Barracks Fabrique Street*, a copy of which is held by the Archives of the Séminaire de Québec. Executed after a watercolour (1830) by Robert Auchmety Sproule (1799-1845), this engraving was published in 1832, and Légaré undoubtedly had a copy - perhaps that now in the Séminaire - in his collection. The disposition of the buildings and the general lay-out of the

When Légaré's collection of pictures was acquired by the Séminaire de Québec in 1874, lot 267 was entitled *Quebec pendant le choléra de 1832 (Quebec during the Cholera of 1832)*. This picture was subsequently mentioned in the Laval University catalogues (SQ) published in 1913, 1923, and 1933. In the French editions of 1913 and 1933, it bears the title *Le grand choléra à Québec, (1832)*; in the 1923 English edition, it is called *During the cholera-morbus at Quebec*. The painting remained at the Séminaire de Québec until 1958 when it was exchanged with Gilbert, the Quebec City antique dealer. Because of an error in the Séminaire files, it then bore the title *Place de la Cathédrale à Quebec en 1840 (The Cathedral Square in Quebec City in 1840)* and corresponded to no. 509 of the manuscript continuation of the 1933 catalogue. Purchased by Mr William P. Wolfe from the antique dealer Gilbert in 1957, the picture was acquired by the National Gallery of Canada two years later.

From 1825 onwards, immigration into Canada had increased greatly. It was encouraged by the Montreal merchants who were anxious to populate the wild parts of Canada, obtain labour for the great canal-building projects of the time, and reduce the numerical superiority of the French Canadians. In 1831, immigration figures reached the record number of 50,254. The government in London was in favour of this immigration which helped counter

market place are exactly the same in both the engraving and the painting. However, the similarity ends there. In Sproule's work, this square in upper town is shown in full daylight, and it is a peaceful scene. In Légaré's canvas, on the contrary, the action takes place at night and, moreover, in a dramatic atmosphere.

Despite the late hour, the market place is bustling with activity. This is concentrated in the lower part of the picture. To the left, in the background, a priest, accompanied by two men, is coming out of the right-hand door of the cathedral, probably to minister to the dying. On the right, still in the background, a hearse followed by a procession, probably of Irish immigrants, moves off towards Sainte-Anne Street. The foreground has a veritable human frieze illustrating different aspects of the dramas caused by the cholera: scenes of weeping or despair, a figure suddenly struck by the disease, corpses being heaped on to a cart, and so on. All this nocturnal activity in the heart of Quebec City well conveys man's helplessness when confronted by such a destructive and implacable scourge.

Cholera at Quebec City is one of the oldest night scenes in Canadian painting. In addition to its documentary aspect, Légaré shows a rare pictorial audacity for his day. It is also a work striking for its dramatic intensity, in which the artist bears witness to his profound attachment to his town and to his fellow-citizens.

National Gallery of Canada, Ottawa

20 *Corpus Christi at Nicolet* c. 1832
Oil on canvas, 40.0 x 62.2 cm

Provenance: Abbé Jean Rainbault, curate of Nicolet; Abbé Hubert Robson, parish priest Drummondville?; Mrs Pierre Duhamel, Deschambault?; Louis Carrier, Montreal; National Gallery of Canada, 1956 (6459).

Exhibitions: 1962-1963, Bathurst, N.S., New Town Hall, Regina Public Library, Edmonton Art Gallery, Calgary Allied Arts Centre, Beaverbrook Art Gallery, Fredericton, *Painting in Canada 1840-1900;* 1966-1967, London, Hamilton, and Sarnia, *The Artist in Early Canada;* 1974, Montreal, *Expo 67: Man and His World* (Museum of Fine Arts), *From Micmac to Montreal.*

Bibliography: Diocesan Archives of Nicolet, Letters from Mgr Panet to M. Raimbault (vol. 5, p. 29, 3 Jan. 1831); Account Books of the Parish of Nicolet, 1784; ANQ-TR, Register of the Notary Public L.M. Cressé (4 Mar. 1822) no. 134, (26 Apr. 1823) no. 480, (18 June 1826) no. 2208, (24 June 1841); Bouchette (1815), pp. 342-346; Bouchette (1831), see entry "Nicolet"; Bois (1869), pp. 69-86; Douville (1903), book I, *passim;* Bellemare (1924), pp. 364X-368; Bellerive (1925), p. 16; Colgate (1943), p. 109; Morisset, *La peinture traditionnelle* (1960), pp. 98-99; *National Gallery of Canada: Catalogue of Paintings and Sculpture, Vol III Canadian School* (1960), p. 170, repr.; Giroux (1972), pp. 3,7, repr. in col. (detail); Tremblay

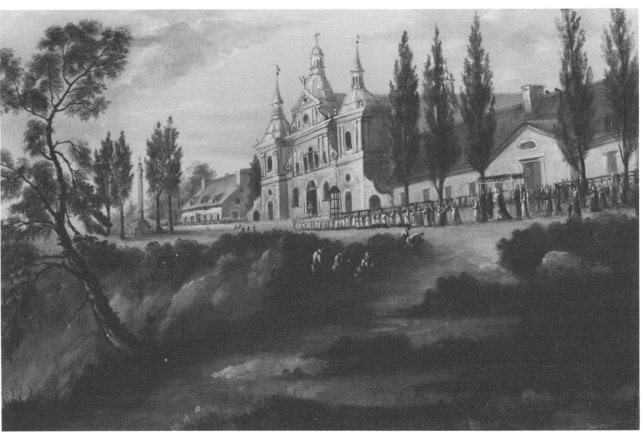

20

(1972), p. 161; Letters from Mgr Albertus Martin of Nicolet to Nicole Cloutier & John R. Porter, 12 and 28 August and 16, 24, and 27 August 1976 and 9, 20, and 27 Feb. 1977, now in National Gallery of Canada.

The parish of Nicolet had Abbé Jean Raimbault (1770-1841) as its *curé* from 1806 to 1841. In the biography he devoted to Raimbault in 1869, Abbé Louis-Édouard Bois wrote as follows (trans.):

> From the first years he was *curé* of Nicolet, M. Raimbault did everything possible to give the Feast of the Blessed Sacrament a splendour that it had never before attained and, each year, he surpassed the manifestations of preceding years with a zeal whose memory has survived in the college, the presbytery, and throughout the parish. He had even had a little picture painted that could still be seen in his rooms a few years before his death, showing the procession of the Blessed Sacrament issuing forth from the parish church in Nicolet. This charming little canvas, placed between two engravings, *The Word Incarnate* and *The Last Supper,* produced a fine effect and showed the tender devotion of this pious pastor to Jesus Christ made flesh to nourish his fellow-men. This small painting gave us an idea of the parish church of Saint-Jean-Baptiste in Nicolet and its adjoining buildings at that time. It showed M. Raimbault's taste for the fine arts and, as has already been noted, his great devotion to the Holy Eucharist. It can be said that throughout his life he had worked on the embellishment of the House of God.

The little picture described in this passage corresponds perfectly with Légaré's work, except for the direction of the procession. However, Abbé Bois's description was written nearly thirty years after he had seen the painting, which easily accounts for the error. When Raimbault died in 1841, part of his furniture and belongings were auctioned. In the account of the sale, it is mentioned that a certain Mr Robson acquired "a painting" for the sum of 10 shillings. This may have been *Corpus Christi at Nicolet,* bought by the Rev. Hubert Robson, then parish priest at Drummondville. In any case, we then lose track of the painting to find it again perhaps at the beginning of the century in the collection of Mrs Pierre Duhamel. In his book, published in 1925, Georges Bellerive indeed mentions a Légaré painting entitled *The Procession* "in front of the church at Gentilly, which is in the sitting room of Mrs Pierre Duhamel, Légaré's niece [*sic*]." Is this the same picture bearing the wrong title, or is it another work? We cannot tell for certain. Nevertheless, we know that shortly after 1946, Mrs Pierre Duhamel of Deschambault sold to Mr Louis Carrier of Montreal a picture by Légaré entitled *The Property of the Artist's Parents at Gentilly* (see cat. no. 80). And it was from this same Louis Carrier that the National Gallery of Canada acquired *Corpus Christi at Nicolet* in 1956.

The village of Nicolet is situated on the south bank of the Saint Lawrence, 130 kilometres as the crow flies upstream from Quebec City. The surveyor general, Joseph Bouchette, described it in 1831 as follows:

> The village of Nicolet is pleasantly situated on the

banks of the river Nicolet, about a mile from its mouth; its appearance, whether approached by the river or by either of the roads, is calculated to attract the notice of a traveller, and offers inducements for visiting it sufficient to repay an ordinary journey by the admirers of nature's favoured spots. This village, containing about 90 houses with a church in the centre, is remarkable for its beautiful situation on the side of the gentle acclivity, covered with some majestic oaks and crested with a tuft of lofty pines. [The] Roman Catholic church, 140 ft. by 50 ft., [is] decorated with some valuable paintings (…) In this village, about the beginning of the present century, a college for the education of youth was founded under the auspices of the then Catholic bishop of Quebec. It stands on a spot well calculated by the natural beauties of its situation to assist the views of so excellent an establishment. The building is on a simple, unostentatious, but convenient plan, possessing all requisite accommodation for the director, masters, and seventy pensioners. The success and reputation of this institution obtained for it a royal charter in the reign of George the Third. The original building having been found inadequate to the accommodation of the increased number of students, a new edifice of considerably enlarged dimensions was commenced in 1827 and is now far advanced towards completion.

As we shall see, this description explains several elements in Légaré's painting. This is divided into two quite contrasting horizontal sections. The roadway going off to the left marks this dividing line. The lower part is rather dark and severe. On the left-hand side, a slope leading down to the Nicolet river can be discerned. In front of this slope stands a stunted tree whose curve unites the two parts of the painting. The foreground is diagonally crossed by a track edged by bushes and leading into the thick of the procession that winds along the road leading to the parish church. Near the meeting point of the two roads, five figures are kneeling down to adore the Blessed Sacrament. Seen sideways, the imposing church front occupies the centre of the upper part of the painting. This was the fourth church in Nicolet and was built in 1783. At the top of the pediment of the façade stands a statue of Saint John the Baptist, the patron saint of the parish, acquired in 1784. To the left of the church, the presbytery, a heavy and spacious late eighteenth-century building, can be seen. A column resting on a plinth stands opposite the church. Surrounded by a railing and framed by four slender trees, its capital supports a ball which seems to be surmounted by a cross. Probably completed about 1830, this monument had probably been erected to commemorate the Jubilee celebrations of 1825. To the right of the church, behind a row of poplars, can be seen the façade of the first seminary in Nicolet, founded in 1807. Parallel to the road like the presbytery and the church front, it is a long, one-storey, stone building surmounted by a high roof. It measured 36 metres in length and 11.4 metres in depth. A wide pediment pierced by an oval opening surmounts the main door, in the middle of the façade. It is opposite this door that the monstrance with the Blessed

21

Sacrament is passing, held by the officiating priest, perhaps Abbé Raimbault himself. He is sheltered by a processional canopy held by four men in formal attire. Beside them walk four choirboys, each holding a candlestick. In front of the canopy, two incense-bearers cense the Blessed Sacrament. They are preceded by a long line of clergy and choirboys, in surplices, which reaches to the main door of the church where a processional cross and banner can be made out. A group of men, women, and children bring up the rear behind the canopy.

Elements of the painting, and relevant documents, suggest that the work was executed about 1832. At that time, Abbé Raimbault, who commissioned the picture, could look with pride on his achievements in the parish of Nicolet. As priest of the parish since 1806, he had spared no efforts. He had embellished his church by adorning it with pictures from the Desjardins Collection and installing an excellent organ. It was also he who, in 1817, had domed side-towers added to the church front. Having been rather too ambitious, he had to have these towers lowered in 1822-1823. He also had the presbytery repaired three years later, and it was during his time as parish priest that the Jubilee Column was erected. Lastly, he was the first head of the seminary founded in 1807. He

even supposedly drew up the plans for this building at the request of Mgr Plessis, the institution's benefactor.

Everything in the painting Raimbault had ordered from Légaré was dear to him and in some way summed up his life's work. He was sad to see the members of his seminary move away when the new college was opened about 300 metres from the old one in 1831. Since the new institution had its own chapel, Abbé Raimbault was henceforth deprived of the prescence of the seminary students and clergy at the great feast-day celebrations of the Church. Abbé Douville, author of a history of the Nicolet seminary, tells us that there was an exception to the rule, and Légaré's picture seems to corroborate this (trans.):

Religious services for the community were held in the chapel of the new college from its inception in October 1831 and have always been held there since. There has only been one occasion in the year when the whole seminary attends the service in the parish church and takes part in it; this is the Sunday of the procession of the Blessed Sacrament or the solemnity of Corpus Christi. According to *ancient* and *solemn* custom, on that day the students perform all the ceremonies, including the figures, of ancient tradition,

22

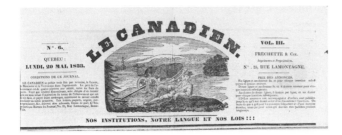

executed by a group of incense and flowerbearers. This procession is always very solemn and performed with pomp, amidst a great show of flags, banners, and insignia borne by the students and others, and sacred ornaments worn by the priests and seminarists. None who has ever witnessed it will forget it.

National Gallery of Canada, Ottawa

21 *The Church of Sainte-Foy*
Oil on canvas, 37.5 x 50.2 cm

Provenance: Légaré's Quebec Gallery of Paintings; Séminaire de Québec, Quebec City, 1874 (Archives, Portfolio 159-G, p. 15).

Bibliography: ANQ-Q, Register of the Notary Public Michel Tessier (21 Dec. 1827) no. 434; ANQ-Q, Register of the Notary Public Antoine Archange Parent (7 Dec. 1841) no. 8927; ASQ, *Séminaire 12*, no. 41 (1874), p. 3, no. 84; IBC, "R.B." and Séminaire de Québec/Archives files; Cameron & Trudel (1976), p. 152; Scott (1919), p. 63.

This oil on canvas was acquired by the Séminaire de Québec at the 1874 sale of Joseph Légaré's collection of pictures. In the manuscript catalogue of this collection, lot

22a Masthead of the newspaper *Le Canadien* of Quebec City, Edition of 20 May 1833, Engraving after a design by Joseph Légaré, National Library of Canada, Ottawa

44

the day after the English general had blown up the church of Sainte-Foy. But whatever Légaré's motives for painting this work, it remains a remarkable picture. Indeed, it has an exceptionally fine luminous quality and an eloquent austerity by which the artist conveys how firmly the Catholic faith was rooted in Quebec soil in his time.

Séminaire de Québec, Quebec

22 *The Canadien* 1833
Oil on canvas, 16.8 x 24.1 cm

Inscription: Across the top, *LE CANADIEN*.

Provenance: Louis Mulligan, Montreal; Jean Palardy, Montreal, *c.* 1950; Musée du Québec, Quebec City, 1972 (A 72 43 P).

Bibliography: Le Canadien (17 May 1833) p. 2, (20 May 1833) p. 1, (11 Nov. 1836) p. 1, (14 Nov. 1836) p. 1; Couinard (1881), vol. 1, p. 26; Beaulieu & Hamelin (1965), pp. 179-180.

The newspaper *Le Canadien* was founded in Quebec City in 1806 to defend the interests of French Canadians and to offset the influence of *The Quebec Mercury,* founded in 1805, which served the interests of the anglophone community. From 1831 to 1842, *Le Canadien* was owned jointly by Étienne Parent, who took care of the editorial side, and J.-B. Fréchette, who looked after the printing.

On Friday, 17 May 1833, on page 2, an item appeared in *Le Canadien* as follows (trans.):

> This year, we are going to achieve a goal that we were only partially able to attain last year, namely to print our paper in type more to the liking of most readers. We are also on the point of adding to our paper an ornament that we have wanted to give it for a long time; this is a masthead, a vignette, representing a Canadian farmer in the middle of his field. His oxen and his plough are beside him, and he himself is resting or smoking his pipe, which in common parlance means the same thing. In the background, the beginning of a Canadian village can be seen, and on the other side, the view ends in a forest and mountains. It is thus that we try to respond to the encouragement we receive, and we promise never to be behindhand in this respect.

It was on Monday, 20 May 1833 that the masthead described by the newspaper's editor appeared for the first time. It would be published for the last time in the edition of Friday, 11 November 1836. A new frontispiece appeared, with an explanatory note, on Monday, 14 November 1836. The editor hoped that "it will meet with the approval of the most difficult critics," which suggests critics of the former frontispiece.

"This new frontispiece has no need of explanations; the emblems it comprises are all easy to understand. The

23

24

main emblem, the mapleleaf, has been, as all know, adopted as the emblem of Lower Canada, while the rose is that of England, the thistle of Scotland, and the shamrock of Ireland." Moreover, this new masthead included the words *UNION* and *LIBERTY*.

Joseph Légaré's small picture that served as a model for the engraving of the masthead used by *Le Canadien* from 1833 to 1836 belonged to Mr Jean Palardy when it was acquired by the Musée du Québec in 1972 (see cat. no. 223).

The picture was certainly ordered from Légaré by the owners of the newspaper *Le Canadien*, who probably specified the contents in detail. Before 1836, Légaré's political opinions were similar to those held by *Le Canadien*, and the painter must have had frequent dealings with the editor, Étienne Parent. When the latter withdrew his support from L.-J. Papineau, considered too radical, Légaré was to be found in the company of the group of journalists publishing *Le Libéral* (June-November 1837) and combatting *Le Canadien*.

The picture *The Canadien* shows a young peasant resting, dressed and capped in local cloth and smoking a clay pipe. Relaxed and at ease in his surroundings, this peasant has unhitched his oxen from the plough. In the left foregound can be seen part of a pine tree and, behind, a stretch of water as well as a church and four houses symbolizing a village. The background landscape depicts mountains and forest. The inscription *LE CANADIEN* is painted in the sky, at the top of the picture. In Légaré's day, the word *Canadien* was commonly used to describe only the French-speaking inhabitants of the country. The picture is a visual portrait of the idea *Canadiens* had of themselves.

The inscription *LE CANADIEN* is partly erased, as if someone had tried to remove it. In the newspaper, it appears over the engraving which is, on the whole, very faithful to the painting. An alteration is visible at the top and to the right of the picture: the front and steeple of a church as well as two houses can be made out. The final composition is much more successful, however, than this first attempt.

Musée du Québec, Quebec

23 Lord Aylmer c. 1833
Oil on canvas, 43.0 x 32.7 cm

Inscription: verso, on canvas, *Ursulines de Québec/Ce portrait es/*[half-erased]*/Ce portrait est celui de notre ci devant/cher Gouverneur le Lord/Aylmer qui est parti/de Québec le 17 Sept/a deux heures l'après midi/1835 - /C'est Lady Aylmer, qui/nous a fait ce présent.* (Ursulines of Quebec City. This portrait [half-erased] This portrait is that of our previous dear Governor, Lord Aylmer, who left Quebec City on 17 September 1835, at two o'clock in the afternoon. It was Lady Aylmer who made us a gift of it.)

Provenance: Lady Aylmer; Monastère des Ursulines de Québec, Quebec City, 1835.

Exhibitions: 1887, Montreal, The Numismatic and Antiquarian Society of Montreal, *Canadian Historical Portraits and other Objects relating to Canadian Archaeology,* cat. no. 180; 1892, Montreal, The Numismatic and Antiquarian Society of Montreal, *Canadian Historical Portraits and Antiquities,* cat. no. 37.

Bibliography: Le Canadien (2 Dec. 1833) p. 2; *The Quebec Mercury* (3 Dec. 1833) p. 3; IBC, Ursulines de Québec file; Le Jeune (1931), vol. I, pp. 104-106; Tremblay (1972), pp. 50, 76, 77, 80.

Executed about 1833, this small painting belonged to the Governor's wife, Lady Aylmer, who gave it to the Ursuline Sisters of Quebec City the day before she sailed for England in September 1835. She asked that it be hung with its pendant, a portrait of herself (see cat. no. 24), in the room of the Mother Superior. These two pictures have remained in the keeping of the Ursuline Convent in Quebec City ever since. They were exhibited in Montreal on two occasions at the end of the nineteenth century.

Lord Aylmer (1775-1850) was a professional soldier. He was Governor General of Canada from 1830 to 1835. With little experience in civil administration, he met many difficulties during his term of office, a time when the colony was passing through critical times. He was violently opposed to Louis-Joseph Papineau, head of the popular party, concerning the control of public money and the distribution of positions in the public service. Aylmer was recalled to England in 1835.

When Aylmer's portrait was painted, Joseph Légaré was a member of the Literary and Historical Society of Quebec City of which the Governor was patron. Until January 1834, meetings had even been held occasionally in the latter's residence, at the Château Saint-Louis. In November 1833, when Légaré opened a gallery in his new house, on Sainte-Angèle Street, where he exhibited his collection of paintings and engravings, Lord Aylmer came to visit him. From the newspapers, we learn that he then expressed his satisfaction to the artist and congratulated him on his zeal and good taste. It was perhaps as a result of this meeting that Légaré painted the portraits of Lord and Lady Aylmer.

Lord Aylmer is shown seated in an armchair placed between two pilasters. He head is turned towards the left of the picture and he is smiling. He is dressed in military uniform with cuffs and epaulettes. On the front of his buttoned coat are pinned various decorations including the Grand Cross of the Order of the Bath. This official portait shows a certain awkwardness due to the curious way in which the subject's legs are crossed.

Monastère des Ursulines de Québec, Quebec

24 *Lady Aylmer* c. 1833
Oil on canvas, 43.0 x 32.9 cm

Inscription: Ursulines de Québec/Ce portrait est/celui de notre chère/Lady Aylmer, cette/chère Dame nous/a été vraiment

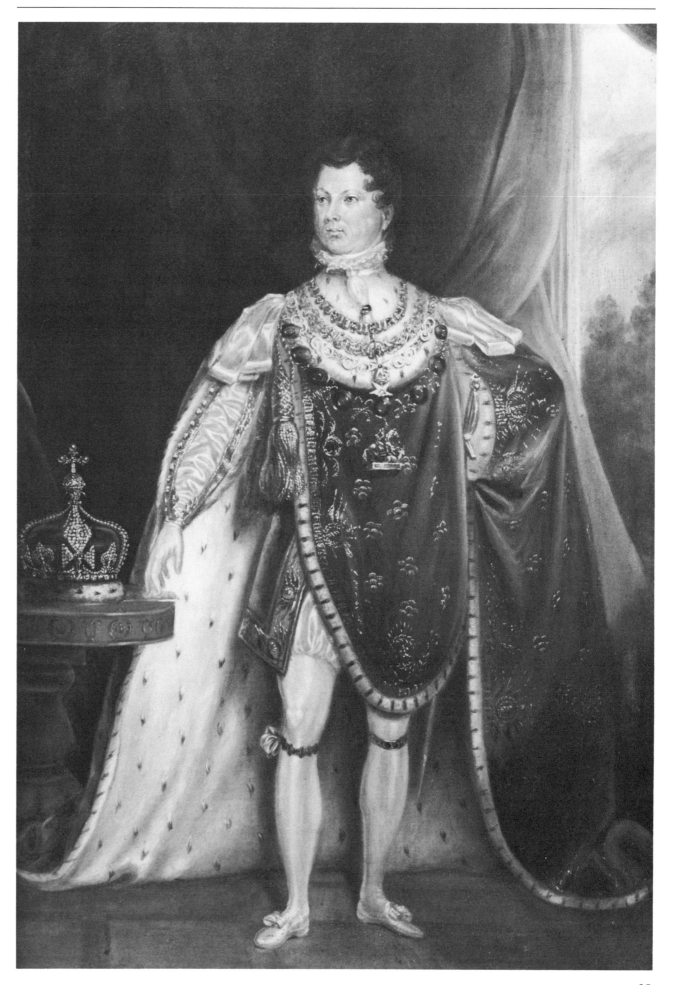

une/tendre & sincère/Amie./Ce présent vient d'elle/même partie jeudi le/17 sept 1835. (Ursulines of Quebec City. This portrait is that of our dear Lady Aylmer, that dear Lady was truly a sympathetic and sincere friend of ours. This gift comes [to us] from her very own hands, she who left Thursday 17 September 1835.)

Provenance: Lady Aylmer; Monastère des Ursulines de Québec, Quebec City, 1835.

Exhibitions: 1887, Montreal, The Numismatic and Antiquarian Society of Montreal, *Canadian Historical Portraits and Other Objects Relating to Canadian Archaeology,* cat. no. 181; 1892, Montreal, The Numismatic and Antiquarian Society of Montreal, *Canadian Historical Portraits and Antiquities,* cat. no. 37 (one of two); 1952, Quebec City, Musée du Québec, *Exposition rétrospective de l'art au Canada français,* cat. no. 71, repr.

Bibliography: IBC, Ursulines de Québec file, Lejeune (1931), vol. I, p. 106; Morisset, *La peinture traditionnelle* (1960), p. 97; Harper (1966), p. 80; Tremblay (1972), pp. 50, 76, 77, 80.

This portrait is the pendant to that of Lord Aylmer (see cat. no. 23) and its history is the same. It is not surprising that Lady Aylmer gave these two pictures to the Ursuline Sisters of Quebec City when she left for England in 1835, for she was a benefactor and friend to them during her stay in Quebec.

Born Louisa Anne Call, she had married Aylmer on 4 August 1801. She accompanied her husband to Quebec City when he was appointed Governor-General of Canada in 1830. There, she became very friendly with Lieutenant-Colonel James Patterson Cockburn, the watercolourist, whose enthusiasm for the picturesque beauty of the town and surrounding countryside she shared. She is the author of a manuscript entitled *Recollections of Canada,* dating from 1831-1832. It contains very interesting observations concerning life in Quebec at that time. Lady Aylmer died on 13 August 1862, surviving her husband, by whom she had no children, by twelve years.

Lady Aylmer's portrait has suffered the ravages of time. Its surface is covered with innumerable cracks which prevent proper appreciation. There are so many in the lower part of the picture that it is even impossible to tell whether the artist's model was standing or seated when the portrait was painted. It can, in fact, be seen no further than the hips, but the work is still of considerable interest.

A soft light coming from the left of the picture causes the figure to stand out from the neutral background, which is crossed by a diagonally arranged drapery. The lighting shows to advantage an aristocratic face remarkable for a sweetness of feature and richness of finery. Lady Aylmer has her hair piled high on her head, surmounted by a comb, and rich pendant earrings dangle from her ears. Her delicate neck emerges from a kind of ruff or collar which stands out from the bodice of her dress. A belt held by a buckle encircles her slim waist, contrasting with her puffed sleeves from which emerge delicate hands, elegantly crossed below the belt.

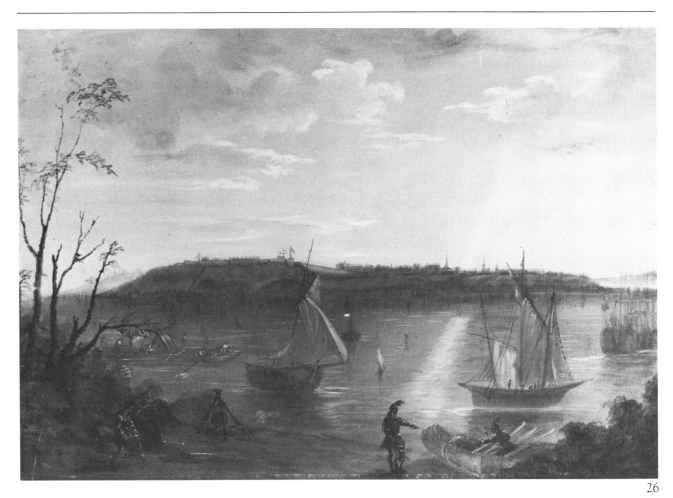

26

Légaré only painted portraits occasionally; it was a *genre* for which he had little liking. In this respect, his portrait of Lady Aylmer seems a real success: he conveys all the grace and character of his model in a masterly fashion.

Monastère des Ursulines de Québec, Quebec

25 *George IV* 1834
Oil on canvas, 66.7 x 45.1 cm

Provenance: Jacques Viger, Mayor of Montreal; Lactance, eldest son of Louis-Joseph Papineau; Papineau family, Montebello; private collection.

Exhibition: 1973-1974, Ottawa, National Gallery of Canada, *People's Art: Naïve Art in Canada,* cat. no. 42, repr.

Bibliography: La Bibliothèque Canadienne (15 Nov. 1829) p. 202; *The Quebec Gazette* (6 Aug. 1829) p. 3, (23 Nov. 1829) pp. 1-2, (10 Dec. 1829) pp. 2-3, (14 Jan. 1830) pp. 2-3; *The Quebec Mercury* (4 Aug. 1829) pp. 397-398 (7 Nov. 1829) p. 575, (16 Jan. 1830) p. 28, (27 Feb. 1830) p. 113, (31 Aug. 1852) p. 2; private collection, letter from Joseph Légaré to Jacques Viger (14 June 1834); Morisset, *La peinture traditionnelle* (1960), p. 97; Cauchon (1971), p. 91; Tremblay (1972), pp. 54-55.

On 14 June 1834, Joseph Légaré wrote the following letter to Jacques Viger, Mayor of Montreal:

Sir,

I take the liberty of sending you by the Steamboat *Eagle* the small painting of His late Majesty George the Fourth, to be presented by you to the oldest son of the Honorable J.-L. Papineau, Speaker of the House of Assembly, as you were good enough to promise during the conversation that I had the honour to have with you on this subject last winter.

I was not able to send it to you sooner, having been delayed by the workman who made the frame.

I beg you at the same time to present my respects to the Hon. Papineau and believe me,

Sir,

Your very humble and obedient servant,
Joseph Légaré.

On the evidence of this letter, Viger seems to have ordered a portrait of George IV (1762-1830) from Légaré in 1833 as a gift for Lactance, the eldest son of Louis-Joseph Papineau (1786-1871). Elected a member of the Legislative Assembly in 1808, Louis-Joseph Papineau had from then on devoted all his energies to politics. He was for many years Speaker of the House. Légaré was one of his most ardent supporters, especially backing the 92 Resolutions that Papineau, as leader of the popular party, or "Parti canadien," put forward in 1834. After the politician's

death, Légaré's *George IV* remained in the Papineau family. Before its acquisition by a collector a few years ago, it was still on view in Papineau's seigneurial residence at Montebello, Quebec.

On 4 August 1829, *The Quebec Mercury* announced the exhibition of a portrait of George IV - King of England from 1820 to 1830 - in the rooms of the Literary and Historical Society, in the Union Building. The public was invited to come and admire this painting, a copy made by the English painter Wheatley after a work by his master, Sir Thomas Lawrence (1769-1830).

The same edition of the paper carried a long description of the picture:

PORTRAIT OF HIS MAJESTY

Mr Jones arrived from Montreal yesterday, with a splendid full length portrait of His Majesty which is exhibiting in the rooms of the Literary and Historical Society, in the Union Buildings. This picture possesses high merit, and is a copy of the famous portrait painted by Sir Thomas Lawrence, immediately after the Coronation, which is now at Oxford. - It is by Mr. Wheatley, an artist who paints under Sir Thomas Lawrence, and who executes the draperies and other subordinate parts of the great artist's portraits, the face therefore in the picture now exhibiting may properly be said to be the only part copied, the robes, decorations and crown being by the same hand which executed the same parts of the Oxford picture. His Majesty is represented standing in an easy dignified posture, his right hand extended to a table on which stands the Crown, manufactured for the Coronation by Messrs. Rundell & Bridge, and for which they received £20,000 for the use of the jewels, and £3,000 for the workmanship. The whole figure of His Majesty is graceful and expressive of that natural ease and dignity for which he has always been so conspicuous. The face is a striking likeness, though at first sight it appears somewhat young for a man of His Majesty's years, yet, on close inspection the marks incidental to advanced life are plainly discoverable. The arrangement of the robes is particularly happy, concealing the corpulency which, of later years, has taken somewhat from the symmetry of His Majesty's person; the richness of the velvet and the shining gloss of the satin are admirably shewn, and the embroidery on the robe appears absolutely worked in gold. - The Collars of the several orders with which His Majesty is decorated have the like appearance of reality, and by the happy introduction of a dark back ground of extraordinary depth, the jewels of the Crown are so admirably brought out, that were a second Colonel Blood present they would tempt his fingers to purloin the pictured gems, so exquisite is the imitation. The picture is one which must please every one, the connoisseur sees in it the skill of the artist who has contrived so wonderfully to subdue the glaring colours and light parts, and produce from these unfriendly materials a chaste and harmonized effect which could only be achieved by the hand of a master. Those who enter into details will admire the

27

fidelity with which the gems and precious stones are made to glitter, the gold to beam in its massive richness, and the soft lustre of the velvet and satin in which the portrait is decked - whilst those who have seen our beloved monarch will esteem it for the true portrait of Him who is "Aye every inch a King." - The picture we understand is for sale; and we hope that it will not be permitted to leave the province, it ought to remain in the metropolis of British North America whether considered as a work of art, or as the portrait of a monarch who lives in the hearts of his subjects.

At the time this article appeared, Légaré was a member of the Literary and Historical Society of Quebec, to which he had lent his personal collection of paintings for an exhibition in the rooms in Union Building, and this was where Wheatley's *George IV* was hung in August 1829. On 7 November of the same year *The Quebec Mercury* announced that Légaré had almost completed a copy of this picture. This news was immediately repeated by the editor of *La Bibliothèque canadienne* who added his comment:

PORTRAIT OF THE KING

We were glad to see the copy of His Majesty's portrait that Mr Légaré of this town is now copying from that of Mr. Wheatley, after the original by Sir Thomas Lawrence. Mr Légaré has succeeded perfectly in catching the tone of the picture he is studying, and the drapery as well as the jewels and the gold embroidery are remarkably well imitated. The picture is

nearly completed, and it is a fine example of the skill of this Canadian artist, who had only his good taste and his natural talents to guide him in the art that he has cultivated and which he practises with honour for himself and for his country. We should learn with pleasure that he feels enough encouragement to induce him to continue to follow the lofty paths of his profession; we are sure that a little instruction and the opportunity to study the great masters would place Mr Légaré well above a mediocre painter.

Mercury

We have ourselves had the opportunity of seeing Mr Légaré's work. It was then only a sketch; but the part that was completed seemed to us a perfect imitation of Mr Wheatley's copy. We even detected an improvement in it, namely the face which appeared too young in the work of the English painter, seemed, in that of our compatriot, more in keeping with the age of His Majesty, at the time of his coronation.

Editor.

On 23 November *The Quebec Gazette,* in its turn, congratulated the artist for his copy, emphasizing the fact that it had been seen and admired by Governor Kempt and Lieutenant-Colonel James Patterson Cockburn, a connoisseur in the matter. The newspaper took the opportunity of announcing the impending acquisition of Légaré's picture for the Legislative Council Chamber, which was confirmed a few days later. In January 1830, the painter Jean-Baptiste Roy-Audy also made a copy of

28

Wheatley's portrait of George IV, which had just been acquired for the decoration of the Legislative Assembly Chamber.

Légaré's work was destroyed in 1854 when the parliament building in Quebec City was burned to the ground (see cat. no. 186). Fortunately, his small version of 1834 gives us some idea of it, and corresponds perfectly with the detailed description of Wheatley's painting that appeared in *The Quebec Mercury* on 4 August 1829. Légaré has skillfully surmounted the difficulties posed in copying a royal portrait, rich in textures and abounding in details.

Private Collection

26 Quebec City at Sunset c. 1835
Oil on cardboard pasted on canvas, 37.1 x 53.6 cm

Provenance: Miss Yvonne French, Gloucester, England; Musée du Québec, Quebec City, 1958 (A 58 326 P).

Exhibition: 1965, Ottawa and Quebec City, National Gallery and Musée du Québec, *Treasures of Quebec*, cat. no. 48.

Bibliography: ASQ, Verreau collection, Letter from Joseph Légaré to Jacques Viger (6 Dec. 1839), box 61, no. 4; ASQ, *Séminaire 12*, no. 41 (1874) p. 7 (no. 276); Morisset, *La peinture traditionnelle* (1960), p. 99; Giroux (1972), p. 6.

This painting was acquired in England by the Musée du Quebec in 1958. On 6 December 1839, Légaré wrote to Jacques Viger in Montreal to tell him that he had a series of oil-on-paper sketches that would be suitable for his *Album*, since the largest only measured 6 or 7 inches by 5 inches. He added "I have already made a similar set for a lady from Liverpool" and quoted the titles. These included "a view of Quebec City from Point Lévis." It is interesting to note, even if this is not the same work, that Légaré worked for British customers, some to be found among officers of the garrison. *Quebec City at Sunset* was perhaps one of these paintings sold by Légaré during his lifetime and which turned up later in England.

In the manuscript catalogue of Légaré's collection of paintings sold to the Séminaire de Québec in 1874, lot 276 bore the title *Indian Scene at Lévis*. Although this painting has not been traced, it may perhaps have been the same subject repeated by Légaré. The view of Quebec City from Lévis was considered as one of the finest landscapes in the world and British watercolourists visiting Quebec never failed to paint it. Légaré portrays it here, in sketch form, at the time of day the sun sinks behind the town, giving it a highly romantic luminous quality.

In the background, to the left, a Martello tower can be made out and topping Cape Diamond, the Citadel with its inclined plane. Next come the familiar outlines of the upper town: the monument to Wolfe and Montcalm, the Château Saint-Louis, the steeples of the Anglican cathedral and Notre-Dame de Québec. The buildings of the lower town, and its quays, disappear into the shadow of the cliff. The Saint Lawrence is covered with ships and boats among which, to the left, can be seem a raft of wood intended either for export or ship-building. The foreground shows us Indians on the river bank, women and children to the left near a cooking-pot, and men to the right busying themselves with a large bark canoe reminiscent of the one Légaré painted in his *Landscape with Wolfe's Monument* (see cat. no. 42).

Musée du Québec, Quebec

27 Château Haldimand and the Citadel
Oil on paper, 36.2 x 54.0 cm

Inscription: verso, top c., *Québec/£1-10 0*; also *verso*, top c., under the first inscription but in another hand, *Les anciennes Barraques de l'Artillerie. Au centre,/ le monument Wolfe et Montcalm et à l'arrière-/ plan, la Citadelle.* (The old artillery barracks. In the centre, the Wolfe and Montcalm monument, and in the background, the Citadel.) *Verso 1.1., Vieux château* (The old castle).

Provenance: Légaré's Quebec Gallery of Paintings; Séminaire de Québec, Quebec City, 1874 (Archives, Portfolio 159-G, p. 48).

Bibliography: ASQ, *Séminaire 12*, no. 41 (1874), p. 7, nos 290-292; Cameron & Trudel (1976), pp. 95, 98, 100.

This oil on thick paper was acquired by the Séminaire de Québec at the 1874 sale of Joseph Légaré's collection of paintings. In the manuscript catalogue of this collection, lots 290, 291, and 292 are each described as "batch of oil sketches." This work was perhaps one of them. It belongs to a group of oils on paper that we have been able to attribute to Légaré (see cat. nos 10 and 21). It was restored at the National Gallery of Canada in 1976. On the back, there is a pencil sketch representing two men; it has been crossed out with numerous pencil strokes.

When he painted this work, Légaré was standing in the middle of the inner courtyard of the Château Saint-Louis. Only the outbuildings of the latter can be seen, to the left. Opposite, we see part of the Château Haldimand. In the background, beyond a wall, rise the fortifications of the Citadel. A flag flies there not far from a signal station. More to the right, in the midst of a cluster of greenery, the top of the monument erected in memory of Wolfe and Montcalm can be seen. The first stone of this monument had been laid in 1827 by the Governor, Lord Dalhousie. As for the Château Haldimand, it bears the name of the governor who began its construction in 1784. The building was officially opened, however, by his successor, Lord Dorchester, in 1787. It was the governor's residence until 1811. This sober building subsequently housed civil and military offices. After being used for other purposes during the second half of the nineteenth century, it was

29

demolished in 1892 to make way for the present Château Frontenac.

Through its symbolic elements, this work by Légaré illustrates British power in North America, of which Quebec City had been the hub since the Conquest. Despite the splendid late-afternoon sky which crowns the scene, there is a certain sadness in this view of buildings and fortifications seemingly deserted by man.

Séminaire de Québec, Quebec

28 The Hôpital-Général, Quebec City
Oil on paper, 35.1 x 51.1 cm

Inscription: verso l.r., Hôpital-général.

Provenance: Légaré's Quebec Gallery of Paintings; Séminaire de Québec, Quebec City, 1874 (Archives, Portfolio 159-G, p. 12).

Bibliography: AHGQ [various documents related to the building itself]; ASQ, *Séminaire 12*, no. 41 (1874), p. 7, nos 290-292; IBC, "R.B." and Séminaire de Québec/Archives files; Cameron & Trudel (1976), pp. 156-159; Porter, "L'Hôpital-Général de Québec" (1977).

This oil sketch was acquired by the Séminaire de Québec

at the 1874 sale of Joseph Légaré's collection of paintings. In the manuscript catalogue of this collection, lots 290, 291, and 292 are each described as "batch of oil sketches." This work was perhaps one of them. Gérard Morisset wrongly attributed it to an English painter visiting Quebec about 1846 and whole initials he took to be R.B. (see cat. nos 10 and 21). This work was restored at the National Gallery of Canada in 1976.

The Hôpital-Général de Québec was founded in 1692 by Mgr de Saint-Vallier, the second bishop of Quebec. Some time earlier, the latter had acquired the former Recollect monastery situated near the Saint Charles River, about a kilometre and a half from Quebec City. There, he installed the Augustinian Sisters detached from the Hôtel-Dieu de Québec to devote themselves to the care of the poor, the old, and the sick. In Légaré's day, the institution fulfilled practically the same functions as at its foundation. Also, the running of a boarding school and the care of the insane from the Quebec area had since been added to its former tasks.

In Légaré's sketch, the main façade of the Hôpital-Général is seen slightly from the side. The monotony of this long building is broken by two *avant-corps*, the roofing of which - pierced by a small bull's-eye window - presents a curious-looking outline. The two-storey stone building is topped by a double sloping roof pierced by dormer windows and chimneys. The lightning conductors installed by Abbé Jérôme Demers in 1824 can also be seen. Three doors lead into the building. The one on the left, the

simplest of the three, gives access to the chaplain's apartments. The two others are arched and framed in the classical style. On the first floor, they are both surmounted by a statue placed in a niche. The left-hand door opens into the vestibule of the chapel, while the door to the right leads to the men's ward and the storehouse of the community. By and large, the front of the Hôpital-Général dates back to the early eighteenth century, with the exception, however, of the part to the right of the second *avant-corps.* This was an extension built in 1818 by John Cannon, according to the specifications of the architect François Baillairgé. Paid for by the government, it housed those of the insane who were believed curable. The façade was to be raised by one storey in 1850.

The centre of the sketch is filled by a majestic elm which hides part of the façade. It stands near a small bridge whose handrail can be seen. This little bridge spanned a stream which flowed past the institution at that time and eventually joined the Saint Charles River. Its waters had served for some years to turn a water mill, and it is this squat building that stands out behind a screen of trees on the extreme right of the sketch. Between the mill and the main body of the façade, the kitchen and bakery wing of the institution is suggested in the background. The lower half of the sketch is used to set off the buildings of the Hôpital-Général. Légaré has merely added brush strokes to suggest a khaki-coloured field.

From the late eighteenth century, several English watercolourists had taken an interest in the Hôpital-Général de Québec. Légaré is the first Quebec painter to join their ranks and give us a faithful rendering of the building between 1825 and 1850.

Sémainaire de Québec, Quebec

29 The Old Water Mill of the Hôpital-Général de Québec
Oil and graphite on paper, 34.3 x 49.5 cm

Inscription: verso, u.c., Hôpital-général.

Provenance: Légaré's Quebec Gallery of Paintings; Séminaire de Quebec, Québec City, 1874 (Archives, Portfolio 159-G, p. 13).

Bibliography: AHGQ [various documents relative to the building itself]; ASQ, *Séminaire 12*, no. 41 (1874), p. 7, nos 290-292; IBC, "R.B." and Séminaire de Québec Archives files; Cameron & Trudel (1976), pp. 156-159; Porter, "L'Hôpital-Général de Québec" (1977).

This oil sketch was acquired by the Séminaire de Québec at the 1874 sale of Joseph Légaré's collection of paintings. In the manuscript catalogue of this collection, lots 290, 291, and 292 are each described as "batch of oil sketches." This work was perhaps one of them. Gérard Morisset wrongly attributed it to an English painter visiting Quebec about 1846 and whose initials he took to be R.B. (see cat. nos 10 and 21). This work was restored at the National

Gallery of Canada in 1976.

This oil on paper in a way completes the sketch showing the front of the Hôpital-Général (see cat. no. 28). It more or less corresponds to the right-hand part of the hospital. From left to right, the north end of the façade - corresponding to the extension built in 1818 for the insane - the bakery wing in the background, and nearer to us, the old water mill which this time fills the centre of the composition, can all be recognized.

This solid edifice had been built in 1702 to enable the nuns to grind the wheat from their seigneury of Notre-Dame-des-Anges themselves. Not only could they thus avoid buying hundreds of bushels of wheat each year, but they could also make a profit from the operation. The mill even fulfilled the needs of their copyholders from the Seigneurie des Îlets and those of the surrounding parishes. The building was thus of crucial importance to the nuns. Also, as the mill only worked for part of the year because of the lack of water, they had a windmill built in 1710. The archives of the community mention that in 1777 the water mill was used as a laundry and that several rooms had been made in it. Excavations made in front of the Hôpital-Général in 1816 revealed a large stone culvert which formerly carried the water needed for the working of the mill. The building was demolished in 1859.

In Légaré's work, the old stone mill is seen from the side. It stands on an incline. A gully bordered with bushes, through which flowed a stream, separates it from the field in the foreground. On the left side, a drainpipe pours sewage from the Hôpital-Général into the gully. On the edge of the gully, to the right of the line of bushes, trees wave their slender branches. Two of them partly hide the old mill while the others stand higher and to their right. They blend into the spendid landscape of the valley of the Saint Charles River. In this right-hand part of the work, from the field in the foreground, we see sections of the wooden fence which enclosed the hospital grounds at the time. Further in the distance, in the background, can be seen the meander of the Saint Charles River with its verdant borders, and further still, the pale roofs of two houses. These are the buildings of the farm of the Seigneurie des Îlets, a property owned by the nuns of the Hôpital-Général de Québec.

This oil on paper is a much more finished work than that showing the hospital façade. Its complex yet well-balanced composition, and the skillful range of colours employed, make it a success worthy of Légaré's best canvases in this genre.

Séminaire de Québec, Quebec

30 *Portrait of a Man* 1837
Graphite on paper, 19.6 x 14.5 cm

Inscription: signed and dated l.r., *J.L. 1837.*

Provenance: Bernard Desroches, Montreal; Musée du Québec, Quebec City, 1968 (A 68 157 D).

We know nothing about the original provenance of this work, but its date suggests the possibility of a link with the troubles of 1837, during which Légaré was arrested as a *patriote*. Thus, this portrait may well be that of a personage involved in the events of that year.

The man is shown half-length. His partly unbuttoned coat reveals a check waistcoat. His features are vigorous. The face is severe and his look penetrating. His hair is worn in the Papineau style, a lock brushed back from his forehead.

This drawing, which conveys remarkable strength, is one of the very few by Légaré to come down to us.

Musée du Québec, Quebec

31 *Niagara Falls* c. 1838
Oil on canvas, 95.3 x 152.4 cm

Provenance: Légaré's Quebec Gallery of Paintings; Séminaire de Québec, Quebec City, 1874.

Bibliography: The Quebec Mercury (25 Oct. 1838), p. 2, reprinted 27 Oct. and 3 & 10 Nov. 1838; AJQ, Register of Notary Public Jean-Baptiste Delâge (6 Dec. 1872), no. 2921; ASQ, *Seminaire 12*, no. 41 (1874), p. 3, no. 125; ASQ, Box 41-G. section F; ASQ, Portfolio 160-G, pp. 83-84; Laval University Catalogues (SQ) (n.d. I) p. 1, (1880) p. 3, no. 2, (n.d. IV) p. 9, no. 2, (n.d. V) p. 9, no. 2, (n.d. VI) p. 8, no. 2, (1889) p. 8, no. 2, (1893, in French and English) p. 8, no. 2, (1894) p. 7, no. 4, (1898) p. 8, no. 2, (1901) p. 8, no. 4, (1903) p. 8, no. 2, (1905) p. 7, no. 2, (1906) p. 10, no. 2, (1908) p. 86, no. 320, (1909) p. 57, no. 320, (1913) p. 62, no. 342, (1923) p. 72, no. 342, (1933) p. 81, no. 234; Bouchette (1815), pp. 39-41; Bouchette (1832), vol. I, pp. 138-147; Lemoine (1876), p. 362; Bellerive (1925), p. 16; Colgate (1943), p. 109; Harper (1966), p. 82.

In the fall of 1838, *The Quebec Mercury* published the following advertisement on four different occasions:

FOR SALE

A COLLECTION of 8 of the finest VIEWS of the Country, representing the different FALLS near QUEBEC; also a View of Quebec, and the NIAGARA FALLS, well framed, and to be seen at the Quebec Picture Gallery. Quebec, 25th October, 1838.

Légaré was one of the owners and founders of the Quebec Picture Gallery and it is quite possible that the "views of the Country" offered for sale there in 1838 were his own works. Pictures by Légaré are, in fact, known to fit all the subjects listed in the advertisement, particularly three versions of Niagara Falls (see cat. nos 31, 32, 208). All three were acquired by the Séminaire de Québec at the 1874 sale of Joseph Légaré's collection of pictures. However, the manuscript catalogue of this collection only mentions one *Niagara Falls* (lot 125), which probably corresponded to the largest of the versions painted by Légaré. Lemoine tells us that this painting was exhibited

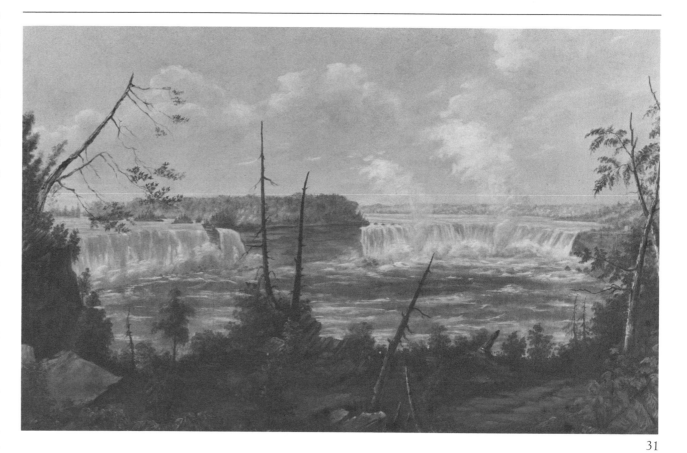

31

in the hall of Laval University (SQ) in 1876. It was subsequently mentioned in most of the catalogues published by that institution, up until 1933. It was cleaned on two occasions, in 1962 and 1972.

The Niagara River joins Lakes Erie and Ontario. It is remarkable for its splendid cataracts that reach the height of fifty metres and which Joseph Bouchette described in 1832 in the following terms:

> At the Falls the river forms a sharp angle, by departing from its previous course, which is almost due west, and bending suddenly to the N.N.E. Below the Falls its character become entirely changed; its width is contracted from upwards of a mile to scarcely four hundred and fifty yards, and at some points less; its bed, instead of lying between low banks smiling with the arts of agriculture, sinks hundreds of feet into a deep chasm, walled by perpendicular or impending cliffs.
>
> The Falls of Niagara are divided by Goat Island into two unequal sections; that on the east being called the American or Fort Schlosher Fall - the other, on the west, the Horse-Shoe, or, simply, the Great Fall, by way of pre-eminence. The former lies exclusively in the state of New York, and also half of the latter; it being divided through the point of the Horse Shoe, between the United States and Canada. The direct width of the cataract, from shore to shore, is about 1100 yards, forming the chord of an irregular arc, described by the face of the island and the ledge of both falls.
>
> The face of Goat Island, which intervenes between these awful cataracts, keeps them three hundred and thirty yards asunder, and perhaps adds greatly to their romantic effect and beauty, by destroying the sameness which one unbroken sheet of water would present, although the collective waters of the Niagara, thus hurled down *en masse*, might, if possible, be still more grand and astounding.

Légaré's painting gives us a general view of Niagara Falls. The American Falls can be seen to the left and the Great Falls to the right. Separated by Goat Island, they hurtle down into a basin of swirling waters. Clouds of spray rise opposite the Horseshoe Falls. The cataracts are seen from the opposite river bank. This strip of uneven ground, dotted with trees and stunted trunks, is an effective offset to the composition of the picture. A fine range of browns give the latter its predominating tonality.

We do not know whether Légaré painted Niagara Falls on the spot. He made at least one small sketch in oils representing this subject before 1839 (see cat. no. 207). A visit to Niagara is possible, but we have nothing to prove it. He may equally well have copied one of the numerous engravings showing the Falls that were on the market in his day. The Archives of the Séminaire de Québec, moreover, have versions of these published in 1823 and 1844, and it is not impossible that they may formerly have belonged to Légaré. The artist may also have owned a copy of *Views of Niagara*, published by the American George Catlin (1796-1872) in 1831 - now to be found in the New York Public Library. There are similarities, indeed, between some of Catlin's illustrations and the versions that Légaré painted of Niagara Falls.

Séminaire de Québec, Quebec

32 Niagara Falls *c.* 1838
Oil on canvas, 73.6 x 99.1 cm

Provenance: Légaré's Quebec Gallery of Paintings; Séminaire de Québec, Quebec City, 1874.

Bibliography: The Quebec Mercury (25 Oct. 1838), p. 2 and reprinted 27 Oct. and 3 & 10 Nov. 1838; ASQ, *Séminaire 12,* no. 41 (1874); Laval University Catalogues (SQ) (n.d. I) p. 1, (1880) p. 3, no 4, (n.d. IV) p. 9, no. 4, (n.d. V) p. 9, no. 4, (n.d. VI) p. 9, no. 4, (1889) p. 8, no. 4, (1893, in French) p. 8, no. 4, (1893, in English) p. 9, no. 4, (1894) p. 7, no. 7, (1898) p. 8, no. 4, (1901) p. 8, no. 7, (1903) p. 8, no. 4, (1905) p. 8, no. 4, (1906) p. 11, no. 4, (1908) p. 86, no. 322, (1909) p. 58, no. 322, (1913) p. 62, no. 343, (1923) p. 72, no. 343, (1933) p. 81, no. 235; Bouchette (1815), pp. 39-41; Bouchette (1832), vol. I, pp. 138-147; Lemoine (1876), p. 362; Bellerive (1925), p. 16; Colgate (1943), p. 109; Harper (1966), p. 82.

This oil on canvas was acquired by the Séminaire de Québec at the 1874 sale of Joseph Légaré's collection of paintings. In the manuscript catalogue of this collection, lots 41, 46, 58, 95, 156, 176, 234, 275, 281, and 293 are entitled merely *Waterfall.* This painting perhaps corresponded with one of these. It was certainly exhibited with another large version of Niagara Falls in the hall of Laval University (SQ) in 1876, and subsequently appears in most of the catalogues published by that institution. It was restored in March 1962.

If this picture is compared with the large version of the Séminaire de Québec (see cat. no. 31), it is obvious that the falls are seen from a different angle and from further away. The American Falls and the foaming waters of the Niagara River - on which a fragile boat can be made out - thus acquire added importance while the Horseshoe Falls are relegated to the background. Nearer to us, a triangle of forest of mixed conifers and stunted tree trunks fills the bottom right-hand corner of the painting. While effectively suggesting the right bank of the river, this layout enables the artist to emphasize both the movement of the river and the diagonal composition of the picture.

Speaking of the prodigious Niagara cataracts in 1815, Joseph Bouchette states that they are "one of the most extraordinary spectacles of nature, and offering the imagination the most striking union of sublimity and grandeur, of magnificence and terror. The most animated picture, whether born beneath the burning brush of the artist guided by the liveliest imagination, or flowing from the most eloquent pen that can embellish a narration, would probably still be far from doing justice to the reality."

Such a sight could not therefore help but attract artists who witnessed it. We have lost count of the number of those who, since the eighteenth century, have tried to portray the grandiose character of Niagara Falls in their works. Among them, Légaré has the merit of having been the first native painter to have demonstrated his sensitivity to the beauty of the site.

Séminaire de Québec, Quebec

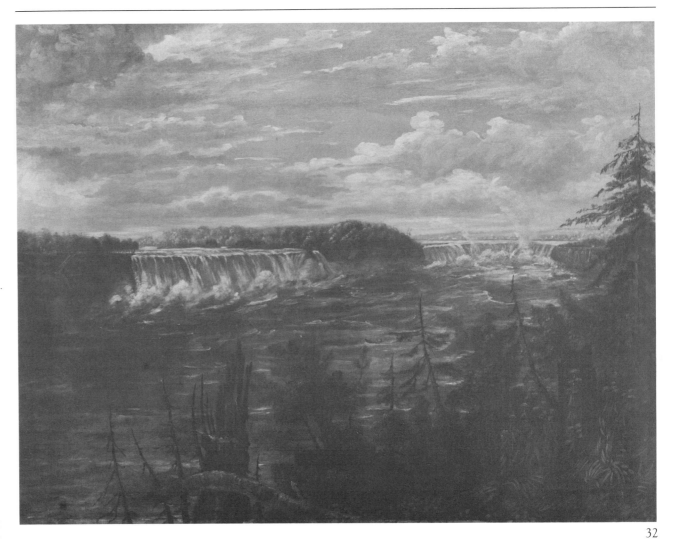

32

33 Landscape
Oil on canvas, 26.0 x 45.6 cm

Provenance: Légaré's Quebec Gallery of Paintings; Séminaire de Québec, Quebec City, 1874 (Archives, Portfolio 159-G, p. 57).

Bibliography: ASQ, *Séminaire 12,* no. 41 (1874).

This oil sketch was acquired in 1874 by the Séminaire de Québec at the sale of Joseph Légaré's collection of paintings. In the manuscript catalogue of this collection, lots 290, 291, and 292 are each described as "batch of oil sketches." This work was perhaps one of them. It was restored at the National Gallery of Canada in 1976.

We have not been able to identify with certainty the landscape shown in this apparently unfinished sketch, but it could possibly represent the Île d'Orléans seen from some high point on the Côte de Beaupré. Wherever it is, however, we are dealing with a work that illustrates Légaré's technical skill. With great economy of means, the artist succeeds in conveying the variety of planes, the depth, and luminosity of the landscape before him. To achieve his purpose, he does not hesitate to fill his composition with elements of which he was so fond, such as sharp-cornered rocks and stunted tree trunks standing out against a sky crisscrossed by superbly sketched clouds.

Séminaire de Québec, Quebec

34 The Annunciation 1839
Oil on canvas, 100.7 x 75 cm

Inscription: signed and dated l.l., on a scroll, *J. Légaré/ 1839.*

Provenance: Pierre Pelletier, Quebec City, 1839; Monastère des Augustines de l'Hôpital-Général de Québec, 1839 (P-26).

Bibliography: AHGQ, Annales, vol. III (1794-1843), see entry 1839; AHGQ, Journal tenu par les Novices, vol. I (1837-1857), p. 13; AHGQ, Registre des Dons et aumônes (1693-1956), p. 97; Bibliothèque nationale, Paris, Est. Da 30; IBC, Hôpital-Général de Québec file; *Journal de Québec* (16 May 1871) p. 1; Lemoine (1872), p. 22; Morisset, "Joseph Légaré, copiste à l'Hôpital-Général de Quebec" (1935), p. 2; Mâle (1951), p. 242; Porter (1975), p. 14; Porter & Désy (1978); Réau, Book II, vol. 2, pp. 174-194.

In June 1839, Pierre Pelletier, a Quebec merchant, gave the community of the Hôpital-Général de Québec a painting representing the mystery of the Annunciation. The painter Joseph Légaré had just finished this picture and had sold it to him for the sum of £6. Pelletier's daughter, Marie-Louise Émilie, was a novice at the time with the Augustinian Sisters of the Hôpital-Général. Four months later, she was to make her solemn vows and sign her act of profession under the name of Sister Saint-Alphonse. The painting was restored at the National Gallery of Canada in 1978.

The Annunciation is the episode - as recounted in the Gospel according to Saint Luke - in which the Archangel Gabriel appears to the Virgin Mary and announces to her that she will conceive and bear the Son of God. In the form of a dove, the Holy Ghost then descends from Heaven towards the future Mother of Jesus.

In Légaré's painting, the scene takes place in a room with a tiled floor in which the Virgin's bed can be seen in the background. The Virgin is shown kneeling, almost full-face towards the viewer, before a prayer stool. Slightly turned towards the angel, she lays her hand on her breast in gesture of humility and submission. The angel Gabriel appears on the right. Standing on the clouds, he holds a lily branch in his right hand, symbolizing Mary's virginity. In his left hand, he points to the radiant dove of the Holy Ghost in the heavens, surrounded by clouds against which the heads of angels can be seen here and there.

Légaré's work is remarkable both for its suppleness of treatment and for the subtlety of its colouring. To paint the picture, he in all likelihood copied an engraving of an altar painting that the French artist, Louis de Boulogne (1654-1733), had executed for the chapel at Versailles.

Monastère des Augustines de l'Hôpital-Général de Québec, Quebec

35 *The Sainte-Anne River Falls* c. 1839
Oil on paper, 38.4 x 53.3 cm

Inscription: verso, r., parallel to the r. edge, is a now-illegible inscription.

Provenance: Légaré's Quebec Gallery of Paintings; Séminaire de Québec, Quebec City, 1874 (Archives, Portfolio 159-G, p. 59).

Bibliography: ASQ, *Séminaire 12,* no. 41 (1874); *The Quebec Mercury* (23 July 1840), pp. 3-4; Bouchette (1831), see entry "Ste. Anne, river."

This oil sketch was acquired by the Séminaire de Québec at the 1874 sale of Joseph Légaré's collection of paintings. In the manuscript catalogue of this collection, lots 290, 291, and 292 are each described as "batch of oil sketches." This work was perhaps one of these. It may also correspond with one of the ten "waterfalls" mentioned by this document (see cat. no. 32). It was restored at the National Gallery of Canada in 1976.

33

In Légaré's day, excursions to the many waterfalls in the country around Quebec City were frequently organized during the summer season. Those on the Sainte-Anne River attracted a great number of visitors, both local and from further afield. The Sainte-Anne River is situated between the parishes of Saint-Joachim and Saint-Ferréol downstream from Quebec. It flows into the Saint Lawrence River to the east of the parish of Sainte-Anne-de-Beaupré. Three kilometres from the confluence, the course of the river is very broken and it is here that its most remarkable falls are to be found. In July 1840, *The Quebec Mercury* published a long article entitled *The Falls of St. Anne,* in which a visit to the falls is highly recommended for its picturesque and romantic qualities. The writer of the article gives many details concerning the numerous vantage points, the variety of the falls and rapids, the amazing depth of the river bed, and the deafening noise that greets the visitor. In the course of his description, he insists on the impressive beauty of a place where the river, after splitting into two streams for part of its length, unites its waters which then hurtle down into an immense rocky cauldron.

This is the spot that Légaré has painted in the sketch preserved at the Séminaire de Québec. From a rock outlined in the foreground, we see the main stream of the river flow through a narrow gap carved out of the rock. Further away, beyond two stratified rocks at whose foot lies a tree trunk, we perceive a dark pool whose sparkling

water reflects the curve of the rock face. The overflow from this basin joins the mainstream to hurtle down into a chasm on the left-hand side of the picture. From this chasm, which is not shown in the sketch, a cloud of vapour rises, against which a small fir tree and several slender wild plants stand out.

Légaré's work is painted with rare mastery. The artist has faithfully depicted the movement of the waters and the many planes of the strata in the rock face. His sketch shows a fine range of ochres, greens, and turquoise highlighted by the dark rock in the foreground.

Légaré painted another version of the Sainte-Anne Falls. This is a small oil on paper that Jacques Viger ordered from him in 1840 as an illustration for his *Album* (see cat. no. 209). The composition of this work shows a certain number of variations with the present work. Thus, the upper part of the rock face is revealed with a strip of sky above. Moreover, the silhouettes of two onlookers appear in the foreground. This sketch in the keeping of the Séminaire de Québec may possibly have served as a preliminary version for the work exhibited.

Since 1973, the site of the falls on the Sainte-Anne River has been enhanced by a new access road, but the part painted by Légaré has hardly changed in appearance. The visitor will easily understand why the painter and several of his contemporaries were prompted to paint this scene. It must also be remembered, however, that these falls enjoyed an astonishing reputation at that time, which the

author of *The Quebec Mercury* article echoed in 1840:

> No one who has visited them can ever efface the picture from the mind; those who have not, would do well to avail themselves of the first opportunity, if they be desirous of witnessing one of the most picturesque water falls - the most wonderful hardly excepting Niagara - on this continent.

Séminaire de Québec, Quebec

36 *The Sault-à-la-Puce Falls* c. 1839
Oil on paper, 47.0 x 58.7 cm

Provenance: Légaré's Quebec Gallery of Paintings; Séminaire de Québec, Quebec City, 1874 (Archives, Portfolio 159-G, p. 56B).

Bibliography: ASQ, *Séminaire 12*, no. 41 (1874); Bouchette (1831), see entry "Sault a la Puce."

This oil sketch was acquired by the Séminaire de Québec at the 1874 sale of Joseph Légaré's collection of paintings. In the manuscript catalogue of this collection, lots 290, 291, and 292 are each described as "batch of oil sketches." This work was perhaps one of these. It may also correspond with one of the ten "waterfalls" mentioned in this document (see cat. no. 32). It was restored at the National Gallery of Canada in 1976. On the back of the sketch, Légaré drew two pencil studies for a *Nativity* (see cat. no. 91).

In 1831, Joseph Bouchette thus described the Sault-à-la Puce River:

> Sault a la Puce is a small stream descending from the high lands in the rear of the parish of Chateau Richer, in the S. of Côte de Beaupré. It winds through a mountainous and woody country, and is entitled to notice for its very Romantic falls, where its stream is precipitated from 3 declivities in succession; and for the beautiful and truly sylvan scenery that decorates its banks, especially when the autumnal foliage displays its multiplied variety of beauteous tints. It waters the P. of Chateau Richer, and falls into the St. Lawrence about ¼ of a league E. from the church, and at a little distance N.W. from the public road [see cat. no. 78].

In this work, the lower falls of the Sault-à-la Puce are seen from the side. They flow from left to right between vaguely outlined rocks and a hastily sketched forest. Above them, in the background, another waterfall flowing in the opposite direction can be seen. The result makes a fine contrast. The sky is reduced to a small triangle which offsets that of the lower falls, more massive and less clear in outline. In the foreground of the pool into which the waters flow, Légaré has added two twisted tree trunks which form a tilted U-shape. The outline of the left-hand trunk corresponds with that of the upper waterfall. As to

35

the other, the painter has considerably reduced its length and his alteration is obvious.

This dull-toned sketch was used as a preliminary study for two more of the artist's works, both of which present slight variations. One of them, a small oil on paper, illustrates one of the pages of Jacques Viger's *Album*, to be found in the Montreal Municipal Library (see cat. no. 210). It was one of the sketches that Viger bought from Légaré in 1840. The other work is a rather dark picture which belongs to the Musée du Québec Collection (see cat. no. 212).

Séminaire de Québec, Quebec

37 *The Chaudière Falls*
Oil on paper, 36.8 x 55.3 cm

Inscription: verso u.c., *Chutes de la rivière Chaudière?* (Chaudière River Falls?).

Provenance: Légaré's Quebec Gallery of Paintings; Séminaire de Québec, Quebec City, 1874 (Archives, Portfolio 159-G, p. 51).

Bibliography: ASQ, *Séminaire 12,* no. 41 (1874); Bouchette (1831), see entry "Chaudière, river."

This oil sketch was acquired by the Séminaire de Québec at the 1874 sale of Joseph Légaré's collection of paintings. In the manuscript catalogue of this collection, lots 290, 291, and 292 are each described as "batch of oil sketches." This work was perhaps one of these. It may also correspond with one of the ten "waterfalls" mentioned in this document (see cat. no. 32). It was restored at the National Gallery of Canada in 1976.

In a work published in 1831, Joseph Bouchette advised visitors to the Chaudière Falls to view them from different vantage points, the best being a rocky ledge jutting out into the river basin (see cat. no. 61). He also suggested admiring the falls from another rocky point behind and parallel to the latter. It was from this second spot that Légaré painted the sketch now belonging to the Séminaire de Québec.

In this work, the falls are seen from the front, from the edge of the pool into which they flow. Huge rocks fill the right side of the picture and hide part of the falls. The arrangement of these rocks, and the way they are disposed, gives a fine feeling of depth to the composition. The work is painted with great economy of means both in touch and colour. The artist has merely soaked his paper with oil to give the sky its yellow hue which harmonizes with the brown of the rocks and the blue grey of the waters.

Séminaire de Québec, Quebec

38 *The Montmorency Falls* c. 1839
Graphite, gouache, and oil on paper, 31.9 x 54.0 cm

Inscription: verso u.c., *Chutes Montmorency* (Montmorency Falls); also *verso* l.r., *Montmorency/Comté de Québec* (Montmorency/Quebec County).

Provenance: Légaré's Quebec Gallery of Paintings; Séminaire de Québec, Quebec City, 1874 (Archives, Portfolio 159-G, p. 49).

Bibliography: AMUQ, Desjardins Correspondence, Letter from Abbé Louis-Joseph Desjardins to Sister Saint-Henry (winter 1841-1842); ASQ, *Séminaire 12,* no. 41 (1874); Bouchette (1815), pp. 439-440; Bouchette (1831), see entry "Montmorenci river"; Bouchette (1832), vol. I, p. 278.

During the winter of 1841-1842, Abbé Louis-Joseph Desjardins wrote to Sister Saint-Henry of the Ursuline Convent in Quebec City to tell her of his intention of sending Canadian landscapes to friends in Europe through the good offices of the painter, Théophile Hamel, who was to sail for Europe in the spring of 1843. He confided to her that Légaré wished to execute these landscapes, adding that the artist had sent him "an oil painting on cardboard" representing the "Sault de Montmorencis" to examine for this purpose. Abbé Desjardins enclosed this work with his letter to obtain the nun's opinion concerning Légaré's work.

The work mentioned in Abbé Desjardin's letter might conceivably correspond with an oil sketch acquired by the Séminaire de Québec at the 1874 sale of Joseph Légaré's collection of paintings. In the manuscript catalogue of this collection, lots 290, 291, and 292 are each described as "batch of oil sketches." This work was perhaps one of these. It may also correspond with one of the ten "waterfalls" mentioned in this document (see cat. no. 32). It was restored at the National Gallery of Canada in 1976.

In 1831, Joseph Bouchette described the Montmorency Falls in the following terms:

> [Montmorency River] runs over an irregularly broken rocky bed until it arrives at the celebrated cataract called the *Falls of Montmorenci*, where its breadth is from 16 to 20 yards. A little declination of the bed before it reaches this point gives a great velocity to the stream, which, being impelled over the brink of a perpendicular rock, falls in an extended sheet of water, of a whiteness and fleecy appearance· nearly resembling snow, into a chasm among the rocks. An immense spray rises from the bottom in curling volumes, which when the sunshine displays its bright prismatic colours produce an effect inconceivably beautiful. At the bottom of the fall the water is restrained within a basin formed by the rocks, whence, after its impetuosity is subdued, it flows in a gentle stream into the St. Lawrence, a distance of about 300 yards ... These celebrated Falls are nearly 250 ft. high, being 100 ft. higher than the Falls of Niagara.

Speaking of the vegetation to be found there, he added the following year:

> The lower regions of the cliffs are destitute of vegetation, but it gradually makes its appearance at the elevation of 50 or 60 feet, and continues with more apparent vigour to the highest point of the towering banks, the verge of which is lined with shrubs and trees.

To paint the Montmorency Falls, Légaré chose the best possible vantage point, namely from the left bank of the basin below the falls. His work has an exceptionally luminous quality about it. Painted in bold brushstrokes with an almost impressionist touch, it presents a limited range of colours in which tones of orange predominate. This oil on paper served as a sketch for a picture now in a private collection (see cat. no. 39).

Séminaire de Québec, Quebec

39 *The Montmorency Falls* c. 1839
Oil on canvas, 55.6 x 81.4 cm

Bibliography: ASQ, Verreau Collection, Letter from Joseph Légaré to Jacques Viger (6 Dec. 1839), Box 61, no. 4; Bouchette (1831), see entry "Montmorenci river"; Bouchette (1832), vol. I, pp. 278-279.

On 6 December 1839, Légaré wrote to Jacques Viger in Montreal to tell him that he had on hand small sketches on paper representing various landscapes. He added that he had a large painting of "the Montmorency Falls measuring 2 feet by 3." This work may possibly be the same as the picture we are now studying (the sizes differ by a few inches). The present owner of this landscape bought it in London a few years ago at an art sale. It was at another such sale that he bought the picture entitled *The Chaudière Falls* (see cat. no. 61). *The Montmorency Falls* may possibly be one of the paintings that the artist sold at the time to British visitors to Quebec. When the latter returned to England, they liked to take these pictures back with them as souvenirs of their stay.

A sight unrivalled anywhere in the world according to Joseph Bouchette, the Montmorency Falls never failed to impress all those who visited them. The surveyor-general of Lower Canada, furthermore, made the following comment on this subject in 1831:

> These justly celebrated Falls are visited by all travellers, who arrive at Quebec with the means and the leisure to gratify their inclination for the beauties of nature. When the St. Lawrence is at full tide, these Falls constitute the most magnificent object in the province.

With a scene of such interest, it is not surprising that Légaré painted the Montmorency Falls on several occasions (see cat. nos 203-206). The London version is one of the most remarkable of the surviving canvases. To

36

paint it, Légaré made use of a sketch on paper belonging to the Séminaire de Québec collection (see cat. no 38). Indians and Whites of different classes appear in the final work, in which the whiteness of the falls makes a fine contrast with the greens and yellows dominating the composition. Two canoes ripple the quiet waters of the basin while in the foreground a rocky point covered in vegetation and stunted tree trunks adds a feeling of depth to the work.

Private Collection

40 *Queen Victoria* c. 1839
Oil on canvas, 2.41 x 1.56 m

Provenance: Légaré's Quebec Gallery of Paintings; Séminaire de Québec, Quebec City, 1874.

Bibliography: L'Ami de la religion et de la patrie (4 Oct. 1848), p. 655; *L'Aurore des Canadas* (18 Oct. 1839) p. 3, (20 August 1842), pp. 2-3; *Le Canadien* (23 Sept. 1839) p. 3 and reprinted 25 & 27 Sept. and 9 Oct. 1839, (14 Oct.

36a *Study for a Nativity,* 1842, Graphite on paper, drawing *verso* of cat. no. 36

1839) p. 2, (2 Oct. 1848) p. 3; *Le Castor* (4 June 1844), p. 3 and reprinted 13 June, 9, 25, & 30 July, 1 & 6 August, 19, 24, & 26 Sept., and 9 & 17 Oct. 1844, (23 July 1844) p. 2; *La Minerve* (7 Sept. 1848), p. 2; *The Quebec Mercury* (12 Oct. 1839), p. 3, (6 May 1845), p. 2, 5 Oct. 1848), p. 3; *Journals of the Legislative Assembly of the Province of Canada*, 1844-1845 Session, vol. 4, pp. 243, 251; AJQ, Register of the Notary Public Jean-Baptiste Delâge (6 Dec. 1872), no. 2921; ASQ, *Seminaire 12*, no. 41 (1874), p. 6, nos 225, 261; IBC, Laval University Museum file; Laval University Catalogues (SQ) (n.d. I) p. 2, (n.d. II) p. 1, (n.d. III) p. 18, no. 9 (n.d. V) p. 30 manuscript, (1894) p. 28, no. 1, (1898) p. 30, no. 1, (1901) p. 30, (1903) p. 29, no. 9, (1905) p. 30, no. 9, (1906) p. 40, no. 9, (1908) p. 87, no. 197, (1909 descriptive), p. 35, no. 197, (1909 Musée de peintures), p. 21, no. 197, (1909) p. 44, no. 197, (1913) p. 59, no. 314, (1923) p. 68, no. 414, (1933), p. 46, no. 206; Valentine Museum, Richmond, Virginia, File on Sully's portrait of Queen Victoria; Lemoine (1876), p. 363, no. 1; Bellerive (1925), p. 17; Colgate (1943), p. 109; Morisset, *La peinture traditionnelle* (1960), p. 97; Harper (1966), p. 81; Biddle & Fielding (1969), pp. 46-65, 305; Harper (1970), p. 194; Tremblay (1972), pp. 136-139, 161-162, 192-193; Reid (1973), p. 48; *Trésors des communautés religieuses de la ville de Québec* (1973), p. 145; Lord (1974), p. 54.

Upon the death of William IV on 20 June 1837, Victoria (1819-1901) acceded to the throne of England. The coronation ceremony took place on 28 June 1838. Some time before, toward the end of March or the beginning of April, amid the preparations for the coronation, the young Queen granted sittings to a famous American artist, Thomas Sully (1783-1872). The Society of the Sons of Saint George in Philadelphia, the city where the painter lived, had ordered a portrait of the new Queen from him when he sailed for England in 1837. In its letter to the Queen, the Society recommended the painter Sully to her as "the most accomplished portrait painter of America."

It was upon his return from London, in his Philadelphia studio, from 30 September 1838 to 14 January 1839, that Thomas Sully painted the full-length portrait of Queen Victoria that he sold for $1,000 to the Society of the Sons of Saint George. This picture - which was still hanging in this society's rooms in Philadelphia in 1921, and that we know after an old photogravure - was used by the Society to raise funds. Taking advantage of the general curiosity to see what the new sovereign looked like, the Society circulated the painting throughout the United States and Canada. The admission fee to this travelling exhibition was devoted to the society's charitable activities.

The picture was exhibited in Quebec City, in Joseph Légaré's Gallery of Painting, 18-28 September 1839, as confirmed by the following advertisement which appeared in *Le Canadien* (trans.):

> Queen Victoria. This superb original life-size picture of Queen Victoria depicted in her coronation robes, by Sully, for and at the request of the Society of the Sons of St. George, in Philadelphia, presented to Her Majesty by Lord Melbourne, is now on show at the Picture Gallery, Upper Town market, until Saturday

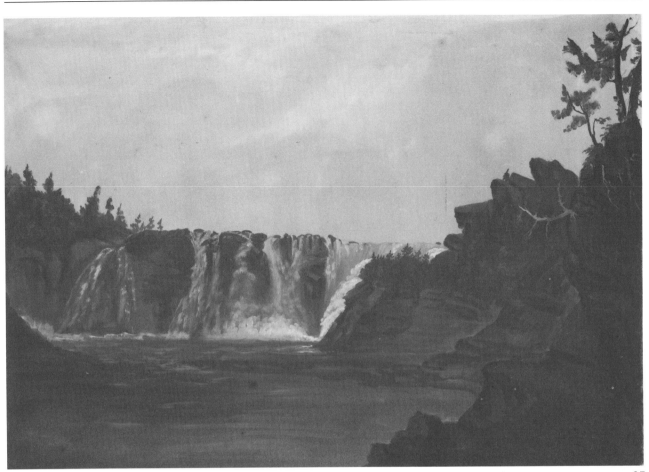

37

next only, the 28th of this month.

> Admission fees will be devoted to the charitable funds of the Society, which was founded in 1772 to provide assistance to Englishmen, and to the Wives and Orphans of Englishmen in needy circumstances.

> Price of admission for one person 1s. 3d., for the duration of the exhibition 2s. 6d.
> Quebec, 17 Sept. 1839.

In the edition of 14 October 1839, the newspaper *Le Canadien* published an article that explains the circumstances in which Légaré made a copy of Sully's painting (trans.):

> M. Légaré, whose painting has already honoured this country, has just offered to the curiosity of the public a new work from his brush, of a merit that has excited the approval and astonishment of all those that have had occasion to see it, knowing the circumstances under which it was executed. It is nothing less than a faithful and perfect reproduction of Sully's famous portrait of the young Queen Victoria in all the splendour of her coronation robes, which was exhibited in this town for several days. It was during the short intervals between the time the exhibition was open each day that M. Légaré made a superb copy of the painting in question, so exact that all those who have

seen it have declared that had they not known it was a copy, they would have believed themselves before the original itself. Such perfection in so short a time and with such a disadvantage for such work, will make this painting one of its author's finest claims to the consideration of his country.

> Through disinterestedness no less worthy of praise than his painting, M. Légaré has exhibited it free of charge at the Gallery of Painting where it can now be viewed.

> It now remains to be seen whether the artist's merit will be recognized and his works rewarded as are their due. The place for the picture in question is in one of our public buildings.

L'Aurore des Canadas echoed on 18 October the flattering article published in *Le Canadien*. The newspaper *The Quebec Mercury* had been a little less enthusiastic in its edition of 12 October. The editor has only words of praise for Légaré's *tour de force*, even though he does not find the copy as good as the original.

Joseph Légaré made two versions of Sully's painting, one large (the present work) and one somewhat smaller (see cat. no. 199). In August 1842, one of his portraits of Queen Victoria was included in the exhibition and sale he organized in Madame Saint-Julien's salons in Montreal. Two years later, one of them was offered for sale to Notary Archibald Campbell in Quebec City. In May 1845, Légaré exhibited a portrait of Queen Victoria at the Mechanics'

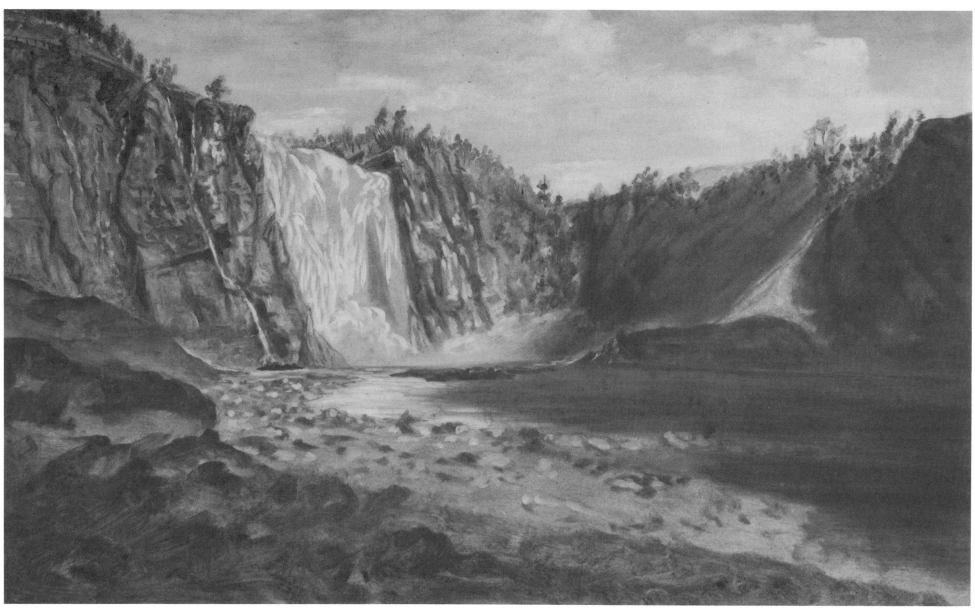

38

Institute of Quebec City. One of the artist's versions was also included in an exhibition and sale held in Montreal in September 1848 and in Quebec City the following month. Légaré did not succeed in selling either of his versions, even though there was no lack of public buildings at the time. On 23 July 1844, the editor of the newspaper *Le Castor* had expressed the hope that the government would acquire Légaré's large portrait of Queen Victoria to decorate the new Assembly Chamber in Montreal. In August of the same year, Légaré had approached the Speaker of the Chamber, the Hon. Augustin Cuvillier on the subject. On 10 February 1845, he made a fresh attempt by writing to the latter's successor, Sir Allan MacNab. All these efforts were in vain. In 1874, at the sale of Joseph Légaré's collection of paintings at the Séminaire de Québec, lot 261 was the large version of the copy of Sully's picture and lot 225 was the small version. The various catalogues of the paintings of the Séminaire de Québec (L.U.) often mention the large version that still hangs in the former *grand salon* of Laval University (Salon of the

Séminaire de Québec, Pavillon du Collégial).

Thomas Sully's painting shows us Victoria mounting steps to the throne of England before which a stool is placed to help her take her seat. She is dressed in her coronation robes and wears a tiara. The crown and sceptre are, however, placed on a table on the left of the picture, for at the time she sat for the artist, she had not yet been crowned. *Le Canadien* of 23 September 1839 thus described the picture (trans.):

As a piece of painting, this picture is of unquestionable merit, and as a portrait, it has the principal virtue, namely that of resemblance, according to the opinion of those persons who have seen the original. Queen Victoria is depicted mounting steps to reach a chair, with her face turned towards the beholder. This posture was adopted by the artist to counter the difficulties afforded by the smallness of the Queen's person, and is not without its advantages.

Sully's painting was exhibited in Quebec City 18-28 September and Joseph Légaré produced his copy of it about 12 October. According to the newspapers, this copy was very similar to the original in all respects. The latter measured 2.39 x 1.47 metres and Légaré's large copy measures 2.41 x 1.56 metres. The small copy (from the Séminaire de Québec) measures 105.4 x 64.8 centimetres.

It is likely that it was the small copy that Légaré exhibited in October 1839 at his Quebec Gallery. It seems less finished than the large copy which he probably painted shortly afterwards, hoping to sell it so that it might be placed in a public building. Nor is it impossible that Légaré made other copies that have now disappeared.

In making copies of Victoria's portrait, Joseph Légaré gave one more example of his feeling for publicity and sought to attract the attention of the Quebec public to his gallery. After the period of the troubles of 1837-1838, he was also probably anxious to reinstate himself in the good graces of the British authorities.

Séminaire de Québec, Quebec

Inscription: signed and dated l.r. J. LÉGARÉ *Pinxit*/1840; *verso* PEINT PAR J. LÉGARÉ ECUY./EN 1840/ L'ÉCRITURE MOULÉE EXE/CUTÉE PAR NOTRE SŒUR ST./FRANCOIS XAVIER NÉE BARBER. (Painted by J. Légaré Esq./In 1840. The capital letters [were] executed by our Sister St. Francis Xavier née Barber.); *recto* l.c. *Premier monastère Des Ursulines De Québec/Avec Ses Dépendances Bâti En 1641-2, Et Brûlé en 1650.* (First convent of the Ursulines of Quebec City, with its outbuildings. Built in 1641-1642 and destroyed by fire in 1650.); *recto,* on the left, a legend: *A. Dépot. B. Montée au parloir. C. Petite sacristie. D. Porte extérieure de la/chapelle du couvent. E. Parloir au second étage/par lequel la plupart des/religieuses et des élèves/lors de l'incendie du monas/tère en 1650, s'échappèrent/en rompant les grilles. F.F.F. Dortoir des religieuses G.G. Infirmerie des religieuses. H.H. Dortoir des éleves pen-/sionnaires. J. Cellule q'occupait la mère/Marie de l'Incarna-/tion, lors de l'incendie K. Boulangerie. L.L. Réfectoire des religieuses M. ANTIQUE FRÊNE, géant/séculaire sous lequel les/religieuses, dans les pre-/miers temps, instrui-saient,/dans chacune de leurs lan-/gues sauvages, et préparient/au baptême, les néophytes/ALGONQUINES HURONNES/et MONTAGNAISES./Ce FRÊNE, âgé aujourd'hui (1840)/d'environ 500 ans, of-/fre encore aux sœurs du mo-/nastère son ombre fraîche,/et des souvenirs touchants. N. Maison de MADAME DE/LA PELTRIE, bâtie en/1642 et démolie en 1836.* And on the right: *O. Mme DE LA PELTRIE qui/rentre chez elle après/une visite aux cabanes des/indiens. P. M. D'AILLEBOUT gouver-/neur de la colonie, et M./DUPLESSYS BOCHART/gouverneur de 3 Rivières,/en promenade à cheval. Q. La mère St. Joseph qui visite/les cabanes des femmes/indiennes. R. St. Laurent, sœur converse/d'un merite rate. S.S.S. Ruisseau aujourd'hui desséché TTT. La grande vallée, aujourd'hui/RUE ST. LOUIS. V. Le R.P. Jér. Lalle-ment SJ,/premier des missions du Ca-/na-/da. W. Le R. P. D'OLBEAU, l'un des 3/premiers missionnaires ré-/collets qui aborderent à-/Québec en 1616, annonçant/la foi aux indiens. X. Arrivée des Hospitalières/et des Ursulines à Québec/le 1 août 1639. Y. La mère MARIE DE L'IN-/CARNATION enseignant-/le catéchisme sous le/VIEUX CHÊNE à des/filles ALGONQUINES/et MONTAGNAISES. Z. La mère St. Athanase mai-/tresse de la classe des é-/lèves canadiennes-françaises.* A. Stores. B. Parlour steps. C. Small sacristy. D. Exterior entrance to the convent chapel. E. Second-storey parlour from which most of the sisters and pupils escaped by breaking down the window-grilles during the fire in the convent in 1650. F.F.F. Nun's dormitory. G.G. Nuns' infirmary. H.H. Boarders' dormitory. J. Cell occupied by Mother Marie de l'Incarnation at the time of the fire. K. Bakery. L.L. Nuns' refectory. M. Ancient ash, a centuries-old giant beneath which the nuns, from the outset, taught in each of the Indian languages and prepared Algonquin, Huron, and Montagnais neophytes for baptism. This ash, about 500 years old at the present time (1840), still profered its cool shade and poignant memories to the sisters. N. Madame de la Peltrie's house, built in 1642 and demolished in 1836. On the right: O. Mme DE

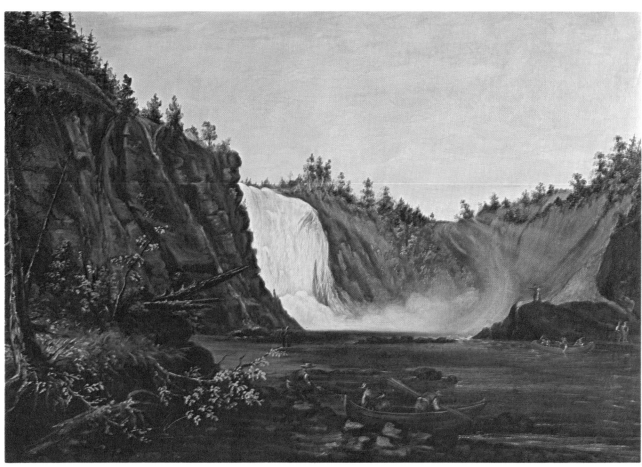

39

LA PELTRIE returning home after a visit to the Indians' huts. P. M. D'AILLEBOUT, governor of the Colony and M. DUPLESSYS BOCHART, Governor of Three Rivers, on horseback. Q. Mother St. Joseph visiting the huts of Indian women. R. Sister St. Laurent, a convert of great merit. S.S.S. A stream that has now dried up. T.T.T. The great valley, today St. Louis Street. V. The Rev. Father Jérôme Lallemant, sj, first Canadian mission. W. The Rev. Father D'OBLEAU, one of the first three Recollect missionaries to land at Quebec City in 1616, proclaiming the faith to the Indians. X. Arrival of the Sisters of Mercy (Hospitalieres) and Ursuline Sisters at Quebec City on 1 August 1639. Y. Mother MARIE DE L'INCARNATION teaching the catechism under the OLD OAK to ALGONQUIN and MONTAGNAIS girls. Z. Mother St. Athanasius, mistress of the class of French-Canadian pupils.

Provenance: Monastère des Ursulines de Québec, Quebec City.

Bibliography: AMUQ, Abbé Thomas Maguire, "Notes sur l'érection primitive du Monastère des Ursulines de Québec"; AMUQ, Desjardins Correspondence, Letter from Abbé Louis-Joseph Desjardins to Sister Saint-André, (28 Jan. 1848); AMUQ, Sister Marcelle Boucher, *Inventaire annoté des tableaux conservés au Monastère des Ursulines de Québec en 1976,* no. 51, note 17; ASQ, Portfolio 160-G, p. 25; (anon.) *Les Ursulines de Québec depuis leur établissement jusqu'à nos jours,* vol. IV (1866), pp. 701, 703, 713-730;

Duvernois, *Vestiges de plus de 300 ans d'histoire* (1967); *Trésors des communautés religieuses de la ville de Québec* (1973), pp. 51, 100, repr. in col.; National Gallery of Canada, Letter from Sister Marcelle Boucher, archivist of the Monastère des Ursulines, to Jean Trudel (7 Aug. 1972).

The history of this painting is linked with Abbé Thomas Maguire (1776, Philadelphia-1854, Quebec) who was chaplain to the Ursulines in Quebec City from 1832 to 1854. Considered by the Ursulines as "the second founder" of their convent, Abbé Maguire saved the community from a financial crisis by examining the accounts, titles, and papers concerning their property. Vitally interested in history, Maguire wrote several manuscripts, one of which was entitled (in French) *Notes on the first construction of the Ursuline Convent in Quebec City: on the two fires it has suffered: as well as on the divers changes and additions to the buildings which have taken place since its establishment: with some digressions which seem indicated by circumstances.* This work, retracing the origins of the convent, was illustrated. On page 31 of the manuscript, under *Indications for an Understanding of the Plan of the Ursuline Convent in Quebec, destroyed by fire in 1650: and also of the Plan of the adjoining grounds,* a series of letters and figures are to be found opposite captions which do not correspond with those of Légaré's picture, but have some similarities. Curiously, the two plans mentioned in the manuscript are missing, which suggests that they may have been removed

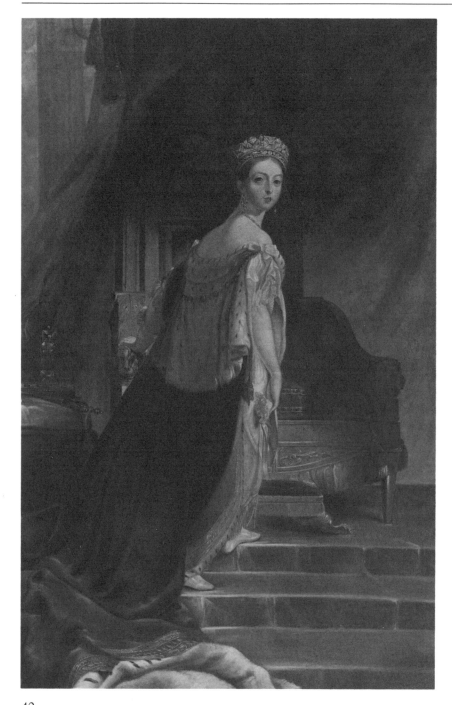

40

40a Thomas Sully
Queen Victoria 1838-1839
Oil on canvas 1.5 x 2.4 m
Society of the Sons of Saint George,
Philadelphia (Reproduction of an old
photogravure taken from Biddle
and Fielding, 1969, p 305)

and given to Légaré at the time he decided to paint his picture.

The laying of the first stone for the first Ursuline Convent in Quebec took place in 1641, which means that in 1841 the Ursulines would be celebrating their bicentennial. The circumstances surrounding the painting of the picture, dated by Légaré as 1840, thus become much clearer. Wishing to mark the anniversary of the beginnings of their first convent, the Ursulines had recourse to the historical knowledge of Abbé Maguire and the talent of Joseph Légaré to reconstitute a visual document, an historical picture. They were thus able to provide in a more tangible form, for their novices and pupils, the scope of their work in the early days of New France and thus show the continuity and importance of their educational mission through the years. It should also be noted that the list of the Ursulines' pupils includes the names of Caroline Légaré - who may have been Joseph's daughter, born in 1822 - and Adelaide Légaré - who may have been another of his daughters, born in 1827.

Ever since 1840, this picture has remained in the Ursuline Convent in Quebec City.

Légaré was asked to paint a picture like an open history book, a primer of the history of the first Ursuline Sisters in Quebec. Since the picture alone was not sufficient, it therefore had to include an explanatory text. The content of the painting was undoubtedly discussed at length between Légaré and Abbé Maguire, the spokesman for the cloistered nuns. It was most probably the two plans missing from Abbé Maguire's manuscript that served as a basis for working out the picture while its captions helped to elaborate the texts. Abbé Maguire in his manuscript separated the building, constructed in 1641-1642, from the surrounding grounds. In one explanatory text, he identified the various parts of the convent (sacristy, chapel, dormitory, bakery, and so on) and in another the various occupations of the first nuns on the land which belonged to them. These captions do not correspond with those of Légaré's picture in which all this was to have been coordinated: the captions on the left of the picture, however, mainly concern the buildings connected with the Ursulines, while the captions on the right concern the Ursulines and their activities.

Two documents belonging to the Archives of the Séminaire de Québec and perhaps coming from Légaré's estate, were used in the preparation of the painting. One of these, drawn in ink, is a sketch of the first convent under which there are two columns of captions exactly corresponding to those on the left and right of the picture and divided in the same way. The only difference is that the captions of the drawing are much shorter than those of the picture in which they have been lengthened so that the two columns might be of about equal length. The other document, drawn in lead pencil, is obviously a first attempt at a sketch. The letters do not correspond with either Maguire's captions or Légaré's. However, all the main elements of the central picture of Légaré's painting can be found in this document with differences such as the presence of "little French-Canadian and Indian girls playing in the Convent courtyard" or the absence of the Governor of Three Rivers who appears in the Légaré.

There are also three vignettes in the corners, one of which, in the bottom left-hand corner, was not copied by Légaré. Similarities between the captions of the Maguire manuscript and this sketch are numerous and suggest that it was a working document that Abbé Maguire gave to Légaré who based his painting largely on it.

Légaré's work is much more complete than the preparatory sketches. For the composition of the painting, the artist has found a *trompe-l'œil* solution of great ingenuity and undoubtedly based on his knowledge of European engravings and paintings. Since he had to depict the history of the first Ursulines, he painted three scrolls still rolled at the ends in the manner of ancient maps. He has placed them against the background of the picture at the bottom of which, to the left, the first Recollects can be seen landing at Quebec in 1616, and, to the right, the first Ursulines landing in 1639. He thus establishes the religious setting for the evangelization of the Indians in Quebec and manages to place the title of the picture on an island of land in the centre of the two scenes which might well be a symbolic representation of the New World. At the same time, the false scrolls are superimposed on a real landscape.

The narrow band of the left-hand scroll bears the captions referring to the buildings, including that of the house of Mme de la Peltrie, the distinguished benefactor of the Ursulines upon their arrival in Quebec. It is quite logically topped by a vignette in which "Mother St. Athanase" is to be seen teaching French-Canadian and Indian girls inside the convent. Above these captions, Légaré has painted a trophy composed of a bow and two tomahawks and below them another trophy, this time consisting of an open book (the Bible?) surmounted by a cross and flanked by a chalice and a ciborium.

Since the captions on the right-hand scroll refer to activities outside the convent, the vignette which caps them depicts Marie de l'Incarnation teaching Indian girls out of doors under "the old oak." The top trophy shows a quiver full of arrows, while that at the bottom depicts a beaver.

The central scroll is painted by Légaré in a much less precise manner than the drawing belonging to the Séminaire. The receding perspective leading to the convent is much more successful. Several details are worth mentioning. In the foreground, and as a foil, tree stumps are a reminder of the clearing of the forest. M. Duplessis, added by Légaré, recalls the foundation of an Ursuline Convent at Three Rivers. The Indian, in front of Duplessis and d'Ailleboust, presents them with a beaver, an important source of trade between France and her colony. Légaré could not resist the temptation of painting one of those broken trees (near to Mme de la Peltrie's house) that he often used in his landscapes.

In his complex enterprise of giving the Ursulines a picture representing the early days of their history in Quebec, Légaré has been successful. He was helped in the task by Abbé Maguire and Mother Saint-François-Xavier, who patiently executed the letters for the captions. The lettering used for the captions on the left-hand side of the picture is still preserved, moreover, in Abbé Maguire's manuscript.

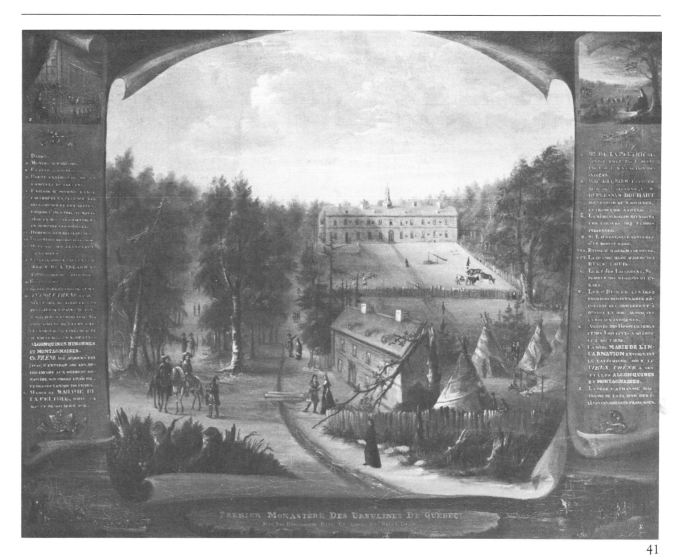

41

41a Abbé Thomas Maguire (?), Preliminary sketch for a painting by Joseph Légaré, *First Convent of the Ursulines of Quebec, c.* 1840, Ink on paper, 33 x 29.8 cm, Archives du Séminaire de Québec, Quebec

41b Abbé Thomas Maquire (?), Sketch and captions for Légaré's *First Convent of the Ursulines in Quebec City, c.* 1840, Ink on paper, 30.8 x 18.7 cm, Archives du Séminaire de Québec

In addition to an extremely effective didactic tool, a "speaking picture," Légaré provided the Ursulines with a model for their art classes. In the nineteenth century, the teaching of drawing was part of the curriculum for the Ursulines' pupils and Légaré's picture was copied many times by the teaching nuns or by their students. The Ursulines themselves own two copies, there is another at the Château Ramezay in Montreal, and the National Gallery of Canada probably possess the version closest to the original and for many years attributed to Légaré. Copied at the convent in 1847, and presumed to be by Sister Georgina Van Felson, it drew compliments from Abbé L.-J. Desjardins and from Légaré himself.

Monastère des Ursulines de Québec, Quebec

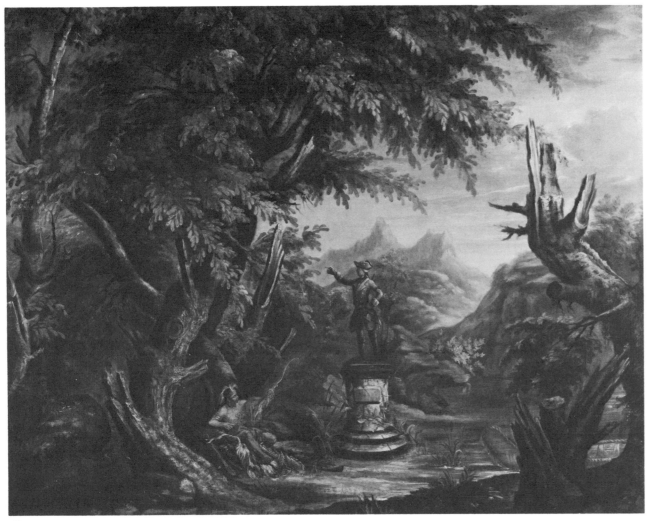

42

42 Landscape with Wolfe Monument c. 1840
Oil on canvas, 1.31 x 1.75 m

Provenance: Mrs Jean Rousseau, Quebec City; Musée du Québec, Quebec City, 1955 (A 55 109 P).

Exhibitions: 1965, 15 Sept.-13 Nov., London, Burlington House, *Commonwealth Art Treasurers;* 1967, Ottawa, National Gallery of Canada, *Three Hundred Years of Canadian Art,* cat. no. 91, repr.

Bibliography: L'Ami de la religion et de la patrie (4 Oct. 1848) p. 655; *Le Canadien* (2 Oct. 1848) p. 3; *The Quebec Mercury* (5 Oct. 1848) p. 3; ASQ, Portfolio 70-G; *Recent Acquisitions by Canadian Museums and Galleries* (1956), p. 295, repr.; Morisset, *La peinture traditionnelle* (1960), pp. 64x (repr.) 99; Harper, *Three Centuries of Canadian Painting* (1962), p. 418; Harper (1966), pp. 81-82, repr.; J.-N. Tremblay (1967), no. 33, repr.; Trudel (1970), pp. 34-37, repr.; C. Tremblay (1972), pp. 196-199, repr.; Reid (1973), p. 47; Lord (1974), p. 54.

In 1848 this picture was included in an exhibition of thirty-one works at the Quebec Assembly Chamber. These works were to be raffled off by Joseph Légaré on October 23. No. 7 bore the title, *Wolfe's Monument* and was valued at £7. 10. 0d.

In 1955 the painting was acquired from Mrs Jean Rousseau by the Musée du Québec, and was restored by Mr. Claude Picher that same year. It was restored once more in 1966, this time by the National Gallery of Canada.

In the collection of engravings belonging to Joseph Légaré and which are now housed in the Archives of the Séminaire de Québec, there is one, *Mercury Putting Argus to Sleep (Mercure endormant Argus),* made in 1768 by the engraver Émile Carlier after a painting by Salvator Rosa (1615-1673), which Légaré used as a model for his picture. In this engraving squared off for transfer, the landscape was closely copied by the painter but the mythological subject was omitted. In the engraving, Mercury is seen playing his flute to put Argus, the shepherd, to sleep, so that he may steal the cow Io, whom he is supposed to be watching.

42a Emile Carlier, *Mercury Putting Argus to Sleep* 1768, Engraving after a work by Salvator Rosa, 24.1 x 39.4 cm, Archives du Séminaire de Québec, Quebec

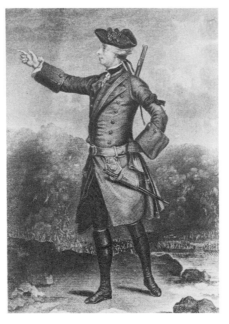

42b R. Houston, *Major-General James Wolfe,* Engraving after a drawing by Captain Hervey Smyth (Reproduced from *Old Quebec* of Parker and Bryan, Toronto, 1903)

By adding new elements to his picture, Légaré turns it into an allegory which could be interpreted in various ways. The most plausible interpretation is related to the mythological subject of the engraving. If we assume that the cow Io is replaced by the bark canoe, the shepherd Argus is replaced by the Indian, and Mercury by the Wolfe Monument, the allegory is linked to Légaré's political ideas after the troubles of 1837.

The canoe is, in fact, a means of transport related to the development of the country. The Indian lying on an animal skin at the foot of the statue is the first owner of the country, and it should be added that French-Canadians identified themselves strongly with the Indians during the first half of the nineteenth century (cf. *Le Canadien* 30 April 1838, p. 3). The Indian in the picture is probably a chief: he wears a feathered headdress, earrings, an armlet, and a circular jewel (a medal?) hanging on his chest. He is armed: a tomahawk, a quiver full of arrows, an axe, and a gun lie around him. In his left hand, he holds a bow that he seems to be offering to Wolfe's statue. He is the defender of the country surrendering his arms.

Wolfe is depicted standing on a circular stone pedestal bearing a broken plaque on which nothing is apparently written. To represent Wolfe's statue. Légaré used an etching that was popular at that time and based on a drawing by Captain Hervey Smyth (1743-1811), one of Wolfe's officers. Wolfe here symbolizes the conqueror but perhaps also the whole anglophone "establishment" of the 1830s: indeed, if Wolfe takes the place of Mercury, it must not be forgotten that the newspaper that defended the interests of the English-speaking population (and the rival of the newspaper *Le Canadien*, with which Légaré was connected) was *The Mercury*.

Musée du Québec, Quebec

43 Caldwell Manor and the Etchemin Mills after 1840
Oil on canvas, 58.4 x 87.6 cm

Provenance: Mrs J. Alexandre Alleyn, Quebec City; Musée du Québec, Quebec City, 1956 (A 56 404 P).

Exhibition: 1967, (summer), Quebec City, Musée du Quebec, *Peinture traditionnelle du Québec*, cat. no. 39 repr.

Bibliography: *Le Canadien* (2 Jan. 1850) p. 1, (23 Oct. 1854) p. 2; *The Quebec Mercury* (15 Jan. 1833) p. 4; J.-E. Roy (1900) vol. 3, p. 366 and *passim*; Le Jeune (1931) vol. I pp. 272-276; Wallace (1963), pp. 9-10.

This picture is perhaps connected in one way or another, through its provenance, with Charles Alleyn (1817-1890), who was born in Ireland, at Myrus Wood, County Cork. Settling in Quebec City with his parents, having emigrated to Canada in 1834, Charles Alleyn was called to the bar in 1840 and played an active role in politics, being elected Mayor of Quebec City in 1854 and member of parliament for the town that same year. In 1849, he had married Zoé,

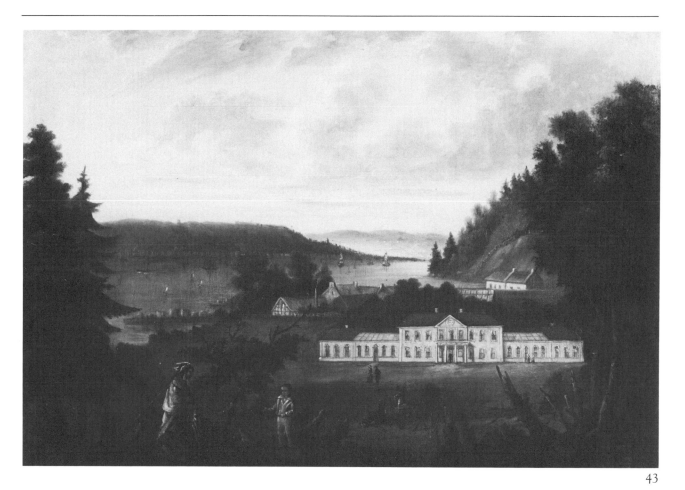

43

the daughter of Philippe Aubert de Gaspé. Charles Alleyn knew Légaré, having supported his candidacy in 1850 at a by-election, and as a member of the provincial committee for the Paris Universal Exhibition committee in 1854.

Sold by Mrs J. Alexandre Alleyn to the Musée du Québec in 1956, the painting was restored in 1966 at the Montreal Museum of Fine Arts.

When sold to the Musée du Québec, this picture was identified as representing "the castle of Lord Termoy at Trobolgan, Co. Cork, in Ireland," where Judge Richard Alleyn (1836-1883) was supposed to have been born. An examination of the painting, however, contradicts this identification. From the south bank of the Saint Lawrence, the very characteristic outline of Quebec City can be seen, with a Martello tower, the Citadel on Cape Diamond and the dome of the new Legislative Building. Houses, wharves, and stores in the lower town can also be seen, as well as sailing boats and a steamer. In the background, we see the Côte de Beaupré, with its farmhouses surrounded by fields, and the Laurentian Mountains. We are, in fact, near the mouth of the Etchemin River, at the spot where, at the beginning of the nineteenth century, Henry Caldwell (1738-1810), seigneur of Lauzon, had built himself a manor.

Born in Ireland, Henry Caldwell had come to Canada with the British troops. He had first of all rented from General Murray, and then bought from his estate in 1801, various seigneuries including that of Lauzon. As Receiver-General of Canada, he had used government funds to develop his own properties. Not far from his flour

mills, he had had sawmills built at the mouth of the Etchemin to prepare wood from his forests for export to England. J.-E. Roy thus described Caldwell Manor and its surroundings:

> Between the little saw river and the Etchemin, on the banks of the Saint Lawrence, opposite Sillery, the landscape is delightful and perfectly made for the pleasure of the eyes.
>
> It is on this corner of land, overshadowed by a steep hill then covered in gigantic pines and from whence the view embraces the whole roadstead of Quebec, that Caldwell chose to build his manor. As always, he did things in a princely way. Without being sumptuous in its architectural structure, the house was, however, planned so as to give all the comfort of the generous hospitality with which Caldwell was wont to receive his guests. The thick forest in which it was set was cut back so as to afford fine views of the river. Clumps of trees were grouped together, wide avenues were traced and skillful hands designed fine English gardens.
>
> It is easy to imagine that during the summer season, there was no lack of visitors to this enchanted nook. Local tradition is still full of stories about the sumptuous parties that were given there.

Well before the death of Henry Caldwell, his son, Sir John Caldwell (1775-1842), administered the family property. Upon his father's death, he inherited the post of

Receiver-General in his turn, and led a luxurious existence during the summers at his manor on the Etchemin. In 1823, however, the scandal of his administration and of that of his father became public knowledge. Lengthy legal proceedings were instituted which were hotly debated for nearly twenty years. John Caldwell died in Boston. He left a son, Henry John, born in 1801.

Caldwell Manor is shown on the centre right of Légaré's painting. It is a large house in neo-classical style with the central block flanked by two wings. This central block, with its pavilion roof, has jutting eaves surmounted by a pediment supported on the first floor by pilasters. The main door, forming a balcony, is supported by Doric columns. Strangely enough, the front of the house, for this is the side facing us, does not look out on to the magnificent Quebec landscape, but faces inland as if it were meant to impress visitors. On either side, the wings with their arched windows have sections of glass roofing, suggesting that plants or fruit were grown there. These wings probably also housed the servants' quarters. This house was not exceptional for the country around Quebec at that time: all the rich merchants and public servants had residences such as this at Sillery, Sainte-Foy, or near the town. They were only lived in by their owners during the summer. The Caldwells, moreover, had another similar house, Belmont, on the road to Sainte-Foy. Behind Caldwell Manor, standing on a rise, may be seen a platform to the left on which merchandise is heaped, and the roofs of various buildings that are probably the mills and workmen's houses. The foreground of the picture is edged on each side by sturdy-looking trees, and in the middle are stumps which suggest a gap in the forest to give a good view of the manor.

Two deer, one lying down and one standing, occupy the centre of the composition. In the main doorway of the manor, a male figure can be distinguished, and two women converse at the door of the right wing. In front of the left wing, but nearer to us, stand a couple. In the foreground, to the left, an Indian holding a branch on which fish are strung approaches a boy whose straw hat has fallen to the ground and who holds a child's plaything, a cup-and-ball, in his hands. Between the Indian and the boy, two trees interweave their branches.

It is not possible to identify these figures, nor the precise significance of the painting. It may perhaps have been ordered by Sir John Caldwell before his departure from Canada towards the end of his life. This is a reasonable assumption, for in the picture are Quebec City, where he had worked as an administrator and politician, as well as a part of the forest that he had exploited, the mills he had built and improved, the ships that exported his products to England, the manor in which he gave fabulous parties, and even one of the Indians who lived by hunting and fishing on his lands. This Indian might possibly symbolize the inhabitants of Caldwell's seigneuries paying him homage, a symbol emphasized by the joined trees.

Légaré knew Caldwell when they were both members of the Literary and Historical Society of Quebec. Neither the provenance nor the date of the picture, however, permit us to interpret it with any certainty.

Musée du Québec, Quebec

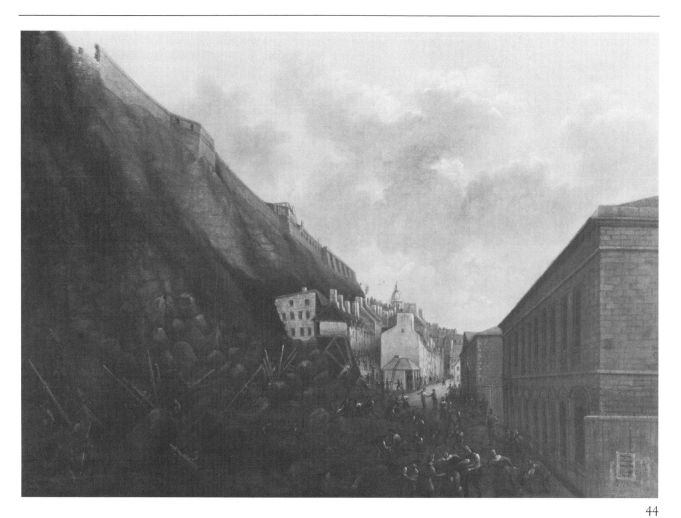

44

44 Landslide at Cape Diamond c. 1841
Oil on canvas, 81.3 x 110.8 cm

Inscription: l.r. on the poster pasted on the hording, VENTE / PAR / ENCAN / CHEZ / LA
[. . .] / + / [. . .]RE / 184 [. . .] (Auction sale at 184?)

Provenance: Légaré's Quebec Gallery of Paintings; Séminaire de Québec, Quebec City, 1874.

Exhibition: 1965, Ottawa and Quebec City, National Gallery of Canada and Musée du Québec, *Treasures of Quebec,* cat. no. 50, repr.

Bibliography: Le Canadien (17 May 1841) p. 1, (19 May 1841) p. 2, (21 May 1841) p. 2, (28 May 1841) p. 2, (31 May 1841) p. 2, (20 June 1842) p. 2; AJQ, *Séminaire 12,* no. 41 (1874), p. 2, no. 43, p. 3, no. 88; IBC, Musée de l'Université Laval file; Laval University Catalogues (SQ) (1913) p. 63, no. 351, (1923) p. 72, no. 351, (1933) p. 81, p. 243; Beaudet (1890), p. 32x; *Les Eboulements du Cap Diamant* (1914), pp. 234-236; Bellerive (1925), p. 15; *Les peintures de Légaré sur Québec* (1926), p. 432; Morisset, *La peinture traditionnelle* (1960), p. 100; Harper (1966), pp. 82-83, repr.; Giroux (1972), p. 3; Tremblay (1972), pp. 159, 160, 163, repr.; Reid (1973), p. 49; Lord (1974), pp. 52-53, repr.; Dahl *et al.* (1975), pp. 287-290, plan no. 315.

44a Detail: W. B. Ord and Henry Vavasour, *Quebec—Record plan of Ordnance property called for by the Inspector General's letter dated 11th Oct., 1848,* 1850, 74.5 x 163.1 cm, Public Archives of Canada, Ottawa, (Showing the precise spot of the 1841 landslide)

In its edition of 17 May 1841, the newspaper *Le Canadien*, under the heading *An Appalling Disaster*, announced that "between eleven and half past eleven this morning, part of the cape, situated opposite the king's store, of about two *arpents* in width, caved in with a terrible noise, carrying with it the wall of the fortifications over the houses that stood on Champlain Street at this spot." The landslide occurred on a very rainy day, and the garrison troops immediately started to search the rubble. Eight houses were destroyed and fifty-two people buried, twenty-two of whom were rescued alive. Some of the victims were of Irish extraction.

On 19 May, *Le Canadien* published a more detailed article giving an explanation of the incident (trans.):

> ... there are fears for another part of the cape, and the people have all moved out; this part was cut perpendicularly, either because of the mining operations that were being carried out there, or because of successive partial landslides, and the stones swept down show the action of water and frost, which had separated the parts of the rock and taken away its closeness. The surrounding wall of the fortifications was built right on the edge of the cliff, and by its weight and by forcing the upper waters to follow the line of its foundations, may have helped to hasten, if not partially to cause, the disaster that we are now deploring

During Légaré's lifetime, two other landslides took place, one on 19 June 1842 and the other on 14 July 1852, but their consequences were not as disastrous as that of 1841. It was the 1841 slide that Joseph Légaré painted. The picture was acquired by the Séminaire de Québec at the 1874 sale of Légaré's collection of paintings. He may well have painted two pictures of this disaster because lot 43 of the inventory of his collection bears the title *Landslide in Lower-Town, Quebec* and lot 88 *Rockslide in Lower-Town, Quebec*. But, in the catalogues of the Séminaire de Québec (L.U.) pictures, only one painting is indicated, under the English title *A Rubbish in the Lower-Town, Quebec* (in 1923) and in French *Éboulis du cap Diamant à Québec* (in 1913 and 1933). Only one picture has been traced in the files of the Séminaire de Québec Museum. It was restored in 1950, 1960, and 1969.

To paint the landslide, Joseph Légaré set up his easel on Champlain Street looking towards the lower town. Champlain Street goes off to the left (to-day Petit Champlain Street) while to the right it becomes Cul-de-Sac Street which ends at the house now known as the Maison Chevalier. Between this house, part of which can be seen in the background to the right, and the Queen's Store built in 1821 (to the right, with a pediment on its front) is Cul-de-Sac Harbour. The Queen's Store was built on the Queen's Quay belonging to the Crown. The building nearest to us, to the right, is the Customs House built about 1833. At the intersection of the two roads, the small building is a guardhouse to shelter the sentinels watching over the security of the store and customs. Further off, over the roofs can be seen the lantern-topped dome of the new Legislative Building then under construction

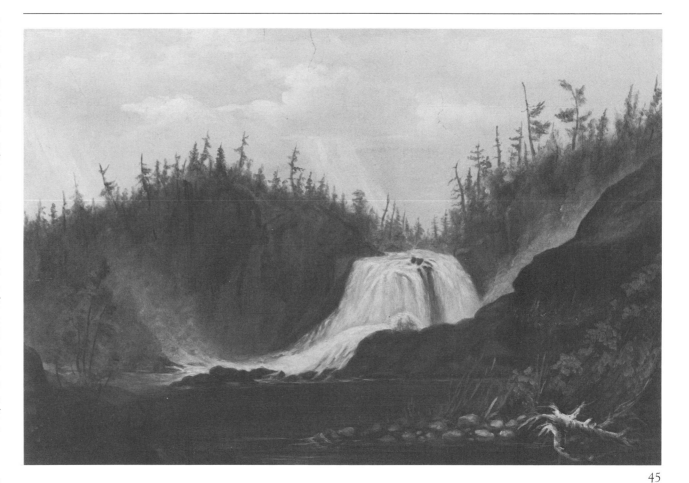

45

(destroyed by fire in 1854). To the left, on the top of the cliff, rises the outside wall of the fortifications, part of which has just collapsed.

As reported in *Le Canadien* of 17 May, a house can also be seen that is "entirely broken, but not quite buried in the slide." Among the huge pieces of rock, rescue workers are busily digging out victims. Others, in the right foreground, are carrying a body. People are running up from lower town, others are staring at the scene. Strangely enough, and contrary to reports in the newspaper *Le Canadien*, the only soldiers to be seen are not helping in the rescue work but standing near the guardhouse. It would be risky to give a political interpretation of the painting, but it should be noted that *Le Canadien* itself questions the lack of precaution on the part of the military engineers who built the outer wall of the fortifications.

For people living in the lower town, Cape Diamond was a constant threat. Other landslides took place after Légaré's death: in 1864 (four victims), 1875 (six victims), and 1889 (thirty-five victims). The photographer Louis-Prudent Vallée was quick to take a photograph of this last disaster. The inhabitants of these constantly-threatened streets were obviously not among Quebec's most prosperous citizens.

The subject of this painting can be compared with that of *Cholera in Quebec City* (see cat. no. 19) or numerous pictures depicting fires. In perpetuating the memory of the catastrophe, Légaré's aim was perhaps to be the memory of the people of Quebec City with whom he was so strongly identified and for whom he worked so hard. The scope

of the subject of this painting is certainly more than just the portrayal of the incident.

Séminaire de Québec, Quebec

45 The Saint-Ferréol Falls
Oil on paper pasted on cardboard, 37.1 x 54.6 cm

Provenance: Mgr Omer Plante; Séminaire de Québec, Quebec City, 1947.

Exhibition: 1952, Quebec City, Musée du Québec, *Exposition rétrospective de l'art au Canada français*, cat. no. 69.

Bibliography: IBC, Laval University File; Laval University Catalogues (SQ), 1933 onwards, no. 387; Bouchette, see entry for 1831, under "Ste. Anne, river."

We do not know the origin of this painting given to the Musée du Séminaire de Québec by Mgr Omer Plante in 1947. In the continuation of the 1933 manuscript catalogue, it bears the title *Sault-à-la-Puce, near Beaupré*, and Légaré is said to have painted it about 1840. This is apparently not the correct title. Indeed, one of the small oils on paper belonging to the Monastère dès Ursulines in Quebec City shows the same falls and bears two old inscriptions identifying these as the Falls of Saint-Ferréol (see cat. no. 46). Saint-Ferréol is a parish situated on the

Côte de Beaupré, not far from which flows the Sainte-Anne River and one of its tributaries, the Jean-Larose River, whose rough course gives rise to many picturesque views (see cat. nos 35, 60). It is one of these that Légaré has painted in oil on paper now to be found in the Musée du Séminaire de Québec.

In this work, the bed of the river is suggested by the curved outline of the pine forest that covers its banks. This outline similarly draws attention to the white mass of the falls opposite our vantage point. Beneath the pressure of the waters crashing down on the rocks, clouds of vapour form and rise on both sides of the falls. This results in a composition that offsets the forest depicted above. On the right side of the painting, the unleashed flood of the torrent hits a rocky point which forces it over to the left side. It is behind this rock that the calm waters of the basin fed by the falls can be seen. In the foreground, a rocky island stands out on which vegetation has taken hold and against which the sad remains of a tree trunk have come to rest.

Séminaire de Québec, Quebec

46 *The Saint-Ferréol Falls* c. 1842
Oil on paper, 12.1 x 16.5 cm

Inscriptions: u.l., *St Ferréol*; l.l., *Peint pour cet Album par Jos. Légaré Écuyer* (Painted for this album by Jos. Légaré Esquire); across bottom of sheet: *VUE de la cataracte de St. Ferréol, dont les eaux mugissantes, qui tombent dans un gouffre profond, présentent un aspect fort imposant* (View of the Saint-Ferréol cataract, whose roaring waters, plunging into a deep chasm, present a very impressive sight).

Provenance: Monastère des Ursulines de Québec, Quebec City (Archives, Abbé Maguire album, p. 37).

Bibliography: AMUQ, *Album de notre vénéré père M. le G.V. Maguire, Aumônier de ce Monastère depuis le 14 mai 1832 jusqu'au 17 juillet 1854*; ASQ, Verreau Collection, Letter from Joseph Légaré to Jacques Viger, 6 Dec. 1839, Box 61, no. 4; Bouchette, see entry for 1831, under "Ste. Anne, river."

The Ursulines ordered this oil on paper from Légaré to illustrate one of the pages of an album they intended as a gift for their chaplain, Abbé Thomas Maguire (see cat. no. 41). The album includes another of Légaré's works entitled *The Mills of Jeune Lorette and the Cascades of the Saint Charles River* (see cat. no. 51). The paper of both was restored in 1977.

On 6 December 1839, Légaré wrote to Jacques Viger in Montreal to tell him that he had a series of small oil sketches on paper that would be suitable for his *Album* since the largest only measured 6 or 7 inches by 5 inches. Among the titles he then lists is *The Saint-Ferréol Falls*. It was perhaps this sketch or an identical work that he subsequently sold to the Ursuline Sisters of Quebec.

This landscape is a slightly different version from the

46

oil on paper belonging to the Séminaire de Québec Museum (see cat. no. 45). It is brighter than the latter work and differs in the treatment of the vegetation - trees stand out on both sides of the sketch. Two Indian hunters are sketched in the lower left-hand corner of the work. Both hold bows and the figure on the right is about to draw an arrow.

Monastère des Ursulines de Québec, Quebec

47 *The Huron Village of Jeune Lorette*
Oil and gouache on paper, squared off and mounted, 35.6 x 50.5 cm

Inscription: At the bottom, on mount, *Village des Sauvages. Ancienne Lorette* (Indian Village at Ancienne Lorette) - though the word "Ancienne" has been stroked out in pencil and replaced by "Jeune."

Provenance: Légaré's Quebec Gallery of Painting; Séminaire de Québec, Quebec City, 1874 (Archives, Portfolio 159-G, p. 9).

Bibliography: ASQ, *Séminaire 12*, no. 41, 1874; IBC, "R.B." and Séminaire de Quebec/Archives files; Bouchette, see

entry for 1831, under "St. Charles (R. and L.)"; Cameron & Trudel (1976), p. 153.

This oil sketch was acquired by the Séminaire de Québec at the 1874 sale of Joseph Légaré's collection of paintings. In the manuscript catalogue of this collection, lots 290, 291, and 292 are each described as "batch of oil sketches." This work was perhaps one of these. It may also be one of the ten "waterfalls" mentioned in this document (see cat. no. 32). Gérard Morisset wrongly attributed it to an English painter visiting Quebec City and whose initials he took to be R.B. (see cat. nos. 10 and 21). This work was restored by the National Gallery of Canada in 1976.

After successive settlements on the Île d'Orléans, Notre-Dame-de-Foye, and Ancienne-Lorette, the Hurons finally settled at Jeune Lorette in 1698. This village is situated on the banks of the Saint Charles River near an impressive waterfall. Here is the description that Surveyor-General Joseph Bouchette gave of the river, the falls, and the village in 1831:

The river, called by the Indians *Cabir Coubat* on account of its windings and meanderings, is formed by the union of several streams that rise in the S. section of the T. of Stoneham, in the co. of Quebec. It then descends into the St. Ignace fief, where it expands into a beautiful lake, to which it lends its

name. Soon after it has issued from this lake it receives the united waters of two small streams, that run from lakes Segamite and Sebastian, with this addition it bends suddenly to the s. and takes in the tributary stream of Nelson River. It then passes the Indian Village and rolls over a steep and irregular rock 30 ft. high, forming a beautiful and romantic cataract. In passing a mill which is under the fall the current becomes extremely narrow, and for the space of 3 miles is bounded by woody banks, on which are frequent openings cut through the trees, disclosing the rushing waters. The rapidity of the stream opposed by rocks produces a quantity of white foam upon its gloomy surface, accompanied by murmuring sounds. The water-fall with the smaller cascades above it, the mill, the bridge, the village and the distant hills form an agreable landscape. From this cataract the river descends in numerous and graceful curvatures to the St. Lawrence, into which it falls a little above the City of Quebec, forming an estuary which is almost dry at low water, with the exception of the bed of the river, and offers a convenient strand for river craft and boats.

The falls near the village of Jeune Lorette greatly interested Joseph Légaré because of their picturesque quality. We have been able to trace five works of the artist that convey the beauty of the place and the variety of the vantage points to be found there (see cat. nos 47-51). When taken in sequence, they constitute an eloquent illustration of Bouchette's remarks.

To paint the first of these works, Légaré placed himself to the south of the falls, at the top of an escarpment from where a general view of the river and village could be had. The foreground consists of a thin strip of land edged by a tree trunk to the left and by pine trees to the right. Somewhat veiled by the foliage of various scrawny wild plants, the rapids occupy the middle ground of the composition. Higher up, in the background, a bridge spans the river. To its left, a house partly hiding an outbuilding can be seen. On the other bank, on the extreme right, stands the mission church and presbytery. The houses of the village form a frieze running from the river to the church, not far from which can be seen the square of a cemetery with a cross planted in its midst. Nearer to us is the track of a fenced road leading to the Lorette mills hidden from us by the pine trees in the foreground.

The Huron Village of Jeune Lorette is a squared off sketch, without doubt used by the artist to paint a picture that we have unfortunately not been able to trace. While illustrating Légaré's methods, it enables us to appraise his technical skill. Indeed, this work painted on the spot is overflowing with vigour. It is bathed in a vibrant light which catches the buildings, the rock slopes, and the pushing waters of the falls. These roaring falls painted with an impressionistic touch and with a sureness of hand approaching mastery cannot but arouse our admiration.

Séminaire de Québec, Quebec

47

48 *The Saint Charles River Falls at Jeune Lorette*
Charcoal, gouache, and oil on paper, 38.4 x 53.4 cm

Inscription: verso, u.c. *Rivière et cascades / Paysage non identifiable?* (River and cascades / landscape unidentifiable?).

Provenance: Légaré's Quebec Gallery of Painting; Séminaire de Québec, Quebec City, 1874 (Archives, Portfolio 159-G, p. 50).

Bibliography: ASQ, *Séminaire 12,* no. 41, 1874; Bouchette (1831), under "St. Charles (R. and L.)."

This oil sketch was acquired by the Séminaire de Québec at the 1874 sale of Joseph Légaré's collection of paintings. In the manuscript catalogue of this collection, lots 290, 291, and 292 are each described as "batch of oil sketches." This work was perhaps one of these. It may also be one of the ten "waterfalls" mentioned in this document (see cat. no. 32). This work was restored at the National Gallery of Canada in 1976.

In this sketch, in which ochre tones predominate, we find ourselves at the foot of the slope from which we were looking at the village of Jeune Lorette in the previous work (see cat. no. 47). Before us, the Saint Charles River makes an almost right-angled bend. In the background, in the upper part of the work, we again find the Jeune Lorette bridge and the sketchy outline of some of the houses in the village. The river bed fills almost the whole width of the sketch. Towards the right, a narrow stream of water surrounds a huge rock. The outer wall of one of the Lorette mills can be seen to its immediate right.

The layout of this sketch is very daring. The grey sky is confined to a thin strip in the upper part of the work. This enables the artist to highlight the wild strength of the falls whose waters are massed in contrasting planes.

Séminaire de Québec, Quebec

49 *The Saint Charles River Falls at Jeune Lorette*
Oil on canvas, 57.2 x 83.7 cm

Provenance: Légaré's Quebec Gallery of Painting; Séminaire de Québec, Quebec City, 1874; antique dealer Gilbert, Quebec City, 1958; Musée du Québec, Quebec City, 1958 (A 58 538 P).
Exhibitions: 1959, 12 July-23 Aug & 3-23 Sept., Vancouver and Winnipeg, Vancouver Art Gallery and Winnipeg Art Gallery, *The Arts in French Canada,* cat. no. 170; 1965, Ottawa and Quebec City, National Gallery of Canada and Musée du Québec, *Treasures of Quebec,* cat. no. 49; 1967 (summer), Quebec City, Musée du Québec, *Peinture traditionnelle du Québec,* cat. no. 36, repr.

48

Bibliography: ASQ, Séminaire 12, no. 41, 1874; Laval University Catalogues (SQ) (1913) p. 63, no. 352, (1923) p. 72, no. 352, (1933) p. 81, no. 244; Bouchette (1831), under "St. Charles (R. and L.)"; Bellerive (1925), p. 17; Colgate (1943), p. 109; Morisset, La peinture traditionnelle (1960), p. 100; Reid (1973), p. 48, repr.; Lord (1974), p. 51, repr.

This oil on canvas was acquired by the Séminaire de Québec at the 1874 sale of Joseph Légaré's collection of paintings. In the manuscript catalogue of this collection, ten lots were merely entitled Waterfall (see cat. no. 32). This work was perhaps one of these. The picture is mentioned thereafter in the Laval University (S.Q.) catalogues, published in 1913, 1923, and 1933. In the French editions of 1913 and 1933, it bears the name Cascades de la rivière Saint-Charles à Lorette. In the English edition of 1923, it is entitled Water Falls on the S. Charles River at Indian Lorette. The painting remained at the Séminaire de Québec until 1958 when an exchange was made with antique dealer Gilbert who sold it the same year to the Musée du Québec. It was restored in 1959.

When Légaré painted this work - or a preliminary sketch for it - he was standing near the Lorette mills, on the bank opposite the place from which he had painted The Saint Charles River Falls at Jeune Lorette (see cat. no. 48). It is therefore from the side that we now see the narrow stretch of water flowing round a rock before joining the main stream of the river, whose course serves as a base for the diagonal composition of the picture. Its steep sides reveal broken rock formations on which the vegetation has nonetheless managed to find a hold. On the left, a stunted tree stretches out its twisted branches while, more to the right, in the background, the upper part of two buildings can be seen which appear in the sketch entitled The Huron Village of Jeune Lorette (see cat. no. 47).

In this work Légaré has gone to great lengths to convey as faithfully as possible the variety of light effects on the water, rocks, and vegetation.

Musée du Québec, Quebec

50 The Jeune Lorette Mills and the Saint Charles River Falls
Oil on paper, 30.2 x 49.5 cm

Inscription: verso, l.l., Rivière Jacques Cartier d; verso, l.r., Rivière Jacques Cartier dans le/ comté de Portneuf, Québec et Montmorcy (Jacques Cartier River in the County of Portneuf, Quebec and Montmorency).

Provenance: Légaré's Quebec Gallery of Painting; Séminaire de Québec, Quebec City, 1874 (Archives, Portfolio 159-G, p. 52).

Bibliography: ASQ, Séminaire 12, no. 41, 1874; Bouchette (1831), under "St. Charles (R. and L.)"; Cameron & Trudel (1976), p. 153.

This oil sketch was acquired by the Séminaire de Québec at the 1874 sale of Joseph Légaré's collection of paintings. In the manuscript catalogue of this collection, lots 290, 291, and 292 are each described as "batch of oil sketches." This work was perhaps one of these. It may also correspond with one of the ten "waterfalls" mentioned in this document (see cat. no. 32). It was restored at the National Gallery of Canada in 1976.

This oil on paper is the fourth in the series of works that Légaré devoted to the waterfalls at Lorette (see cat. nos 47, 49, 51). It depicts the part of the Saint Charles River which, after rounding a sharp elbow bend, rushes through narrows to widen out again amidst hurtling waters. To the right of the falls stand the flour mill and sawmill of Jeune Lorette. Both date from the French régime. To their immediate left, we recognize a house that Légaré painted in two of his other works (see cat. nos 47, 49). Dark rock stratifications and an autumn forest - in which are strewn here and there those dead tree trunks the artist so liked to paint - fill the remainder of this work. Only the figures of two men standing on a rock in the foreground stand out against the foaming waters. The artist has not painted them to scale so they give an impression of vastness to the surrounding landscape. There is a fine contrast between the blue grey of the sky and the orange tones of the forest in this hastily executed sketch, which probably served as a preliminary study for a small oil on paper belonging to the Monastère des Ursulines in Quebec City (see cat. no. 51).

Séminaire de Québec, Quebec

51 The Jeune Lorette Mills and the Saint Charles River Falls c. 1842
Oil on paper, 12.4 x 15.9 cm

Inscription: signed u.l., J. Lorette; l.l., Peint pour cet Album par Jos. Légaré Écuyer (Painted for this album by Joseph Légaré Esquire); across bottom of sheet, VUE/ de la belle cascade formée au pied du moulin a farine de la Jeune Lorette/ par la petite rivière qui fait tourner ce moulin (View of the fine waterfall that forms below the flour mill at Jeune Lorette and which operates it).

Provenance: Monastère des Ursulines de Québec, Quebec City (Album of Abbé Maguire, p. 91).

Bibliography: AMUQ, Album de notre vénéré père M. le G.V. Maguire, Aumônier de ce Monastère depuis le 14 mai 1832 jusqu'au 17 juillet 1854; Bouchette (1831), under "St. Charles (R. and L.)"; Cameron & Trudel (1976), p. 153.

This oil on paper was ordered by the Ursulines of Quebec from Légaré to illustrate one of the pages of an album they intended as a gift for their chaplain, Abbé Thomas Maguire

49

(see cat. no. 41). The album contains another work by Légaré entitled *The Falls of Saint-Ferréol* (see cat. no. 46). The paper of both was restored in 1977.

It was possibly with a view to painting this small landscape that Légaré made the sketch on paper that now belongs to the Séminaire de Québec (see cat. no. 50). Only slight differences distinguish the two works. In the left-hand part of the Ursulines' version, the forest takes up less space while the waters of the river are wider. There is also a certain distance between the mills and the house in the background. Lastly, the figures at the water's edge have been replaced by two Hurons conversing in a setting familiar to them. Painted to scale, these two figures correct the disproportion we had noted in the Séminaire de Québec version.

Monastère des Ursulines de Québec, Quebec

52 *Memorials of the Jesuits of New France* 1843
Oil on canvas, 1.32 x 1.65 m

Inscription: on the painting, *Le P. de Brébeuf brûle/en/1649* (Father Jean de Brébeuf martyred by fire in 1649); at bottom of Charlevoix engraving, *J. LEGARE pinx./B. Retrouve SCULP./CHARLEVOIX.* On the book spines: first row top, *Histoire du Paraguay* (3 vols); second row left,

Moeurs des Sauvages (2 vols); in centre [illegible]; to right, *Histoire et description générale de la Nouvelle-France* (2 vols, completing, with the open volume, the 3-vol. set).

Provenance: Jesuit Fathers, Montreal; Residence of the Jesuit Fathers, Quebec City.

Bibliography: AJQ, Register of the Notary Public Jean-Baptiste Delâge (6 Dec. 1972), no. 2921; (anon.) *Lettres des nouvelles missions du Canada 1843-1852,* pp. 107-108; Lane & Browne (1906), p. 285; Barbeau (1957), p. 204; Harper (1970), p. 194; Porter & Trudel, *L'orfèvrerie en Nouvelle-France* (1974), pp. 28, 60-61.

In 1843, the preaching of a week-long pastoral retreat that brought together the clergy of the Quebec diocese was entrusted to a Jesuit priest. The retreat was held at the Séminaire de Québec. "One idea was uppermost in all minds," wrote Father Félix Martin in 1843, "this was the memory of the Society of Jesus that had returned to Canada for the first time after more than forty years, and begun its work by entrusting to one of its sons one of the most important ministries in places so rich in memories."

On the last evening of the retreat, the Bishop of Quebec, Mgr Signay, and his coadjutor, Mgr Turgeon, thanked the Jesuit preacher (trans.):

They offered him at the same time a picture of great

interest to us; it is the work of a local artist and the priests had just bought it. In the foreground, the life-size copy of a silver bust of Father de Brébeuf can be seen, kept with an important relic in one of the Quebec communities. All the memorials relating to local history and productions are near him, and in the distance can be seen the martyrdom of this heroic man and his selfless companions. Even the frame is a precious object to us: it was the fine ornament of one of the pictures belonging to the church of our College in Quebec City.

This painting remained in the keeping of the Jesuits in the Montreal area until its recent transfer to the Jesuit Residence in Quebec City. It was exhibited for a time at the Jesuit Residence in Sillery. It was restored in 1974 at the National Gallery of Canada.

The clergy who commissioned the picture from Légaré probably specified the iconography to be included in it, and several sources were used to complete the final composition. In the centre of the painting, on a table, stands the reliquary-bust of Father Jean de Brébeuf, the Jesuit martyred in Huron country on 16 March 1649. This silver reliquary, whose coffin-shaped base contained Brébeuf's skull, was kept at the Monastère des Augustins de l'Hôtel-Dieu in Quebec City in Légaré's day. Légaré had certainly studied it closely, for his copy is exact except for one detail: he has transformed the silver bust which rested flat on the wooden base by adding an intermediate silver base. This gives the reliquary the majesty of an antique bust which it does not, in fact, have. It thus takes on a new dimension in the picture and the upper part of Brébeuf's body forms an oval in the centre of the composition.

The reliquary is slightly turned towards the right-hand corner of the painting so that the eye travels towards a hunting trophy lying on the table and towards the landscape background seen through an opening. The hunting trophy consists of several birds, a quiver full of arrows, a bow (note the alteration indicating a slight change in the composition), and a woven Indian basket. It is a kind of symbolic offering from the Indians to the memory of Brébeuf and Gabriel Lalemant, his companion, depicted to the right of the trophy, in the landscape. Another kneeling Jesuit can also be seen being shot by an Indian. For this scene, Légaré based his composition on an engraving illustrating page 1 of the first volume of the original edition of Charlevoix's work entitled *Histoire et description générale de la Nouvelle-France.*

If the whole emphasis of the painting tends towards the right, towards the glorious and violent epic of the Jesuits in the early days of the French colony, the left part of the picture represents the living memory of this far-off time immortalized in writing. For this part of the painting, Légaré drew his inspiration from a European canvas in his collection, *Still-Life with the Portrait of Calvin,* attributed to the painter Christoph Pierson (1631-1714) of which he made a copy, now at the Musée du Québec (see cat. no. 250). It was probably from this work that he took the idea of the open book and the engraving. The title page of the book is that of the first of the three volumes of the *Histoire et description générale de la Nouvelle-France avec le Journal*

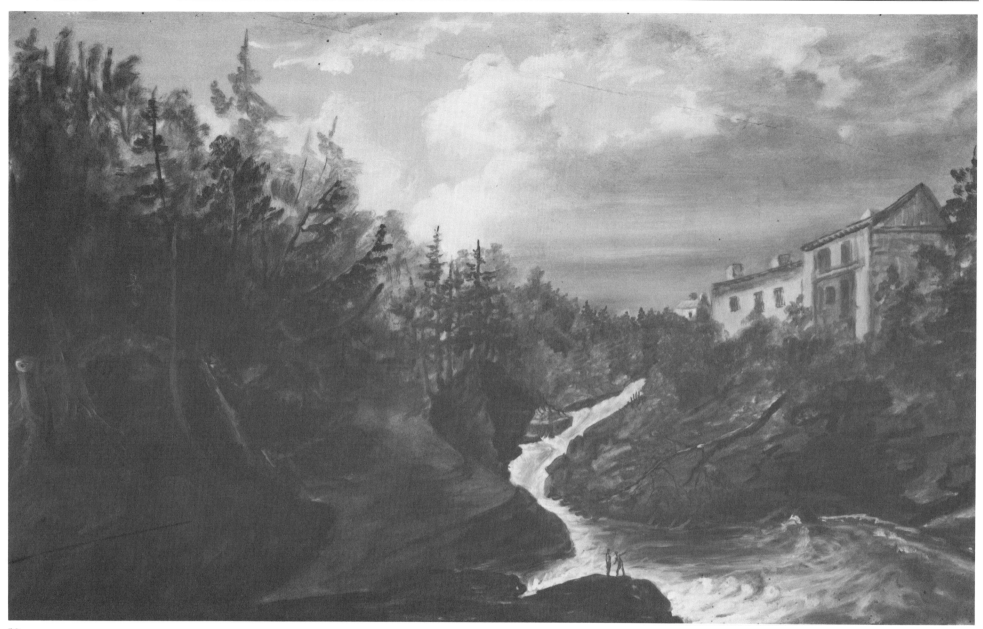

50

historique d'un Voyage fait par ordre du Roi dans l'Amérique Septentrionale. The two other volumes stand to the right of the open book. These three volumes were published in Paris in 1744 by the Jesuit Pierre-François-Xavier de Charlevoix (1682-1761). The original edition did not, however, include an engraved portrait of Charlevoix, which was eventually published as a frontispiece in the new edition that appeared in 1866. The engraving we see in the picture bears the inscriptions at the bottom, J. LEGARE Pinx. and B. Retrouve SCULP. in addition to CHARLEVOIX. In 1842, Légaré had exhibited in Montreal a portrait of Charlevoix that now belongs to the Jesuit Residence in Saint-Jérôme (see cat. no. 181). The two portraits are similar but pose questions as to both the artist's source and the real identity of the Jesuit represented.

Among the other volumes whose titles can be read on their spines are three other volumes by Charlevoix on the top shelf comprising his Histoire du Paraguay published in

Paris in 1756. Beneath these books are two volumes by Jesuit Joseph-François Lafiteau (1681-1746) published in Paris in 1724, Mœurs des sauvages amériquains, comparées aux mœurs des premiers temps. Copies of these volumes as well as the two works by Charlevoix appearing in the picture were to be found in Légaré's own library. It is almost impossible to make out the titles of the three other books lying flat and serving as a stand for a crucifix, various manuscripts, and a piece of parchment on which is written: Le P. de Brébeuf brûlé en 1649 (Father Brébeuf burned in 1649). A correction reveals that it was a goblet rather than a crucifix that had originally been painted: the sufferings of Christ are a pendant here to the sufferings of the Jesuits in the New World. Flowers on the volumes are in honour of the memory of those who wrote them.

Résidence des pères Jésuites, Quebec

53 The Martyrdrom of Fathers Brébeuf and Lalement c. 1843
Oil on canvas, 67.6 x 97.2 cm

Provenance: Jacoby's House of Antiques, Montreal; Mrs Mary Barriere, Westmount, 1969; National Gallery of Canada, Ottawa, 1977 (18795).

Bibliography: Jacoby's of Montreal, *Highly Important Paintings and Sculpture of Great Masters of Canadian and European Art* (sale catalogue) 1969, pp. 118-119, cat. no. 161, repr.; *Lettres des Nouvelles Missions du Canada, 1843-1852*, p. 25.

It was in 1843, shortly after the return of the Jesuit Fathers to Canada, that Joseph Légaré painted *Memorials of the Jesuits of New France* (see cat. no. 52). He had therefore certainly been in contact with the Jesuits at that time. *The Martyrdom of Fathers Brébeuf and Lalemant* is also a picture

related in its subject to the Jesuits. Unfortunately, we have no information concerning its provenance prior to 1969. It is very possible, however, that the painting was ordered from Légaré by the Jesuits who were given certain missions to accomplish after their arrival. From 2 July 1842, for example, they took charge of the parish of Laprairie and very probably sought visual means of evoking their famous predecessors of New France.

This painting was put up for sale in Montreal, at an auction at Jacoby's House of Antiques on 22, 23, and 24 October 1969. It was then bought by Mrs Mary Barriere of Westmount who sold it to the National Gallery of Canada in 1977. It was probably in 1969 that it was restored and remounted on canvas.

Jean de Brébeuf was martyred by the Iroquois on 16 March 1649 in Huron country (the Midland area, in Ontario) with Gabriel Lalemant, his companion, who died on 17 March 1649. In *Historiæ Canadensis* by François Du Creux, a book published in Paris in 1664, there was an engraving by Grégoire Huret (1606-1670) depicting the Jesuits martyred by the Iroquois. This engraving was well known in Quebec in Légaré's day, and Légaré made use of it, faithfully reproducing Brébeuf, Lalemant, and their torturers, but leaving out the scenes of martyrdom of the other Jesuits. In an addition to his composition, Légaré has painted, to the right of the central group, an Indian holding a torch who seems to be guiding a group that can be made out further away in the woods.

This painting was an opportunity for Légaré to paint one of his finest landscapes. It is primarily the latter which compells attention and almost makes one forget the horrible scene in the foreground. This contrast between the beauty and serenity of the landscape and the violence of the Jesuits' suffering was intentional on Légaré's part: it creates a balance that makes the main subject of the painting endurable. On the high promontory, to the left, can be seen what seems to be a flag floating from a flagstaff. It has not been possible to identify the landscape with certainty, but it is reminiscent of the view of Quebec from the Pointe-à-Pizeau at Sillery.

An infra-red examination of the picture reveals a change in composition on the right where Légaré had first of all painted trees, including a huge dead tree-trunk, leaning out of the picture. This movement of the trees would have broken the balance of the composition in which, in the final version, the movement is inward.

In the *Josephte Ourné* (see cat. no. 56), Légaré was inspired by the French romantic notion of the "noble savage," whereas in *The Martyrdom of Fathers Brébeuf and Lalemant*, it was the Canadian concept of the "barbarous savage" in which all the ancestral fears, in the nineteenth century, were contained.

National Gallery of Canada, Ottawa

**54 *The Martyrdom of a Jesuit Father* c. 1843
Oil on cardboard, 15.8 x 17 cm**

Inscription: verso, a receipt from Notary Berthelot Dartigny,

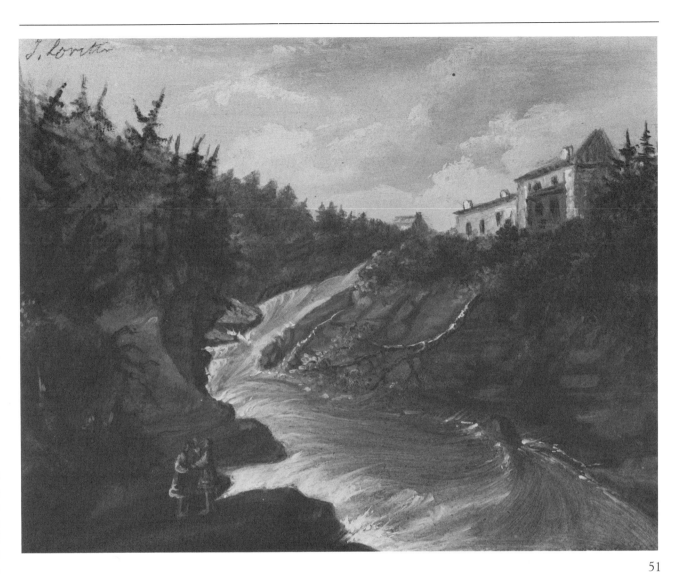

51

dated 17 June 1782, relating to a piece of land at Saint-Henri de Lévis.

Provenance: Attic of the Hôtel Croteau, Saint-Henri de Lévis; private collection, 1963.

We do not know the origin of this work discovered in the attic of a hotel at Saint-Henri de Lévis in 1963. Although it has no relation with the subject represented, the notary's receipt pasted on the back of the work - and earlier in date than the painting - lends additional probability to the theory that *The Martyrdom of a Jesuit Father* had formerly been acquired by a Saint-Henri resident. This oil on cardboard was cleaned a few years ago.

In the centre of an X-shaped composition, a Jesuit - probably Father Isaac Jogues (1607-1646), killed by an axe blow to the head by the Iroquois on 18 October 1646 at Ossernenon (Ariesville, N.Y.) - is kneeling on a rock. With his arms crossed and a crucifix in his right hand, he turns his eyes towards heaven. While a shaman tries in vain to torment the martyr, an Indian with a knife in his belt prepares to hit him with a tomahawk. In the background, to the right, a group of imperturbable Indians look on. All are adorned with silver jewelry from the trading of furs and wear headbands stuck round with

feathers. The scene takes place in a forest at night. The green foliage of the trees makes a contrast with the reddish light of a large fire which lights up the scene and against which the figures in the foreground stand out.

This work is probably related to the picture entitled *The Martyrdom of Fathers Brébeuf and Lalemant* that Légaré painted in about 1843 (see cat. no. 53). For this latter painting, the artist drew his inspiration from an engraving by Huret from which he borrowed the main group in the foreground. There are similarities between other elements of this same engraving and *The Martyrdom of a Jesuit Father.* Moreover, the Indians in the background may be compared with some of the figures in *The Martyrdom of Fathers Brébeuf and Lalemant.*

Légaré may have painted other scenes of martyrdom that have now disappeared. Thus, in the manuscript catalogue of the sale of his collection of paintings to the Séminaire de Québec in 1874, lot 203 was curiously entitled *Martyrdom of Father Leboeuf* (ASQ, *Séminaire* 12, no. 41).

Private Collection

73

52

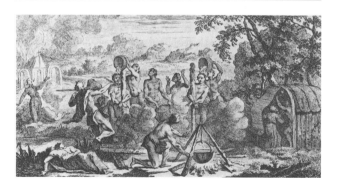

55 Indian Scalping His Prisoner
Oil on canvas, 90.0 x 77.0 cm

Provenance: Légaré's Quebec Gallery of Painting; Séminaire de Québec, Quebec City, 1874; antique dealer Gilbert, Quebec City, 1957; Dr Herbert T. Schwartz, Montreal; Musée de Vaudreuil, Vaudreuil (X973.1132).

Bibliography: ASQ, *Séminaire* 12, no. 41 (1874), p. 2, no. 54; Laval University Catalogues (SQ), 1933 onwards (no. 628); *La Presse* (21 July 1961), repr.; Dumouchel & Boileau, 1975, no. 5.

This picture was acquired by the Séminaire de Québec at the 1874 sale of Joseph Légaré's collection of pictures. In the manuscript catalogue of this collection, lot 54 was entitled *Sauvage scalpant son prisonnier (Indian Scalping his Prisoner)*. The picture does not appear in the various Séminaire de Québec (LU) catalogues: it seems to have been consigned to oblivion. In the continuation in manuscript of the 1933 catalogue, it is, however, listed as being by an unknown painter and bears the title *An Indian in 3/4, scalping a Corpse*, under no. 628.

In 1957 it came into the hands of the antique dealer Gilbert of Quebec City and finally ended up in the Musée de Vaudreuil where it is listed in the catalogue under the title *Indien scalpant une victime, supplice d'un prisonnier chez les Iroquois (Indian Scalping a Victim, Torture of a Prisoner by the Iroquois)*. The painting was restored in 1978.

A grimacing Indian wearing an earring and a headband stuck round with white feathers is seen in three-quarters profile in the process of scalping another Indian whom he holds with his right hand and whose head is seen in profile. The victim also wears earrings, and his skull is already partly bared. The scene is horrible and Légaré has done his utmost to emphasize the description of the Indians' "barbaric customs."

This picture, of which we know nothing of the circumstances in which it was painted nor the date of its execution, must be compared with works such as *Massacre of Hurons by the Iroquois* (see cat. no. 12), *The Martyrdom of Fathers Brébeuf and Lalemant* (see cat. no. 53), and *The Despair of an Indian Woman* (see cat. no. 59). It is the notion of the "barbarous savage" that is expressed in these works, as opposed to that of the "noble savage," represented in Légaré's work by *Josephte Ourné* (see cat. no. 56), and by his *The Engagement of an Indian Girl* (see cat. nos 57, 58).

Musée de Vaudreuil, Vaudreuil

56 Josephte Ourné c. 1844
Oil on canvas, 131.5 x 95.5 cm

Inscription: *verso* on the canvas, *Josephte Ourné ... âgée de .../fille d'un Chef Sauvage d'Ocnawaga* (Josephte Ourné ... aged ... daughter of an Ocnawaga Indian Chieftain); *verso* on a metal plate affixed to the left-hand panel on the back

of the frame, 364.

Provenance: Légaré's Quebec Gallery of Painting; Séminaire de Québec, Quebec City, 1874; antique dealer Gilbert, Quebec City, 1958; M. Bernard Desroches, Montréal; National Gallery of Canada, Ottawa, 1975 (18309).

Exhibition: 1907, 26 Aug.-9 Sept., Toronto, Canadian National Exhibition, Department of Fine Arts, (OSA) *Section II: Portraits of Historic Interest*, cat. no. 31.

Bibliography: *L'ami de la religion et de la patrie* (4 Oct. 1848), p. 655; *Le Canadien* (2 Oct. 1848) p. 3; *Le Castor* (4 June 1844) p. 3, reprinted 13 June, 9, 25, & 30 July and 1 & 6 Aug. 19, 24, 26 Sept. and 9 & 17 Oct. 1844; *The Quebec Mercury* (5 Oct. 1848) p. 3; ASQ, *Séminaire 12, no. 41* (1874), p. 5, no. 179; Laval University Catalogues (SQ) (n.d. I) p. 4, (n.d. III) p. 14, no. 6, (1880) p. 7, no. 126, (n.d. IV) p. 19, no. 126, (n.d. V) p. 19, no. 126, (n.d. VI) p. 19, no. 126, (1889) p. 19, no. 126, (1893, in French) p. 19, no. 126, (1893, in English) p. 19, no. 126, (1894) p. 19, no. 126, (1898) p. 21, no. 126, (1901) p. 21, no. 126, (1903) p. 27, no. 6, (1905) p. 27, no. 6, (1906) p. 36, no. 6, (1908) p. 87, no. 156, (1909, in English) p. 38, no. 156, (1913) p. 63, no. 364, (1923) p. 73, no. 364, (1933) p. 18, no. 256; Lemoine (1876), p. 367, no. 152; Bellerive (1925), p. 16; Morisset, *Peintres et tableaux*, vol. II (1937), p. 76; Colgate (1943), p. 109; Morisset, *La peinture traditionnelle* (1960), p. 98; Tremblay (1972), p. 196; Godsell (1976), pp. 45, 46, 49, repr.

Between 4 June and 17 October 1844, the Quebec City newspaper *Le Castor* twelve times published an advertisement in which different paintings were offered for sale. These were exhibited in the office of Notary Public Archibald Campbell, a friend and client of Légaré (see cat. nos 57, 59). The titles of some of the works mentioned in the advertisement suggest that they were pictures painted by Légaré or belonging to his personal collection. One of them bears the title *Portrait of an Indian Chief's Daughter*. This may well be the present picture. It was perhaps this same picture which, in 1848, was included in an exhibition of thirty-one works at the Legislative Assembly Chamber which were to be sold at a lottery on 23 October 1848: this would then be no. 6 entitled *An Indian Woman* and valued at £20. We do not know what happened to this lottery, but in 1874, when Joseph Légaré's collection of paintings was sold to the Séminaire de Québec, lot 179 bore the title *Indian Girl*. Subsequently, the different catalogues of the Séminaire de Québec (LU) paintings thus list a picture by Joseph Légaré: *Portrait of Josephte Ourné, aged 25, Daughter of an Abenaki Chief*. Only the 1913 and 1933 catalogues show a variation in the entry: "Josette" instead of "Josephte."

The picture remained at the Séminaire de Québec until 1958 when an exchange was made with the antique dealer Gilbert of Quebec City. At that time, it was in very poor condition: the top left corner had almost disappeared, as if the picture had been exposed to fire. It was rescued by Mr Bernard Desroches of Montreal, who had it restored in 1972-1973 and sold it to the National Gallery of Canada

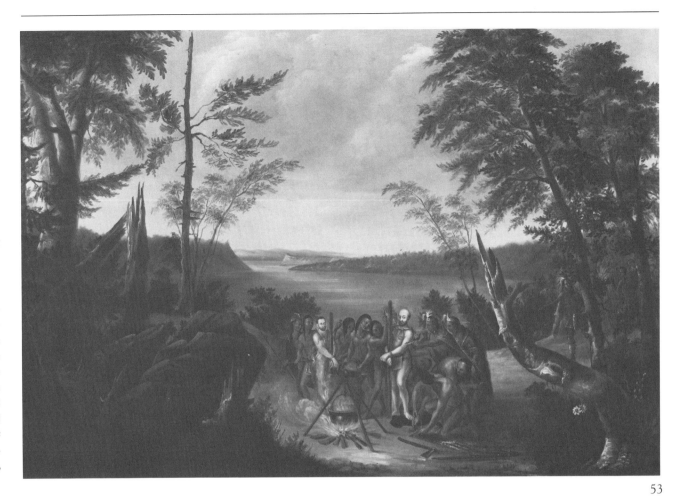

53

in 1975.

Before being remounted in 1972-1973, this painting bore a handwritten inscription on the back as follows: *Josephte Ourné ... âgée de/fille d'un chef sauvage d'Ocnawaga*. This inscription differs from the Séminaire de Québec catalogue entries in the sense that if "Ocnawaga" means "Caughnawaga," Josephte Ourné cannot be the daughter of an Abenaki. Research has not been able to establish who she was, nor to what circumstances she owes this portrait by Légaré.

Standing before a background of dense and sombre forest, Josephte Ourné holds a fishing rod in her left hand, on the line of which two trout are hooked, and in her right hand a bird. The painter originally had her hold a catfish in her right hand, but for some reason changed the fish to a bird. With feathers in her hair, Josephte Ourné is adorned in all her finery, with her flower-embroidered dress, her necklace, her earrings, and her silver *couette* (see cat. no. 57). She thus displays pieces of jewelry that the fur-traders exchanged with the Indians.

More than a portrait of an Indian, unique in Légaré's work, it was perhaps his own notion of the Indian that he had wished to convey in this painting. If the proud and fine figure standing before her forest is tinged with romanticism, the attributes with which she is adorned relate directly to fishing, hunting, and trade with the white man.

National Gallery of Canada, Ottawa

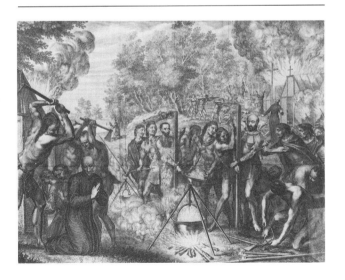

53a Grégoire Huret, *The Martyrdom of the Jesuit Fathers*, Engraving illustrating the work by François Ducreux entitled *Historiae Canadensis* (Paris, 1664)

57 *The Engagement of an Indian Girl* 1844
Oil on canvas, 1.20 x 1.58 m

Provenance: Archibald Campbell, Quebec City, 1844 ?; Estate of Colonel J.B. Maclean, Puslinch Township, Ontario; The Presbyterian Church of Canada; Wellington County Museum, Fergus, Ontario, 1968.

Bibliography: Le Castor (28 Mar. 1844) pp. 1-2, (2 Apr. 1844) pp. 1-2, (4 Apr. 1844) pp. 1-2, (9 Apr. 1844) pp. 1-2, (11 Apr. 1844) pp. 1-2, (18 Apr. 1844) p. 2; *The Quebec Spectator* (6 Oct. 1848) p. 2.

From *Le Castor* of 18 April 1844, we learn that the picture we entitle *The Engagement of an Indian Girl* was painted that year at the same time as *The Despair of an Indian Woman* (see cat. no. 59). According to the same newspaper article, Notary Public Archibald Campbell (1790-1862), an art-lover and admirer of Légaré's work, was supposed to have bought the two pictures even before they were finished. Both were exhibited in one of the rooms of the Assembly Chamber in Quebec City in October 1848. They were not, however, part of the works put up for sale at a lottery by Légaré at that time. We then lose track of the picture, *The Engagement of an Indian Girl* (see cat. no. 59). After belonging to the late Colonel J.B. Maclean, and then to the Presbyterian Church of Canada, the work now hangs in the Wellington County Museum at Fergus, Ontario. It has been very considerably restored over the years.

An Indian girl and her suitor occupy the centre of the composition. Curiously clad in a rich red dress of European style, the Indian girl is sitting on the ground with her legs crossed and her head leaning on her right hand. Her dress, hair style, and jewelry are very similar to those of Josephte Ourné, an Indian girl whose portrait Légaré painted at the same period (see cat. no. 56). Shyly, she holds out her left hand listlessly to receive the gift that the Indian boy beside her lays at her side. The boy is clothed in a loincloth and wears a fur on his back. He wears feathers on his head and a ring in his ear. In an attempt to obtain the girl's consent, he points with his left hand to a pile of birds that he has killed with his bow and arrows. Moccasins – perhaps other gifts – appear to the left of the Indian girl. The couple is seen in front of sharp-edged rocks with the great trees of the forest towering above. A clearing opens out to the right, while wigwams of an Indian encampment can be seen to the left. In the foreground, other trees rise on either side of the picture and strengthen the composition.

In its edition of 28 March 1844, the newspaper *Le Castor,* printed and published in Quebec City by Napoléon Aubin, printed under its front-page heading "Mélanges Littéraires" the first episode of a story entitled *Kosato, Le Pied Noir. Fragment d'une histoire à faire.* The last episode of this long narrative appeared on 11 April 1844. Its author, who signs himself "Boitard," was probably the French naturalist Pierre Boitard (1789-1859). He tells the complicated story of Kosato, a Blackfoot, and his wife Kitchy, for whom he was contending with his infamous chief Shi-whi-shi ouaiter. It is a romantic and violent tale

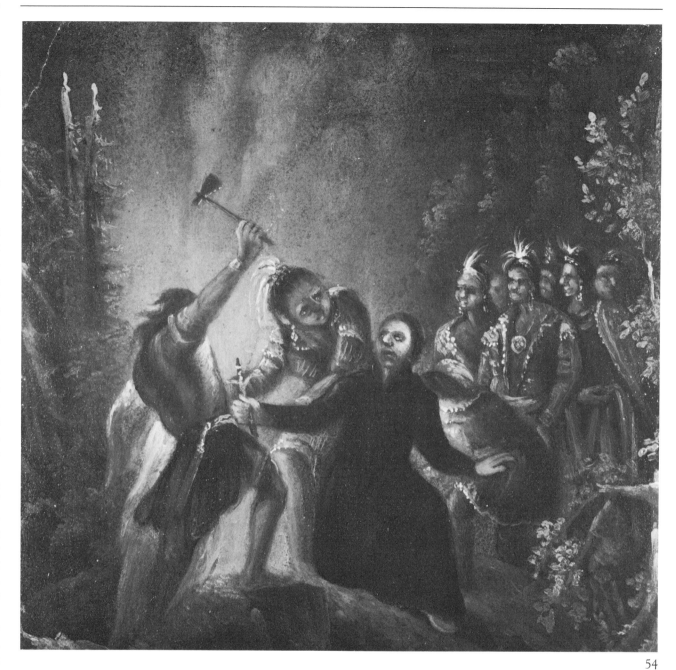

54

containing all the elements of the European view of Indian customs, their passions, and their wars, in the grandiose setting of their forests.

On 18 April 1844, *Le Castor* published the following article (trans.):

> At the same time that we were printing the interesting historical tale that the traveller-author BOITARD has taken from his prolific portfolio, under the picturesque title of KOSATO THE BLACKFOOT, an artist of this town was tracing in no less eloquent characters two scenes also taken from Indian life depicting both its pleasant softness and its frightful energy. We mean two remarkable pictures that the excellent Canadian painter, M. Jos. Légaré, is now completing. We shall not try to describe the beauties of these two works which, like all those issuing from

the same brush, are a great step ahead of their predecessors; everyone may go and visit them and judge for himself.

One is a charming landscape in which a wild, fresh, and tranquil nature competes in primitive coquetry with the two figures which animate its foreground and form its main subject. A young Indian offers gifts and consequently his hand to the girl he loves and chooses as his companion; the latter, without replying, easily reveals by her smile that both hand and gifts are welcome. Everything seems to us well harmonized in this picture in which the spring greenery, the rich foliage of the trees, the transparency of the air, contribute perfectly to the effect that the artist wished to create.

The second painting is in terrifying contrast to the

previous one, both as an *objet d'art* and as a philosophical painting of the customs of those nations which peopled the land of America before the Europeans arrived. It is a massacre and the burning of a wigwam. We advise those who would go and visit Mr Légaré's painting first of all to read the fine scene in which Kitchy, near the bloodstained body of her husband, sobs a funeral chant; they will see how the painter has been able to make of the same subject, through the mere inspiration of talent and imagination, a touching and beautiful page like that of the author, but starker still and more poignant and also more lasting. The painting is lit only by the flames of the bark huts, and the problem of chiaroscuro has been very successfully overcome; the reflections of light touching certain distant objects here and there through the forest produce a magnificent effect.

In concluding this short and imperfect account of two works by the artist who, among those of whom the country is already proud, distinguishes himself by works of local interest, we believe it is true to say that the two pictures we have just mentioned have been bought, even before completion, by an art-lover of this town, Arch. Campbell, Esq., who values his acquisition very highly, especially as a monument in future to the first efforts of the Canadian school.

Those who wish to see these pictures should hurry since they will be delivered very shortly.

The episodes depicted by Légaré in *The Engagement of an Indian Girl* and *The Despair of an Indian Woman* do not really correspond with actual scenes in Boitard's tale, but they do draw their inspiration directly from the atmosphere created by the story "as philosophical picture of the customs of these nations." In other words, Boitard's tale is not the direct literary source of Légaré's paintings but motivates him to paint, through its link with one of his favourite subjects, the Indians.

Despite this reservation, the artist's contemporaries seem to have been so moved by Boitard's tale that they saw illustrations of it in Légaré's pictures. Thus, when the artist showed his two pictures to the public during his exhibition at the Assembly Chamber in 1848, a correspondent from *Le Canadien* described them as "two Indian canvases of striking veracity, the subject of which is taken from the story *Kosato*." The reporter from the newspaper *The Quebec Spectator* for his part, contributed the following comment:

An Indian tradition which tells a frightful tragedy in which a young warrior fell a victim to the tomahawk of his father-in-law, is truly represented in two paintings; the first exhibits the warrior asking the consent of his *blonde,* and evidently receiving it, the second shows his wigwam in flames, and by the red glare which it casts everywhere, the body of the warrior is seen at a distance with a hideous gash in the forehead; the young bride is seated beside him, and her uplifted eyes bespeak the agony that rends her soul. It would

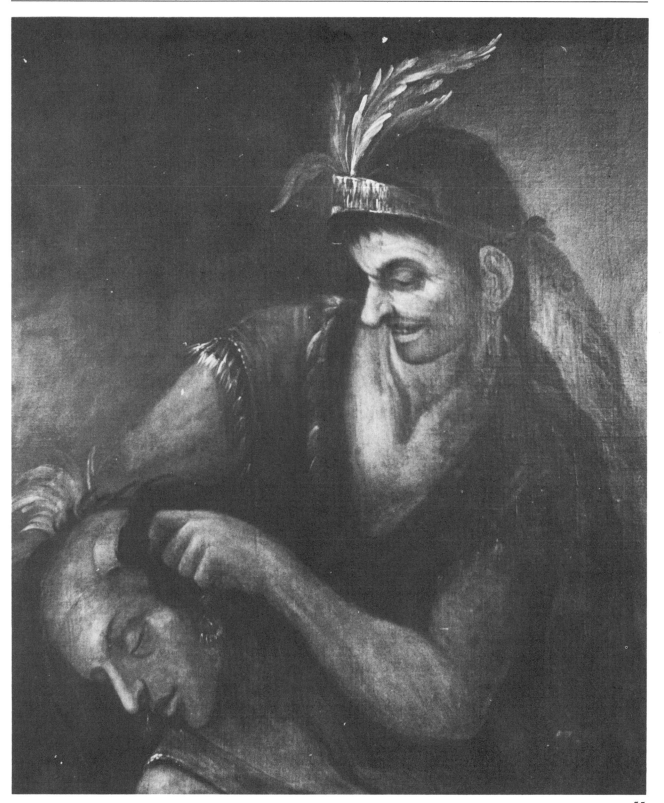

55

be impossible for us to convey anything like a true idea of these and many others of Mr Légaré's paintings, but we could recommend that all who have a moment's time to spare call and see for themselves.

In contrast to the "frightful energy" represented in *The Despair of an Indian Woman*, *The Engagement of an Indian Girl* represents the "pleasant softness" of Indian life. The composition of the two paintings is basically the same but it is less taut in *The Engagement of an Indian Girl*, an incident taking place by daylight in the enchanted setting of a spring forest. We have found a small version of the same subject which presents some interesting variations (see cat. no. 58).

Wellington County Museum, Fergus

58 *The Engagement of an Indian Girl* c. 1844
Oil on paper, 15.2 x 18.8 cm

The present owner of this magnificent little oil on paper acquired it about fifteen years ago from the grand-daughter of the painter Georges Théodore Berthon (1806-1892). The latter had apparently received it as a gift from an artist friend of the family when she was only a little girl.

The layout of the work is very much the same, except for a few details, as that of the large version in the Wellington County Museum (see cat. no. 57); the principal variations are in the two main figures. Their attitudes, costumes, and ornaments show marked differences. The Indian girl in the work exhibited is sitting on her suitor's right and she wears a very low-cut dress and moccasins. She is looking at her fiancé who is clad in all his finery and wearing a real Indian headdress. He points with his right hand to his hunting trophies in the left foreground. Probably to symbolize the union of these two young people, the willows mingle their branches over their heads.

Private Collection

59 *The Despair of an Indian Woman* 1844
Oil on canvas, 1.35 x 1.79 m

Provenance: Archibald Campbell, Quebec City, 1844?; Légaré's Quebec Gallery of Painting; Séminaire de Québec, Quebec City, 1874; antique dealer Gilbert, Quebec City 1958; Musée du Québec, Quebec City, 1965 (A 65 90 P).

Exhibition: 1967 (summer) Quebec City, Musée du Québec, *Peinture traditionnelle du Québec*, cat. no. 37, repr.

Bibliography: Le Castor (28 Mar. 1844) pp. 1-2, (2 Apr. 1844) pp. 1-2, (4 Apr. 1844) pp. 1-2, (9 Apr. 1844) pp. 1-2, (11 Apr. 1844) pp. 1-2, (18 Apr. 1844) p. 2; *The Quebec Spectator* (6 Oct. 1848) p. 2; *Le Canadien* (13 Oct. 1848) p. 2; AJQ, Register of the Notary Public Jean-Baptiste Delâge (6 Dec. 1872), no. 2921; ASQ, *Séminaire 12*, no. 41

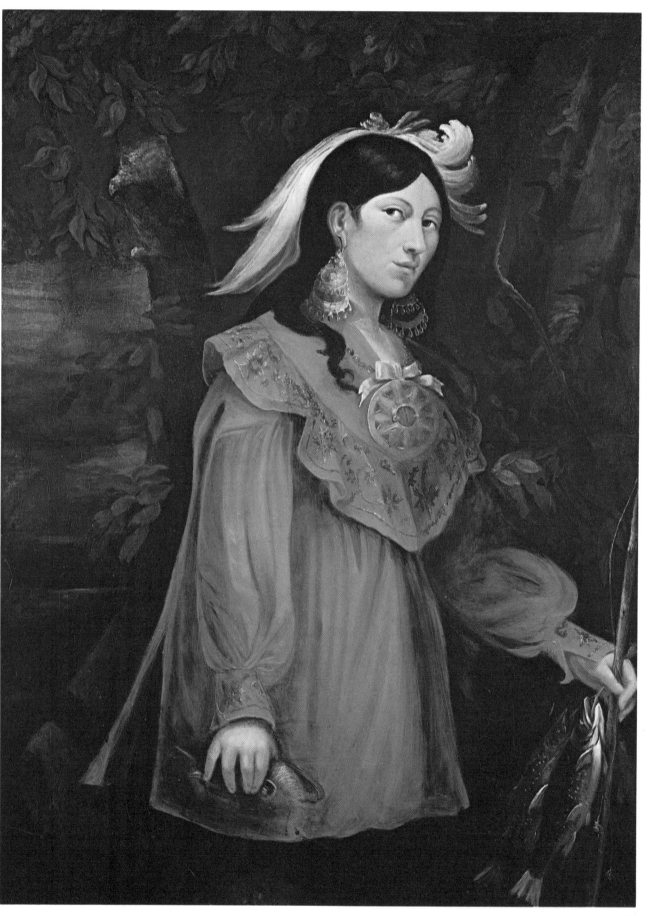

56

(1874), p. 3, no. 98; Laval University Catalogues (SQ) (n.d. I) p. 2, (n.d. II) p. 1, (n.d. III) p. 14, no. 7, (1880) p. 5, no. 44, (n.d. IV) p. 13, no. 44, (n.d. V) p. 13, no. 44, (n.d. VI) p. 13, no. 44, (1889) p. 13, no. 44, (1893, in French) p. 13, no. 44, (1893, in English) p. 13, no. 44, (1894) p. 13, no. 44, (1898) p. 15, no. 44, (1901) p. 15, no. 44, (1903) p. 27, no. 7, (1905) p. 28, no. 7, (1906) p. 36, no. 7, (1908) p. 87, no. 157, (1909) p. 38, no. 157, (1913) p. 62, no. 363, (1923) p. 73, no. 363, (1933) p. 82, no. 255; Lemoine (1876) p. 363, no. 3; Bellerive (1925), p. 16; Colgate (1943) p. 109; Morisset, La peinture traditionnelle (1960) p. 98; Hubbard (1963), pp. 55-56; Hubbard (1964), p. 56; Ostiguy (c. 1965), p. 106; Tremblay (1972), pp. 39-41, 196.

The Despair of an Indian Woman is the pendant of the picture entitled *The Engagement of an Indian Girl* (see cat. no. 57), the two works forming a kind of diptych. *Le Castor* of 18 April 1844 tells us that they were painted that year and that Notary Archibald Campbell, one of Légaré's admirers and an art-lover, was supposed to have bought them even before they were completed. The two pictures were exhibited in one of the rooms of the Assembly Chamber in Quebec City in October 1848 but were not included in the works sold off at a lottery by Légaré at that time. They may quite possibly have been in the artist's possession, in spite of the report in *Le Castor* of 18 April 1844 concerning their acquisition by Campbell.

In the inventory of the communal belongings of Légaré and his wife, begun in December 1872, there is mention of a picture entitled *The Blackfeet,* a work that Mrs Légaré kept in her sitting room and which was valued at eight piastres. Shortly after her death, the inventory was again made in April 1874 and this time there is mention of two works respectively bearing the following titles: *The Blackfeet* (valued at three piastres) and *Cosato* (valued at two piastres). They were acquired by the Séminaire de Québec at the same time as almost the whole of Légaré's collection of paintings. In the manuscript catalogue of that collection belonging to the Archives of the Séminaire de Québec, (ASQ) lot 98 is entitled *Supplice d'une indienne (Torment of an Indian Woman)* and lot 305 *Cosato, les pieds noirs (Cosato, the Blackfeet).* The *Torment of an Indian Woman* is probably the same painting as *Despair of an Indian Woman* that we are studying here. On the other hand, *Cosato, the Blackfeet* might be the same as *The Engagement of an Indian Girl* - now in the collection of the Wellington County Museum (see cat. no. 57) - or it might be another picture that has since disappeared.

In 1876, Lemoine mentions the presence of *Despair of an Indian Woman* at the Séminaire de Québec. Our picture subsequently appears in the different Séminaire de Québec (LU) catalogues under the French titles *Désespoir d'une femme indienne dans les forêts d'Amérique* or *Désespoir d'une indienne,* and as *Despair of an Indian Woman in the Forest of America* or *Despair of an Indian Woman,* in English. It is often mentioned in these catalogues that Légaré won a medal for this picture from the Montreal Arts Society in 1826, whereas in actual fact it was in 1828 that Légaré was awarded a medal for *Massacre of Hurons by the Iroquois* (see cat. no. 12) by the Society for the Encouragement of Arts and Sciences in Canada in Quebec City.

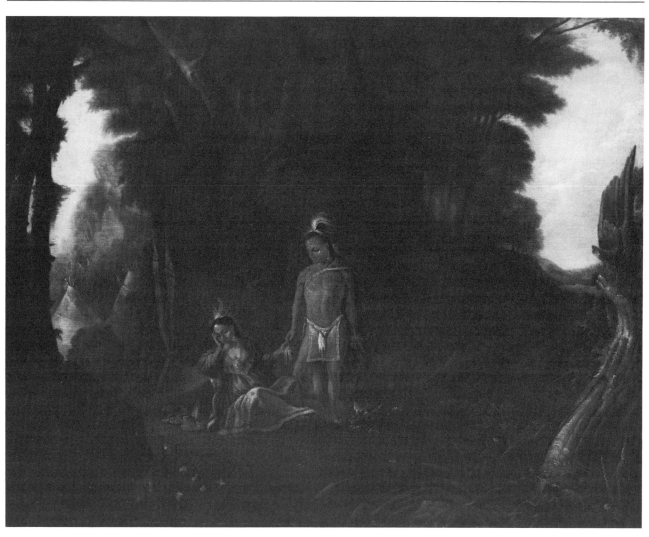

57

In 1958, the painting *The Despair of an Indian Woman* was exchanged by the Séminaire de Québec with the antique dealer Gilbert of Quebec City who resold it in 1965 to the Musée du Québec. See cat. no. 57 for extensive reprints and commentary relative to this painting.

The scene we are observing takes place at night in the forest. The centre of the picture is occupied by a wigwam in front of which we see an Indian woman with long hair and earrings. Curiously draped in a European-style dress, she is crouching near the body of an Indian who lies with a broken skull on the ground beside her while, in the entrance to the wigwam, we see a bow, a quiver full of arrows, and a tomahawk. To the right, the corpse of another Indian, tomahawk in hand, lies across a path leading to a clearing in which a violent fight is taking place. To the left, we see the gleam of the other burning wigwams of the Indian camp, and it is this light that falls dramatically on the Indian woman who, with her eyes turned heavenwards, laments the death of her husband.

In contrast with the "pleasant softness" of the picture *The Engagement of an Indian Girl, The Despair of an Indian Woman* represents the "frightful energy" of Indian life. The composition of the picture forms a W with the wigwam in the centre. It is a tight composition, with sharp outlines and fire as its predominant element. The scene takes place at night when the forest becomes threatening and the trees no longer serve for hunting, but for war. In spite of the very North American subject of the painting, it is difficult to avoid seeing in the central group a European source of inspiration, the *Pietà.*

Musée du Québec, Quebec

60 *The Saint-Ferréol Falls*
Oil on canvas, 75.1 x 88.4 cm

Provenance: Pierre-Joseph Olivier Chabeau Quebec City; Mrs Arthur Vallée, Quebec; Musée du Québec, Quebec, 1947 (A 47 2 P).

Exhibitions: 1948, Quebec, 26 Sept.-24 Oct., Musée du Québec, *Exposition du centenaire de l'Institut canadien du Québec;* 1952, Quebec, Musée du Quebec, *Exposition retrospective de l'art au Canada français,* cat. no. 70; 1958, Paris, Grands magasins du Louvre, 17 Jan.-22 Feb., *Les arts au Canada français;* 1962, Bordeaux, Musée de Bordeaux, *L'art au Canada,* cat. no. 21; 1966, Vancouver, Vancouver Art Gallery, *Images for a Canadian Heritage,* cat. no. 29; 1967,

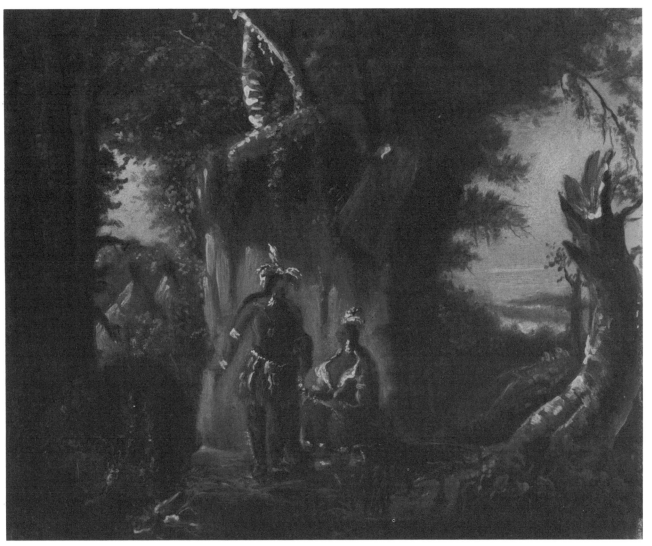

58

In the foreground, completely separated from the landscape and standing out against a frieze of plants, trees, and dead tree trunks, three figures can be seen immediately below the falls. They are an Indian man and two Indian women. One of the Indian women is sitting on the ground: she wears a feather-decked hat, earrings, and has long hair. In front of her stands an Indian man with his head shaved, leaving only a lock of hair in the middle into which feathers are stuck. Dressed in trapper's clothes, he wears earrings and a medal hangs round his neck. He holds a large bird by the neck and seems to be offering it to the seated woman. Behind these two figures stands another Indian woman. To the left of the group, in the centre of the painting, there is a pile of fish and birds on the ground, the fruits of hunting and fishing. This scene is reminiscent of the two versions of *The Engagement of an Indian Girl* (see cat. nos 57, 58).

Traced by the tree-trunks in the foreground and extending over the rocks, the composition of the painting is oval-shaped and the water is its predominant element. The scene takes place in the enchanted setting of a spring forest in which the Indians fished and hunted to make a living. *The Saint-Ferréol Falls* thus illustrates one of the numerous aspects of Indian life that Légaré liked to portray from time to time in his works.

Musée du Québec, Quebec

61 *The Chaudière Falls*
Oil on canvas, 54.9 x 85 cm

Bibliography: Bouchette (1815), pp. 505-507; Bouchette (1831), under "Chaudière, river"; Bouchette (1832), vol. I, pp. 299-300.

The present owner of this landscape bought it in London several years ago at an auction sale. It is therefore possible that *The Chaudière Falls* is one of the pictures that the artist sold at the time to British visitors to Quebec City. When these visitors returned to England, they liked to take these paintings back with them as souvenirs of their stay.

In a book published in 1815, the surveyor-general Joseph Bouchette gives the following description of the falls on the River Chaudière (trans.):

> The River Chaudière, which crosses the seigneury [of Lauzon] and flows into the Saint Lawrence about two leagues above Quebec City, is of considerable width Its bed is uneven and confined by rocks which jut from its sides and cause violent rapids; the current dropping over the different rocks results in falls of a considerable height; the most remarkable are those called the Chaudière, about four miles before the river joins the Saint Lawrence. Narrowed by the jutting points which advance on either side, the precipice over which the waters rush is little more than sixty-five yards in width, and the height from which they

Ottawa, National Gallery of Canada, *Three Hundred Years of Canadian Art,* cat. no. 90; 1973, Madison, Hanover, Austin, Elvahjem Art Centre, Hopkins Centre Art Galleries, University of Texas Art Museum, *Canadian Landscape Painting 1670-1930,* cat. no. 9, repr.

Bibliography: Rapport des Archives du Québec (1963) vol. 41, p. 170; Bouchette (1831), under "St. Anne, river"; Hubbard (1957), pp. 19, 24, repr.; Park (1957), text by R.H. Hubbard, p. 117; Morisset, *La peinture traditionnelle* (1960), pp. 99-100; Hubbard (1960), p. 61; Hubbard (1963), p. 55; Hubbard (1964), p. 56; Harper (1966), p. 82; Wade (1966), p. 185X, repr.; Giroux (1972), p. 6.

The eleventh clause of the will of Pierre-Joseph-Olivier Chauveau (1820-1890), signed on 12 September 1884, mentioned that he bequeathed to his daughter Honorine, the wife of Dr Arthur Vallée of Quebec City, "the falls of Saint Ferréol, painting by Légaré." This was undoubtedly the same picture since the Musée du Québec acquired it from Mrs Arthur Vallée in 1947. Chauveau played an important part in the political life of Quebec City for which he was elected member of parliament for the first time in 1844, with Légaré's support. He was later prime minister of the Province of Quebec from 1867 to 1873. The painting was restored by the National Gallery of Canada in 1947.

Saint-Ferréol is a parish situated on the Côte de Beaupré, north-west of Saint-Joachim, through the length of which flows the Sainte-Anne River (see cat. no. 35) which forms the falls of Saint-Ferréol not far from the village. Joseph Bouchette described them in 1831 in the following terms:

> Having attained the level, a rough path for nearly 1½ miles conducts the visitor, after a sudden descent, into a most solitary vale of rocks and trees, almost a natural grotto, through the centre of which the stream rushes until it escapes by a narrow channel between the rocks, and continues roaring and tumbling with augmenting velocity. From below there is a striking view of the cataract, which combined with the natural wildness and extraordinary features of the scenery defies description; the painter alone could convey to the mind the representation with effect.

This is the landscape that Joseph Légaré painted as background for his picture, successfully capturing all the

fall is about 130 feet. Great masses of rocks which rise above the surface of the stream, at the very start of the falls, divide the waters into three parts which form separate cataracts which reunite before reaching the basin below into which they flow. The continuous action of the water has carved deep hollows in the rock which give a rounded form to the mass of water rolling with white and shining foam as it descends, and greatly add to the suberb effect of the falls; since the spray from the water is promptly dispersed by the wind, it produces in the sunlight a diversity of the most brilliant prismatic colours. The darkish hue of the woods which stretch on each side to the edge of the river makes a striking contrast with the snow-white brilliance of the torrent; the headlong movement of the river which rushes among the rocks and hollows as it makes its way towards the Saint Lawrence, and the continual noise occasioned by the cataract itself, together make a strong impression on the senses and amply satisfy the curiosity of the astonished spectator. The woods along the banks of the river, in spite of the proximity of the capital, are so difficult of access that strangers visiting the cataracts must be accompanied by a guide.

Repeating the same observations in 1831, Bouchette this time indicates to his reader the different places from which the view of the falls is particularly remarkable (see cat. no. 37). The best of these vantage points, the one from which the view is most awe-inspiring, he states, is to the left of the falls themselves, from a rocky point that juts out into the basin. It is from this spot that Légaré has painted *The Chaudière Falls*. This work is a perfect illustration of Bouchette's description.

In the foreground may be seen tall if stunted fir trees and dead tree trunks. To the right are two seated Indians, one of whom is smoking a pipe. To the left, in the middle distance, visitors contemplate the grand spectacle of the Chaudière Falls. Beyond the Falls may be seen a strip of thick forest, bordering the riverbed and disappearing into the distance on the right-hand side of the picture.

We have found a variation of this work in the store rooms of the Séminaire de Québec museum (see cat. no. 202). This picture, in rather poor condition, was painted from the same place. It shows a few differences, particularly in the disposition and outline of the trees in the foreground. Since its treatment is less detailed and the composition not so well balanced, it may possibly have been a preliminary sketch for the splendid painting found in London.

Private Collection

62 Tree
Oil on paper, 59.7 x 47.2 cm

Inscription: verso, c.r., lengthwise: £ 2.10.0.

Provenance: Légaré's Quebec Gallery of Painting; Séminaire

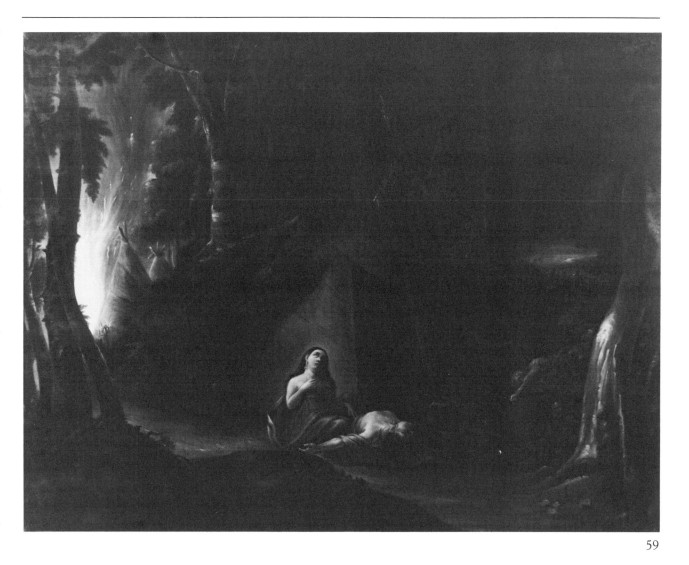

59

de Québec, Quebec, 1874 (Archives, Portfolio 159-G, p. 54).

Bibliography: Catalogue of the Quebec Gallery of Paintings, 1852, p. 15, no. 16; ASQ, *Séminaire* 12, no. 41 (1874).

This oil on paper was acquired by the Séminaire de Québec at the 1874 sale of Joseph Légaré's collection of pictures. In the manuscript catalogue of this collection, lots 290, 291, and 292 are each described as "batch of oil sketches." This work was perhaps one of these. It is part of a group of oils on paper that we have succeeded in attributing to Légaré (see cat. nos 10, 21). It was restored at the National Gallery of Canada in 1976. The inscription to be found on the back of the work was probably the price for which the painter vainly tried to sell it.

An old and majestic tree stands at a right angle on a slope. The disposition of its strong branches corrects the imbalance that might have resulted from this incline. Other trees are silhouetted in the background against a sky amost entirely covered in white clouds.

This oil on paper is not without resemblance to certain works by the Italian painter and engraver Salvator Rosa (1615-1673). Légaré was probably inspired by an engraving by Rosa or by another artist. It is not superfluous to point out the existence of the "Portfolio containing Studies of

Trees" (Catalogue of the Quebec Gallery . . . , 1852).

Whatever the case, Légaré, in this work, is treating a subject that leaves little room for artifice. Through his sense of light and colour, he succeeds in creating a powerful and sensitive composition. Competing with the shade, the slanting light catches the different levels of the uneven ground, the wild flowers, the bark of the tree-trunks, and the transparent foliage of the branches. While underlining the contrast between the green and orange tones, the lighting lends a fine effect of depth to the whole composition.

Séminaire de Québec, Quebec

63 Tree and Castle
Oil on paper, 59.0 x 46.7 cm

Inscription: verso, c.r., lengthwise: £ 2-10-0.

Provenance: Légaré's Quebec Gallery of Painting; Séminaire de Québec, Quebec, 1874 (Archives, Portfolio 159-G, p. 55).

Bibliography: Catalogue of the Quebec Gallery of Paintings,

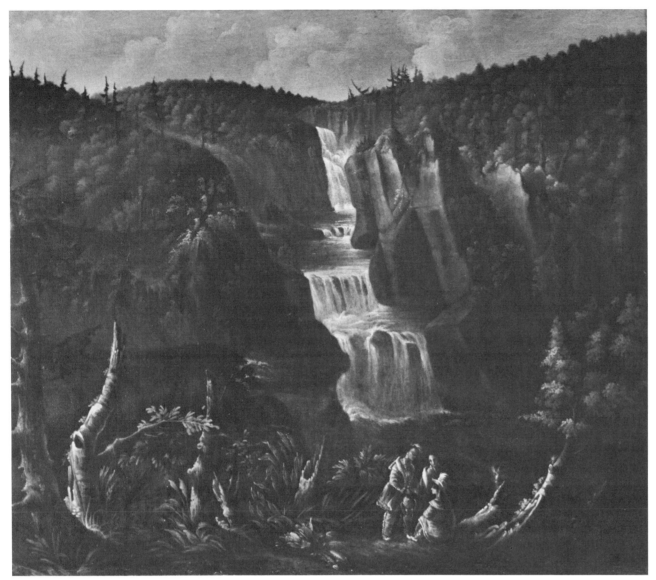

60

1862, p. 15, no. 16; ASQ, *Séminaire* 12, no. 41 (1874), p. 3, no. 90.

This oil on paper was acquired by the Séminaire de Québec at the 1874 sale of Joseph Légaré's collection of pictures. In the manuscript catalogue of this collection, lot no. 90 bears the title *Tronc d'arbre (Tree Trunk)*. This lot may correspond with the work we are now studying. It was restored at the National Gallery of Canada in 1976.

Like the composition entitled *Tree* (see cat. no. 62), this work may be compared with certain paintings and engravings of Salvator Rosa. An imposing tree fills the centre of the picture. Its roots have bored their way through massive rocks. It spreads its foliage against a background of dense forest while a clearing to the right reveals the two corner towers of a castle. In this composition, it is the tree-trunk which is the predominant feature. The artist has used it as a pretext for a fine piece of painting. A carefully harmonized range of colours bring out the fissures, knots, and fibrous tissues of the bark in a strong expressive manner. Such a trunk is reminiscent of those to be found in several of Légaré's compositions, and especially in *Land-*

scape with Wolfe Monument and *The Martyrdom of Fathers Brébeuf and Lalemant* (see cat. nos 42, 43).

Séminaire de Québec, Quebec

64 *The Natural Steps at Montmorency*
Oil on paper pasted on board, 45.1 x 57.8 cm

Provenance: (?) Mrs Hector Painchaud, Outremont; private collection.

Bibliography: Bouchette (1831), under "Montmorenci river"; Bouchette (1832), vol I, p. 280; Bellerive (1925), p. 17; Colgate (1943), p. 109; Morisset, *La peinture traditionnelle* (1960), p. 100; Cauchon (1968), p. 2.

In a book published in 1925, Georges Bellerive mentions the existence, in the collection of Mrs Hector Painchaud of Outremont (Montreal), of a work by Légaré with the title: "*The Natural Steps,* on the Montmorency River, that

industry has caused to disappear." This picture may possibly correspond with an oil on paper now owned by a Montreal collector and entitled: *The Natural Steps at Montmorency.*

After talking at length of the Montmorency Falls situated thirteeen kilometres to the north-east of Quebec City, Joseph Bouchette made the following brief comment in 1831 about part of the river whose waters fed these falls:

> The next place worthy of attention is the extraordinary appearance of the bed of the R. Montmorenci, which is there formed on a considerable angle of depression, having on either side banks of stratum presenting the form of natural steps and surmounted by woods.

The surveyor was to give further details of his observations in another book published the following year:

> Above the Falls is a neat tool-bridge, and, about half a mile higher up, are the *natural steps,* a section of the banks of the river, so called from its exhibiting a series of rectangular gradations of rock, resembling stairs, and supposed, by some, to be formed by the abrasion of the waters, though, by others, deemed to be original in their formation.

In the centre of Légaré's painting flow the quiet and shallow waters of the Montmorency River. The stream is marked by natural steps extending on the banks at each side. A dense forest encloses this setting of flat rocks reflected in the water. The whole scene presents a very well-balanced composition thanks to the W-shaped outline of the forest, the perspective of the uneven river bed and to the presence of two huge rocks on either side of it.

A few carefully-placed figures break the apparent immobility of this composition. In the left foreground, a peasant woman with a baby on her back holds a long stick with which she prudently guides a stocky boy and his dog. Higher, to the right, two men can be seen conversing, one a priest leaning on a stick. Behind them, on a rocky spur, three society ladies exchange remarks about the beauty of the place. The presence of these figures adds interest to Légaré's picture. The artist seems to have wanted rock stratifications to symbolize social stratifications that existed in his day.

Private Collection

65 *The Jacques Cartier River Falls*
Oil on canvas, 80.8 x 111.1 cm

Provenance: Légaré's Quebec Gallery of Painting; Séminaire de Québec, Quebec, 1874.

Exhibition: 1952, Quebec, Musée du Quebec, *Exposition rétrospective de l'art au Canada français,* cat. no. 68.

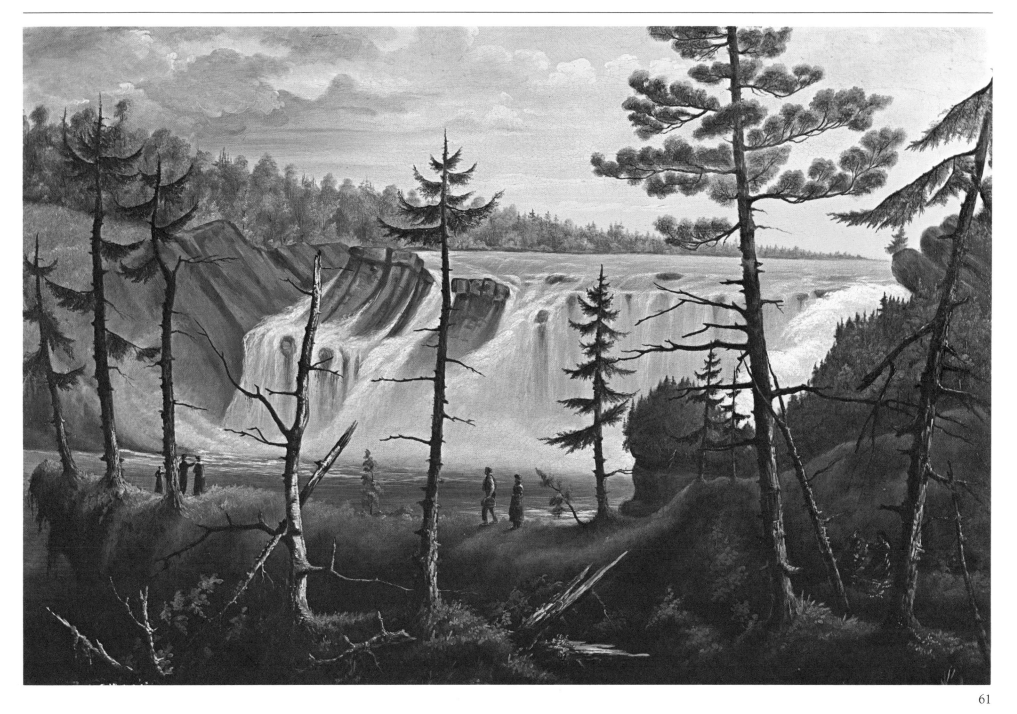

61

Bibliography: ASQ, *Séminaire 12*, no. 41 (1874); IBC, Musée de l'Université Laval file; Laval University Catalogues (SQ) (n.d. I) p. 1, (1880) p. 3, no. 5, (n.d. IV) p. 9, no. 5, (n.d. V) p. 9, no. 5, (n.d. VI) p. 9, no. 5, (1889) p. 8, no. 5, (1893, in French) p. 8, no. 5, (1893, in English) p. 9, no. 5, (1894) p. 7, no. 5, (1898) p. 8, no. 5, (1901) p. 8, no. 5, (1903) p. 8, no. 5, (1905) p. 8, no. 5, (1906) p. 11, no. 5, (1908) p. 86, no. 323, (1909) p. 58, no. 323, (1913) p. 62, no. 346, (1923) p. 72, no. 346, (1933) p. 81, no. 238; Bouchette (1815), pp. 400-405; Bouchette (1831), under "Jacques Cartier river"; Lemoine (1876), p. 362; Bellerive (1925), p. 17; Colgate (1943), p. 109.

This picture was acquired by the Séminaire de Québec at the 1874 sale of Joseph Légaré's collection of pictures. In the manuscript catalogue of this collection, lot 91 bears the title *Pont sur la rivière Jacques Cartier (Bridge over the Jacques Cartier River)*. Despite the mention of a bridge, it is not impossible that this lot may correspond with the picture before us, but it is more probably another of Légaré's works that has since disappeared. Our picture more likely corresponds with one of the ten lots merely entitled "Waterfall" in the document in question (see cat. no. 32). Whatever the case may be, *The Jacques Cartier River Falls* was, in 1876, hanging in the hall of Laval University (SQ). It subsequently appears in most of the catalogues published by that institution, bearing three successive titles: *Chute dans la Rivière Jacques Cartier* and *Chutes sur la rivière Jacques-Cartier*, in French; *Falls of the Jacques-Cartier River* and *Falls on the Jacques Cartier River*, in English. It was restored in March 1950 by a nun from the Couvent du Bon Pasteur, in Quebec City.

In 1815 Joseph Bouchette thus described the Jacques Cartier River:

After a winding course through little-known mountainous country, it reaches the townships of Tewkesbury and Stoneham which it crosses, and flows in a south-south-west direction for about 46 miles, through the seigneuries of Saint-Ignace, Saint-Gabriel, Faussembault, Neuville, Belair, and the Jacques Cartier fief, where it falls into the Saint Lawrence. From the townships onwards, its stream presents a wild aspect, and it is both majestic and impetuous in its course, which rushes across valleys between high mountains, and often violently crossing precipices and huge fragments of rocks that bar its way. Since its bed is strewn with rocks, the great

number of falls and rapids, as well as the violence of the current, especially in the spring and after the autumn rains, make it generally impracticable for canoes and boats of all sorts From the heights on either side of the river stretch vast forests through which different paths are traced and kept open during the various seasons by the Indians, especially by those from the village of Lorette who consider the lands at an immense distance to the north as their hunting grounds. The view along the river is generally varied, picturesque, and extraordinary, and in this setting nature presents a thousand combinations of grandeur, beauty, and wild magnificence that are unrivalled in any other country.

While widening out to the rocky mass in the foreground, the bed of the Jacques Cartier dominates the centre of Légaré's picture. The river winds its way between huge blocks of rock which mark and modify its course. The violence of the current has hurled stumps and logs upon these rocks and onto the eroded banks of the river. The outline of the banks and that of the forest gives the painting a solid X-shaped composition. By a perspective effect, this arrangement draws the attention to several buildings to be seen in the background.

We cannot state with certainty which falls on the Jacques Cartier River Légaré has painted in this work. They may well be, as Gérard Morisset claimed, those that flow not far from the present village of Pont-Rouge. Whatever the case may be, in painting a subject of this nature, Légaré has once more succeeded in reflecting the interests of his contemporaries. Bouchette wrote in 1831 that for some years the Jacques Cartier River had attracted the public's attention and that the people of Quebec liked to make outings there when the weather was seasonable.

Séminaire de Québec, Quebec

66 *The Etchemin River Basin at Saint-Anselme* **before 1846**
Oil on canvas, 81.3 x 110.5 cm

Provenance: Légaré's Quebec Gallery of Painting; Séminaire du Quebec, Quebec, 1874.

Bibliography: Le Journal de Québec (4 Aug. 1846) p. 2; ASQ, *Séminaire 12*, no. 41 (1874); IBC, Musée de l'Université Laval file; Laval University Catalogues (SQ) (n.d. I) p. 1, (1880) p. 3, no. 3, (n.d. IV) p. 9, no. 3, (n.d. V) p. 9, no. 3, (n.d. VI) p. 8, no. 3, (1889) p. 8, no. 3, (1893, in French) p. 8, no. 3, (1893, in English) p. 9, no. 3, (1894) p. 7, no. 3, (1898) p. 8, no. 3, (1901) p. 7, no. 3, (1903) p. 8, no. 3, (1905) p. 7, no. 3, (1906) p. 10, no. 3, (1908) p. 86, no. 321, (1909) p. 57, no. 321, (1913) p. 62, no. 345, (1923) p. 72, no. 345, (1933) p. 81, no. 237; Lemoine (1876), p. 362; Bellerive (1925), p. 16; Colgate (1943), p. 109; Morisset, *La peinture traditionnelle* (1960), p. 100?; Harper (1966), p. 82.

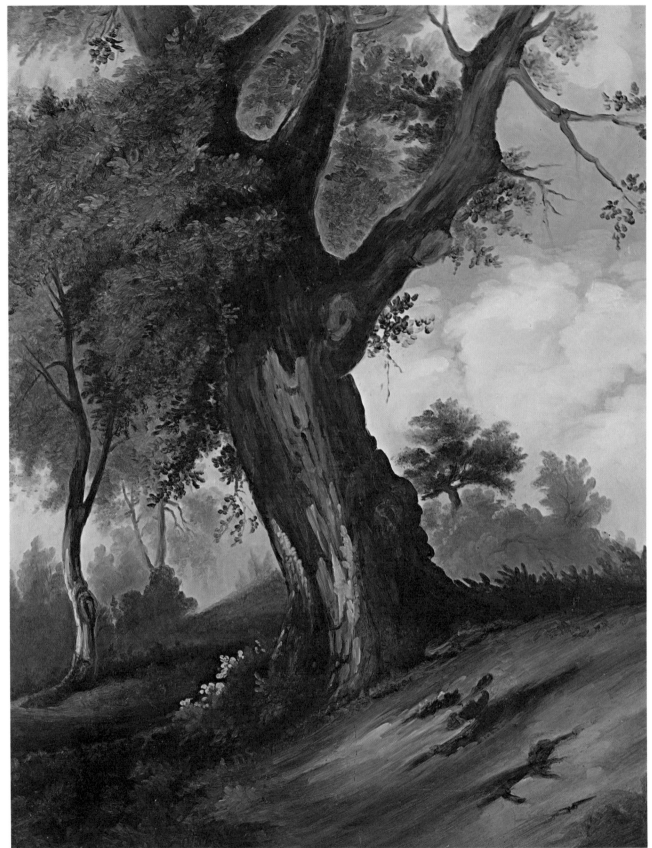

62

This picture was acquired by the Séminaire de Québec at the 1874 sale of Joseph Légaré's collection of pictures. In the manuscript catalogue of this collection, lots 51, 61, 62, 74, 78, 89, 111, 124, 129, 143, 191, 212, and 240 are merely entitled *Landscape. The Basin of the Etchemin River at Saint-Anselme* may possibly be one of these. Lemoine tells us that in 1876 our picture was entitled *The Basin of Parish of St. Anselme before the Church was built* and that it was hung in the hall of Laval University (SQ). It is subsequently listed in nearly all the catalogues published by that institution, and bears, with a few variations, the following titles: *Le bassin de S. Anselme (avant la construction de l'église)* and *Le bassin de la rivière Etchemin, à St-Anselme*, in French; *The basin of the parish of St Anselm before the church was built*, *The basin of river Etchemin, at St. Anselm* and *Basin of the Etchemin River, at Saint Anselme*, in English. It was restored in 1946 and cleaned in October 1970.

Starting from Lake Etchemin, the river of the same name crosses Dorchester and Lévis counties before flowing into the Saint Lawrence not far from the site of the former Caldwell Manor (see cat. no. 43). Near Saint-Anselme, about twenty-five kilometres from its mouth, it becomes a wide and shallow stream in the shape of a basin.

Recounting an excursion that he had just made on the south bank of the Saint Lawrence as far as Saint-Anselme, the editor of the newspaper *Le Journal de Québec* wrote as follows in the edition of 4 August 1846 (trans.):

> Until now, the citizens of Saint-Anselme had no real church; the lower part of the presbytery served this purpose. But this spring, they spontaneously formed the pious plan of erecting a temple appropriate to the worship of God, and the work is already well advanced. The church will be 130 feet in length by fifty-five in width. Saint-Anselme has some charming sites and picturesque aspects; this very new, but already populous, parish promises to be prosperous.

Légaré painted *The Basin of the Etchemin River at Saint-Anselme* before the church of this parish was built. Indeed, no steeple dominates the sunlit village whose fine stone houses can be seen in the background of the painting. Nearer to us the dark blue basin of the river fills the entire width of the composition. In the foreground a rocky point, on which lie two uprooted tree trunks, juts out into the basin. Dressed in the typical style of the *Canadiens* of the time (see cat. no. 22), four peasants enjoy a fishing expedition. One of them baits his line while another, pipe in mouth, holds his rod out over the water. The two others are depicted in a boat, one seated, the other standing. Further off, near the spot where the river bed narrows, three other boats can be seen. The scene certainly takes place in autumn: the men are quite warmly dressed, smoke rises from the village chimneys, and a few ducks rest in the centre of the basin before pursuing their seasonal migration.

Over and above its subject evoking the peaceful nature of country life, Légaré's painting is remarkable both for its composition and its light effects. Carefully placed and looking in various directions, the figures in the foreground

63

draw the spectator's attention to the different points of interest of the surrounding scene. The picture planes are integrated by a skillful use of curves, but the light underlines their contrasts. Beneath a romantic sky painted in the English manner, the areas of shade contrast with the sunlit areas, and the quiet surface of the basin presents a fine range of reflections.

Séminaire de Québec, Quebec

67 Still-Life with Grapes
Oil on canvas, 88.9 x 73.8 cm

Inscription: Signed l.r.: *J. Légaré.*

Provenance: (?)Mrs Omer Paré, Quebec; Mr Raoul Guay, Sillery; Musée du Québec, Quebec, 1951 (A 51 122 P).

Exhibitions: 1967 (summer), Quebec, Musée du Québec, *Peinture traditionnelle du Québec*, cat. no. 40, repr.; 1972, 2-16 March, St John's Memorial University, *Newfoundland: Quebec Fortnight.*

Bibliography: L'Ami de la religion et de la patrie (4 October 1848) p. 655; *Le Canadien* (2 October 1848) p. 3; *The Quebec Mercury* (6 May 1845) p. 2, (5 October 1848) p. 3; Bellerive (1925), p. 14; Morisset, *Peintres et tableaux*, vol. I (1936), p. 177.

In 1845, Légaré exhibited about ten pictures at the Mechanics' Institute in Quebec City. In its edition of 6 May, *The Quebec Mercury* reported the event and gave the list of the works shown. One of these bore the following title: *Clusters of Grapes - natural*. Three years later, the artist presented an exhibition of thirty-one works at the Assembly Chamber. They were to be sold at a lottery on 23 October, and different Quebec newspapers published an advertisement to this effect that included the list of works. No. 4 bore the title *Grappes de Raisins* (or *Grapes* in English) and was valued at £20. We do not know the consequence of this lottery. Nevertheless, in 1925 Bellerive mentions in his book that "*The Vine*, copied at the University, belongs to Mrs Omer Paré, of Quebec City, grand-daughter of Légaré and daughter of Notary Cinq-Mars." Lastly, in 1951 the Musée du Québec bought from a Sillery antique dealer a still-life by Légaré entitled *Nature mort aux raisins (Still-Life with Grapes)*. Perhaps this was the same picture that, after being exhibited in 1845 and 1848, may have belonged to Légaré's descendants and at last fell into the hands of an antique dealer.

It is equally possible that the work exhibited in 1845 and 1848 was a still-life with grapes from Légaré's collection and attributed to a seventeenth-century Italian painter which now belongs to the Musée du Séminaire de Québec (UL).

Légaré made at least two copies of this painting at unknown dates. (One by Plamondon is also housed in the Musée du Québec.) The one in the Musée du Québec closely corresponds with the original, even in size. Heavy

64

bunches of grapes mixed with large vine leaves stand out against a dark green background of foliage. The other version belongs to the National Gallery of Canada and shows some variations (see cat. no. 68).

Musée du Québec, Quebec

68 Still-Life with Grapes
Oil on canvas, 95.0 x 126.4 cm

Inscription: Towards l.l., on the tree trunk: *Jos. Légaré pinxit.*

Provenance: Mr Herbert T. Schwartz, Montreal; National Gallery of Canada, Ottawa, 1968 (15684).

Exhibition: 1972, Ottawa, National Gallery of Canada, *Progress in Conservation and Restoration*, no. 26.

Bibliography: see cat. no. 67; Godsell (1976), pp. 46, 47, and 49, repr.

We do not know the origin of this painting. It may quite possibly have been the picture included in the exhibitions held in Quebec City in 1845 and 1848, and which belonged to Légaré's descendants (see cat. no. 67). Whatever the case, it was from Mr Herbert T. Schwartz of Montreal that the National Gallery of Canada bought the canvas in 1968.

This painting is based on a work that belonged to Légaré and is now part of the Séminaire de Québec collection. Unlike the Légaré version at the Musée du Québec, it is not just a faithful copy. Indeed, the artist gives quite a different dimension to his work. His still-life is here set in a landscape. To the left of the picture, we now find a leafy tree-trunk at whose foot rests a butterfly. Between this tree and the vine grove, a perspective opens to reveal, beyond a stretch of water, the outline of a town set against mountains and a wide strip of sky against which several vine leaves stand out in the foreground.

In this picture, Légaré successfully explores a new facet of his talent as a copyist. Once again, the copy becomes a pretext for an interpretation not lacking in originality.

National Gallery of Canada, Ottawa

69 *The Fire in the Saint-Roch Quarter, Seen from*
Côte-à-Coton, Looking Westward 1845
Oil on canvas, 1.74 x 2.49 m

Provenance: Légaré's Quebec Gallery of Painting; Séminaire
de Québec, Quebec, 1874.

Bibliography: L'Ami de la religion et de la patrie (8 Sept. 1848),
(9 Oct. 1848) p. 670; *L'Aurore des Canadas* (26 June 1845),
p. 2; *Le Canadien* (30 May 1845) pp. 1-2, (2 June 1845) pp.
2-3, (4 June 1845) p. 2, (6 June 1845) p. 2, (9 June 1845)
p. 2, (11 June 1845) p. 2, (12 June 1845) p. 2, (27 June
1845) p. 2, (29 Sept. 1848) p. 2; *Le Castor* (30 May 1845)
p. 2, (2 June 1845) p. 2, (5 June 1845) p. 2, (9 June 1845)
pp. 1-2; *La Minerve* (7 Sept. 1848) p. 2; *The Quebec Mercury*
(29 May 1845) p. 2, (31 May 1845) p. 2, (7 June 1845) p.
2; *The Quebec Spectator* (6 Oct. 1848) p. 2; AJQ, Register of
the Notary Public Jean-Baptiste Délâge (6 Dec. 1872), no.
2921; ASQ, *Séminaire 12,* no. 41, 1874; IBC, Musée de
L'Université Laval file; Laval University Catalogues (SQ)
(n.d. I) p. 1, (1880) p. 3, no. 6, (n.d. IV) p. 9, no. 6, (n.d.
V) p. 9, no. 6, (n.d. VI) p. 9, no. 6, (1889) p. 8 no. 6, (1893,
in French) p. 8, no. 6, (1893, in English) p. 9, no. 6, (1894)
p. 7, no. 1, (1898) p. 8, no. 6, (1901) p. 7, no. 1, (1903)
p. 8, no. 6, (1905) p. 8, no. 6, (1906) p. 11, no. 6, (1908)
p. 86, no. 324, (1909) p. 58, no. 324, (1913) p. 62, no. 344,
(1923) p. 72, no. 344, (1933) p. 81, no. 236; Lemoine
(1876), p. 362; Bellerive (1925), p. 15; (anon.) *Les peintures
de Légaré sur Québec* (1926), p. 432; Robson (1932), p. 20;
Colgate (1943), p. 108; Morisset, *La peinture traditionnelle*
(1960), p. 100; Harper (1966), p. 82; Cauchon (1968), p.
3; Harper (1970), p. 194; Tremblay (1972), pp. 159-161,
193-194; Lord (1974), pp. 51-52.

65

The fire in the Saint-Roch quarter of Quebec City took
place on 28 May 1845. It began about eleven-thirty in the
morning, when the furnace of a steam engine in the
tannery belonging to Mr Richardson of Saint-Vallier
Street, at the foot of the Côteau Sainte-Geneviève,
exploded. The fire rapidly engulfed the whole tannery and
neighbouring houses were soon ablaze. Efforts to get the
blaze under control were in vain, for a strong west wind
scattered the sparks and new fires broke out at some
considerable distance, near Saint-Roch Church and in Mr
Munn's shipyards. With ever-increasing force, the wind
spread a sheet of flames over the quarter, and it blazed
until midnight. Some 1650 houses were destroyed. Most
of the inhabitants lost all their belongings, and could count
themselves lucky to escape alive from the caprices of the
flames fanned by the whirlwind. The fire stopped at
Saint-Charles Street, at the foot of Côte de la Canoterie,
where troops blew up two houses and prevented its
advance on lower town below Cape Diamond. Many new
fires broke out in the upper town, but were brought under
control. The Artillery Barracks narrowly escaped destruc-
tion.

More than twelve thousand people were left homeless.
Tragic scenes occurred and Joseph Légaré distinguished
himself by saving a woman called Maranda from the
flames; "dangerously ill," she was then taken to the

Hôtel-Dieu. Several people, about twenty in all, lost their
lives and many others were badly burned. The Convent of
Saint-Roch was saved, but the church itself was destroyed,
as well as the chapel of Saint-Pierre, several breweries,
wharves, forges, and stores.

The quarter destroyed consisted mainly of wooden
buildings, and the roofs of the stone houses were made of
shingles which hastened their destruction. The population
of the district was described in *Le Canadien* of 12 June 1845
as follows (trans.):

> Part of the population on which this calamity more
> immediately falls, mainly consisting of Canadians of
> French origin, made their living by manual work, and
> are now without employment through the destruction
> of the factories and other business establishments
> where they found work, or through the simultaneous
> destruction of the property of those in bettter
> circumstances and who might have been able to
> employ or help them. All classes of society have,
> directly or indirectly, really suffered from this enor-
> mous calamity.

Help was rapidly organized right from the day after the fire.
A "General Committee to relieve those who suffered from

the fire of 28 May 1845" was set up. Joseph Légaré played
an active part on this committee, raising money, among
other activities, in the Palais quarter. Many of the home-
less found refuge with citizens in the Saint-Jean quarter.

We know three pictures by Joseph Légaré which deal
with the fire in the Saint-Roch quarter (see cat. nos 69, 70,
227) and three that deal with the fire in the Saint-Jean
quarter (see cat. nos 71-73). In 1848, Légaré tried to sell
three of his fire scenes: these may have been *The Fire in
the Saint-Roch Quarter, Seen from Côte-à-Coton, Looking
Westward,* its pendant representing the same scene looking
eastward (see cat. no. 70) and *The Fire in the Saint-Jean
Quarter Seen Looking Westward* (see cat. no. 71) in its large
version. These were perhaps the pictures that were
exhibited and put up for sale, with other paintings belong-
ing to Légaré, in Montreal during the week beginning 7
September 1848. The pictures of the fires elicited
comments such as the following, taken from *L'Ami de la
religion et de la patrie* (trans.):

> We are informed that M. Légaré, an artist of this
> town, is now in Montreal where he is offering pictures
> for sale, among which are the three paintings made by
> this gentleman of the fires in Quebec City in 1845.
> It would seem that our town council has refused to

66

Two days after the fire in the Saint-Roch quarter, the following text was published in *Le Canadien* (trans.):

> You can walk through Saint-Roch as through a ploughed field, only the chimneys remain standing to show that just a few days ago there were fifteen hundred houses there that contained fifteen thousand people. It is a vast panorama, worthy of the artist's brush and the observer's eye. From the standpoint of the Côteau Sainte-Geneviève, seated on the débris that the fire has left behind it, you can contemplate this space of at least half a square league, and in this part of the city that can be seen as the city of the dead, at sunrise or by moonlight, you might take the living for ghosts that make their way through this vast field of destruction.

Both artist and observer, Légaré had chosen precisely the viewpoint on the Côteau Sainte-Geneviève, at the top of the Côte-à-Coton, to paint a "vast panorama" of desolation. So as to convey the scene in full, he painted a view looking westward, and then eastward, hardly moving his position, thus creating an impressive diptych. The report in *Le Canadien* very accurately describes Légaré's pictures of the fire in the Saint-Roch district and perhaps persuaded him to undertake these works.

Less than a month after the fire, a Montreal newspaper, *L'Aurore des Canadas*, mentioned that he was hard at work (trans.):

> We have at last been able to contemplate with our own eyes this indescribable scene of Saint-Roch consumed by fire; we have been able to see this vast plain of debris and ruins scarcely cool, these shells of houses blackened by the smoke of this disastrous fire that left such deep traces of mourning and desolation in this old capital upon which misfortune seems to have preyed during the last few years. A white-haired old man was there, seated on the rubble surveying with sunken eyes the extent of this scene in which thousands of chimneys still standing are there like so many monuments to attest the vanity of the things of the flesh. "When one sees this great and wretched picture unveil before one's eyes," he told us, "one feels the need to raise them, despite oneself, towards that power above whose breath reduces us to ashes with all that we build. Ah! Monsieur, the good Lord must have been very angry with us," he added, looking at Saint-Roch Church, "since he did not even spare his temple!" Those were the words of the old man. Indeed, the heart bleeds and the tongue is silent before the spectacle that the artist's hand is now attempting to convey. M. Légaré is busy trying to seize the whole scene, this pile of ruins that cannot be seen without weeping, that cannot be left behind without an uneasy feeling. One must be a witness of the scene he presents to find what the imagination refuses to paint. A few victims of the fire, here and there, rebuild what the terrible element devoured in the

buy these pictures and that because of this refusal, M. Légaré decided to make the journey to Montreal to dispose of them. In our opinion, the town council of Quebec could not put the town's money to better use than in buying these paintings which recall in all their terrible sublimity the memory of one of the greatest afflictions ever to have struck Quebec. It will be shameful for the citizens of Quebec if these canvases ever adorn other walls than the meeting place of our municipal corporation.

The same pictures were then exhibited in Quebec City, in the Assembly Chamber, from 29 September 1848 until the end of October, and comments were once more published - especially in *Le Canadien* - concerning the fire pictures (trans.):

> We shall probably have the opportunity of making fresh remarks concerning this exhibition; for the moment, we shall merely say that all the newspapers in Montreal, where some of the paintings remained for a week, expressed their surprise that the Quebec City corporation had never had the idea of acquiring the pictures depicting the fires in Saint-Jean and Saint-Roch to conserve them. Our municipal council could not do better than to follow the advice from the newspapers of the capital; we are sure that it would

have the citizens' support in so doing.

On 9 October, three lines appeared on this subject in *L'Ami de la religion et de la patrie*: "M. Légaré, artist, has written a letter to the corporation in which he offers to sell it his pictures on the 1845 fires." In spite of this publicity campaign, Légaré did not succeed in selling his paintings to Quebec City.

The Fire in the Saint-Roch Quarter, Seen from Côte-à-Coton, Looking Westward was acquired by the Séminaire de Québec at the 1874 sale of Joseph Légaré's collection of pictures. At that time, six paintings of fires were sold. A document mentions four pictures of Saint-Jean and two of Saint-Roch, while another mentions four pictures of Saint-Roch and two of Saint-Jean. These were, in fact, the six paintings now known, namely three of Saint-Jean and three of Saint-Roch. Problems of identification already existed at the time. Our picture appeared in 1876 in Lemoine's book, *Quebec Past and Present*, under the title *St. Roch Suburbs, after Fire of 1845, view taken from Côte-à-Coton, looking westward*. The various catalogues of Laval University mention it under this title, or under the titles *St. Roch de Québec, après l'incendie de 1845, vue prise du haut de la Côte-à-Coton, en regardant vers l'Ouest*, and *Faubourg St-Roch, après le feu du 28 mai 1845, partie ouest; vue prise du sommet de la Côte-à-Coton*, with a few slight variations. Restored in 1972, this large painting still belongs to the

twinkling of an eye. But what speaks most eloquently of the very fraternal charity of our fellow-citizens in Quebec City is that there is not one trace of misfortune apart from these smoking ruins. Each has found lodging - a house, a family to take him in and comfort him. How could heaven not have pity on such a population? Quebec, says a prophecy, must perish by fire. Alas! Could this be the realization of these painful words - this lamentable event before which words are powerless and feelings inadequate! What is not least to be deplored is that the disastrous lesson that Quebec has just received does not commit the people to rebuild according to a new plan. The terrible experience they have just had should, however, it seems to me, change the determination of the fire victims to rebuild according to their former foundations. But in the face of such a still-recent misfortune, dare one utter the reproach?

The "white-haired old man" is certainly an allusion to a long lyrical text entitled "Les Ruines" and signed Pietro, published by *Le Canadien* on 6 June. It concerned a white-haired old man walking through the ruins, of whom the author wrote: "You might take him for death roaming his domains." The whole of this text describing the ruins and the misfortunes of a girl who had lost both family and lover were really an appeal to the public's generosity for those who had lost all their possessions. It ended with a call to the insensitive: "Let them look at the ruins! Let them at last hear this cry of the Poor: Charity! Charity for the love of God." Légaré's pictures may quite possibly have been painted to be shown to a wide public who would not hestitate to contribute to the relief fund that people were trying to collect.

The Fire in the Saint-Roch Quarter, Seen from Côte-à-Coton, Looking Westward shows us a part of the district probably on the very night following the fire. The painter has taken up his stance on the Côteau Sainte-Geneviève, at the top of Côte-à-Coton, looking westward. The walls of the upper town are behind him. At the top of the hill, to the left, we can see the chimneys of several houses in the Saint-Jean quarter where the fire also took hold. In the painting, the street starting to right of centre and which, with the slope of the Côteau Sainte-Geneviève, forms the vanishing point of the composition, is Saint-Vallier. Along this street, the building with a pediment and bull's-eye window is the Chapel of Saint-Pierre, or the chapel of the French-speaking Protestants, mainly used by Quebec families who had come from Jersey and Guernsey. More to the right, in the background, flames still rise from the tall structure of Saint-Roch Church while the convent, behind, has been spared. Right at the back of the painting, to the right, can be seen the cluster of buildings of the Hôpital-Général de Québec (see cat. no. 28), beyond a forest of stone chimneys.

The only figures in the picture are on the left, at the top of the hill. A group of three people, in the foreground, is easier to see than the others. It consists of two women, one seated, the other standing, and a man on his knees holding what seems to be a cloth or sheet. He has extracted a few possessions, probably china, that he has succeeded

67a Michelangelo Pace called Campidoglio, attributed to *Still-Life with Grapes,* Oil on canvas, 88.9 x 74.3 cm, Musée du Séminaire de Québec, Quebec

67b Detail: Légaré's signature from cat. no. 67.

67

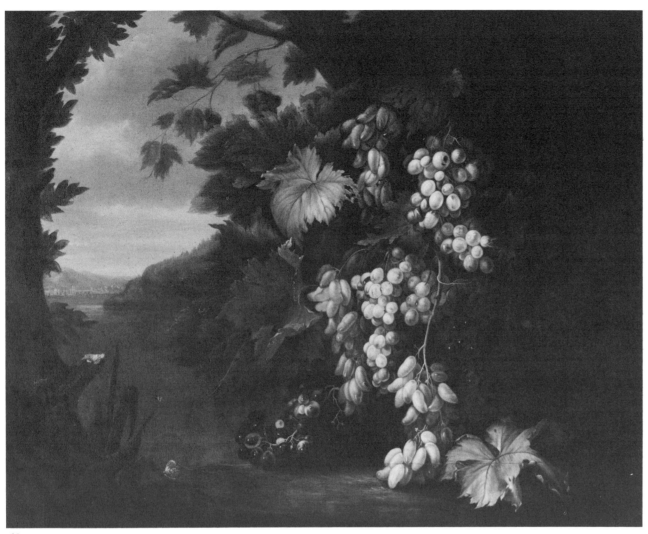

68

behind the male figure standing in the foreground. From the top of the Côteau Sainte-Geneviève, we look towards the Saint Charles estuary and the Laurentians, which stand out in the distance behind the Côte de Beaupré. On the far left, on Saint-Vallier Street, the front of the Chapel of Saint-Pierre can be seen. All this part of the district is nothing but ruins - overlooked, to the right, by the fortifications of Quebec and the Royal Artillery Barracks.

The right foreground, corresponding here with the left foreground of the view looking westward, shows a family who have succeeded in snatching a table, chairs, a desk, and even a picture from the flames. The woman is seated, hugging a sleeping child in her arms, and trying to comfort her husband who lowers his head while turning his back on the fire. Further off, a couple sorts out its possessions, and a woman is seated holding her head in her hands. Other citizens of the Saint-Roch quarter with a few pieces of furniture can be seen still further off. The presence of the victims is more forceful in this painting than in its pendant.

Séminaire de Québec, Quebec

in saving from the fire. There were no figures in a first and smaller version that Légaré made of this painting and which is preserved at the Musée du Québec under the title *After the Fire in the Suburb of Saint-Roch* (see cat. no. 227). Until 1958, this work belonged to the Séminaire de Québec. The fact that Légaré added several Saint-Roch citizens in his large version, and painted the complete view of the district in two pictures, adds weight to the idea that these works were designed to show the extent of the disaster so as to collect money for the victims.

Séminaire de Québec, Quebec

70 **The Fire in the Saint-Roch Quarter, Seen from Côte-à-Coton, Looking Eastward** 1845
Oil on canvas, 1.75 x 2.54 m

Provenance: Légaré's Quebec Gallery of Painting; Séminaire de Québec, Quebec, 1874.

Bibliography: Laval University Catalogues (SQ) (n.d. I) p. 1, (1880) p. 3, no. 1, (n.d. IV) p. 9, no. 1, (n.d. V) p. 9, no. 1, (n.d. VI) p. 8, no. 1, (1889) p. 8, no. 1, (1893, in French) p. 8, no. 1, (1893, in English) p. 8, no. 1, (1894) p. 7, no. 2, (1898) p. 8, no. 1, (1901) p. 7, no. 2, (1903) p. 8, no. 1, (1905) p. 7, no. 1, (1906) p. 10, no. 1, (1908) p. 86, no. 319, (1909) p. 57, no. 319, (1913) p. 63, no. 347, (1923) p. 72, no. 347, (1933) p. 81, no. 239; Lemoine (1876), p. 362; see cat. no. 69.

Since this painting is the pendant of *The Fire in the Saint-Roch Quarter, Seen from Côte-à-Coton, Looking Westward,* its history is identical. It appears in 1876 in Lemoine's book *Quebec Past and Present,* under the title *St. Roch Suburbs, after Fire of 1845, View from the Top of Côte-à-Coton, Looking towards the East.* The various catalogues of Laval University mention it under this title or under the titles *St. Roch de Québec, après l'incendie de 1845, vue prise du haut de la Côte-à-Coton, en regardant vers l'Est* and *Faubourg St-Roch, après le feu du 28 mai 1845, partie est; vue prise du sommet de la Côte-à-Coton* with some slight variations. Restored in 1972, this large painting is still in the Musée du Séminaire de Québec.

The Fire in the Saint-Roch Quarter, Seen from Côte-à-Coton, Looking Eastward completes the westward view in its pendant. To paint this view, Légaré moved a little from his previous vantage point and went further toward the west so that the slope of the Côte-à-Coton can be seen

71 **The Fire in the Saint-Jean Quarter, Seen Looking Westward** 1845
Oil on canvas, 1.51 x 2.21 m

Provenance: Légaré's Quebec Gallery of Painting; Séminaire de Quebec, Quebec, 1874; Scott Symons, Toronto, 1959; Art Gallery of Ontario, Toronto, 1976.

Exhibition: 1967, 9 June-30 July, Montreal, Montreal Museum of Fine Arts, *The Painter in the New World,* cat. no. 302, repr.

Bibliography: *Le Canadien* (30 June 1845) p. 1, (2 July 1845) p. 2, (14 July 1845) p. 2, (16 July 1845) p. 2, (30 July 1845) p. 2, (6 Aug. 1845) p. 2, (20 Aug. 1845) p. 2, (10 Sept. 1845) p. 3; *The Quebec Mercury* (1 July 1845) p. 2, (10 July 1845) pp. 2-3, (12 July 1845) p. 2, (2 Aug. 1845) p. 2, (30 Aug. 1845) pp. 2-3; AJQ, Register of the Notary Public Jean-Baptiste Delâge (6 Dec. 1872), no. 2921; ANQ-Q, Register of the Notary Public Édouard Tessier (9 Feb. 1842); ASQ, *Séminaire 12,* no. 41, 1874; Laval University Catalogues (SQ) (n.d. I) p. 1, (1893, in French) p. 8, no. 7, (1894) p. 7, no. 6, (1898) p. 8, no. 7, (1901) p. 8, no. 6, (1903) p. 8, no. 7, (1905) p. 8, no. 7, (1906) p. 11, no. 7, (1908) p. 86, no. 325, (1909) p. 58, no. 325, (1913) p. 62, no. 341, (1923) p. 72, no. 341, (1933) p. 81, no. 233; Lemoine (1876), p. 362; Bellerive (1925), p. 15; anon. *Les peintures de Légaré sur Québec* (1926), p. 432; Robson (1932), p. 20; Colgate (1943), p. 108; Morisset, *La peinture traditionnelle* (1960), p. 100; Tremblay (1972), pp. 159-161.

The fire in the Saint-Jean quarter occurred on Saturday, 28 June 1845, exactly a month after the fire in the Saint-Roch quarter. The fire broke out at eleven o'clock in the evening, in a shed behind the house of Notary Michel Tessier, on d'Aiguillon Street, just beyond the Saint-Jean

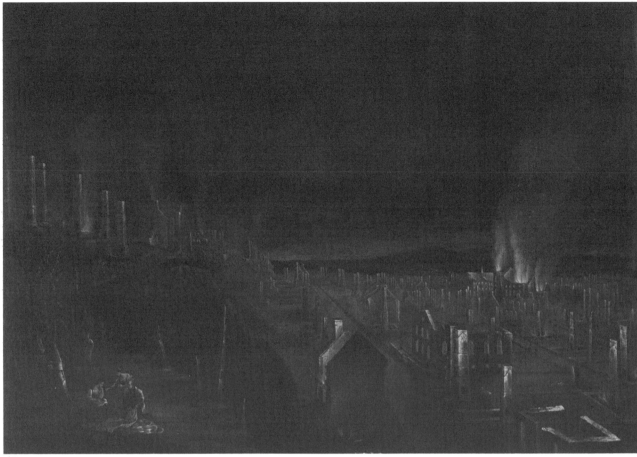

69

Gate. The wind was violent that night and blew from the north-east. Since the firemen could not find water, the flames quickly swept on, and many fires broke out throughout the entire area. The Saint-Jean quarter was entirely destroyed, as well as almost the whole Saint-Louis quarter. The fire raged until eight o'clock in the morning. In all, 1302 houses were burned down, and the Royal Artillery blew up another thirteen in an attempt to halt the flames. The latter explosions killed two people and wounded several others, but the fire itself caused far less loss of life than that of Saint-Roch. But it left another ten thousand people homeless. In two months, the suburbs of Quebec City had been wiped off the map.

The houses in the Saint-Jean quarter were of the more well-to-do than those in Saint-Roch. Many of them were built of stone, but the roof shingles were just as vulnerable as those of the wooden houses of Saint-Roch. Apart from the houses, the fire in Saint-Jean destroyed two schools, including one belonging to the Frères des Écoles chrétiennes, the Catholic orphanage, the chapel of the Protestant cemetery, and a Methodist chapel. It plunged all the citizens of Quebec into despair, as attested by this extract from *The Quebec Mercury* of 1 July:

What is now to become of us? Our workmen of all descriptions, are ruined and houseless; many who had commenced their re-establishment after the last fire have been again burnt out; their former savings and the assistance afforded by the charitable and from private sources alike sacrificed.

It must be remembered that many Saint-Roch inhabitants had found refuge in Saint-Jean and that the fire now affected a different section of the population. This was underlined in *Le Canadien* of 14 July (trans.):

This new disaster has upset all hopes, paralysed all courage. The population affected this time is to be pitied far more than the first time. The citizens of Saint-Roch were strong working carpenters, who can always find work, and even build their own shelters. The Saint-Jean and Saint-Louis quarters were inhabited by small investors, professional men, small businessmen, and small industrialists; it was a less energetic, less industrious population than that of Saint-Roch.

Notary Michel Tessier, at whose house the fire had broken out, had been married to Joseph Légaré's sister, Thérèse, since 1829, and he was the notary with whom Légaré had most dealings. Moreover, Légaré owned a one-storey house on Saint-Jean Street, on the northern side, that he had bought in 1842 and which he rented out as a source of income. He was therefore affected personally, in more ways than one, by the fire in the Saint-Jean quarter.

In 1848, *The Fire in the Saint-Jean Quarter, Seen Looking Westward*, in its large version, was most likely exhibited in Montreal in September, and in Quebec City in October,

with the two large paintings of the fire in Saint-Roch seen from Côte-à-Coton (see cat. nos 69, 70). *The Fire in the Saint-Jean Quarter* was acquired by the Séminaire de Québec at the 1874 sale of Joseph Légaré's collection of pictures. It was perhaps this canvas that was hung from 1893 onwards in the entrance hall of Laval University, with the two of the Saint-Roch fire viewed eastwards and westwards. The various catalogues of Laval University mention it under the titles *Faubourg St-Jean, pendant le feu du 28 juin 1845; vue prise de la porte St-Jean* and *St. John Suburb's destruction by fire, June 1845* with some slight variations. Sold to Mr Scott Symons in 1959, this painting was acquired in 1976 by the Art Gallery of Ontario, where it was restored.

When the fire broke out in the Saint-Jean quarter, Joseph Légaré had not even finished his pictures of the Saint-Roch fire. Like many other citizens from the upper town, he probably made his way to the ramparts, near the Saint-Jean Gate, to observe this second disaster described in the following terms by *The Quebec Mercury* in its edition of 12 July:

During the height of the fire, the scene was awfully grand. An area of about half a mile was at one time in flames, the lucid volume precluding any view beyond. As the several buildings fell, a shower of bright sparks shot up into the air, and were carried onward in their career of devastation. At day break, the scene was truly magnificent to an uninterested spectator. The whole horizon was illuminated, the valley of the St. Charles was as distinct to the view as at mid-day, and the meandering river of that name reflected an unearthly light. Ever and anon, as the flames shot upwards, might be seen crowds of people congregated on the heights in rear of St. John's suburb, on the glacis adjoining the city wall, and on the ramparts themselves. The thoroughfares were impeded by the refugees. Every species of vehicle was in requisition for the transport of goods. The hoarse cry of the firemen and soldiery mingled with the despairing wail of the sufferers: such a scene of despair has seldom been witnessed.

Shortly after, pooling his personal observations with those of his fellow-citizens, Légaré decided also to paint the fire in the Saint-Jean quarter.

The ramparts of Quebec City, near the Saint-Jean Gate, afforded a raised vantage-point equal to that of the heights of the Côteau Sainte-Geneviève to paint the fire looking westward. This time, Légaré chose to paint the fire at its height: a curtain of flames and sparks blocks out the horizon and blends into the black sky. In the centre of the picture, the vanishing point is formed by Saint-Jean Street. To the left begins Saint-Joachim Street and to the right d'Aiguillon Street. The houses, mostly of stone in contrast to those of the Saint-Roch district, are in flames. Before us, in the foreground, are the grass-covered slopes which gently rise towards the city walls that cannot be seen. On top of the slopes, as far away from the fire as possible, its victims have piled up their possessions and, standing guard over them, look powerlessly at the scene. On the far right,

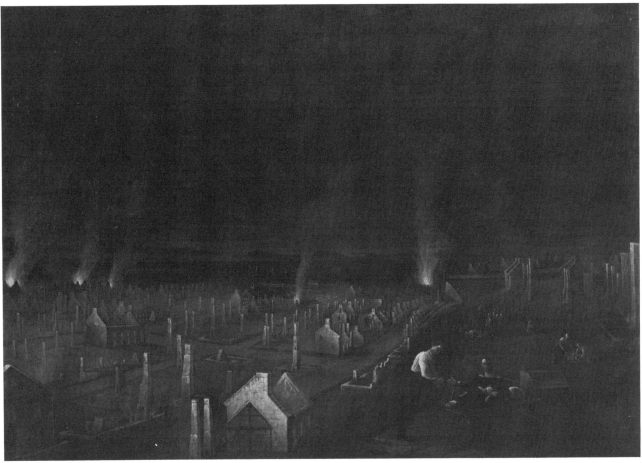

70

among them, are three Frères des Écoles chrétiennes whose burned school had been attended by six hundred pupils.

In the centre of the picture, the street cutting through the slopes of the fortifications and leading to the Saint-Jean Gate is congested by a crowd of refugees. At the entrance of the lane, a detachment of armed soldiers with fixed bayonets mounts guard and sees that order is maintained. Other soldiers stand sentinel on the edge of the slope.

Much more than in his pictures of the Saint-Roch fire, Légaré is tempted in this canvas to highlight the victims and the intensity of the fire itself. By the vantage point chosen, the colours of the painting, and its composition, he has undoubtedly succeeded in painting the best of his series of fire pictures. He had previously painted a small version of the same subject which he used as a preliminary sketch (see cat. no. 72).

Art Gallery of Ontario, Toronto

72 *The Fire in the Saint-Jean Quarter, Seen Looking Westward* 1845
Oil on canvas, 81.3 x 110.5 cm

Provenance: Légaré's Quebec Gallery of Painting; Séminaire de Québec, Quebec, 1874; antique dealer Gilbert, Quebec, 1958; Musée du Québec, Quebec, 1958 (A 58 470 P).

Exhibition: 1967 (summer), Quebec, Musée du Québec, *Peinture traditionelles du Québec,* cat. no. 38, repr.

Bibliography: AJQ, Register of the Notary Public Jean-Baptiste Delâge (6 Dec. 1872) no. 2921; ASQ, *Seminaire 12,* no. 41, 1874; IBC, Musée de l'Université Laval file; Laval University Catalogues (SQ) (n.d. I) p. 1, (1880) p. 11, no. 2, (n.d. IV) p. 30, no. 2, (n.d. V) p. 30, no. 2, (n.d VI) p. 30, no. 2, (1889) p. 30, no. 2, (1893, in French) p. 30, no. 2, (1893, in English) p. 30, no. 2; Lemoine (1876), p. 362; Cauchon (1968), repr. in col.; Giroux (1972), p. 3; Tremblay (1972), pp. 159-161; Reid (1973), p. 49, repr. in col.; Lord (1974), pp. 51-52; see cat. no. 71.

Since this painting is a first version of *The Fire in the Saint-Jean Quarter, Seen Looking Westward* belonging to the Art Gallery of Ontario (see cat. no. 71), it has the same history. It was probably acquired by the Séminaire de Québec at the 1874 sale of Joseph Légaré's collection of pictures. It is perhaps this picture which we know to have hung, at least until 1893, in the first salon of Laval University. It appears in 1876 in Lemoine's book, *Quebec Past and Present,* under the title *Destruction by Fire of St. John's Suburbs, 28 June 1845.* Various catalogues of Laval University mention it under the titles *Incendie du faubourg S. Jean de Québec, nuit du 28 juin 1845, Incendie du Faubourg St-Jean du 28 juin 1845* or in English with the same title as in Lemoine's book. However, it may possibly have been the large version of the Saint-Jean fire looking westwards.

When the painting came into the possession of the antique dealer Gilbert in 1958, it was believed to represent the fire in Saint-Roch. The same year, the Musée du Québec acquired the picture and retained this identification. In October 1968, Michel Cauchon devoted an entire *Bulletin* of the Musée du Québec to a study of this work without changing either the title or the identification, and trying, with difficulty, to identify the vantage point chosen by Légaré.

Logically, the small version of the fire in the Saint-Jean district looking westwards is quite probably the first that Légaré painted. It differs from the large version in several respects. If the framing of the scene, to left and right, is identical, less importance is given to the fiery sky in the small version while more is accorded the victims. In the large version, the retaining walls of the fortification slopes are cut by the bottom of the picture, and the crowd congesting the street leading to the Saint-Jean Gate does not distract the eye from the raging fire. In the small version, the retaining walls are shown in their entirety, and the street leading to the gate, crowded with refugees, extends to the left-hand corner of the painting. The balance of the composition is therefore different, for the crowd, in the foreground, catches the eye and holds the interest while in the large version, the crowd, though present, no longer distracts us from the fire.

The number of people seeking refuge on the slopes also differs from one painting to the other. There are far less people in the large version, but the figures are painted with greater detail. On the whole, one gets the impression that the painter was more spontaneous in the small version but made changes and corrections to the large version so as to give it more rigour and strength. This is one of the most significant examples of Légaré's concern for giving the greatest effectiveness to his works according to what he wanted them to convey.

Musée du Québec, Quebec

73 *The Fire in the Saint-Jean Quarter, Seen Looking Eastward* 1845
Oil on canvas, 95.2 x 125.7 cm

Provenance: Légaré's Quebec Gallery of Painting; Séminaire de Québec, Quebec, 1874; Scott Symons, Toronto, *c.* 1958; Art Gallery of Ontario, Toronto, 1974 (74/34).

Exhibitions: 1967, 9 June- 30 July, Montreal, Montreal Museum of Fine Arts, *The Painter and the New World,* cat. no. 219, repr.; 1973, Madison, Hanover, Austin, Elvehjem Art Centre, Hopkins Centre Art Galleries, University of Texas Art Museum, *Canadian Landscape Painting 1670-1930,* cat. no. 9, repr.

Bibliography: The Quebec Mercury (10 July 1872) pp. 1, 3; AJQ, Register of the Notary Public Jean-Baptiste Delâge (6 Dec. 1872), no. 2921; ASQ, *Séminaire 12,* no. 41, 1874; Harper (1966), pp. 82, 85; Cauchon (1968), p. 3; Giroux (1972), p. 3; Tremblay (1972), pp. 159-161; Reid (1973),

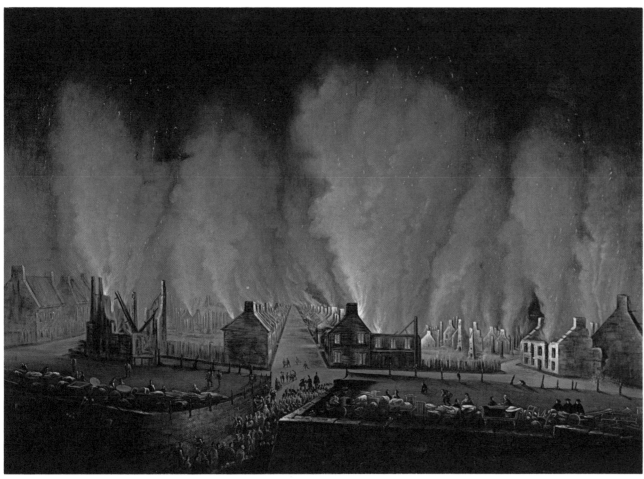

71

p. 49; Lord (1974), pp. 51-52, repr.; Dahl *et al.* (1975), pp. 249-250, plan no. 262; Godsell (1976), p. 46.

This painting is complementary to the two others depicting the fire in the Saint-Jean quarter. It was certainly one of the six pictures of fires acquired by the Séminaire de Québec at the 1874 sale of Joseph Légaré's collection of paintings. It is not to be found, however, in the various catalogues of Laval University, and there is therefore a possibility that it was relegated to some corridor or attic in the Séminaire after the purchase in 1874. Acquired about 1958 by Scott Symons (who had it restored), it has been known, identified, and published until now under the title *Ruins after the Fire in Saint-Roch Suburbs*. It has been in the collection of the Art Gallery of Ontario since 1974.

When Légaré painted the Saint-Roch fire, he tried to give a complete view in two paintings looking in different directions. When, a month after the first fire, another equally disastrous fire took place, Légaré tried to apply the same principle and paint the extent of the disaster area from two different angles that could do full justice to the calamity. The awe-inspiring sight of the Saint-Jean quarter in flames was easily visible from the heights of the ramparts looking westward. The painter transferred his observations onto a small-size canvas. He could only, however, see the Saint-Jean quarter looking eastward much later that night: to do so he had to wait for the fire to die down. In fact, he had to cross the burning district to find

a vantage point at its other end. The moment chosen by the artist to represent the Saint-Jean quarter looking eastward is therefore different. Beneath the crescent moon, dawn is seen breaking while the flames are finally quenched, to the right, in the Saint-Louis district.

The vantage point posed a problem: Légaré was not able to stand on the ramparts or on the Côteau Sainte-Geneviève to overlook the scene. Logically, he chose one of the only heights he could find at the western end of the Saint-Jean quarter, the rocks on a high piece of ground also used as a quarry. These rocks can be seen in the foreground of the picture, forming very uneven land on which several houses were built. The street crossing the picture in its width to disappear to the left is Sainte-Geneviève Street. To the right, leading towards the town, is Nouvelle Street which is separated from Saint-Joachim Street, on the left, by a lane. Saint-Jean Street cannot be seen on the left of the picture. Between Saint-Jean Street and Saint-Joachim Street lay the Protestant cemetery, in which the rows of graves can easily be seen. Still on the left, in the distance, the city walls and steeples stand out while the Saint Charles basin, the Côte de Beaupré, and the Laurentians can be seen in the distance.

The vantage point did not allow Légaré an exact vanishing point in the line of a street. In this canvas, it is the crescent moon that somewhat assumes this role, drawing the eye towards the background of the painting,

beyond the forest of chimneys. There are very few figures in this picture. In the centre, to the left, a completely isolated couple fills a gap. To the right, there is more activity going on, and two men can even be seen carrying a third. This view looking eastward differs considerably from the view looking westward and has far more in common with the paintings of the Saint-Roch fire.

Légaré paintings of the fires in Quebec City in 1845 cannot be considered separately. Had he followed their logical sequence, Légaré would probably have painted a large version of the Saint-Jean fire looking eastward. For one reason or another, he does not appear to have done so. Similarly, we do not know whether he tried to collect money for the fire victims by showing his pictures to the public, but he very probably had that intention. The curiosity of the public had been roused not only in Canada, but in the United States and England where contributions had been sought for a relief fund to help the victims of the Quebec fires.

It is interesting to note that the painter and illustrator John Murray (1810-active 1868) of Montreal had made a drawing, before 7 July 1845, showing the fire in the Saint-Jean quarter seen from the Saint Charles River, which enabled him to include the ruins of the Saint-Roch district. This drawing was lithographed in New York and published by the engraver A. Bourne of Montreal; a third of the profits from the sale was donated to the fire victims. It should also be added that several plans of Quebec City showing the extent of the fires were published by newspapers such as *L'Illustration* (5 July 1845) or *The Quebec Mercury* (12 July 1845). Alfred Hawkins, in Quebec City, hastened to sell his plan of Quebec City for 1845 as early as 3 July, colouring the disaster areas of Saint-Jean and Saint-Roch. He advertised it in *The Quebec Mercury* on 10 July, stating that public institutions and individuals could obtain this plan so as to send it away by post. Légaré was not alone in his attempts to describe the fires of 1845.

Art Gallery of Ontario, Toronto

74 *The Saint-Louis Theatre Fire* **1846**
Oil on cardboard, 30.5 x 23.2 cm

Inscriptions: *verso, c.: Feu du Théâtre/St Louis* (St. Louis Theatre Fire).

Provenance: Légaré's Quebec Gallery of Painting; Séminaire de Québec, Quebec, 1874 (Archives, Portfolio 159-G, p. 19).

Bibliography: *Le Canadien* (15 June 1846), pp. 2-3; *The Illustrated London News,* vol. IX, no. 220 (18 July 1846), pp. 35-36; *The Quebec Mercury* (13 June 1846) p. 2, (16 June 1846) p. 2; ASQ, *Séminaire 12,* no. 41, p. 2 (no. 59); Gagnon (1912), pp. 194-199; P.-G. Roy (1931), pp. 294-298; Drolet (1967), p. 67; Harper (1970), p. 149.

A year after the Saint-Roch and Saint-Jean fires (see cat. nos 69-73, 227), a new catastrophe caused more loss of life

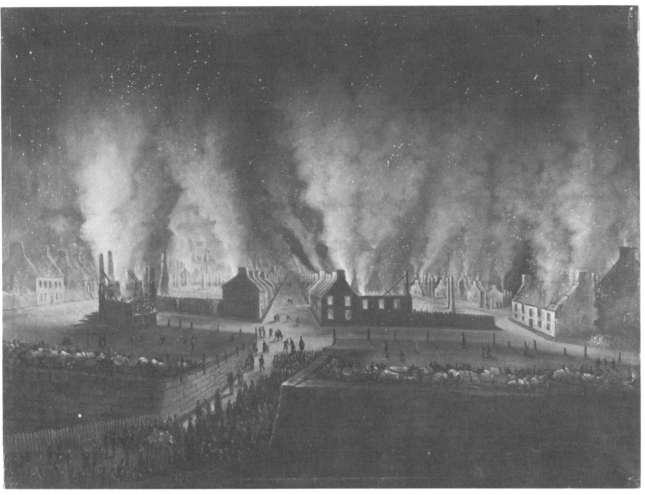

72

the rescuers. (trans.)

Lamentable cries were to be heard; several wretches at this supreme moment, seeing that all human aid was impossible and hoping for nothing more than divine mercy, cried out to Mr O'Reilly whose voice they heard. "Give us absolution!"

The minister of consolations, worn out by fatigue and effort, lifted his hand to bless and pardon them! The victims' heads are clumsily shown in the narrow staircase; behind them appear the flames and smoke that will soon envelop them. It may be asked whether Légaré had been a witness of the calamity or whether he drew his inspiration from the reports published in the Quebec newspapers to which his version of the drama closely corresponds. "As far as we could see, there was a sea of heads, of writhing bodies, and outstretched arms." Légaré certainly knew several of the victims of the fire, including the wife and two sons of Frédéric-Théodore Molt, the organist of Notre-Dame, to whom he had rented one of his houses in 1842. He must also have known the wife and daughter of the editor of *Le Canadien,* Ronald McDonald.

It is not surprising that Légaré kept this sketch in his files and never used it to complete a painting. The subject would have been too painful and detailed for the grief-stricken families.

From the stylistic point of view, the pile of heads can be compared with that appearing on the right of another of Légaré's pictures, *The Martyrdom of Fathers Brébeuf and Lalemant* (see cat. no. 53).

Séminaire de Québec, Quebec

75 *Portrait of a Man* 1846
Watercolour and pen on paper, 21.7 x 17.4 cm

Inscription: Initialled and dated, l.r., in an oval: *J.L./1846.*

Provenance: The Cartier Gallery, Montreal; Musée du Québec, Quebec, 1965 (A 65 110 D).

This unidentified portrait perhaps originally figured in a family album. It undoubtedly had as its pendant the portrait of an unknown lady also belonging to the Musée du Québec (see cat. no. 76). They were both acquired from the same dealer in 1965 and are more or less identical in size.

The work bears obvious traces of having originally been in an oval frame. The man is seated in an upholstered armchair with wooden uprights that can be seen from the side. Turning his body towards the right, he looks sideways at the spectator. His gaze is aristocratic, and his hair is carefully dressed. He poses. He is elegantly turned out; his suit, waistcoat, and *jabot* (neckcloth) adorned with a jewel add to his distinguished appearance. He holds a book negligently in his right hand.

The drawing of this portrait is characterized by its suppleness and precision. The artist, in this watercolour, shows great sureness of touch.

Musée du Québec, Quebec

in Quebec City than the two previous disasters combined. This time, it occurred in the upper town, at the Saint-Louis Theatre, situated at the far eastern end of Sainte-Anne Street, near the Place d'Armes. This theatre was one of the buildings surrounding the Château Saint-Louis (destroyed by fire in 1834); it had originally been a military riding-school. In 1839, the officers of the Coldstream Guards turned the building into a theatre.

On 12 June 1846, Mark Robert Harrison (English, 1819-1894), a painter who had settled in Hamilton, and his brother Thomas C. Harrison (c. 1825-1846) presented at the Saint-Louis Theatre an exhibition of "chemical dioramas" which included views of the city of Rameses, Orléans Cathedral, the city of Jerusalem (with the Crucifixion, and so on). Dioramas were large-sized canvases giving a general view of the landscape or the event described and which were brought to life by lighting effects that threw one part of the canvas or another into relief. They were very popular in Quebec City and there were nearly 300 spectators at the performance on 12 June.

This performance ended at ten o'clock and most of the audience had left the building. Fire broke out on the stage as the result of an error in handling the equipment. The youth who was supposed to extinguish the camphor-oil lamps dropped one, and the fire spread immediately to the curtains and canvases of the diorama. Crying "Fire!" the spectators who remained in the theatre all rushed towards

the same exit: a narrow staircase leading from the boxes to one of the entrance doors. They immediately jammed in the passage, inextricably wedged together so that they could not move, and within only a few feet of the exit. Even the rescuers could not do more than extract two or three people from this human mass, and watch, powerless to help, the death of these unfortunate spectators. Forty-five people thus perished, men, women, and children - including the young brother of the painter Mark Robert Harrison. It was a disaster affecting all classes of Quebec society that Légaré sketched.

The sketch was acquired by the Séminaire de Québec at the 1874 sale of Joseph Légaré's collection of paintings; in the catalogue of which it appears under the title *Feu du théâtre, à Québec.* Gérard Morisset wrongly attributed this work to an English painter who visited Quebec about 1846, whose initials he took to be R.B. (see cat. nos 10, 21). In the keeping of the Archives of the Séminaire de Québec, the sketch was restored in 1976 at the National Gallery of Canada.

It is a horrible scene that Légaré depicts in this canvas. In the foreground, to left and right, powerless rescuers stand aside to let us see the pile of heads of those about to die (there are more than forty-five in this sketch). To the right stands a priest raising his arm to give absolution. This was Abbé Bernard O'Reilly who was then curate at Notre-Dame de Québec and who happened to be among

76 *Portrait of a Lady* (?) 1846
Watercolour, pen and gouache on paper, 22.5 x 17.3 cm (irregular)

Provenance: The Cartier Gallery, Montreal; Musée du Québec, Quebec, 1965 (A 65 111 D).

This portrait is probably the pendant of a *Portrait of a Man* belonging to the Musée du Québec (see cat. no. 75). Three of the corners of the rectangular sheet on which the oval of the portrait was painted have been cut off, which accounts for the irregular size of the work.

The young woman is seated in a three-quarters position, on a seat with a semi-circular back. In her clasped hands, she holds a handkerchief against her dress. The dress is beautiful and elaborate, and its fine cut enhances the beauty of the sitter's figure. A three-string necklace adorns her *décolleté*. With her head bent, the young woman looks shyly at the viewer. Her coiffure is gentle and parted in the middle. Her eyes are lively, her nose slightly aquiline, and her mouth finely drawn. The curve of her head coincides with the outer line of a drapery which fills the upper right-hand part of this harmonious portrait.

Musée du Québec, Quebec

77 *Clermont* c. 1850
Oil on canvas, 66.1 x 99.2 cm

Provenance: Légaré's Quebec Gallery of Painting; Séminaire de Québec, Quebec, 1874.

Bibliography: ASQ, *Séminaire 12*, no. 41 (1874) p. 7 (no. 280); Laval University Catalogues (SQ) (after 1933) no. 518; Lemoine (1865), pp. 92-93; DBC, X (1972), pp. 144-149.

When Légaré's collection of pictures was acquired by the Séminaire de Québec in 1874, lot 280 was entitled *Vue de Clermont, près de Québec* (*View of Clermont, near Quebec City*). There is no subsequent mention of this picture in any of the catalogues published by Laval University (SQ), but it does appear as no. 518 in the continuation in manuscript of the 1933 catalogue under the vague title *Landscape, House, River*. This painting was restored at the National Gallery of Canada in 1978.

About 1850, René-Édouard Caron (1800-1876), then president of the Legislative Council, had a house built at Sillery that he called Clermont. It stood about five kilometres from Quebec City, and two acres of land separated it from the road leading to the town. When he became the second Lieutenant-Governor of Quebec in 1873, Caron left this house to take up official residence at Spencer Wood. In 1919 Clermont, after changing hands several times, was destroyed by fire.

Joseph Légaré knew René-Édouard Caron very well. We need only mention that they worked together on the Quebec City Council from 1833 to 1836, that they were vice-chairman and chairman respectively of the Consti-

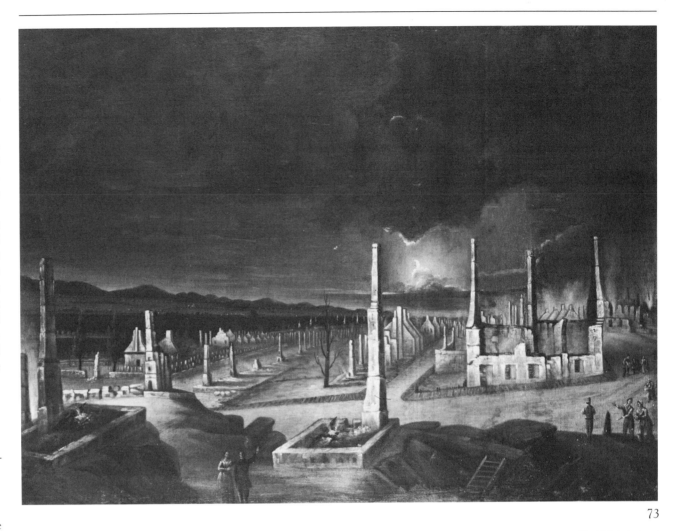

73

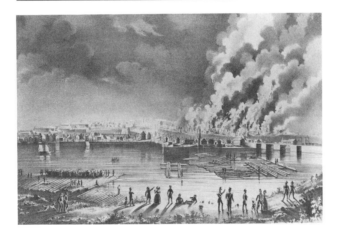

73a G. T. Sanford, *View of Quebec, Canada from the river St Charles; shewing the conflagration of June 28th 1845, and the ruins of the fire of May 28th, 1845*, 1845, Engraving after a drawing by John Murray, 33.0 x 50.2 cm, Photo from Public Archives of Canada, Ottawa

73b Detail: *Map of Quebec City*, July 1845, 50.0 x 64.3 cm, Public Archives of Canada, Ottawa, (Showing the areas of the fires of 1845)

tutional Committee for Reform and Progress in 1847, and that they held similar offices in the Saint-Jean-Baptiste Society of Quebec for several years. It would take too long to recall all the occasions upon which the two men met, most of the time to collaborate on some similar task or to defend similar ideas.

As painted by Légaré, Clermont appears to be a rich and comfortable residence with a magnificent view over the Saint Lawrence and its south bank. The house occupies the right-hand part of the picture and is seen from the side. A drive leading to the two entrances encircles the building. Behind it, the forest stretches into the distance. The plan of Caron's residence starts with a two-storied square topped by a roof whose four gently sloping sides are surmounted by a balustrade. An *avant-corps* against which a pillared veranda stands is built out on the river side. On the opposite side, it is matched by a small doorway. The house has numerous shuttered windows. The small bay addition and the shape of the side-wall of the house, show the owner's wish to take the greatest possible advantage of the view over the surrounding countryside and the river in particular. The waters of the river extend into the left part of the painting and Légaré has painted numerous sailboats and steamboats; the south bank of the river is dotted with houses. Nearer to us, in the foreground, are trees arranged to enhance the composition and attract attention towards the house. Between them and the river, the roofs of two houses surrounded by fir trees stand out in the distance.

The composition of Légaré's picture is skillful. As we have seen, the work consists of two vertical parts which are both separate yet indissociable. While seeking to highlight the residence of the important M. Caron, the artist has succeeded in harmonizing it perfectly with the picturesque beauty of the Saint Lawrence valley.

Séminaire de Québec, Quebec

78 *Election Scene at Château Richer* *c.* 1851
Oil on canvas, 64.2 x 95. 9 cm

Provenance: Légaré's Quebec Gallery of Painting; Séminaire de Québec, Quebec, 1874.

Exhibitions: 1948, Sept.-Oct., Quebec, Musée du Québec, *Exposition du centenaire de l'Institut Canadien;* 1959, 12 July-23 Aug., Vancouver & Winnipeg, Vancouver Art Gallery and Winnipeg Art Gallery, *The Arts in French Canada,* cat. no. 172; 1965, Ottawa & Quebec, National Gallery of Canada and Musée du Québec, *Treasures of Quebec,* cat. no. 51, repr.

Bibliography: L'Ami de la religion et de la patrie (2 Aug. 1848) p. 438, (4 Aug. 1848) p. 446; *Le Canadien* (26 July 1848) p. 3, (2 Aug. 1848) p. 2, (3 Dec. 1851) p. 2, (15 Dec. 1851) p. 2, (17 Dec. 1851) p. 2, (29 Sept. 1852) p. 2; ASQ, *Séminaire 12,* no. 41 (1874); Laval University Catalogues (SQ) (1903) p. 27, no. 3, (1905) p. 27, no. 3, (1906) p. 36,

74

no. 11, (1913) p. 63, no. 353, (1923) p. 72, no. 353, (1933) p. 81, no. 245; Bellerive (1925), p. 16; Colgate (1943), p. 109; Morisset, *La peinture traditionnelle* (1960), p. 99; Harper (1966), p. 82; Cauchon (1968), p. 2; Harper (1970), p. 194; Giroux (1972), p. 2; Tremblay (1972), pp. 187-190, 199, repr.; Lord (1974), pp. 53-54, repr.

The political event to which Légaré's painting alludes took place on Saturday, 29 November 1851, and it is also reported by the newspaper *Le Canadien* in the edition of 3 December 1851 (trans.):

> MONTMORENCY RIDING. – In his newspaper of yesterday evening, M. Cauchon publishes a long account of what happened at Château-Richer last Saturday at the nomination of candidates. He says first of all that he left his house accompanied by 53 carriages transporting the most respectable citizens of Quebec; that with him, in the same carriage, was Mr Maguire, one of the Quebec City candidates, and MM. Casault and Langlois, lawyers; that he was also accompanied by all the pilots of Quebec and some from the Ile [d'Orléans], about 50 in number; that when he reached Château-Richer, the number of carriages escorting him had grown to 102, and that a considerable number of farmers had also come to meet him from the parishes of Saint-Joachim, Sainte-Famille, and Saint-Ferréol; lastly that "all those who accompanied M. Cauchon were *excessively* respectable citizens," and that "M. Guay had only been able to gather four carriages, including his own." It is difficult to square this estimate of the respective forces with the rest of M. Cauchon's account. His version scarcely agrees with that sent us by an "eye-witness," and that several other eye-witnesses assure us conforms in all respects with the truth. We give this with all the necessary reserves:
>
> *Canadien blood spilled!!!*
>
> Mr Editor, Sir,
>
> Yesterday morning, the day appointed to choose a candidate to represent us in parliament, a complete battalion advanced on our peaceful and patriotic riding composed of a hundred and three men, at the head of which was the leader Cauchon. This battalion, probably organized according to the society of "good principles," included all M. Cauchon's most devoted supporters. At the sight of the large cortège following behind M. Cauchon, the electors assembled in large numbers at Château-Richer readily revealed the trick M. Cauchon wanted to play on them by showing himself on one side and weapons on the other. M. Guay, accompanied by four or five peaceful friends, had also come here at the request of a large number of electors.
>
> After the reading of the election writ, M. Guay began to speak and expressed in polite terms the reasons which incited him to solicit votes, and dealt at length with the tortuous and contradictory policy of M. Cauchon. The latter, having two young lawyers as advisers, and not being able to refute M. Guay's allegations, tried to employ the weapon of ridicule and

75

as usual M. Cauchon was hoisted on his own petard. During his speech, M. Cauchon several times pronounced the words "Shut up; if you want a quarrel, you won't get anything by it." These threats uttered by M. Cauchon turned tempers sour. Having left the platform, the names "Larose," "Légaré" were then heard. The tumult and cries continuing, M. Cauchon and M. Guay left the decision up to the reporting officer whose wisdom and prudence in this circumstance we cannot but praise. The reporting-officer clearly declared that M. Larose had the right to speak. Well, M. Cauchon, instead of abiding by this decision that he had himself provoked, brazenly declared that the reporting-officer was not competent to decide whether M. Larose or M. Légaré should speak. This declaration on the part of M. Cauchon was like the agreed signal for battle. One of M. Cauchon's supporters first of all hit M. Larose, with no provocation whatsoever. The latter, warned that he would be beaten and an attempt perhaps made on his life, thought it his duty to retire from the organized, armed, and furious crowd of M. Cauchon. Several other citizens, respectable citizens of the riding, similarly warned that M. Cauchon's organized band wanted to beat them and thus punish them for their independence and opposition to the wretched representative of their riding, also withdrew to avoid all trouble. But that did not prevent M. Cauchon's thugs who, about a hundred in number as I stated above, armed with sticks, knotted ropes, hammers, knives, and pistols, rushed on the electors with the most savage ferocity and spilled their blood. The worthy electors, wounded in their honour and independence, countered the attack advantageously, although far inferior in number, though not in courage, and forced the furious allies of M. Cauchon to withdraw and conduct their brawls elsewhere. Then, the electors, who had remained on the battle-field stained by their blood spilled by M. Cauchon's thugs, grouped together once more and surrounded M. Guay and his friends with the greatest enthusiasm. During the action, a respectable farmer from Château-Richer saw himself exposed to the pistol of a certain supporter of M. Cauchon, who threatened him at point-blank range. A rough-and-ready carter from Saint-Roch cynically carried in his arms a large number of long-handled hammers.

I shall not go into any further details, and leave the country to evaluate the scandalous and abominable conduct of M. Cauchon. The riding, I hope, will know how to choose between the candidate who comes with a band of drunkards to intimidate and beat up electors instead of protecting them, and the one who comes almost alone, trusting in the liberality and hospitality of the citizens of the riding, to discuss their interests peacefully and who, to repay his confidence, then sees himself basely struck by his political opponents.

An Eye-Witness.
Montmorency Riding, 30 Novembre 1851.

76

To understand this incident, it should be known that Joseph-Édouard Cauchon (1816-1885) had been a member of the Legislative Assembly since 1844 as representative of Montmorency Riding, and that he was also editor of the *Journal de Québec* which he used for political purposes. Moreover, in 1848, and again in 1850, Joseph Légaré had been an unsuccessful candidate at by-elections in Quebec City, and had encountered on both occasions sustained and fierce opposition from Cauchon. After his defeat in 1848, Légaré had campaigned for electoral reform. The committee of which he was a member had even held a meeting at Château-Richer on 1 August to discuss these reforms with the electors of Montmorency riding and to "take into consideration the political conduct" of their member, Cauchon. This meeting, held at the hotel of Sault-à-la-Puce, had been much talked about and had not pleased Cauchon or his friends.

Légaré was not a candidate at the General Election in 1851, but he insisted on being present at the nomination of the Château-Richer candidates to support the candidacy of Cauchon's opponent, a man named Germain Guay. As for Larose, mentioned as a speaker in the article, this was the mason Joseph Larose, a fierce opponent of Cauchon, and faithful supporter of Légaré in his political campaigns and a formidable speaker. The memorable brawl of 29 November did not prevent Joseph-Édouard Cauchon from being re-elected by 963 to 523 votes for his opponent.

Légaré's painting was probably acquired by the Séminaire de Québec in 1874 with the artist's collection of pictures, although it cannot be definitely identified in the inventories of the time. It appears in various catalogues of Laval University under the titles *Paysage canadien (scène d'élection)*, *Château-Richer*, *Canadian Scenery*, *Château-Richer*, *Scène d'élection au Château-Richer*, *A fight at Château-Richer*.

The landscape represented by Légaré is painted from one of those viewpoints so popular with English topographical painters visiting Canada. Thomas Davies (c. 1737-1812) painted a watercolour in 1788, now in the National Gallery of Canada, showing the same spot but from a slightly different angle. In Légaré's painting, the hills of the Côte de Beaupré can be seen looking westward towards Quebec, at the spot where the Sault-à-la-Puce River (see cat. no. 36) crosses the road skirting the Château-Richer hill, under a wooden bridge. To the left, behind the trees, the Saint Lawrence can be distinguished. It is a verdant landscape under a blue summer sky that Légaré paints here, and not a late-November scene. This suggests that Légaré had a sketch ready in his files that he used without bothering about the season at which the event actually took place.

At first sight, everything in this landscape radiates rustic peace: the sky, the trees, the tilled fields on the hills, the sheep peacefully grazing in the left foreground. However, the curve of the road which leads to the heart of the composition ends in a scene of violence. An epic battle is taking place on the wooden bridge and in front of the houses on the other side of the river. People are running away down the road on both sides, while the combatants can be seen fighting at close quarters with threatening arms, brandishing cudgels and other weapons lifted above the fray. One of the houses, partly hidden by

77

what is probably a stable, is the hotel of Sault-à-la-Puce. It is a low building with two chimneys, in the style of houses of the French régime, but whose arched sign can clearly be seen fixed to the central gable window above a pretentious portico with a pediment supported by columns. This was where political meetings were held at Château-Richer, and it was here that the violent encounter between Cauchon's supporters and opponents took place in 1851.

In the right foreground, in a field, a curious scene takes place. Four children, some armed with a stick, some with a sling and even a bow, seem to be chasing a huge pig while a fifth, armed with a cudgel, also runs towards it but from the opposite side. Credit must be given to Claire Tremblay who, in her Master's thesis in 1972, first associated this pig (*cochon* in French) with Joseph-Édouard Cauchon. This connection becomes all the more obvious if we refer to an article which appeared in *Le Canadien* in September 1852 entitled *Les cochons de la Corporation* (The Corporation Pigs) in which the author takes malicious pleasure in indirectly stressing the importance of Joseph-Édouard Cauchon's rôle in Quebec City (trans.): "Among all peoples, the pig (*cochon*) has finally been reviled. But the moment of justice seems to be drawing near for the porcine race, and this great rehabilitation will be due to the generous Corporation of Quebec City." At the time this picture was painted, the newspaper *Le Canadien* printed pages of attacks on Cauchon, unsparing in its puns. In his painting, Légaré did no more than translate this pun into visual

terms, and everyone in Quebec City must immediately have understood what he wanted to convey.

It is hard, however, today to understand the exact meaning of the allegory intended by Légaré. The four children who seem to be chasing the pig are surely swept along after it, like the majority who swept Cauchon into power. Are they not all rushing towards the other isolated child who comes bravely to meet them like the minority opposed to Cauchon? Will they not meet each other in an unequal and already losing battle? It should also be stressed that the single child stands between the pig and the peaceful flock of sheep ... Whatever the case, the exact meaning of this painting will perhaps never be known.

Over and above the remarkable landscape, the successful composition of this painting, and the direct or indirect allusions to the painter's own political activities, this picture is a *genre* scene faithfully describing electoral customs in Quebec in the nineteenth century.

Séminaire de Québec, Quebec

79 *Lord Elgin* c. 1852
Oil on canvas, 104.8 x 67.3 cm

Provenance: Légaré's Quebec Gallery of Painting; Séminaire de Québec, Quebec, 1874.

Bibliography: *Le Canadien* (22 Aug. 1853) p. 2; *Le Journal*

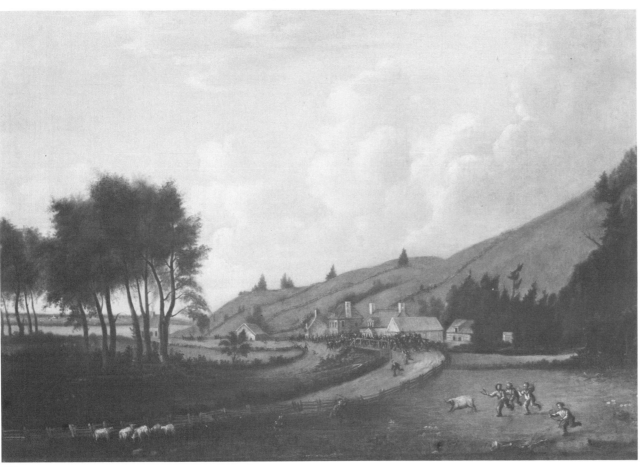

78

de Québec (28 Sept. 1852) p. 2; Laval University Catalogues (SQ) (1913) p. 63, no. 348, (1923) p. 72, no. 348, (1933) p. 81, no. 240; Bellerive (1925) p. 17; Lejeune (1931) vol. I, pp. 592-593; Colgate (1943), p. 109; Harper (1970), p. 194; Reid (1973), p. 48.

Painted about 1852, the portrait of Lord Elgin was probably acquired by the Séminaire de Québec in 1874. However, it only appears in the catalogues of Laval University (SQ) from 1913 onwards.

James Bruce (1811-1863), eighth Earl of Elgin, was Governor of Canada from 1 October 1846 to 19 December 1854. It was under his enlightened administration that responsible government was introduced in 1848 and that the legislature agreed to vote an indemnity to cover material losses sustained during the 1837 Rebellion. In 1854 Elgin favoured the signing of a Reciprocity Treaty with the American government.

Joseph Légaré had the opportunity of meeting Lord Elgin on various occasions from 1847 onwards. Le Journal de Québec of 28 September 1852 describes the circumstances of one of their meetings (trans.):

We learn with pleasure that H.E. the Governor-General has recently visited the picture gallery that our compatriot, M. Légaré, an artist of this town, has established in his house on Sainte-Angèle Street, and opened to the public free of charge for some time now; and we see with pleasure this appreciation, on the part of His Excellency, of the praise-worthy efforts M. Légaré has made for such a long time to perpetuate the taste for painting in Canada. His Excellency was apparently so pleased with his visit that he intends to return in company with Lady Elgin.

On 22 August 1853, Elgin left Quebec for a visit to England. The day before his departure, the citizens of the town held a public meeting to prepare an address to him in which they expressed their satisfaction with his achievements as Governor and the hope that he would soon return. It was on a motion by Légaré that the address was adopted to be presented to Lord Elgin.

We do not know, unfortunately, the exact circumstances which led the artist to paint the Governor's portrait. His Lord Elgin is a full-length portrait. The Governor is shown in civilian dress: as his only decoration, he wears a knight's sash on his breast. His features are haughty. He is slightly turned towards the right of the picture, with his left arm behind his back and the other folded in front of him. He holds a rolled-up document in his hand, a probable allusion to his reforms while Governor of Canada. Although very well balanced, the decoration of the room in which he stands is actually quite simple. To his right, a small, very elaborate rococo-style table can be seen above which opens a window giving onto a sketchy landscape. To his left can be seen the bottom of a pillar mostly hidden by draperies, acting as a set-off.

The great restraint of this portrait contrasts with the richness of the state portrait painted by Théophile Hamel at the same period and also belonging to the Séminaire de Québec.

Séminaire de Québec, Quebec

80 ***The Property of the Artist's Parents at Gentilly*** c. 1853
Oil on canvas, 68.1 x 91.0 cm

Inscription: l.l. [illegible]

Provenance: Mrs Pierre Duhamel Deschambault, Quebec; Louis Carrier, Montreal; Private collection.

Exhibitions: 1946-1947, 10 Jan.-10 Mar., Albany, Institute of History and Art, *Painting in Canada,* cat. no. 24, repr.; 1955, Montreal, Montreal Museum of Fine Arts, *The Arts in French Canada,* no cat. no.; 1962, 11 May-30 July, Bordeaux, Musée de Bordeaux, *L'art au canada,* cat. no. 22; 1973, 30 Mar.-29 Apr. and 11 May-10 June, Ottawa and Montreal, National Gallery of Canada and Montreal Museum of Fine Arts, *Painters of Quebec,* cat. no. 17, repr. in col.

Bibliography: ANQ-Q, Registre de l'état civil de la paroisse Notre-Dame de Québec, *passim;* ANQ-Q, Register of the Notary Public Antoine-Archange Parent (9 Oct. 1818), no. 762; ANQ-Q, Register of the Notary Public Michel Tessier (2 May 1831), no. 163, (26 July 1850), no. 7238; ANQ-Q, Register of the Notary Public Joseph Petit-Clerc (1 July 1848), no. 4470; ANQ-TR, Register of the Notary Public Honoré Tourigny (22 Jan. 1854), nos 389-393; Harper (1962), p. 30, repr.; Tremblay (1972), pp. 196-197; Lacroix (1973), p. 28.

When this painting was shown in Albany, N.Y., in 1946, it was still in the possession of Mrs Pierre Duhamel, a descendant of Joseph Légaré. Known under the title *The Artist's House at Gentilly* it then passed into the collection of Mr Louis Carrier, and then into the hands of another private collector.

Gentilly is a small village on the south bank of the Saint Lawrence about ninety kilometres upstream from Quebec. It was there that Joseph Légaré Sr and his wife Louise (née Routier) decided to retire and finish their days in the peace of the country, far from the town, in about 1850. From 1818 on, Joseph Légaré Sr had been a merchant in Quebec City. In 1831 he had taken his son, Jean-Baptiste (born in 1796) into his business on Saint-Jean Street. Jean-Baptiste and his sister Rosalie (born in 1802), both unmarried, followed their parents to Gentilly, as did Charles-Louis Maxime De Foy, the merchant's grandson.

It is his parents' new home that Légaré has depicted in the centre of his painting. A driveway edged with well-kept flowerbeds leads to the main entrance of the house. It is a fine country residence of which similar examples are still to be found in the Gentilly area. An imposing veranda with decorative elements in Victorian style embellishes the front of the house. There are numerous, symmetrically

arranged doorways. The black roof is pierced by dormer-windows and two chimneys. At a level lower than that of the main house, two summer kitchens are joined on at either side. To the right of the house can be seen the outbuildings for agricultural equipment, animals, and the owners' carriage.

Légaré's parents are to be found among the figures shown in the driveway leading to the house. Their identification by a descendant of Légaré in 1946 seems very probable. They appear in the background, in the middle of the drive. In the foreground, from left to right, are Rosalie and Jean-Baptiste Légaré as well as the artist's three daughters, Caroline, born in 1822, Laetitia, born in 1844, and Célina Légaré, born in 1841. The artist is shown with his wife on the left-hand side of the drive, half way between his parents and the group in the foreground. Due to poor cleaning of the picture and repainting carried out between 1946 and 1973, the attitude of another figure standing behind the artist's parents has been completely changed. It may have been Charles-Louis Maxime De Foy. Similarly, a woman seated on the veranda opposite the second window on the left and a man standing near her, at the foot of the veranda, can scarcely be made out.

In this solidly composed picture with well-defined vanishing points Légaré has successfully conveyed the cohesion of the family circle in his day and the serenity of the country residence where his parents were each in turn to die, his father in 1855 and his mother in 1860.

Private Collection

81 *The Battle of Sainte-Foy* c. 1854
Oil on canvas, 50.0 x 74.5 cm

Provenance: Mrs Joseph Légaré, widow; Mrs Charles Narcisse Hamel (née Célina Légaré), 1974; Joseph Victor Hamel, Saint-Gédéon (Lac Saint-Jean); Mrs Paul Desroches, Grand-Mère; National Gallery of Canada, Ottawa, 1975 (18489).

Bibliography: La Bibliothèque canadienne (15 Apr. 1830), pp. 385-389; *Le Canadien* (15 Feb. 1837) p. 1, (2 Aug. 1837) pp. 1-2, (17 Aug. 1846) p. 2, (20 Aug. 1849) pp. 1-2, (15 May 1854) p. 2; *The Quebec Mercury* (30 Sept. 1854) p. 1; *Catalogue of the Quebec Gallery of Paintings* (1852) p. 13, no. 150; AJQ, Register of Notary Public Jean-Baptiste Delâge (6 Dec. 1872), no. 2921; Garneau, *Histoire du Canada,* vol. III (1848) pp. 240-263; Chouinard (1881), vol. I, pp. 51-92 (by Olivier Robitaille); Casgrain (1908), *passim;* Bellerive (1925), p. 16; Colgate (1943), p. 109; P.-G. Roy (1946), vol. 2, p. 99; Morisset, *La peinture traditionnelle* (1960), pp. 98-99; Lord (1974), p. 49; Trudel, *Joseph Légaré et la bataille de Sainte-Foy* (1977), unpublished.

In the edition of 15 February 1837, the newspaper *Le Canadien* published a long article by the historian François-Xavier Garneau (1809-1866) announcing the

79

80

publication in that same paper of "accounts of skirmishes and battles, in Canada and elsewhere, in which *Canadiens* have taken part." The historian justifies his enterprise in the following terms (trans.):

> I merely wished to give readers a series of these great dramas that are milestones in the life of peoples as in those of men and enable them, as it were, to be present at events in which their ancestors were actors, and which have given *Canadiens* the reputation of bravery which even their enemies were the first to recognize. These simple stories cannot but please *Canadiens,* and they will see how much work and blood Canada has cost them.

The account of the battle of Sainte-Foy, won by Lévis's troops over those of Murray before Quebec on 28 April 1760, was published in *Le Canadien* on 2 August 1837, at the same time as the story of the battle of the Plains of Abraham (this version of the battle had already been published for a smaller public in *La Bibliothèque canadienne* in 1830). In 1848, in the third volume of his *Histoire du Canada,* Garneau repeated his narration of the battle of Sainte-Foy in a modified and more complete version.

Two years earlier, *Le Canadien* had published an article entitled *28 April 1760* in which there was mention of the latest discoveries by the historian Garneau based on the "handwritten memoirs" of Lévis. It gave details of the place of the battle of 28 April, namely the site of the Dumont house and mill of which only the foundations remained at that time. On 20 August 1849, *Le Canadien* reported that bones, remains of weapons, and cannon-balls had been discovered not far from there during the previous summer during land surveying work. The newspaper added that Légaré was about to paint a view of the Dumont mill and its surroundings, giving them their former appearance.

In September 1852, during a walk along the Sainte-Foy road, Olivier Robitaille (a Quebec City municipal councillor from 1851 to 1856), Louis-de-Gonzague Baillairgé, and F.-X. Garneau, in their turn, discovered bones, but this time near the foundations of the Dumont mill, where fierce fights had taken place during the battle of Sainte-Foy. They announced their discovery to the Saint-Jean-Baptiste Society which undertook excavations and uncovered more remains.

In March 1854, the Saint-Jean-Baptiste Society of Quebec adopted a series of resolutions intended to give a decent burial to the remains of the combatants of 1760 and erect a monument to their bravery. To put these resolutions into effect they set up a special committee of which Joseph Légaré was a member. A ceremony of a combined civil, military, and religious nature was planned for May. The most important feature of the procession was the hearse designed by Joseph Légaré (reproduced in *L'Illustration, journal universel* 29 July 1854; see cat. no. 259).

The ceremony of transporting the remains took place on 5 June 1854. The hearse drawn by six horses left the City Hall, passed along the Esplanade, came back to Notre-Dame de Québec and then moved off towards the site of the battle of Sainte-Foy where the burial took place. One of the honorary pall-bearers walking beside the hearse was Joseph Légaré. Starting at nine in the morning, punctuated by speeches, singing, religious ceremonies, and military displays, the translation of the remains only ended at sundown.

On 27 February 1855, the Saint-Jean-Baptiste Society set up another committee to organize the laying of the corner stone of the memorial to 1760 on the following 25 June. Joseph Légaré was a member of this committee and the architect, Charles Baillairgé, drew up the plans for the monument. Joseph Légaré died on 21 June 1855. It was not because of his death that the laying of the corner-stone was postponed until 18 July, but because of the arrival in Quebec of the French corvette *La Capricieuse,* a detachment of whose sailors took part in this new impressive ceremony.

The picture, *The Battle of Sainte-Foy,* was probably painted by Joseph Légaré in 1854, at the time of his direct involvement with the ceremonies commemorating this battle. It was probably this work that earned the artist first prize in the category of historical paintings on a Canadian subject at the Agricultural and Industrial Exhibition of Lower Canada held in Quebec City in September of that year. After Légaré's death, the picture continued to hang in the sitting room of his house. When his widow died in 1874, *The Battle of Sainte-Foy* became the property of their daughter, Célina, whose descendants kept it until 1975 when it was acquired by the National Gallery of Canada from Mrs Paul Desroches. The painting was restored in 1976.

Joseph Légaré was a friend of F.-X. Garneau, and it was the latter's account of the battle of Sainte-Foy which inspired him to paint the picture. The landscape is very like that to be seen today, with the Heroes' Monument still standing on top of the Côteau Sainte-Geneviève, close to the Sainte-Foy road. This was the place where the bones of the combatants were found in 1852. To the right stand a windmill - the Dumont mill - as well as the miller's house. The ruins of these buildings were still visible at the time Légaré was painting the picture. To the left, in the far distance, are the Laurentians, the Côte de Beaupré dotted with farmhouses and the estuary of the Saint Charles River. Near the water, slightly hidden by the trees, houses in the Saint-Roch district can be seen, an anachronism on Légaré's part. The layout of the landscape is somewhat reminiscent of an historical and lyrical description of the site of the battle of Sainte-Foy that *Le Canadien* had published in its edition of 15 May 1854. Légaré was undoubtedly aware of this article before starting to paint his picture.

The artist has confined the whole battle to the area between the Sainte-Foy road and the Côteau Sainte-

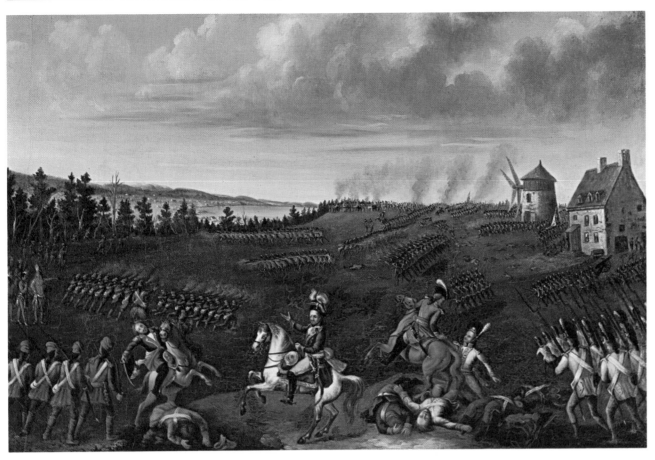

81

81a Attributed to Adam-Frans van de Meulen, *Battle in the Low Countries,* Seventeenth century, 48.9 x 56.5 cm, Musée du Séminaire de Québec, Quebec

a cannon shot that killed his horse," according to F.-X. Garneau (pp. 251-252). Under his horse, a militiaman lies on the ground. To the right, on the side of the French troops, another horseman, Colonel Poularier, gives orders to the soldiers of the Royal-Roussillon brigade who advance in spite of many losses.

Although the model used by Légaré for Lévis on horseback is not known to us - probably an engraving of the Napoleonic era - we have been able to trace a painting from which he drew inspiration for Bourlamaque, Poularier, and the dead soldiers in the foreground frieze. This was a picture attributed to Adam-Frans van der Meulen (1632-1690), now entitled *Bataille dans les basses-terres* or *Scène de bataille (Battle in the Netherlands* or *Battle Scene)* and belonging to the Séminaire de Québec. This painting was part of Légaré's collection of European works which was acquired by the Séminaire de Québec at the same time as many of Légaré's works, in 1874. It was through a Quebec dealer, Johan Christopher Reiffenstein, that Légaré had acquired this picture and it was most probably the canvas entitled *Cavalry Battle* to be found in the catalogue of Légaré's picture gallery published in Quebec in 1852.

The horseman in the foreground to the left is the model for Bourlamaque. That in the centre, with his back turned, is the model for Poularier. In the latter case, Légaré has even faithfully copied, in the same place, under the horse, the two dead soldiers, one lying face down, the other face up. Under Boulamaque's horse, he has repeated the soldier lying on his face by slightly modifying his position. He also copied another body lying on the ground with its feet towards us, on the right of the European painting, and placed it on the right of his own canvas.

There is nothing scandalous or astonishing about this as far as Légaré is concerned. He did not consider this plagiarism, but merely "borrowing" which in no way affected the originality of his own work. The procedure was customary with him, moreover, in pictures of his own composition and he had learned by copying religious paintings at the outset of his career that he could thus obtain much better results than by trusting to his own resources as a painter. Never having been to Europe, never having studied with a professional artist, he used his collection of paintings and engravings as a pictorial dictionary from which he extracted his vocabulary knowing that he was a talented copyist. He could not go wrong in drawing inspiration from the European masters.

The only known visual reconstruction of the battle of 28 April 1760, *The Battle of Sainte-Foy* is one of Joseph Légaré's last works. It is also the epitome of the extent of his pictorial knowledge, in addition to being an excellent example of his manner of painting. Beyond the composition, the colours, the figures, and the setting, beyond the battle depicted, this work is deeply rooted, through the person of Légaré, in the period in which he lived. It becomes a signal of that age consciously sent through time and which touchingly reaches us today.

National Gallery of Canada, Ottawa

Geneviève, whereas it took place over a wider territory in fact. The British troops are here surrounded by regular French troops, *Canadien* militiamen, and Indians. In the background, on the heights, are the Royal Artillery cannon and their crews whose fire plays havoc with the French troops. Red sparks and black smoke escape from guns. The British troops are spread out in front of their artillery and General Murray is perhaps one of the horsemen to be seen behind them.

Lévis's troops carry out a manoeuvre that leaves Murray no other alternative but a retreat on Quebec. The regular French troops attack from the Dumont mill and the *Canadien* militiamen attack the British from the front along the Côteau Sainte-Geneviève. To the left, the Indians do not play a very active part. F.-X. Garneau says that they "stayed in the wood behind, spread out onto the battlefield while the French were pursuing the fugitives, and clubbed to death numerous English soldiers whose hair was subsequently found hanging on the neighbouring bushes" (p. 256).

The composition of the picture is an inverted pyramid with Lévis in full-dress uniform, mounted on a white horse at the apex. He looks towards the viewer and indicates the result of his brilliant stratagem with a wide gesture of his right hand. Lévis is painted rather like an equestrian statue. He is in the foreground of the picture, in a frieze of figures. To the left, *Canadien* militiamen advance, while Bourlamaque, the head of the brigade in charge of commanding the left is "grievously wounded by

Non-Exhibited Works

Author's Note

The entries concerning works exhibited and works not exhibited together form a complete catalogue of Légaré's work - or that attributed to him - which the present state of research has made known to us. For practical reasons of consistency and intelligibility, we have added to the known paintings not exhibited other works about which we have learned from various sources, but which have now disappeared, been destroyed, or cannot be traced. Because of the many dating problems posed by Légaré's works, we have decided to adopt the following thematic classification: 1. Religious Paintings, 2. Secular Paintings, 3. Miscellaneous types of work and uncompleted works.

Where the attribution of certain works to Légaré is uncertain, we have included these in our descriptive catalogue merely expressing a doubt concerning them, while waiting for more detailed research to provide eventual confirmation or refutation of our claims.

Several of the photographs of works not exhibited have been reproduced regardless of their quality. Most of them are strictly documentary photographs taken for research purposes. Since most of the paintings they record have never been shown and access to them is often difficult, we have decided to include small-size reproductions, considering that the presence of the image itself would permit both shorter texts and better understanding on the part of the reader.

I RELIGIOUS PAINTINGS

A THE VIRGIN, THE GOSPEL, AND VARIOUS OTHER SUBJECTS

82 *The Immaculte Conception*
Oil on canvas, about 3.2 x 2.13 m

Bibliography: A.P. de Notre-Dame de Québec, Box 23, no. 310; *Livre de délibérations de N. Dame de Québec* (1825-1864) MS 17A; *L'Ami de la religion et de la patrie* (4 Oct. 1848), p. 655, no. 30, advertisement reprinted on 6, 9, and 13 October 1848, (1 June 1849), p. 2, advertisement reprinted 17 times until September 24, (4 June 1849), pp. 2-3é; *Le Canadien* (2 Oct. 1848), p. 3. no. 30, advertisement reprinted eleven times until 30 October, (13 Oct. 1848), p. 2; *The Quebec Mercury*, (5 Oct. 1848), p. 3, no. 30, advertisement reprinted on 6 October, 1848; Charland (1916), p. 13; Trudel (1973), p. 3.

In 1835, Légaré asked the churchwardens of the parish of Notre-Dame de Québec "for permission to make a copy of the painting of the Conception of the Blessed Virgin," promising to make some urgently needed repairs to the canvas in return. This painting was at the high altar and at the time was attributed to Murillo; it was destroyed in the Cathedral fire in 1922. In 1848 Légaré showed a large copy at an exhibition-sale held in one of the rooms of the Assembly Chamber in Quebec. It was valued at £25. Being unsuccessful in selling his work, Légaré tried again, during the summer of 1849, by publishing an advertisement especially intended for parishes and congregations of the Immaculate Conception. We do not know whether these efforts on the part of the artist met with success.

Work now lost

83 *The Purification of Mary in the Temple* c. 1836
Oil on canvas, 2.24 x 1.47 m.

Provenance: Abbé Louis-Joseph Desjardins; Monastère des Ursulines, Three Rivers, 1836.

Bibliography: Catalogue of the Quebec Gallery of Paintings (1852), p. 5, no. 13; IBC, Joseph Légaré and Trois-Rivières (Ursulines) files; *Les Ursulines des Trois-Rivières,* vol. III (1898), p. 251.

Related works: nos 84 and 85.

A copy of a painting attributed to Domenico Feti (1589-1624), which belonged to Légaré's private collection and is now conserved in the Séminaire de Québec Museum (LU) (Catalogue 1933, no. 86). Légaré's picture forms a pair with *The Presentation of Mary in the Temple.* The two works formerly adorned the outer chapel of the Monastère des Ursulines.

Monastère des Ursulines, Three Rivers

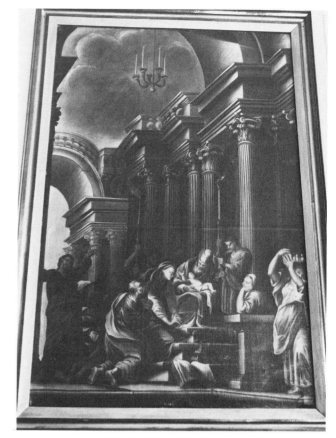

83

84 *The Presentation of Mary in the Temple* c. 1836
Oil on canvas, 2.24 x 1.47 m

Provenance: Abbé Louis-Joseph Desjardins; Monastère des Ursulines, Three Rivers, 1836.

Bibliography: Catalogue of the Quebec Gallery of Paintings, (1852), p. 5, no. 14; IBC, Joseph Légaré and Trois-Rivières (Ursulines) files; *Les Ursulines des Trois-Rivières,* vol. III (1898), p. 251.

Related works: Nos 83 and 85.

A copy of a painting attributed to Domenico Feti which belonged to Légaré and is now in the Musée du Séminaire de Québec (Catalogue 1933, no. 84).

Monastère des Ursulines, Three Rivers

85 *The Presentation of Mary in the Temple* or *Saint Joachim* 1825
Oil on canvas, approx. 3.0 x 2.0 m

Provenance: Church of Cap Santé.

Bibliograph: IBC, Joseph Légaré and Cap Santé files; Bellerive (1925), p. 13; Morisset, "Une belle peinture de Joseph Légaré" (1934), p. 2; Morisset, "La peinture au Canada français" (1934), p. 92; Morisset, "A l'église du Cap Santé" (1936), p. 2; Morisset, *Peintres et tableaux,* vol. II (1937), pp. 137-138; Morisset, *Coup d'œil* (1941), pp. 62-63; Morisset, *Le Cap-Santé* (1944), p. 27.

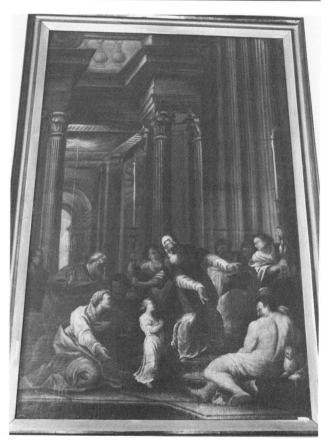

84

Related works: Nos 83 and 84.

In this copy, Légaré has integrated elements taken from two paintings attributed to Domenico Feti which belonged to his private collection and are now conserved in the Musée du Séminaire de Québec - paintings of which Légaré made copies for the Ursulines of Three Rivers c. 1836. The title of the Cap Santé painting may vary according to the importance given to the episode depicted or to the imposing figure of Saint Joachim accompanying his daughter to the temple.

Parish Church, Cap Santé

86 *The Presentation of Mary in the Temple*
Oil on canvas, approx. 2.28 x 1.78 m

Provenance: Church of Ancienne Lorette.

Bibliography: IBC, Joseph Légaré file; *Fêtes solennelles à l'Ancienne-Lorette* (1910), p. 8; Bellerive (1925), p. 13; Morisset, *La peinture au Canada français* (1934), p. 92; *Trésors des communautés religieuses de la ville de Québec* (1973), p. 34; Boisclair (1977), p. 66.

Related work: No. 165.

Partial copy of a painting belonging to the Hôtel-Dieu de Québec.

Church of Ancienne Lorette, Quebec

87 *The Annunciation*
Oil on canvas, 2.60 x 1.54 m

Provenance: Church of Ancienne Lorette; Musée du Québec, Quebec, 1973 (A 73 217 P).

Bibliography: Fêtes solennelles à l'Ancienne-Lorette, (1910), p. 8; Morisset, "Joseph Légaré copiste" [à Ancienne-Lorette] (1934), p. 2; Cauchon (1971), p. 123.

Related works: Nos 1, 34, and 156.

Attributed to Jean-Baptiste Roy-Audy by Morisset and Cauchon, this painting is a reversed version of a work by Légaré belonging to the Hôpital-Général de Québec. The two angels in the upper part are borrowed from a painting by Vouet belonging to the church of Saint-Henri de Lévis and of which Légaré made copies. The angel with long hair and hands crossed on his breast is borrowed from a painting which was destroyed in the Quebec Cathedral fire in 1922, and which was entitled *Le ravissement de saint Paul (The Rapture of Saint Paul).* Three copies of this latter painting by Légaré are known.

Musée du Québec, Quebec

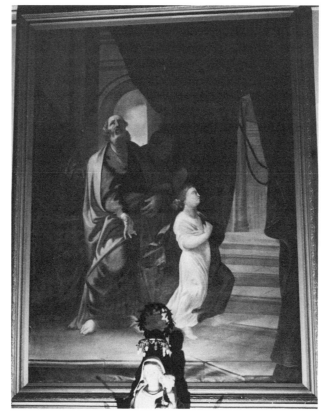

85

87

86

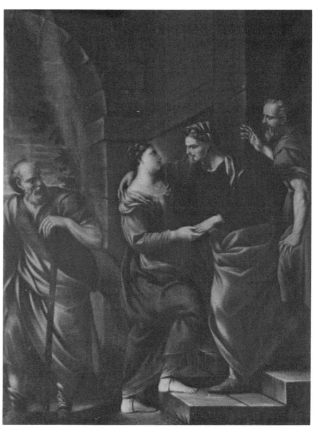

88

88 *The Visitation*
Oil on canvas, approx. 2.28 x 1.78 m

Provenance: Church of Ancienne Lorette.

Bibliography: IBC, Joseph Légaré file; *Fêtes solennelles à l'Ancienne-Lorette,* (1910), p. 8; Morisset, *La peinture au Canada français* (1934), p. 92; Morisset, "Joseph Légaré copiste" [à Ancienne-Lorette] (1934), p. 2.

A copy of a painting belonging to the Monastère des Ursulines of Quebec City.

Church of Ancienne Lorette, Quebec

89 *The Nativity* or *The Adoration of the Shepherds* 1824
Oil on canvas, 2.08 x 1.28 m

Inscription: Signed and dated, c. towards l., on a wall: *J. LEGARE/ pxt/ 1824.*

Provenance: Hôpital-Général de Québec, 1825 (P-21).

Bibliography: AHGQ, Annales, Vol. III (1794-1843), p. 210; Journal de la Dépense et de la Recette (1827-1842), (8 and 12 Oct. 1825); Livre de Comptes (1825-1861), year 1824-1825; Notes diverses (1686-1866), pp. 134-135; IBC, Hôpital-Général de Québec file; *Journal de Québec* (16 May 1871), p. 1; Lemoine (1872), p. 22; *Monseigneur de Saint-Vallier et l'Hôpital-Général de Québec* (1882), p. 503; Beaudet (1890), p. 163; *Album-Souvenir de la Basilique de Notre-Dame de Québec* (1923), p. 19; Morisset, "La Collection Desjardins - Les tableaux de l'ancienne cathédrale de Québec" (1934), p. 810; Morisset, *La peinture au Canada français* (1934), p. 92; Morisset, "Joseph Légaré, copiste à l'Hôpital-Général de Québec" (1935), p. 2.

Related work: No. 90.

A copy of a painting destroyed in the Quebec Cathedral fire in 1922. The latter was a reversed copy from an original attributed successively to Luca Cambioso and Guido Reni (1640-1642) and belonging to the Brera Museum in Milan (information communicated by Laurier Lacroix).

90 *The Nativity* or *The Adoration of The Shepherds* c. 1825
Oil on canvas, approx. 2.30 x 1.25 m

Provenance: Church of Sainte-Foy, Quebec.

Bibliography: Paris, Archives of Sainte-Foy, *Livres des Comptes de Fabrique pour Ste Foye* (1818-1830).

Related work: No. 89 (see cat. no. 113).

Work destroyed

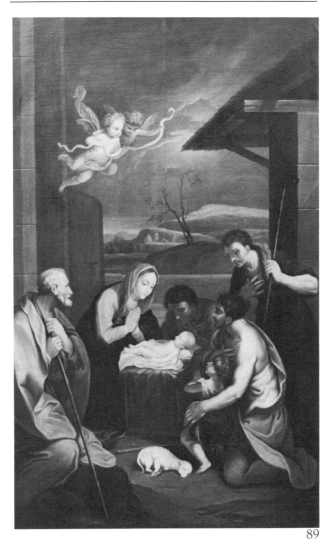

89

90

91 The Nativity c. 1842

Bibliography: AMUQ, *Desjardins Correspondence,* Letter from Abbé Louis-Joseph Desjardins to Sister Saint-Henry, (26 Jan. 1842); *L'Ami de la religion et de la patrie* (4 Oct. 1848), p. 655, no. 29, advertisement reprinted on 6, 9, and 13 Oct. 1848; *Le Canadien* (2 Oct. 1848), p. 3, no. 29, advertisement reprinted eleven times until 30 Oct.; *The Quebec Mercury* (5 Oct. 1848), p. 3, no. 29, advertisement reprinted on 6 Oct. 1848; *Trésors des communautés religieuses de la ville de Québec* (1973), p. 97.

Related work: No. 36a.

In January 1842, through Abbé L.-J. Desjardins, Légaré asked the Ursulines of Quebec for permission to copy the high-altar painting of their outside chapel, a *Nativity* attributed to Le Brun. It was perhaps this copy that was included in an exhibition organized by Légaré in one of the rooms of the Assembly Chamber in Quebec City for the purpose of a lottery planned for 23 October 1848. We do not know what became of this work then valued at £30. We have, however, discovered a sketch based on the Ursulines' painting on the back of an oil on paper painted by Légaré and now belonging to the Séminaire de Québec (see cat. no. 36).

Work now lost

92 The Virgin, Saint Elizabeth, the Infant Jesus, and Saint John the Baptist
Oil on canvas

Provenance: Church of Saint-Nicolas.

Bibliography: IBC, Joseph Légaré file; Magnan (1918), p. 11.

Attributed to Légaré by Magnan, this canvas is described as follows by Abbé Jean-Thomas Nadeau in a letter to Gérard Morisset in 1933:

"At the choir arch, a large canvas of about fourteen feet by twelve, *The Blessed Virgin and Saint Elizabeth* with the two children and a sheep; in the clouds, the eternal Father with chubby angels. Unsigned." Since destroyed in a fire at the church.

Work destroyed

93 The Holy Family Resting in Egypt c. 1820
Oil on canvas, approx. 2.3 x 1.6 m

Provenance: Church of Saint-Roche-des-Aulnaies.

Bibliography: IBC, Joseph Légaré and Saint-Roch-des-Aulnaies files; Morisset, "La Collection Desjardins et les peintures de l'école canadienne à Saint-Roch de Québec" (1934), p. 121; Morisset, "Joseph Légaré, copiste à Saint-Roch-des-Aulnaies" (1935), p. 2; *Jean Restout (1692-1768)* (1970), p. 210, no. 103; Vézina, *Théophile Hamel* (1975), p.

130.

Copy of a picture now belonging to the Séminaire de Québec Museum (Catalogue 1933, no. 47) and which was attributed by Rosenberg and Schnapper to Jean Restout. This picture came to Quebec long before the arrival of the Desjardins Collection (information communicated by Laurier Lacroix).

Parish Church, Saint-Roch-des-Aulnaies

94 (?)The Holy Family resting in Egypt
Oil on canvas, 71.7 x 101.5 cm

Provenance: Mrs Charles Narcisse Hamel (née Célina Légaré), 1874; Thomas Hamel; Mrs Léon Narcisse Hamel, Chicoutimi.

Exhibition: 1973, May, Chicoutimi, Société des Arts de Chicoutimi, Dufour Auditorium, *Peintures anciennes.*

Mrs Léon Narcisse Hamel, Chicoutimi

95 The Holy Family c. 1826
Oil on canvas, approx. 2.3 x 1.6 m

Provenance: Church of Bécancour.

Bibliography: Catalogue of the Quebec Gallery of Paintings, (1852), p. 4, no. 10; IBC, Bécancour file; Morisset, "Joseph Légaré copiste à l'église de Bécancour" (1935), p. 2; Boisclair (1977), pp. 14-15.

Related works: Nos 121, 124, and 177.

Copy of a painting belonging to the Hôtel-Dieu de Québec, with the exception of the God the Father. In his work, Légaré has replaced the God the Father of the Hôtel-Dieu picture by a copy of an *Everlasting Father* which belonged to him and is now in the Séminaire de Québec Museum (LU) (1933 Catalogue no. 154).

Parish Church, Bécancour

96 The Great Holy Family of Francis I c. 1824
Oil on canvas, 2.35 x 1.53 m

Provenance: Hôpital-Général de Québec, 1825 (P-19).

Bibliography: AHGQ, *Annales,* vol. III (1794-1843), p. 210; *Journal de la Dépense et de la Recette* (1827-1843), (8 and 12 Oct. 1825); *Livre de Comptes* (1825-1861), year 1824-1825; *Notes diverses* (1686-1866), pp. 134-135; IBC, *Hôpital-Général de Québec File; Journal de Québec* (16 May 1871), p. 1; Lemoine (1872), p. 22; *Monseigneur de Saint-Vallier et l'Hôpital-Général de Québec* (1882), p. 503; Beaudet (1890), p. 613; Morisset, *La peinture au Canada français* (1934), p. 92; Morisset, "Joseph Légaré, copiste à

93

94

95

97

96

99

l'Hôpital-Général de Québec" (1935), p. 2; "À l'église de Châteauguay," p. 571. Camesaca, *Tutta la pittura di Raffaelo*, vol. II p. 67 and pl. 130.

According to Morisset, this was a copy painted after a picture by Jacques Stella from the Desjardins Collection and which was destroyed at the same time as Nicolet Cathedral - in 1905. Stella's work was itself a copy after a painting by Raphael now in the Louvre. The Hôpital-Genéral canvas was known for many years under the title *The Visitation*.

Monastère des Augustines de l'Hôpital-Général de Québec, Quebec

97 *The Great Holy Family of Francis I*
Oil on canvas, approx. 3.0 x 2.05 m

Provenance: Church of Saint-Joachim de Châteauguay.

Bibliography: IBC, Châteauguay file; Morisset, "À l'église de Châteauguay" (1943), pp. 570-571; Letters from Mrs Pauline Séguin of Valleyfield to John R. Porter, 9 April and 7 October 1975, in the National Gallery of Canada.

Related work: No. 96.

Parish Church, Châteauguay

98 *The Infant in the Temple* c. 1825
Oil on canvas

Provenance: Hôpital-Général de Québec.

Bibliography: AHGQ, Annales, vol. III (1794-1843), p. 210; Journal de la Dépense et de la Recette (1827-1843), (8 and 12 Oct. 1825); Livre de Comptes (1825-1861), year 1824-1825; Notes diverses (1686-1866), pp. 134-135; *Journal de Québec* (16 May 1871), p. 1; Lemoine (1872), p. 22; *Monseigneur de Saint-Vallier et l'Hôpital-Général de Québec* (1882), p. 503; Beaudet (1890), p. 613; Morisset, *La peinture au Canada français* (1934), p. 92; Morisset, "Joseph Légaré, copiste à l'Hôpital-Général de Québec" (1935), p. 2.

This work disappeared from the chapel of the Hôpital-Général de Québec in 1892, when the pulpit on which it was hung was removed.

Work now lost

99 *Jesus as a Youth holding the Cross*
Oil on canvas, 44.3 x 41.6 cm

Provenance: Presbytery of Saint-Malachie (Dorchester Co.); private collection, *c.* 1955.

Copy of an engraving belonging to the Monastère des

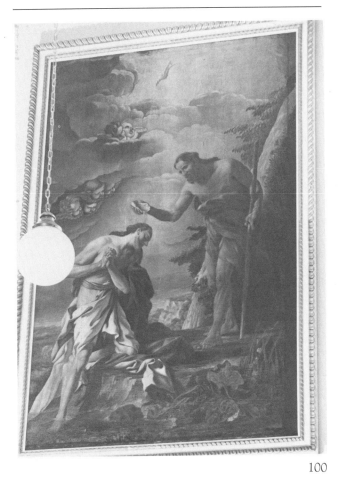

100

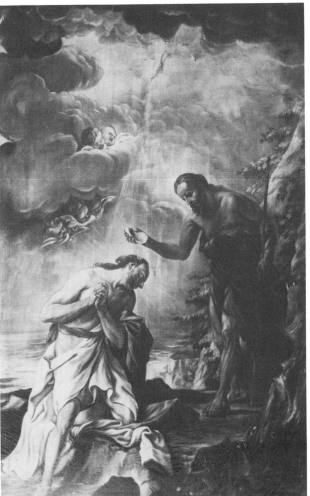

101

Private Collection

100 *The Baptism of Christ* c. 1828
Oil on canvas, approx. 2.3 x 1.6 m

Provenance: Church of Bécancour.

Bibliography: IBC, Bécancour file; Morisset, "La Collection Desjardins à Saint-Michel-de-la-Durantaye et au Séminaire de Québec" (1935), p. 558; Morisset, "Joseph Légaré copiste à l'église de Bécancour" (1935), p. 2; Cauchon (1971), pp. 70-71.

Related works: Nos 101 to 106.

It was not an engraving by Audran after the work by Mignard which served as a model for this painting but more probably a picture by Claude Guy Hallé which was destroyed when the chapel of the Séminaire de Québec burnt down 1 January 1888. The Bécancour *Baptism of Christ* is somewhat reminiscent, moreover, of versions made by several of our nineteenth-century painters, especially the one painted by Jean-Baptiste Roy-Audy in 1824 for the church at Deschambault.

Parish Church, Bécancour

101 *The Baptism of Christ*
Oil on canvas, 2.25 x 1.42 m

Provenance: Church of Saint-Antoine de Baie-du-Febvre (Baieville); Musée du Québec, Quebec, 1970 (A 70 125 P).

Bibliography: Bellemare (1911), p. 159; Duguay (1932), pp. 12-14; Morisset, "La Collection Desjardins à la Baie-du-Febvre" (1935), pp. 436-437; Morisset, "Joseph Légaré copiste à l'église de Bécancour" (1935), p. 2.

Related works: Nos 100 and 102 to 106.

Morisset attributes this painting to Légaré.

Musée du Québec, Quebec

102 *The Baptism of Christ* 1835
Oil on canvas, 98.4 x 70.8 cm

Provenance: Church of Saint-Henri de Lévis.

Bibliography: Parish archives of Saint-Henri, *Registre de la paroisse St Henry* (1781-1847), year 1835.

Related works: Nos 100, 101, and 103 to 106.

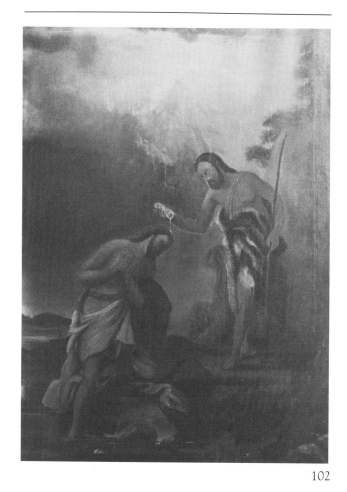

In the parish "Regîstre" for the year 1835, appears the entry: "paid to Mr. Légaré for baptistry painting £6.. 0.. 0." In poor condition, this picture has been completely and very clumsily repainted.

Parish Church, Saint-Henri

103 *The Baptism of Christ* c. 1842
Oil on canvas, approx. 74.0 x 49.0 cm

Inscription: Signed l.l., *J. Légaré.*

Provenance: Church of Saint-Joachim (Montmorency Co.).

Bibliography: IBC, Joseph Légaré and Saint-Joachim files; Morisset, "La Collection Desjardins à la Baie-du-Febvre" (1935), p. 437.

Related works: Nos 100 to 102 and 104 to 106.

As the result of an order from Mgr Signay for the purchase of a picture for the baptistry in 1839, Légaré executed a painting for which he received payment in 1842. Sold or destroyed, the work disappeared from the church in the 1940s.

Work now lost

104 *The Baptism of Christ*

Bibliography: L'Ami de la religion et de la patrie (4 Oct. 1848), p. 655, no. 10, advertisement reprinted on 6, 9, and 13 Oct. 1848; *Le Canadien* (2 Oct. 1848), p. 3, no. 10, advertisement reprinted eleven times until 30 Oct.; *The Quebec Mercury* (5 Oct. 1948), p. 3, no. 10, advertisement reprinted on 6 Oct. 1848.

Related works: Nos 100 to 103, 105 and 106.

In October 1848, Légaré exhibited some of his own works as well as certain paintings from his collection in one of the rooms of the Assembly Chamber in Quebec City for the purpose of a lottery to be held on the 23 of that month. No. 10 was entitled *Baptism by St. John* and valued at £7. 10s. This was perhaps a work painted by Légaré. The artist may quite possibly not have succeeded in selling this picture and donated it to the parish of Saint-Jean-Baptiste in Quebec City three years later (see cat. no. 105).

Work now lost

105 *The Baptism of Christ* c. 1850
Oil on canvas

Provenance: Church of Saint-Jean-Baptiste, Quebec.

Bibliography: IBC Joseph Légaré and Québec (Saint-Jean-Baptiste) files; *Journal de Québec* (16 May 1871), p. 1; Lemoine (1872), p. 20; Bellerive (1925), p. 13 (under a wrong title); Morisset, "La Collection Desjardins à Saint-Michel-de-la-Durantave et au Séminaire de Québec" (1935), p. 558; *Saint-Jean-Baptiste de Québec. Album ...* (1936), pp. 49, 51, 53, and 136.

Related works: Nos 100 to 104 and 106.

Légaré, who had been one of the churchwardens of Notre-Dame de Québec responsible for the building of the new succursal church of Saint-Jean-Baptiste, probably donated this painting shortly after its inauguration. Lemoine recounts that it was a copy of the painting by Claude Guy Hallé then hanging in the chapel of the Séminaire de Québec (see cat. no. 100). Légaré's work was destroyed when the church burnt down on 8 June 1881.

Work destroyed

106 *The Baptism of Christ*
Oil on canvas, 97.8 x 67.3 cm

Provenance: Church of Ancienne Lorette; Church of Saint-Gérard, Val-Bélair (near Quebec City), about 1910.

Bibliography: IBC, Joseph Légaré and Québec (Saint-Gérard) file.

Related works: Nos 100 to 105.

Morisset attributed this work to Légaré with certainty. As the painting was in a very bad state of repair it was thrown out during a "big housecleaning" in 1975.

Work destroyed

107 *The Probatical Pond* 1824
Oil on canvas, 1.96 x 1.51 m

Inscription: Signed and dated, l.l. on a beam at Christ's feet: *Jos LEGARE/pxt/1824.*

Provenance: Hôpital-Général de Québec, 1825 (P-17).

Bibliography: AHGQ, Annales, vol. III (1794-1843), p. 210; Journal de la Dépense et de la Recette (1827-1843), (8 and 12 Oct. 1825); AHGQ, Annales, vol III, Livre de Comptes (1825-1861), year 1824-1825; AHGQ, Annales, vol. III, Notes diverses (1686-1866), pp. 134-135; IBC, Hôpital-Général de Québec file; *Journal de Québec* (16 May 1871), p. 1; Lemoine (1872), p. 21; (anon.) *Monseigneur de Saint-Vallier et l'Hôpital-Général de Québec* (1882), p. 503; Beaudet (1890), p. 163; Morisset, *La peinture au Canada français* (1934), p. 92; Morisset, "Joseph Légaré, copiste à l'Hôpital-Général de Québec" (1935), p. 2; Morisset, "À

106

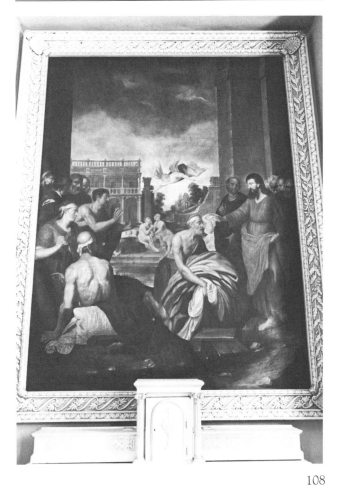

108

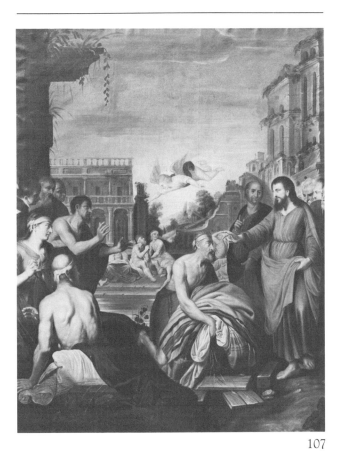

107

109

l'église de Châteauguay" (1943), p. 571.

Related work: No. 108.

Copy of a Dutch painting of which several versions exist attributed to various artists (information provided by Laurier Lacroix).

Monastère des Augustines de l'Hôpital-Général de Québec, Quebec

108 *The Probatical Pond*
Oil on canvas, approx. 3.0 x 2.05 m

Provenance: Church of Saint-Joachim, Châteauguay.

Bibliography: IBC, Châteauguay file; Morisset, "À l'église de Châteauguay" (1943), pp. 570-571; letters from Mrs Pauline Séguin of Valleyfield to John R. Porter, 9 Apr. and 7 Oct. 1975, in the National Gallery of Canada.

Related work: No. 107.

Parish Church, Châteauguay

109 *Christ attended by Angels* c. 1820
Oil on canvas, approx. 2.3 x 1.6 m

Provenance: Church of Saint-Roch-des-Aulnaies

Bibliography: IBC, Joseph Légaré and Saint-Roch-des-Aulnaies files; (anon.) *Album-Souvenir de la Basilique Notre-Dame de Québec* (1923), p. 21; Morisset, "Joesph Légaré, copiste à Saint-Roch-des-Aulnaies" (1935), p. 2; Morisset, *La peinture traditionnelle* (1960), p. 96.

Copy of a painting destroyed in the Quebec Cathedral fire in 1922. A version similar to this work is mentioned in the sacristy of the former collegial church of Briançon (Hautes-Alpes, France) (information provided by Laurier Lacroix).

Parish Church, Saint-Roch-des-Aulnaies

110 *The Flagellation*

Bibliography: L'Ami de la religion et de la patrie (4 Oct. 1848), p. 655, no. 31, advertisement reprinted on 6, 9, and 13 Oct. 1848; *Le Canadien* (2 Oct. 1848), p. 3, no. 31, advertisement reprinted eleven times until 30 Oct.; *The Quebec Mercury* (5 Oct. 1848), p. 3, no. 31, advertisement reprinted on 6 October 1848.

In October 1848, Légaré exhibited some of his own works, as well as certain paintings from his collection, in one of

the rooms of the Assembly Chamber in Quebec City for
the purpose of a lottery planned for the 23 of that month.
No. 31 was entitled *Flagellation* and valued at £23. This was
perhaps a work painted by Légaré. We do not know what
has become of it.

Work now lost

111 Christ falling beneath the Weight of the Cross
Oil on canvas, 64.2 x 80.7 cm

Inscription: Signed and dated, l.r.: *J. Légaré. Px.*

Provenance: Saint-Roch Church, Quebec; Musée du
Québec, Quebec, 1976 (A 76 164 P).

Bibliography: IBC, Joseph Légaré file; Morisset, *La peinture
au Canada français* (1934), p. 93; Morisset, "La Collection
Desjardins et les peintures de l'école canadienne à Saint-
Roch de Québec" (1934), p. 123; Morisset, "La Collection
Desjardins au couvent des Ursulines de Québec" (I)
(1935), p. 862; (anon.) *Trésors des communautés religieuses de
la ville de Québec* (1973), p. 94.

Copy of a painting hanging in the outer chapel of the
Monastère des Ursulines of Quebec City.

Musée du Québec, Quebec

112 Christ on the Cross 1824
Oil on canvas, 2.08 x 1.27 m

Inscription: Signed and dated, l.r., *J. LEGARE/pxt/1824.*

Provenance: Hôpital-Général de Québec, 1825 (P-16).

Bibliography: AHGQ, Annales, vol. III (1794-1843), p. 210;
AHGQ, Journal de la Dépense et de la Recette (1827-1843),
(8 and 12 Oct. 1825); AHGQ, Annales, Livre de Comptes
(1825-1861), year 1824-1825; AHGQ, Annales, Notes
diverses (1686-1866), pp. 134-135; IBC, Hôpital-Général
de Québec file; *Journal de Québec* (16 May 1871), p. 1;
Lemoine (1872), p. 21; (anon.) *Monseigneur de Saint-Vallier
et l'Hôpital-Général de Québec* (1882), p. 503; Beaudet
(1890), p. 163; (anon.) *Album-Souvenir de la Basilique
Notre-Dame de Québec* (1923), p. 15; Morisset, "La Collec-
tion Desjardins-Les tableaux de l'ancienne cathédrale de
Québec" (1934), p. 810; Morisset, *La peinture au Canada
français* (1934), p. 92; Morisset, "Joseph Légaré, copiste à
l'Hôpital-Général de Québec" (1935), p. 2; Porter and
Désy (1973), p. 32; Boisclair (1977), p. 82.

Related works: Nos 113 and 144.

Copy of a painting destroyed in the fire of Quebec Cathe-
dral in 1922. This work was a reversed copy from an origi-
nal by Van Dyck belonging to the Kunsthistorisches

111

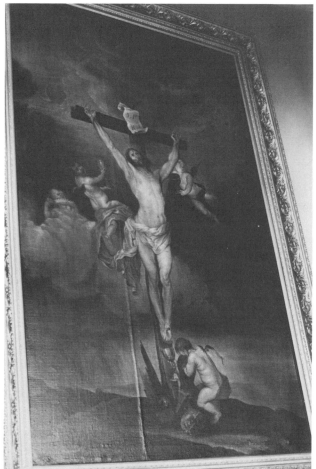

113

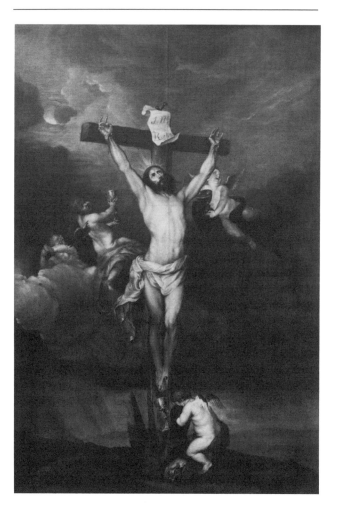

112

Museum, Vienna (information communicated by Laurier Lacroix).

Monastère des Augustines de l'Hôpital-Général de Québec, Quebec

113 Christ on the Cross *c. 1825*
Oil on canvas, approx. 2.3 x 1.25 m

Provenance: Church of Sainte-Foy, Quebec.
Bibliography: Paris archives of Sainte-Foy, Livre des Comptes de Fabrique pour Ste Foy (1818-1830); Vézina, *Théophile Hamel* (1975), pp. 243-244.

Related works: Nos 112 and 114.

The parish archives of Sainte-Foy mention payments "for paintings" in March 1825, February 1826, and February 1827. These payments may correspond with the three pictures which we attribute to Légaré and which were lost in the fire that destroyed the church on 12 June 1977 (see cat. nos 90, 152).

Work destroyed

114 The Crucifixion 1836
Oil on canvas, 4.5 x 2.43 m

Inscription: Signed and dated, l.l.: *J. Légaré px./1836*

Provenance: Church of Saint-Patrice, Quebec; Hospice Sainte-Brigitte, Quebec, *c.* 1875; Pères Rédemptoristes, Sainte-Anne-de-Beaupré, *c.* 1963.

Bibliography: Le Canadien (21 Sept. 1836) p. 2; *The Quebec Mercury* (27 Aug. 1836) p. 1, (24 Sept. 1836) p. 2; Parish archives of the Church of Saint-Patrice, various documents (31 Dec. 1836); IBC, Saint-Patrice file; Gluck (1931), pp. 247, 545; Morisset, "Une belle peinture de Joseph Légaré" (1934), p. 2; Morisset, *Coup d'oeil* (1941), p. 62; Harper (1970), p. 194; O'Gallagher, *Saint Patrick's, Québec* (1976), p. 9.

Related works: Nos 112 and 113.

Finished in 1836, this painting replaced a "Crucifixion" given to the church of Saint-Patrice by the American painter James Bowman (1793-1842) in 1833. The iconography of this picture comes from two sources. The Christ on the Cross and the two angels to his right are copied from a painting that was destroyed in the fire of Quebec Cathedral in 1922 (see cat. no. 112). The rest of the work is copied - probably after an engraving - from *The Crucifixion* that Van Dyck painted in 1630 for the high altar of Saint Michael's Church in Ghent (Belgium).

Oratoire des Pères Rédemptoristes, Sainte-Anne-de-Beaupré

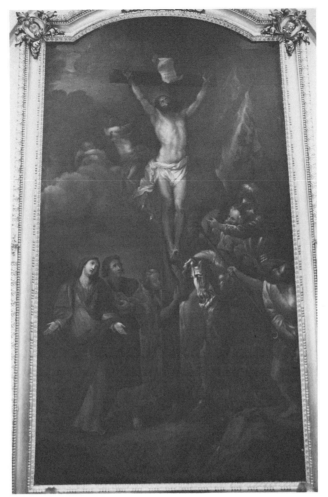

114

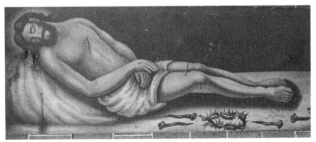

116

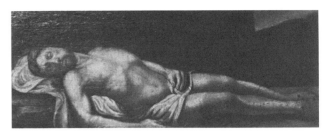

117

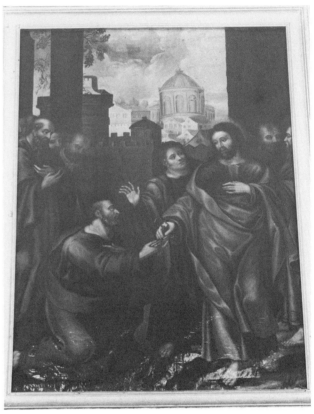

118

115 The Descent from the Cross

Bibliography: L'Ami de la religion et de la patrie (4 Oct. 1848), p. 655, no. 14, advertisement reprinted on 6, 9, and 13 Oct. 1848; *Le Canadien* (2 Oct. 1848), p. 3, no. 14, advertisement reprinted eleven times until 30 Oct.; *The Quebec Mercury* (5 Oct. 1848), p. 3, no. 14, advertisement reprinted on 6 Oct. 1848.

In October 1848 Légaré exhibited some of his own works, as well as certain paintings from his collection, in one of the rooms of the Assembly Chamber in Quebec City, for the purpose of a lottery to be held on the 23 of that same month. No. 14 was entitled *Descent from the Cross* and valued at £5. This was perhaps a work painted by Légaré. We do not know what has become of it.

Work now lost

116 The Dead Christ c. 1821
Oil on canvas, 73.0 x 205.7 cm

Provenance: Couvent Notre-Dame, Caraquet (New Brunswick) (loan from the church of Saint Pierre-aux-Liens, Caraquet).

Has similarities to a large altar frontal belonging to the Monastère des Ursulines of Quebec City.

Couvent Notre-Dame, Caraquet (on loan)

117 The Dead Christ
Oil on canvas, 19.7 x 53.4 cm

Provenance: Mr Édouard Légaré, great-grandson of the artist, Montreal.

Restored shortly before 1960 by a nun from the Couvent du Bon Pasteur in Quebec City.

Mr Édouard Légaré, Quebec

118 Christ Entrusting the Keys to Saint Peter c. 1820
Oil on canvas, approx. 2.3 x 1.6 m

Provenance: Church of Saint-Roch-des-Aulnaies.

Bibliography: The Quebec Mercury (13 July 1819) p. 219; ANQ-Q, Register of Notary Public Alexandre-B. Sirois (25 July 1836), no. 377, cat. no. 7; IBC, Joseph Légaré and Saint-Roch-des-Aulnaies files; Morisset, "La Collection Desjardins à la Baie-du-Febvre" (1935), p. 437; Morisset, "Joseph Légaré, copiste à Saint-Roch-des-Aulnaies" (1935), p. 2.

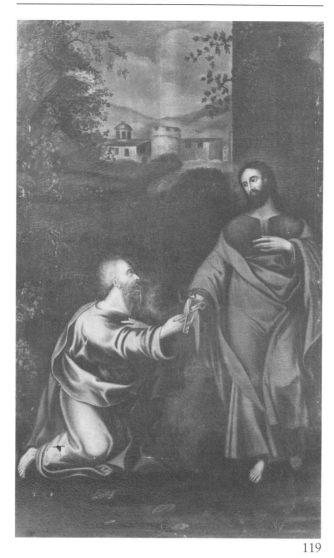

119

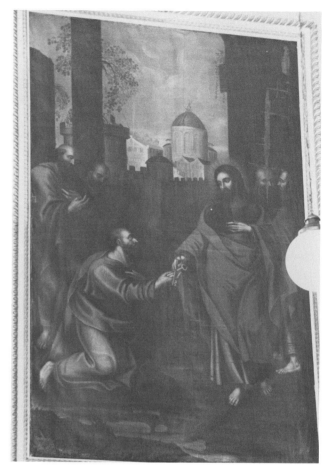

120

123

Related works: Nos 119 and 120.

Perhaps a copy of a painting offered for sale by the dealer Reiffenstein in 1819 and shown in Légaré's Gallery of Paintings, 1833-1836.

Parish Church, Saint-Roch-des-Aulnaies

119 Christ Entrusting the Keys to Saint Peter
Oil on canvas, 2.26 x 1.42 m

Provenance: Church of Saint-Antoine, Baie-du-Febvre (Baieville); Musée du Québec, Quebec, 1970 (A 70 120 P).

Bibliography: Bellemare (1911), p. 159; Duguay (1932), p. 12; Morisset, "La Collection Desjardins à la Baie-du-Febvre" (1935), pp. 436-437; Morisset, "Joseph Légaré copiste à l'église de Bécancour" (1935), p. 2.

Related works: Nos 118 and 120.

Musée du Québec, Quebec

120 Christ Entrusting the Keys to Saint Peter
Oil on canvas, approx. 2.3 x 1.6 m

Provenance: Church of Bécancour.

Bibliography: Morisset, "Joseph Légaré copiste à l'église de Bécancour" (1935), p. 2.

Related works: Nos 118 and 119.

Parish Church, Bécancour

121 The Everlasting Father Surrounded by Angels
c. 1824
Oil on canvas

Provenance: Church of Saint-Philippe, Three Rivers.

Bibliography: Catalogue of the Quebec Gallery of Painting (1852), p. 4, no. 10; IBC, Joseph Légaré and Trois-Rivières (Saint-Philippe) files; Morisset, "Joseph Légaré copiste" [à Trois-Rivières], (1934), p. 2; Morisset, *Peintres et tableaux* (I) (1936), pp. 1-2.

Related works: Nos 95, 124, and 177.

This painting adorned the arch of the transept crossing of' the former parish church of Three Rivers. It was lost when the church was destroyed by fire in 1908. According to Morisset, it was a copy of a work attributed to Nicolas Poussin in Légaré's private collection and now in the Musée du Séminaire de Québec (LU) (1933 Catalogue, no. 154).

Work destroyed

122 Cherub

Provenance: Séminaire de Québec, Quebec.

Bibliography: Laval University Catalogues (SQ) (1903) p. 31, no. 43, (1905) p. 33, no. 43, (1906) p. 45, no. 56.

Mentioned in three of the catalogues of Laval University: "A cherub, a sketch by Légaré" (in English) and "Chérubin. Esquisse de Légaré" (in French).

Work now lost

123 Jacob's Return from Mesopotamia
Oil canvas, 1.04 x 1.55 m

Provenance: Mrs Joseph Légaré, widow; Mrs Charles Narcisse Hamel (née Célina Légaré), 1872; Mr Thomas Hamel; Mrs Léon Narcisse Hamel, Chicoutimi.

Exhibition: 1973, May, Chicoutimi, La Société des Arts de Chicoutimi, Dufour Auditorium, *Peintures anciennes.*

Bibliography: L'Ami de la religion et de la patrie (4 Oct. 1848) p. 655, no. 1, (and reprints); Le Canadien (2 Oct. 1848) p. 3, no. 1, (and reprints); The Quebec Mercury (6 May 1845) p. 2, (5 Oct. 1948) p. 3, no. 1, and reprints; AJQ, Register of Notary Public Jean-Baptiste Delâge (6 Dec. 1872), no. 2921; Bellerive (1925), p. 14.

In May 1845, about a dozen of Légaré's works were exhibited at the Mechanics' Institute of Quebec. *The Quebec Mercury* published the list of these paintings, including *Jacob's Returning from Laban.* Moreover, a picture entitled *Return of Jacob* was exhibited at the Assembly Chamber in 1848. Valued at £30, this was perhaps the artist's model.

Mrs Léon Narcisse Hamel, Chicoutimi

124 The Virgin Mary, Mediatrix
Oil on canvas, 81.3 x 64.8 cm

Provenance: Gérard Morisset, Quebec; Régis Létourneau, Quebec; Jean Soucy, Quebec.

Given to Mr Létourneau by Gérard Morisset who had himself obtained it from a bank manager during the 1930s. This picture is really a kind of collage. To paint it, the artist drew his inspiration from several works. We have been able to identify the source of some of the elements of the painting: the Everlasting Father is borrowed from a canvas attributed to Poussin and which belonged to the artist (see

124

125

cat. no. 121); the female figure holding a child is taken from a work by Vouet, hanging in the church of Saint-Henri, in Lévis (see cat. no. 1); as for the figure on the left, this is a copy of a *Saint Hilaire* attributed to Salvator Rosa which belonged to Légaré and is now in the Musée du Séminaire de Québec (1933 Catalogue, no. 85).

Jean Soucy, Quebec

125 The Virgin Mary, Consoler of the Afflicted
Oil on canvas

Provenance: Church of Saint-Joachim, Châteauguay; Mr Arthur Alary, Montreal, 1961; Presbytery of Châteauguay, 1975.

Bibliography: IBC, Châteauguay file; Morisset, "À l'église de Châteauguay" (1943), p. 572; Letters from Mrs Pauline Séguin of Valleyfield to John R. Porter, 9 April and 7 October 1975, in the National Gallery of Canada.

Related works: Nos 1 and 124.

For the history of this painting, see cat. no. 159. To paint this picture, the artist drew inspiration from a work by Simon Vouet attributed until now to Jacques Blanchard (1600-1638) - belonging to the church of Saint-Roch in Quebec City (information communicated by Laurier Lacroix). In very poor condition and partly repainted, this work was formerly entitled *The Vision of Saint Anthony*. In his copy in Châteauguay, Légaré added to the protagonists of Vouet's work a female figure holding a child that he took from another of that painter's pictures belonging to the church of Saint-Henri de Lévis and depicting *Saint Francis of Paola Raising his Sister's Child from the Dead*. Morisset entitled Légaré's work *The Vision of Saint Jerome*.

Parish Presbytery, Châteauguay

126 Religion and the Times

Bibliography: L'Ami de la religion et de la patrie (4 Oct. 1848) p. 655, no. 20, advertisement reprinted on 6, 9, and 13 Oct. 1848; *Le Canadien* (2 Oct. 1848) p. 3, no. 20, advertisement reprinted eleven times until 30 Oct.; *The Quebec Mercury* (5 Oct. 1848) p. 3, no. 20, advertisement reprinted on 6 Oct.

In October 1848 Légaré exhibited some of his own works as well as certain paintings from his collection in one of the rooms of the Assembly Chamber in Quebec City, for the purpose of a lottery which was to take place on the 23 of that same month. No. 20 was entitled *Religion and the Times* (*La Religion et le temps*, in French) and valued at £20. This was probably a painting attributed to Francesco Albani which belonged to Légaré and which he later sold to the collector Edward Taylor Fletcher from whom the

Séminaire de Québec (LU) subsequently acquired it (1933 Catalogue, no. 120). The work shown in the Assembly Chamber may, however, have been a copy painted by Légaré. If this is so, we do not know what has become of it.

Work now lost(?)

127 A Painting 1828

Provenance: Maison de Maizerets, La Canardière (property of the Séminaire de Québec).

Bibliography: ASQ, Brouillard, 1823-1836 (18 Nov. 1839), p. 396; ASQ, *Séminaire 126*, no. 166, Mémoire de dépenses de Joseph Légaré (16 Nov. 1829).

Translation:
1828 Sept 2-1 Tableau 1.5.0
(Mémoire of 16 November 1829)
1829 November 18-Un tableau pour la chapelle de la Canardière (à Mr Légaré) 30#.
(Brouillard).

Work now lost(?)

B THE SAINTS

128 The Angel Gabriel c. 1842

Bibliography: AMUQ, Desjardins Correspondence, Letter from Abbé Louis-Joseph Desjardins to Sister Saint-Henry, 24 Nov. 1842 (see also May & July 1845); *Trésors des communautés religieuses de la ville de Québec* (1973), p. 97.

In November 1842 Abbé Desjardins wrote to Sister Saint-Henry: "Mr. Légaré would like to make a copy of The Angel Gabriel that he has seen in the storerooms." The original belonging to the Ursulines was still in Légaré's studio during the summer of 1845. We do not know whether Légaré made the proposed copy nor what became of it.

Work now lost

129 Angel holding the Holy Nails

Provenance: Séminaire de Québec, Quebec

Bibliography: Laval University Catalogues (SQ) (n.d. III), p. 17, no. 36.

Mentioned in only one of the catalogues of Laval University: "An angel with the Holy Nails. *Van Dyck.*/A copy by Légaré."

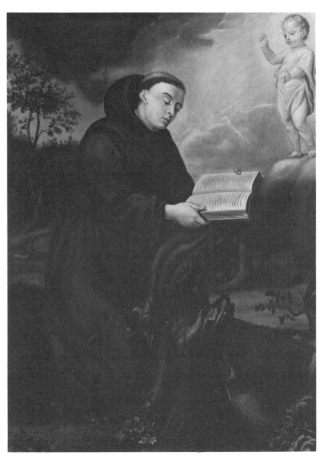

131

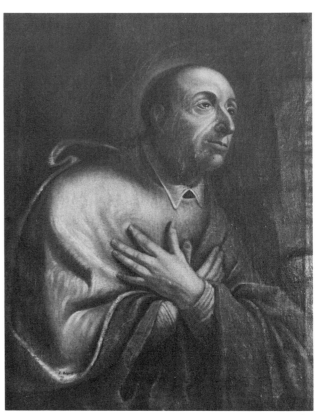

132

Work now lost (?)

130 Saint Ambrose

Bibliography: L'Ami de la religion et de la patrie (4 Oct. 1848)
p. 655, no. 28, advertisement reprinted on 6, 9, and 13 Oct.
1848; *Le Canadien* (2 Oct. 1848) p. 3, no. 28, advertisement
reprinted eleven times until 30 Oct.; *The Quebec Mercury*
(5 Oct. 1848) p. 3, no. 28, advertisement reprinted on 6
Oct.

In October 1848 Légaré exhibited some of his own works,
as well as certain paintings from his collection, in one of
the rooms of the Assembly Chamber in Quebec City, for
the purpose of a lottery planned for the 23 of that same
month. No. 28 was entitled *St. Ambrose*. Valued at £40,
this was probably a European work. We know that Légaré
owned a painting entitled *Saint Ambrose refusing the
Emperor Theodosius Entry to his Basilica*, a work now in the
Séminaire de Québec (LU) (1933 Catalogue, no. 326). The
work shown in the Assembly Chamber may, however,
have been a large size copy painted by Légaré. If this is the
case, we do not know what has become of it.

Work now lost(?)

131 The Vision of Saint Anthony of Padua
Oil on canvas, 1.81 x 1.35 m

Inscription: Signed, l.l.: *J. LEGARE.*

Provenance: Church of Ancienne-Lorette; Musée du
Québec, Quebec, 1973 (A 73 221 P).

Bibliography: IBC, Joseph Légaré file; "Fêtes solennelles à
l'Ancienne-Lorette" (1910), p. 8; Morisset, "Joseph Légaré
copiste" [à l'Ancienne-Lorette] (1934), p. 2.

For many years attributed to Dulongpré, this painting is
based on a work by Daniel Hallé belonging to the church
of Saint-Henri in Lévis.

Musée du Québec, Quebec

132 Saint Charles Borromeo at Prayer
Oil on canvas, 76.2 x 63.5 cm

Inscription: Signed, l.l.: *J. Légaré*

Provenance: Monastère des Ursulines, Three Rivers.

Bibliography: IBC, Joseph Légaré file; Three Rivers
(Ursulines) file; *Les Ursulines des Trois-Rivières,* vol. III
(1898), p. 250.

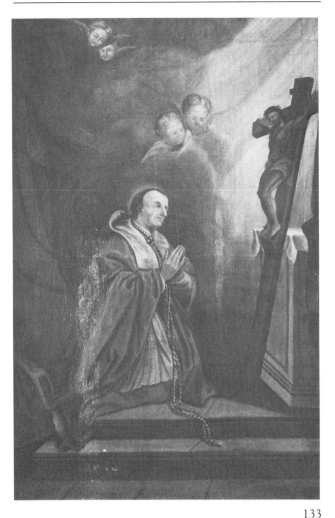

133

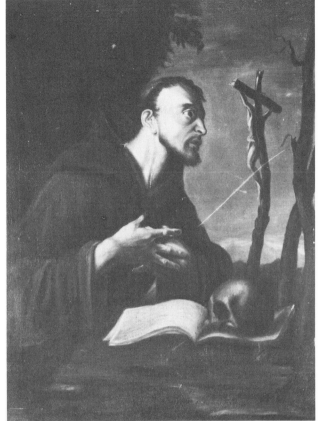

134

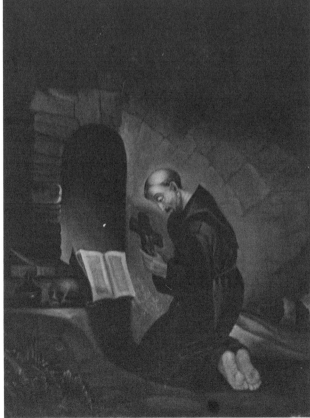

135

136

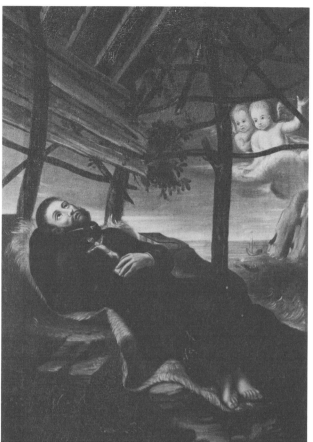

137

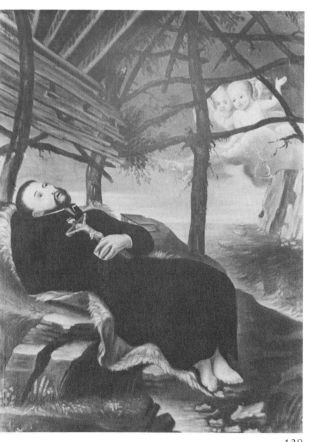

138

133 Saint Charles Borromeo at Prayer
Oil on canvas, 154.3 x 98.5 cm

Provenance: Church of Ancienne-Lorette; Musée du Québec, Quebec, 1973 (A 73 218 P).

Bibliography: IBC, Joseph Légaré file; *Fêtes solennelles à l'Ancienne-Lorette* (1910), p. 8; Morisset, *La peinture au Canada français* (1934), p. 92; Morisset, "Joseph Légaré copiste" [à l'Ancienne-Lorette] (1934), p. 2; Wildenstein, *Les oeuvres de Charles Le Brun* (1965), pp. 18-19, no. 106.

For this copy, Légaré probably drew inspiration from one of the engravings based on a canvas by Le Brun belonging to the church of Saint-Nicolas-du-Chardonnet in Paris.

Musée du Québec, Quebec

134 Saint Francis of Assisi in Ecstasy before a Crucifix
Oil on canvas, 123.2 x 92.7 cm

Inscription: Signed at the bottom, towards the c.: *J. LEGARE.*

Provenance: Church of Ancienne Lorette; Musée du Québec, Quebec, 1973 (A 73 229 P).

Bibliography: IBC, Joseph Légaré file; *Fêtes solennelles à l'Ancienne-Lorette* (1910), p. 8; Morisset, *La peinture au Canada français* (1934), p. 92; Morisset, "Joseph Légaré copiste" [à l'Ancienne-Lorette] (1934), p. 2.

Copy of a painting belonging to the Monastère de Ursulines of Quebec City. Antoine Plamondon made at least two copies of the same picture.

Musée du Québec, Quebec

135 Saint Francis of Assisi at Prayer
Oil on canvas, approx. 2.28 x 1.78 m

Provenance: Church of Ancienne Lorette.

Bibliography: IBC, Joseph Légaré file; *Fêtes solennelles à l'Ancienne-Lorette* (1910), p. 8; Morisset, *La peinture au Canada français* (1934), p. 92; Morisset, "Joseph Légaré copiste" [à l'Ancienne-Lorette] (1934), p. 2.

Related work: Cat. no. 5.

Church of Ancienne Lorette, Quebec

136 Saint Francis of Paola Raising his Sister's Child from the Dead
Oil on canvas, 152.4 x 95.9 cm

Inscription: Signed, l.l., *J. LEGARE.*

Provenance: Church of Ancienne Lorette; Musée du Québec, Quebec, 1973 (A 73 225 P).

Bibliography: IBC, Joseph Légaré file; *Fêtes solennelles à l'Ancienne-Lorette* (1910), p. 8; Morisset, "La Collection Desjardins - À Saint-Henri-de-Lauzon" (1934), p. 321; Morisset, "Joseph Légaré copiste" [à l'Ancienne-Lorette] (1934), p. 2.

Related work: No. 1.

Musée du Québec, Quebec

137 The Death of Saint Francis Xavier c. 1825
Oil on canvas, 54.2 x 39.7 cm

Provenance: Hôpital-Général de Québec, Quebec, 1826 (P-25).

Bibliography: AHGQ, Journal de la Dépense et de la Recette (1827-1843), 10 Feb. 1826; IBC, Hôpital-Général de Québec file: Morisset, "Joseph Légaré, copiste à l'Hôpital-Général de Québec" (1935), p. 2.

Related works: Nos 6 and 138 to 140.

Monastère des Augustines de l'Hôpital-Général de Québec, Quebec

138 The Death of Saint Francis Xavier c. 1826
Oil on canvas, 122.0 x 92.0 cm

Provenance: Church of Sainte-Croix, Lotbinière.

Bibliography: IBC, Louis Dulongpré file; Saint-Croix de Lotbinière file (provisional inventory, card 040-013/001/15).

Related works: Nos 6, 137, 139, and 140.

Gérard Morisset attributed this work to Louis Dulongpré (see cat. no. 6). It was probably painted by Légaré about 1826, since the artist received a payment from the Sainte-Croix parish council in that year.

Parish Church, Sainte-Croix

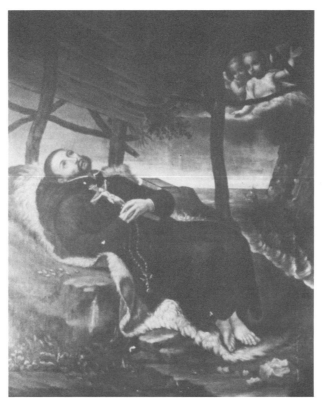

139

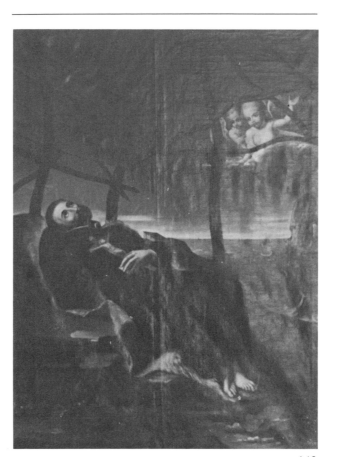

140

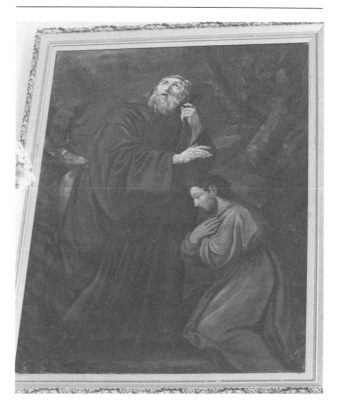

141

142

143

144

145

146

139 The Death of Saint Francis Xavier c. 1831
Oil on canvas, approx. 2.2 x 1.5 m

Provenance: Church of Vaudreuil.

Bibliography: IBC, Louis Dulongpré file.

Related works: Nos 6, 137, 138, and 140.

Gérard Morisset attributed this work to Louis Dulongpré (see cat. no. 6).

Parish Church, Vaudreuil

140 The Death of Saint Francis Xavier
Oil on canvas, approx. 2.28 x 1.78 m

Provenance: Church of Ancienne Lorette.

Bibliography: IBC, Joseph Légaré file; *Fêtes solennelles à l'Ancienne-Lorette* (1910), p. 8; Bellerive (1925), p. 13; Morisset, *La peinture au Canada français* (1934), p. 92; Morisset, "Joseph Légaré copiste" [à l'Ancienne-Lorette] (1934), p. 2.

Related works: Nos 6 and 137 to 139.

Church of Ancienne Lorette, Quebec

141 Saint Giles c. 1854
Oil on canvas, approx. 2.0 x 1.4 m

Provenance: Church of Saint-Gilles, Lotbinière.

Bibliography: Parish archives of Saint-Gilles, *Livre de comptes et de délibérations 1853-1899* (see 16 Oct. 1853, 1855, and 1858); IBC, Joseph Légaré and Saint-Gilles files (provisional inventory, card 28-12-12/001/4).

Related works: Nos 1 and 136.

Parish Church, Saint-Gilles

142 Saint John the Evangelist
Oil on canvas, 46.0 cm (diameter)

Provenance: Church of Ancienne Lorette.

Bibliography: Catalogue of the Quebec Gallery of Painting (1852), p. 9, no. 82; IBC, Joseph Légaré file; *Fêtes solennelles à l'Ancienne-Lorette* (1910), p. 8; Bellerive (1925), p. 13; Morisset, *La peinture au Canada français* (1934), p. 92; Morisset, "Joseph Légaré copiste" [à l'Ancienne-Lorette] (1934), p. 2.

Related works: Nos 143 to 145.

Copy of a work that once belonged to Légaré and is now in the Musée du Séminaire de Québec (LU) (1933 Catalogue, no. 107).

Church of Ancienne Lorette, Quebec

143 *An Evangelist*
Oil on canvas, 46.0 cm (diameter)

Provenance: Church of Ancienne Lorette.

Bibliography: Catalogue of the Quebec Gallery of Painting (1852), p. 6, no. 33; IBC, Joseph Légaré file, *Fêtes solennelles à l'Ancienne-Lorette* (1910), p. 8; Bellerive (1925), p. 13; Morisset, *La peinture au Canada français* (1934), p. 92; Morisset, "Joseph Légaré copiste" [à l'Ancienne-Lorette], (1934), p. 2.

Related works: Nos 142, 144, and 145.

The head of this evangelist is related to that of the hermit in *Saint Jerome in the Desert,* a painting attributed to Claude Vignon. Now in the Musée du Séminaire de Québec (LU), the latter work previously belonged to Joseph Légaré (1933 Catalogue, no. 7).

Church of Ancienne Lorette, Quebec

144 *An Evangelist*
Oil on canvas, 46.0 cm (diameter)

Provenance: Church of Ancienne Lorette.

Bibliography: IBC, Joseph Légaré file; *Fêtes solennelles à l'Ancienne-Lorette* (1910), p. 8; Bellerive (1925), p. 13; Morisset, *La peinture au Canada français* (1934), p. 92; Morisset, Joseph Légaré copiste [à l'Ancienne-Lorette] (1934), p. 2.

Related works: Nos 142, 143, and 145.

Church of Ancienne Lorette, Quebec

145 *An Evangelist*
Oil on canvas, 46.0 cm (diameter)

Provenance: Church of Ancienne Lorette.

Bibliography: See cat. no. 144.

Related works: Nos 142 to 144.

Church of Ancienne Lorette, Quebec

147

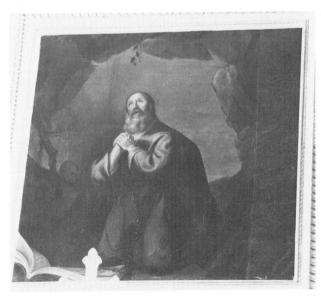

150

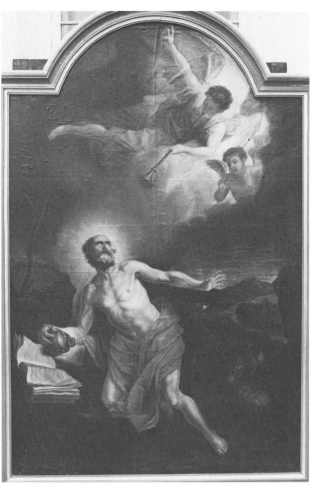

151

146 Saint John the Baptist
Oil on canvas, 80.7 x 62.8 cm

Inscription: Signed, l.l. on the cross: *J. Légaré pxt.*

Provenance: Légaré's Quebec Gallery of Painting; Séminaire de Québec, Quebec, 1874; antique dealer Gilbert, Quebec, 1957; Société Saint-Jean-Baptiste, Quebec.

Bibliography: AJQ, Register of Notary Public Jean-Baptiste Delâge (6 Dec. 1872), no. 2921; ASQ, *Séminaire 12,* no. 41 (1874) no. 184 or 264; Laval University Catalogues (SQ) 1933 onwards, no. 550.

Société Saint-Jean-Baptiste, Quebec

147 Saint John the Baptist
Oil on canvas, 124.2 x 99.7 cm

Provenance: Estate of Lady Langelier; Mr Marc Langelier, Quebec; Musée du Québec, Quebec (1958), (A 58 261 P).

This dark painting was damaged a long time ago and has since been considerably restored. There is some doubt as to whether it is by Légaré.

Musée du Québec, Quebec

152

154

148 Saint Jerome

Bibliography: L'Aurore des Canadas (20 Aug. 1842), p. 2; *The Quebec Mercury* (6 May 1845), p. 2; Tremblay (1972), p. 162.

This work was included in an exhibition and sale that the artist organized in Mrs Saint-Julien's salons in Montreal, in August 1842 (trans.): "... one must go in person to admire with one's own eyes, for example, his Saint Jerome whose effect comes entirely from the chiaroscuro, as does the artist's triumph." This was perhaps the same work that was shown at the Mechanics' Institute of Quebec in May 1845 and mentioned in an article in *The Quebec Mercury:* "St. Jerome in study - by Mr. Legare." If this was the case, it may have been a copy of a painting that Légaré had owned since 1822 following an exchange with the Charlesbourg parish council (see cat. no. 3).

Work now lost

149 Saint Jerome the Hermit

Bibliography: The Quebec Mercury (6 May 1845) p. 2.

In May 1845, a dozen of Légaré's works were included in

153

an exhibition held at the Mechanics' Institute of Quebec. *The Quebec Mercury* published the list of the works shown, and mentioned "St. Jerome - Hermit (Landscape), by Mr. Legare." We do not know what has become of this work, possibly a *Vision of Saint Jerome* (see cat. no. 151).

Work now lost

150 *Saint Jerome* or *Saint Francis of Assisi* c. 1828
Oil on canvas, approx. 1.5 x 1.5 m (right-hand part enlarged)

Provenance: Church of Bécancour.

Bibliography: IBC, Bécancour file; Morisset, "Joseph Légaré copiste à l'église de Bécancour" (1935), p. 2.

We have not been able to find the painting or engraving that served as the source of this picture which Morisset entitled *Saint Jerome* and which the parish account book seems to identify as a representation of Saint Francis of Assisi.

Parish Church, Bécancour

151 *The Vision of Saint Jerome* c. 1824
Oil on canvas, 2.37 x 1.56 m

Provenance: Hôpital-Général de Québec, 1825 (P-20).

Bibliography: AHGQ, Annales, vol III (1794-1843), p. 210; Journal de la Dépense et de la Recette (1827-1843), (8 and 12 Oct. 1825); AHGQ, Livre de Comptes (1825-1861), year 1824-1825; AHGQ, Notes diverses (1686-1866), pp. 134-135; IBC, Hôpital-Général de Québec file; *Journal de Québec* (16 May 1871), p. 1; Lemoine (1872), p. 22; (anon.) *Monseigneur de Saint-Vallier et l'Hôpital-Général de Québec* (1882), p. 503; Beaudet (1890), p. 163; Morisset, *La peinture au Canada français* (1934), p. 92; Morisset, "Joseph Légaré, copiste à l'Hôpital-Général de Québec" (1935), p. 2; Morisset, "La Collection Desjardins au musée de l'université Laval" (I) (1936), pp. 452-456.

Related works: Nos 152 and 153.

Copy of a work by Pierre d'Ulin dating from 1717, belonging to the Desjardins Collection and now in the Musée du Séminaire de Québec (LU) (1933 Catalogue, no. 42).

Monastère des Augustines de l'Hôpital-Général de Québec, Quebec

152 *The Vision of Saint Jerome* c. 1825
Oil on canvas, approx. 130.0 x 87.0 cm

Provenance: Church of Sainte-Foy, Quebec.

155

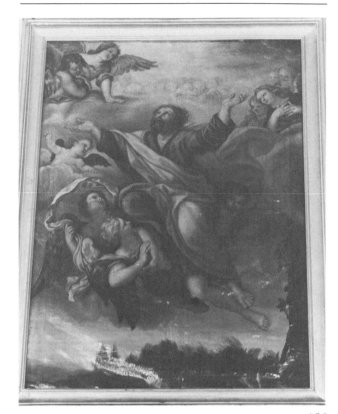

156

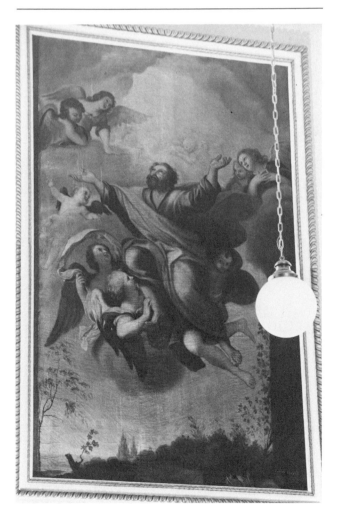

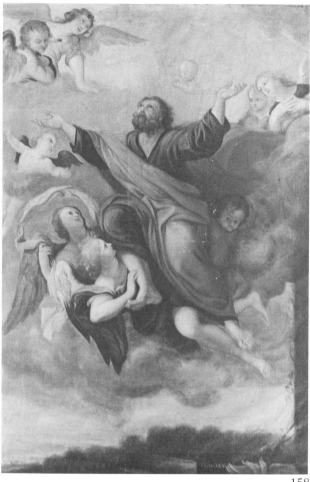

158

159

Bibliography: Parish archives of Sainte-Foy, *Livre des Comptes de Fabrique pour Ste Foye* (1818-1830).

Related works: Nos 151 and 153.

See cat. no. 113.

Work destroyed

153 *The Vision of Saint Jerome*
Oil on canvas, 155.0 x 97.2 cm

Provenance: Church of Ancienne Lorette; Musée du Québec, Quebec, 1973 (A 73 224 P).

Bibliography: IBC, Joseph Légaré file; *Fêtes solennelles à l'Ancienne-Lorette* (1910), p. 8; Morisset, "Joseph Légaré copiste" [à l'Ancienne-Lorette] (1934), p. 2; Morisset, "La Collection Desjardins au musée de l'université Laval" (I) (1936), p. 453.

Related works: Nos 151 and 152.

Musée du Québec, Quebec

154 *The Last Communion of Saint Jerome* c. 1828
Oil on canvas, approx. 2.3 x 1.6 m

Provenance: Church of Bécancour.

Bibliography: ASQ, Portfolio 69-G, p. 9; IBC, Bécancour file; (anon.) *Album-Souvenir de la Basilique de Notre-Dame de Québec* (1923), p. 31; Morisset, "Joseph Légaré copiste à l'église de Bécancour" (1935), p. 2.

Probably a copy of a picture belonging to the Monastère des Ursulines of Quebec City painted after the original by Domenichino in the Vatican Art Gallery. Another version of this painting was lost when fire destroyed the Quebec Cathedral in 1922. Contrary to Morisset's assertion, Légaré did not make use of an engraving belonging to the Séminaire de Québec, since this work was reversed in relation to the artist's painting.

Parish Church, Bécancour

155 *Saint Joachim*
Oil on canvas

Provenance: Church of Saint-Joachim, Châteauguay.

Bibliography: IBC, Châteauguay file; Morisset, "A l'église de Châteauguay" (1943), p. 572; Letters from Mrs Pauline Séguin of Valleyfield to John R. Porter, 9 April and 7 Oct. 1975, in the National Gallery of Canada.

160

162

This painting, situated above the high altar, might quite possibly be a work by Légaré as Morisset suggested. Abundant and obvious repainting, however, prevents us from verifying this attribution.

Parish Church, Châteauguay

156 *The Rapture of Saint Paul* 1820
Oil on canvas, approx. 2.3 x 1.6 m

Inscription: Signed and dated, l.b.: *J. Légaré/pxit/1820.*

Provenance: Church of Saint-Roch-des-Aulnaies.

Bibliography: IBC, Joseph Légaré and Saint-Roch-des-Aulnaies files; (anon.) *Album-Souvenir de la Basilique Notre-Dame de Québec* (1923), p. 21; Morisset, "Joseph Légaré copiste" [à Trois-Rivières] (1934), p. 2; Morisset, "Joseph Légaré copiste à l'église de Bécancour" (1935), p. 2; Morisset, "Joseph Légaré copiste à Saint-Roch-des-Aulnaies" (1935), p. 2.

Related works: Nos 87, 157, and 158.

Copy of a painting attributed to Carlo Maratta by Abbé P.-J.-L. Desjardins which was lost when fire destroyed the Quebec Cathedral in 1922.

Parish Church, Saint-Roch-des-Aulnaies

157 *The Rapture of St. Paul* 1821
Oil on canvas, approx. 2.3 x 1.6 m

Inscription: Signed and dated, l.r.: *J. LÉGARÉ 1821.*

Provenance: Church of Bécancour.

Bibliography: Morisset, "Joseph Légaré copiste à l'église de Bécancour" (1935), p. 2.

Related works: Nos 156 and 158.

Parish Church, Bécancour

158 *The Rapture of Saint Paul* 1822
Oil on canvas, approx. 2.2 x 1.5 m

Inscription: Signed and dated l.l.: *J. Légaré/1822.*

Provenance: Church of Saint-Philippe, Three Rivers.

Bibliography: IBC, Joseph Légaré and Trois-Rivières (Saint-Philippe) files; Morisset, "Joseph Légaré copiste" [à Trois-Rivières] (1934), p. 2; Morisset, "Joseph Légaré copiste à l'église de Bécancour" (1935) p. 2; Morisset,

163

164

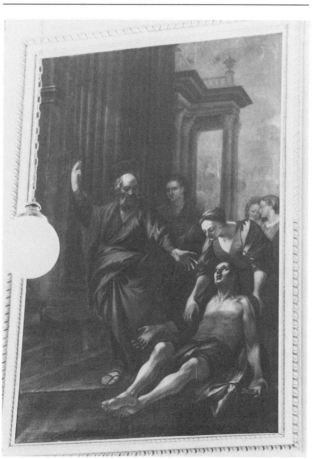

165

"Joseph Légaré copiste à Saint-Roch-des-Aulnaies" (1935), p. 2; Morisset, *Peintures et tableaux,* vol. I, (1936), pp. 1-2; Lord (1975), p. 13.

Related works: Nos 156 and 157.

See cat. no. 164.

Church of Saint-Philippe, Three Rivers

159 Saint Philip Baptizing the Eunuch of Queen Candace
Oil on canvas

Provenance: Church of Saint-Joachim, Châteauguay; Arthur Alary, Montreal, 1961; Presbytery of Châteauguay, 1975.

Bibliography: IBC, Châteauguay file; Morisset, "À l'église de Châteauguay" (1943), p. 572; Letters from Mrs Pauline Séguin of Valleyfield to John R. Porter, 9 April and 7 Oct. 1975, in the National Gallery of Canada.

Related works: Nos 2 and 160.

Originally rectangular in shape, this painting was cut by the decorator Xénophon Renaud to fit into the choir arch about 1914. Partly repainted twenty years later, it was removed from the arch in 1961 when the church was restored under the direction of the Quebec Historic Monuments Commission. Considered by the architect at that time to be of no value, it was given by the latter to the painter Arthur Alary of Montreal. After being approached by Mrs Pauline Séguin, in 1975, Mr Alary agreed to give the work back to the parish of Châteauguay at the same time as *The Virgin Mary, Consoler of the Afflicted* (see cat. no. 125).

Parish Presbytery, Châteauguay

160 Saint Philip Baptizing the Eunuch of Queen Candace
Oil on canvas, 152.4 x 95.3 cm

Inscription: Signed l.b.: *J. LEGARE.*

Provenance: Church of Ancienne Lorette; Musée du Québec, Quebec, 1973 (A 73 223 P).

Bibliography: IBC, Joseph Légaré file; *Fêtes solennelles à l'Ancienne-Lorette* (1910), p. 8; Morisset, *La peinture au Canada français* (1934), p. 92; Morisset, "La Collection Desjardins - À Saint-Henri-de-Lauzon" (1934), p. 326; Morisset, "Joseph Légaré copiste" [à l'Ancienne-Lorette] (1934), p. 2.

Related works: Nos 2 and 159.

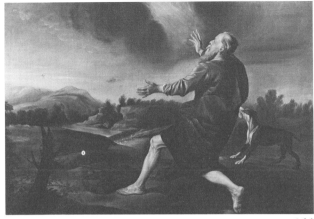

166

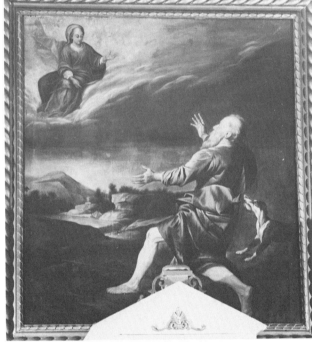

167

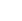

168

Musée du Québec, Quebec

161 Saint Peter in Penitence

Bibliography: The Quebec Mercury (6 May 1845) p. 2.

In May 1845, a dozen of Légaré's works were included in an exhibition held at the Mechanics' Institute of Quebec. *The Quebec Mercury* published the list of the works shown, mentioning "St. Peter in penitence - by Mr. Legare." We do not know what has become of this work.

Work now lost

162 Saint Peter Freed from his Prison 1820
Oil on canvas, approx. 1.5 x 2.0 m

Inscriptions: Signed and dated, l.l.: *J. Légaré / 1820*; l.l.: *C.N.D. / 1940.*

Provenance: Church of Saint-Pierre-aux-liens, Caraquet (New Brunswick); Musée Acadien, Caraquet.

Bibliography: Les Ursulines des Trois-Rivières, vol. III (1898), pp. 74, 85, 91.

Related works: Nos 163 and 164.

Sent by Abbé Louis-Joseph Desjardins to Abbé Thomas Cooke, a missionary at Caraquet, this picture was much repainted by a nun from the Congrégation Notre-Dame, in 1940.

Musée Acadien, Caraquet

163 Saint Peter Freed from his Prison c. 1824
Oil on canvas, 2.37 x 1.36 m

Provenance: Hôpital-Général de Québec, Quebec, 1825 (P-18).

Bibliography: AHGQ, Annales, vol. III (1794-1843), p. 210; Journal de la Dépense et de la Recette (1827-1843), (8 and 12 Oct. 1825); AHGQ, Annales, Livres de Comptes (1825-1861), year 1824-1825; AHGQ, Annales, Notes diverses (1686-1866), pp. 134-135; IBC, Hôpital-Général de Québec file; *Journal de Québec* (16 May 1871), p. 1; Lemoine (1872), p. 22; (anon.) *Monseigneur de Saint-Vallier et l'Hôpital-Général de Québec* (1882), p. 503; Beaudet (1890), p. 163; Morisset, "Joseph Légaré copiste [à Trois-Rivières] (1934), p. 2; Morisset, *La peinture au Canada français* (1934), p. 92; Morisset, "Joseph Légaré, copiste à l'Hôpital-Général de Québec" (1935), p. 2; Morisset, "La Collection Desjardins à Saint-Michel-de-la-Durantaye et au Séminaire de Québec" (1935), p. 559; Morisset, *La peinture traditionnelle*

(1960), p. 96.

Related works: Nos 162 and 164.

Copy of a work - formerly attributed to Charles de La Fosse (1636-1716) - belonging to the Desjardins Collection. It was lost when fire destroyed the chapel of the Séminaire de Québec, 1 January 1888.

Monastère des Augustines de l'Hôpital-Général de Québec, Quebec

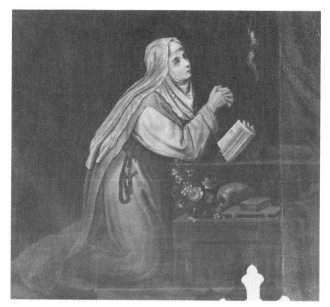

172

164 *Saint Peter Freed from his Prison* c. 1825
Oil on canvas, approx. 2.2 x 1.5 m

Provenance: Church of Saint-Philippe, Three Rivers.

Bibliography: IBC, Joseph Légaré and Trois-Rivières (Saint-Philippe) files; Morisset, *La peinture au Canada français* (1934), p. 92; Morisset, "Joseph Légaré copiste [à Trois-Rivières] (1934), p. 2; Morisset, "La Collection Desjardins à Saint-Michel-de-la-Durantaye et au Séminaire de Québec" (1935), p. 559; Morisset, "Joseph Légaré copiste à l'Hôpital-Général de Québec" (1935), p. 2; Morisset, *Peintures et tableaux,* vol. I, (1936), pp. 1-2; Morisset, *La peinture traditionnelle* (1960), p. 96; Lord (1975), p. 13.

Related works: Nos 162 and 163.

This painting was one of the works that was saved when fire destroyed a church formerly in Three Rivers until 1908. It was classified as a "cultural property" by the Department of Cultural Affairs in 1975, along with two other works by the artist (cat. nos 158 and 167).

Church of Saint-Philippe, Three Rivers

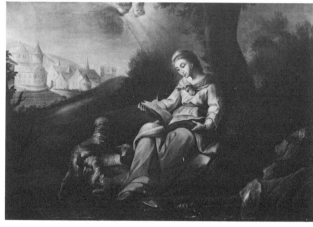

173

165 *Saint Peter Curing a Sick Person* c. 1825
Oil on canvas, approx. 2.3 x 1.6 m

Provenance: Church of Bécancour.

Bibliography: IBC, Bécancour file; Morisset, "Joseph Légaré copiste à l'église de Bécancour" (1935), p. 2; Liste de Tableaux achetés de la Gallerie de feu l'Honble J. Légaré par Mr Fletcher employé au Bureau des Terres (1855) (photocopy in the papers of the Légaré family); Catalogue of the Quebec Gallery of Paintings (1852), p. 5, no. 18.

Morisset is probably not wrong to speak of this painting as "a collection of quotations." However, he does make a mistake when he lists the pictures used by Légaré for his copy. Personally, we were only able to identify one of the artist's models. This was *The Presentation of Mary in the Temple,* belonging to the Hôtel-Dieu in Quebec City and of which Légaré made a partial copy for the church of Ancienne Lorette. In the Bécancour painting, we find the

171

same architectural setting - but reversed - and the two figures in the background. Légaré could also have been inspired by the *Saint Peter Curing the Sick,* a painting in his own collection. It was sold to Fletcher in 1855, and we have not been able to trace it. This work also raises doubts as to its attribution since the parish of Bécancour made a payment "to Mr. Plamondon for the picture of Saint Peter" in 1825.

Parish Church, Bécancour

166 The Vision of Saint Roch
Oil on canvas, 77.5 x 115.6 cm

Provenance: Church of Ancienne Lorette; Musée du Québec, Quebec, 1973 (A 73 220 P).

Bibliography: Catalogue of the Quebec Gallery of Paintings (1852), p. 4, no. 9; *Fêtes solennelles à l'Ancienne-Lorette* (1910), p. 8; Morisset, "Joseph Légaré copiste" [à l'Ancienne-Lorette] (1934), p. 2; Morisset, "La Collection Desjardins au musée de l'université Laval" (II) (1936), p. 116.

Related work: No. 167.

Partial copy of a picture entitled *Elijah throwing his Mantle to the Prophet Elisha* which belonged to the artist and is now in the Musée du Séminaire de Québec (LU) (1933 Catalogue, no. 153). Légaré's work was, for many years, attributed to Dulongpré.

Musée du Québec, Quebec

167 The Vision of Saint Roch c. 1825
Oil on canvas, approx. 1.8 x 1.5 m

Provenance: Church of Saint-Philippe, Three Rivers.

Bibliography: IBC, Joseph Légaré and Trois-Rivières (Saint-Philippe) files; Morisset, *La peinture au Canada français* (1934), p. 92; Morisset, "Joseph Légaré copiste [à Trois-Rivières] (1934), p. 2; Morisset, "La Collection Desjardins au musée de l'université Laval" (II) (1936), p. 116; Morisset, *Peintures et tableaux,* vol. I, (1936), pp. 1-2; Lord, (1975), p. 13.

Related work: No. 166.

See cat. no. 164. Version similar to that of the Musée du Québec, but completed by the addition of a Virgin Mary in the upper left part of the painting.

Church of Saint Philippe, Three Rivers

168 Saint Vincent of Paola Blessing a Convict
Sepia 33.7 x 25.4 cm

Provenance: Légaré's Quebec Gallery of Painting?; Séminaire de Québec, Quebec (?) 1874 (Archives, *Portfolio* 80-G).

This work is probably a copy made from an engraving. We attribute it to Légaré on stylistic grounds.

Séminaire de Québec, Quebec

169 Charity and Saint Catherine

Bibliography: *L'Ami de la religion et de la patrie* (4 Oct. 1848), p. 655, no. 21, advertisement reprinted on 6, 9, and 13 Oct. 1848; *Le Canadien* (2 Oct. 1848), p. 3, no. 21, advertisement reprinted eleven times until 30 Oct.; *The Quebec Mercury* (5 Oct. 1848), p. 3, no. 21, advertisement reprinted on 6 Oct. 1848.

In October 1848, Légaré exhibited some of his own works, as well as certain paintings from his collection, in one of the rooms of the Assembly Chamber in Quebec City, for the purpose of a lottery that was to be held on the 23 of that same month. No. 21 was entitled *St. Catherine and Charity* (*La Charité et Ste. Catherine,* in French) and valued at £20. This was perhaps a work painted by Légaré. We do not know what has become of it.

Work now lost

170 The Burial of Saint Catherine of Alexandria
c. 1840
Oil on canvas pasted on cardboard, 58.4 x 55.3 cm

Provenance: Mrs Pierre Duhamel, Deschambault, Quebec; Louis Carrier, Montreal, *c.* 1953; Musée du Québec, Quebec, 1960 (A 60 915 P).

Bibliography: IBC, Trois-Rivières (Ursulines) file; *Les Ursulines des Trois-Rivières,* vol. III (1898), p. 250.

Copy of a painting belonging to the Monastère des Ursulines of Three Rivers, this picture has been entitled up to now *The Burial of Saint Claire.*

Musée du Québec, Quebec

171 Saint Catherine of Sienna c. 1826
Oil on canvas, 122.0 x 92.0 cm

Provenance: Church of Sainte-Croix, Lotbinière.

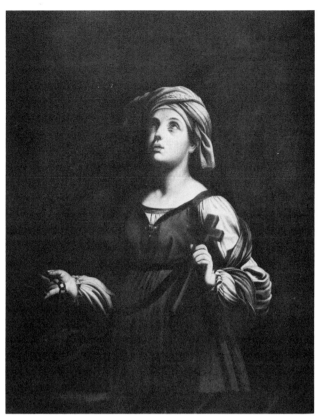

175

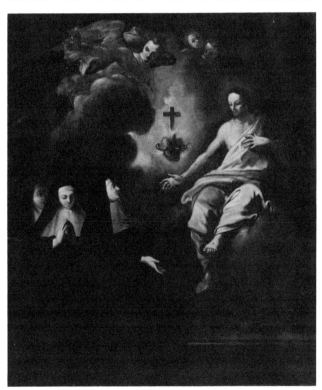

176

131

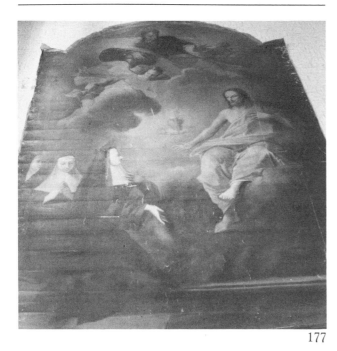

177

181

179

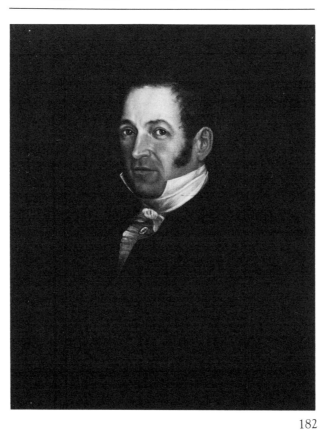

182

Bibliography: IBC, Louis Dulongpré and Sainte-Croix de Lotbinière files (provisional inventory, card 040-013/001/16).

Related work: No. 172.

Having attributed to Louis Dulongpré a painting entitled *The Death of Saint Francis Xavier* belonging to the church of Sainte-Croix (see cat. 138), Morisset attributed *Saint Catherine of Sienna*, a work of the same size, to the same artist. Probably painted by Légaré about 1826, this work shows slight variations compared with the version in the church at Bécancour.

Parish Church, Sainte-Croix

172 *Saint Catherine of Sienna* c. 1828
Oil on canvas, approx. 1.5 x 1.5 m (right-hand part enlarged)

Provenance: Church of Bécancour.

Bibliography: IBC, Bécancour file; Morisset, "Joseph Légaré copiste à l'église de Bécancour" (1935), p. 2; *Deux peintres de Québec* (1970), pp. 78, 79, 134.

Related work: No. 171.

To paint this picture, the artist either made use of an engraving by N. Bazin after Domenico Feti (information communicated by Laurier Lacroix) or a painting entitled *Saint Claire of Assisi* which belongs to the Monastère des Ursulines of Quebec City. When the work was acquired in 1828, it was entitled *Sainte-Thérèse* (see account book). Plamondon painted different versions of the same subject, one of which dates from 1840 and is in the Art Gallery of Ontario, Toronto.

Parish Church, Bécancour

173 *Saint Genevieve tending her Flock*
Oil on canvas, 77.5 x 114.3 cm

Provenance: Church of Ancienne Lorette; Musée du Québec, Quebec, 1973 (A 73 219 P).

Bibliography: *Fêtes solennelles à l'Ancienne-Lorette* (1910), p. 8; Morisset, "Joseph Légaré copiste" [à l'Ancienne-Lorette] (1934), p. 2; Noppen (1974), pp. 27, 30, 31.

Attributed to Dulongpré until now, this copy of a work belonging to the church of Notre-Dame-des-Victoires in Quebec City has more in common with Légaré's style.

Musée du Québec, Quebec

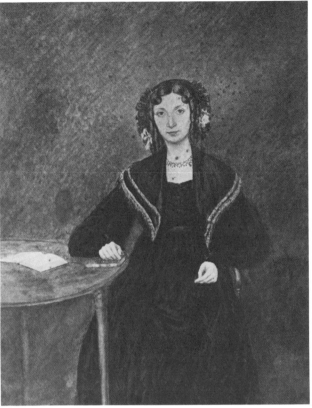

184

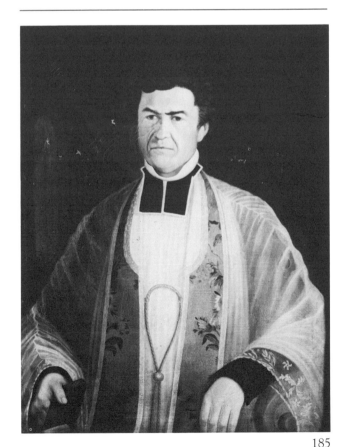

185

174 St. Magdalen

Bibliography: L'Ami de la religion et de la patrie (4 Oct. 1848), p. 655, no. 11, advertisement reprinted on 6, 9, and 13 Oct. 1848; Le Canadien (2 Oct. 1848), p. 3, no. 11, advertisement reprinted eleven times until 30 Oct.; The Quebec Mercury (5 Oct. 1848), p. 3, no. 11, advertisement reprinted on 6 Oct. 1848.

In October 1848, Légaré exhibited some of his own works as well as some of the paintings from his collection in one of the rooms of the Assembly Chamber in Quebec City, for the purpose of a lottery to be held on the 23 of that same month. No. 11 was entitled *St. Magdalen* (*Ste. Magdeleine* in French) and valued at £3. It was perhaps a work painted by Légaré from a picture that belonged to him and today is in the Musée du Séminaire de Québec (LU) (1933 Catalogue, no. 40). Whatever the case may be, we do not know what has become of it.

Work now lost

175 Saint Margaret of Antioch
Oil on canvas, 124.5 x 91.5 cm

Provenance: Church of Ancienne Lorette; Musée du Québec, Quebec, 1973 (A 73 228 P).

Bibliography: IBC, Joseph Légaré file; *Fêtes solennelles à l'Ancienne-Lorette* (1910), p. 8; Bellerive (1925), p. 13; Morisset, *La peinture au Canada français* (1934), p. 92; Morisset, "Joseph Légaré copiste" [à l'Ancienne-Lorette] (1934), p. 2.

Copy of a picture entitled *Saint Cecilia* (she is holding a violin and bow) and in the museum of the Monastère des Ursulines of Quebec City. By changing her attributes, Légaré has turned this figure into a *Saint Margaret of Antioch*. Until now, this work has been wrongly entitled *Saint Agnes*.

Musée du Québec, Quebec

176 The Vision of Saint Margaret Mary Alacoque or Christ Revealing His Heart to Nuns c. 1839
Oil on canvas, 1.33 x 1.12 m

Provenance: Pierre Pelletier, Quebec, 1839; Hôpital-Général de Québec, Quebec, 1839 (P-22).

Bibliography: AHGQ, Journal tenu par les Novices, vol. I (1837-1857), p. 18; IBC, Hôpital-Général de Québec file; *Journal de Québec* (16 May 1871), p. 1; Lemoine (1872), p. 22; Morisset, "La Collection Desjardins au couvent des Ursulines de Québec" (I), (1935), pp. 865-867; Morisset, "Joseph Légaré, copiste à l'Hôpital-Général de Québec,"

(1935), p. 2; Trudel (1972), pp. 39-41, 93; Porter (1975), p. 14.

Related work: No. 177.

Copy of a painting that adorned the altar piece of the Sacred Heart in the chapel of the Monastère des Ursulines of Quebec City.

Monastère des Augustines de l'Hôpital-Général de Québec, Quebec

177 The Vision of Saint Margaret Mary Alacoque or Christ Revealing His Heart to Nuns c. 1840
Oil on canvas, 3.25 x 2.12 m

Provenance: Abbé Louis-Joseph Desjardins; Monastère des Ursulines, Three Rivers, 1840.

Bibliography: Catalogue of the Quebec Gallery of Paintings (1852), p. 4, no. 11; AMUTR, Letter from Abbé Louis-Joseph Desjardins to M. Fortin, Chaplain of the Ursulines of Three Rivers, 31 July and 10 August 1840; IBC, Trois Rivières (Ursulines) file; (anon.) *Les Ursulines des Trois-Rivières*, vol. III (1898), p. 250.

Related works: Nos 121 and 176.

The iconography of this painting is based on two models. The Everlasting Father in the upper part is a copy of a work attributed to Nicolas Poussin in Légaré's private collection and now in the Musée du Séminaire de Québec (LU) (1933 Catalogue, no. 514). The rest of the painting is a copy of the work that adorns the altar piece of the Sacred Heart in the chapel of the Monastère des Ursulines of Quebec City. Now stored in the attic of the Trois-Rivières Convent and in poor condition, Légaré's work was once used as the high-altar painting in the former outer chapel of the institution.

Monastère des Ursulines, Three Rivers

II SECULAR PAINTINGS

A PORTRAITS

178 Judge Becquet

Bibliography: Morisset, *La peinture traditionnelle* (1960), p. 97.

This may well be a portrait of Judge Édouard Bacquet who shared the ownership of certain paintings with Légaré and of whose collection Légaré made an inventory in April and May 1853 (see Porter, *Un projet de musée* [1977], p. 78).

Whereabouts unknown

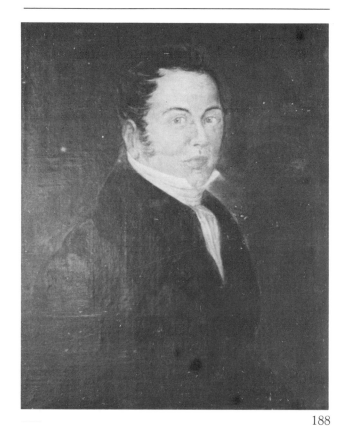

188

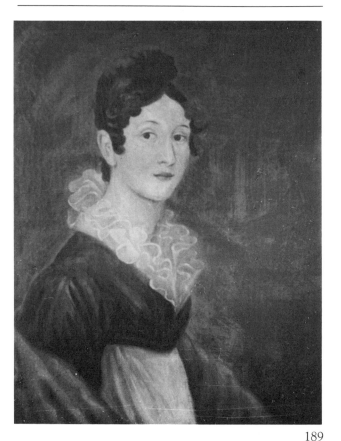

189

179 Madame Philippe Braün c. 1825
Oil on canvas, 68.8 x 56.0 cm

Provenance: Estate of Lady Langelier; Marc Langelier, Quebec; Musée du Québec, Quebec, 1958 (A 58 262 P).

Bibliography: Files of the Musée du Québec; Joseph-Octave Plassis, *Les dénombrements de Québec faits en 1792, 1795, 1798 et 1805*, pp. 69, 116, 165.

From the censuses in Quebec City carried out in 1795, 1798, and 1805, we learn that the artist's father, then a shoemaker, had a neighbour on Saint-Jean Street, called Philippe Braün, a gunsmith. In 1784, Braün had married Marie-Louise Coulombe whose portrait, attributed by Morisset to Légaré, is in the Musée du Québec.

Musée du Québec, Quebec

180 Judge Chabot

Bibliography: Morisset, *La peinture traditionnelle* (1960), p. 97.

Whereabouts unknown

181 Father Pierre-François-Xavier de Charlevoix 1842
Oil on canvas, 36.5 x 33.3 cm

Inscriptions: verso, on a paper pasted on the back: *Ce portrait du Revd pre/Charlevoix est copié/sur l'original de L'Hôtel-Dieu/de Québec venant des Jésuites 1842/Mr Jh Légaré Artiste* (This portrait of the Rev. Father Charlevoix is copied from the original at the Hotel-Dieu in Quebec coming from the Jesuits 1842 Mr Jh. Légaré, Artist). *Verso,* on two papers pasted on the back are two more recent copies of the same text.

Provenance: Archives of the Collège Sainte-Marie, Montreal; Maison des Jésuites, Saint-Jerome.

Bibliography: L'Aurore des Canadas (20 Aug. 1842), pp. 2-3; ASJCF, Saint-Jérôme, Letters from Father Léon Pouliot, sj, to Marie-Nicole Boisclair, 17 and 19 Feb. 1976, (copies in the National Gallery of Canada); *Histoire véritable et naturelle . . .*, by Pierre Boucher (1664), facsimile edition of the original with commentaries and studies (1964), p. 222; Tremblay (1972), pp. 162-163; Boisclair (1977), pp. 40, 41, 160 (with numerous references).

Related work: No. 52.

In August 1842, Légaré organized an exhibition and sale of his paintings in Mrs Saint-Julien's salons in Montreal. A portrait of Charlevoix was one of the works on display, probably the same picture that is now in the Maison des

Jésuites in Saint-Jerome. From the inscriptions - one of which is very old - to be found on the back of the work we learn that it was a copy of a painting then belonging to the Hôtel-Dieu in Quebec City and which had come from the Jesuits. This model perhaps corresponded with a portrait of Father Paul Le Jeune, which was restored in 1831 and which has since disappeared. We are not in a position to identify the personage represented with absolute certainty, in spite of research by Father Pouliot and Miss Boisclair which has revealed connections between an old engraving (1665), depicting Father Le Jeune, and a painting - reversed in relation to the latter work - by Théophile Hamel, dating from 1863 and belonging to the Hôtel-Dieu in Quebec - a painting very similar to that of Légaré. As a result of this research, it seems quite possible that Légaré had painted a portrait of Le Jeune whereas he thought he was painting Charlevoix, and that he was imitated in so doing by Antoine Plamondon (who painted a portrait of Charlevoix for the cabin of the steamship of that name wrecked before 1858) and Théophile Hamel. Unless further research throws more light on this complex question, we can only repeat the old identification of Légaré's painting, basing our opinion on the historical context in which it painted and the items of information that have come to our attention.

Maison des Jésuites, Saint-Jerome

182 Charles-Maxime De Foy c. 1830
Oil on canvas, 75.9 x 62.1 cm

Provenance: Mrs Pierre Duhamel, Deschambault, Quebec; Louis Carrier, Montreal; Musée du Québec, Quebec, 1954 (A 54 31 P).

Bibliography: Bellerive, (1925), p. 17; Morisset, *La peinture traditionnelle* (1960), p. 97.

Charles-Maxime De Foy was a notary in Quebec City. In 1827, he married Louise Légaré, the artist's sister. He died at Gentilly on 4 August 1875. This portrait is a pendant to that of his wife (see cat. no. 14).

Musée du Québec, Quebec

183 Abbé Louis-Joseph Desjardins

Bibliography: Morisset, *Peintres et tableaux*, vol. II (1937), p. 75.

Whereabouts unknown

184 Young Woman seated at a Table
Watercolour on paper, 38.1 x 30.5 cm

Provenance: John L. Russell, Montreal; Mr and Mrs Jules

190

193

191

194

Loeb, Lucerne, Quebec.

Bibliography: Sotheby & Co., *Selected Canadian Paintings from the Collection of Mr and Mrs Jules Loeb of Lucerne, Quebec,* sale (8 April 1970), cat. no. 41, p. 57, repr.

Unsigned work whose attribution to Légaré is doubtful.

Whereabouts unknown

185 *Abbé Narcisse-Charles Fortier*
Oil on canvas, 84.4 x 65.4 cm

Provenance: Church of Saint-Michel, Bellechasse.

Bibliography: IBC, Joseph Légaré and Saint-Michel de Bellechasse files.

Concerning this work, Morisset writes as follows: "Portrait of Abbé Narcisse-Charles FORTIER, former secretary of Mgr Plessis, parish priest of Saint-Michel from 1829 to 1859, where he died on 2 February 1859. No signature. Very probably a work by Joseph LEGARE, about 1845, perhaps earlier." It is difficult for us to judge the authenticity of this attribution, since the painting was destroyed by fire about 1955 "during a great clean-up" (information communicated by the sexton, 24 June 1975). Luckily, we still have a photograph which, after careful scrutiny, does not preclude the possibility of an attribution to Plamondon.

Work destroyed

186 *George IV* 1829
Oil on canvas

Provenance: Legislative Council Chamber, Quebec.

Bibliography: See cat. no. 25.

Related work: No. 25.

This painting was a copy of a work by Wheatley, itself painted after the work of Sir Thomas Lawrence. It was lost when fire destroyed the Legislative Building in 1854.

Work destroyed

187 *A Huron*

Bibliography: AJQ, Register of Notary Public Jean-Baptiste Delâge (6 Dec. 1872), no. 2921.

In the inventory of the joint possessions of Joseph Légaré and his wife, begun in December 1872 and resumed in late

195

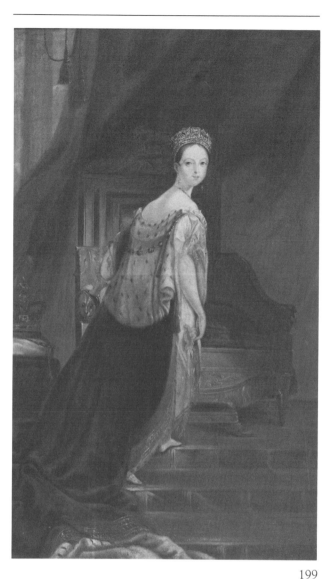

199

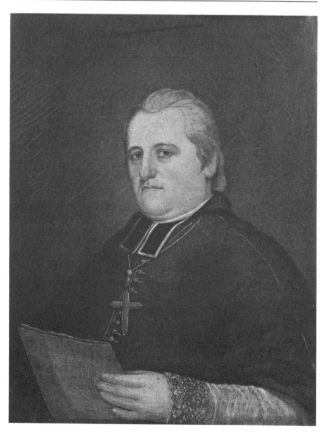

196

April 1874, following a public notice published in the newspapers, a painting entitled *A Huron* is mentioned, a work acquired by the Séminaire de Québec for the sum of "thirty cents" (*trente sous*). We do not know what has become of this work probably painted by Légaré.

Work now lost

188 Louis Lemieux
Oil on canvas, 73.0 x 59.7 cm

Provenance: Miss Gaziella Kirouac; Séminaire de Québec, Quebec, 1942; Jean-Paul Lemieux, Quebec, 1959.

Bibliography: *Le Canadien* (19 Dec. 1842), p. 1; *Le Fantasque* (28 Dec. 1842), p. 3; IBC, Musée de l'université Laval file; Laval University Catalogues (SQ) after 1933, no. 437; Morisset, *La peinture traditionnelle* (1960), p. 97.

Louis Lemieux (1793-1857) was a bookbinder. It was he who went to New York during the winter of 1816-1817 to fetch the paintings of the Desjardins Collection. His portrait is pendant to that of his wife (cat. no. 189).

Jean-Paul Lemieux, Quebec

189 Madame Louis Lemieux
Oil on canvas, 68.5 x 55.9 cm

Provenance: Miss Gaziella Kirouac; Séminaire de Québec, Quebec, 1942; Jean-Paul Lemieux, Quebec, 1959; Gérard Beaulieu, Montreal; private collection.

Bibliography: IBC, Musée de l'université Laval file; Laval University Catalogues (SQ) after 1933, no. 436; Morisset, *La peinture traditionnelle* (1960), p. 97.

Attributed by Morisset to Légaré, this portrait is the pendant of cat. no. 188.

Private Collection

190 Abbé Michel Lemieux
Oil on canvas, 59.7 x 47.0 cm

Inscription: verso, on paper, pasted on the back: *Mr Michel Lemieux, Chapelain des Religieuses de l'Hôtel-Dieu/de Québec depuis 25 ans et demi, décédé le 14 avril 1874 agé de 63/ans, estimé et regretté de tous ceux qui ont eu l'avantage de connaître ses talents et surtout les qualités de son noble coeur, son zèle/et son dévouement pour les pauvres de notre Hôpital, lui ont occasionné bien des fois un grand surcroît de fatigue ce qu'il supportait/toujours avec plaisir, malgré sa faible santé, de jour et de nuit il/était disposé à se rendre auprès d'eux pour exercer son St Ministère, et semblait oublier ses maux pour les soulager.*

202

203

204

"Mr. Michel Lemieux, Chaplain of the Nuns of the Hôtel-Dieu of Quebec for twenty-five and a half years, died on 14 April 1874, aged sixty-three, esteemed and regretted by all who had the privilege of knowing his talents and especially the qualities of his noble heart, his zeal and his devotion for the poor of our hospital, many times caused him much additional fatigue which he always bore with pleasure in spite of his poor health, day and night he was prepared to go to their bedside to exercise his holy ministery, and seemed to forget his own ailments to relieve them."

Provenance: Hôtel-Dieu de Québec (P-52).

Bibliography: IBC, Joseph Légaré file, Morisset, *La peinture traditionnelle* (1960), p. 97; Boisclair (1977), pp. 36-37, no.

Attributed by Morisset to Légaré as a result of information communicated by Mr Lucien Lemieux on 10 July 1935, this painting was completely repainted by a nun in 1969 - from a charcoal sketch by Ludger Ruelland belonging to the Hôtel-Dieu in Quebec City - after an attempted cleaning had removed the whole face. The present appearance of the painting (see Boisclair, repr. 52) has no relation to the original work which we know from an old photograph reproduced herewith.

Monastère des Augustines de l'Hôtel-Dieu de Québec, Quebec

191 Joseph Pageot
Oil on canvas, 68.6 x 53.0 cm

Provenance: Mr P.-S. Lefebvre, Quebec; Musée du Québec, Quebec, 1953 (A 53 80 P).

Exhibition: 1952, Quebec, Musée du Québec, *Exposition rétrospective de l'art au Canada français*, no. 73.

Bibliography: IBC, Joseph Légaré file; Morisset, *La peinture traditionnelle* (1960), p. 97.

On the basis of information communicated by P.S. Lefebvre, Morisset writes as follows in the IBC file concerning the work in question: "Portrait of Joseph PAGEOT, of Ancienne-Lorette, who married Madeleine Renaud. He was the father of Marie-Madeleine Pageot, who married John Hill; John Hill's widow took as her second husband the Quebec silversmith Pierre LESPERANCE."

Musée du Québec, Quebec

192 Mgr Panet 1832

Bibliography: Morisset, *La peinture traditionnelle* (1960), p.

Whereabouts unknown

193 Mgr Joseph-Octave Plessis
Oil on canvas, 70.8 x 52.7 cm

Provenance: Michel Légaré, the artist's great-grandson, Brossard.

Exhibition: 1973, Chicoutimi, La Société des Arts de Chicoutimi, Dufour Auditorium, May, *Peintures anciennes.*

Bibliography: *L'Aurore des Canadas* (20 August 1842), p. 2; AJQ, Register of Notary Public Jean-Baptiste Delâge (6 Dec. 1872), no. 2921; Tremblay (1972), pp. 162-163.

Related works: Nos 194 to 196.

This work was bought back by the artist's widow in 1872 and has remained in the family ever since. It is one of the very few versions of the portrait of Mgr Plessis (1763-1825) that can definitely be attributed to Légaré. It was probably this work which was included in an exhibition of Légaré's paintings in 1842, in Mrs Saint-Julien's salons in Montreal. It was doubtless a partial copy of the large painting by the American painter John James, presented to the bishop on 25 January 1825 by the parishioners of Saint-Roch in Quebec City.

Michel Légaré, Brossard

194 Mgr Joseph-Octave Plessis
Oil on canvas, 76.2 x 61.0 cm

Provenance: Légaré's Quebec Gallery of Painting; Séminaire de Québec, Quebec, 1874.

Bibliography: ASQ, *Séminaire 12,* no. 41 (1874); IBC, Musée de l'université Laval file; Laval University Catalogues (SQ) 1933 onwards, no. 425.

Related works: Nos 193, 195, and 196.

Variant of the painting in the Michel Légaré collection, Morisset considered very likely this work to have been painted by Légaré.

Séminaire de Québec, Quebec

195 Mgr Joseph-Octave Plessis
Oil on canvas, 80.0 x 65.1 cm

Inscription: verso, on a paper pasted on the back of the canvas: *Monseigneur Joseph Octave Plessis né le 3 mars / 1763 ptre Curé de Québec Elu co-adjuteur / le 1er Sept 1797 reçu ses bulles le 30 Sept. 1800, Sacré Evêque / le 25 Janvier 1801 Evêque en Chef et fait son entrée en cette / qualité à la Cathédrale le 27 janvier 1806. décédé le 4e de Décembre 1825. ce tableau a été donné par Mr Louis / Joseph Desjardins avant 1825 ouvrage de*

Mr Légaré [cross-written] *ses cheveux étaient poudré.*
(Monseigneur Joseph Octave Plessis born 3 March 1763,
Curé of Quebec Appointed coadjutor/1st September 1797
received his bulls 30 September 1800, consecrated
Bishop/25 January 1801, Chief Bishop and made his entry
in that/capacity into the Cathedral on 27 January 1806,
died 4 December 1825. This painting was given by Mr
Louis/Joseph Desjardins before 1825, work of Mr.
Légaré/[cross-written] his hair was powdered).

Provenance: Abbé Louis-Joseph Desjardins; Hôtel-Dieu de
Québec, Quebec, before 1825 (P-54).

Exhibition: 1973, Quebec, Musée du Québec, *Trésors des
communautés religieuses de la ville de Québec*, p. 34.

Bibliography: IBC, Joseph Légaré file; Morisset, "La Collec-
tion Desjardins et les peintures de l'école canadienne à
Saint-Roch de Québec" (1934), p. 124; Morisset, "La
Collection Desjardins à l'Hôtel-Dieu et à l'Hôpital-
Général" (1935), p. 621; Morisset, *La peinture traditionnelle*
(1960), p. 97; Boisclair (1977), p. 38, no. 54.

Related works: Nos 193, 194, and 196.

A slightly different version from those of the Michel
Légaré collection and the Séminaire de Québec. In spite of
the inscription on the back of the painting, it is not certain
that this work was by Légaré.

Monastère des Augustines de l'Hôtel-Dieu de Québec, Quebec

196 *Mgr Joseph-Octave Plessis*
Oil on canvas, 90.4 x 64.8 cm

Provenance: Church of Saint-Roch, Quebec; Musée du
Québec, Quebec, 1976 (A 76 158 P).

Bibliography: IBC, Joseph Légaré file; Morisset, "La Collec-
tion Desjardins et les peintures de l'école canadienne à
Saint-Roch de Québec" (1934), p. 124; Morisset, *La
peinture traditionnelle* (1960), p. 97; Boisclair (1977), p. 38.

Related works: Nos 193 to 195.

Variant of the painting belonging to the Hôtel-Dieu in
Quebec City.

Musée du Québec, Quebec

197 *"An Indian"*

Bibliography: AJQ, Register of Notary Public Jean-Baptiste
Delâge, (6 Dec. 1872), no. 2921.

In the inventory of the joint possessions of Légaré and his
wife, begun in December 1872, there is mention of a

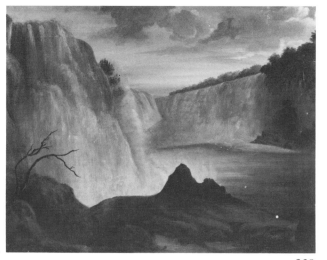

208

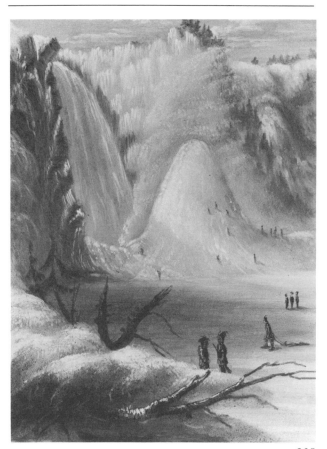

205

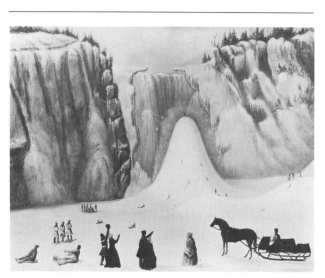

206

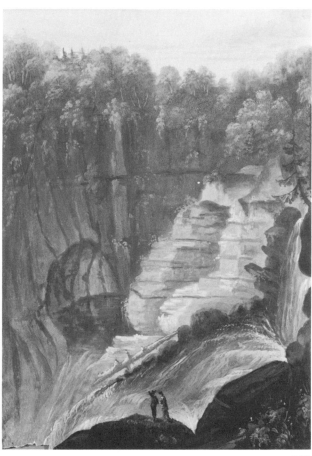

209

painting entitled *An Indian (Un Sauvage)*, a work that Mrs Légaré kept in her sitting room and which was valued at fifteen piastres. We do not know what became of this work probably by Légaré.

Work now lost

198 Mgr Signay

Bibliography: L'Aurore des Canadas (20 Aug. 1842), pp. 2-3; Tremblay (1972), p. 162.

This portrait was included in an exhibition and sale that the artist organized in the salons of Mrs Saint Julien, in Montreal, in August 1842.

Work now lost

199 Queen Victoria c. 1839
Oil on canvas, 105.4 x 64.8 cm

Provenance: Légaré's Quebec Gallery of Painting; Séminaire de Québec, Quebec, 1874.

Bibliography: AJQ, Register of Notary Public Jean-Baptiste Delâge (6 Dec. 1872), no. 2921; ASQ, Verreau Collection, Letter from Joseph Légaré to Jacques Viger, 6 Dec. 1839 (boîte 61, no. 4); ASQ, *Séminaire 12*, no. 41 (1874), p. 6, no. 225; Laval University Catalogues (SQ) (1913) p. 63, no. 349, (1923) p. 72, no. 349, (1933) p. 81, no. 241, see cat. no. 40.

Related work: No. 40.

In a letter addressed to Jacques Viger in December 1839, Légaré writes: "I am also about to finish a superb little picture of the portrait of our Queen Victoria that I will give for the sum of twelve pounds current price. This little picture of the Queen is considered a fine likeness."

Séminaire de Québec, Quebec

B LANDSCAPES

200 Cape Torment from the Sault-à-la-Puce River
c. 1839
Oil on paper, approx. 16.5 x 12.7 cm

Bibliography: ASQ, Verreau Collection, Letter from Joseph Légaré to Jacques Viger, 6 Dec. 1839 (boîte 61, no. 4).

In a letter addressed to Jacques Viger on 6 December 1839, Légaré wrote: "At the moment I have some charming little sketches painted in oils on paper of a size for your album since the largest is not more than 6 or 7 inches by 5 inches. I have already made a similar set for a lady from Liverpool.

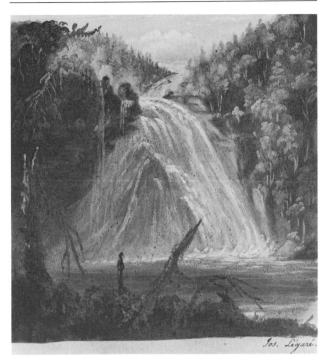
210

213

212

214

They are as follows: a view of Cape Torment from the Puce Rivier, (...)" We do not know what became of this work which Viger did not acquire.

Work now lost

201 Ship Repair Yards at Pointe-Lévis c. 1839
Oil on paper, approx. 16.5 x 12.7 cm

Bibliography: ASQ, Verreau Collection, Letter from Joseph Légaré to Jacques Viger, 6 Dec. 1839 (boîte 61, no. 4).

In a letter addressed to Jacques Viger on 6 December 1839, Légaré wrote as follows: "At the moment, I have some charming little sketches painted in oils on paper of a size for your album since the largest is no more than 6 or 7 inches by 5 inches. I have already made a similar set for a lady from Liverpool. They are as follows: a slipway where ships are repaired at Pointe-Lévis," We do not know what became of this work which Viger did not acquire.

Work now lost

202 The Chaudière Falls
Oil on canvas, 44.5 x 59.7 cm

Provenance: Légaré's Quebec Gallery of Painting; Séminaire de Québec, Quebec, 1874.

Bibliography: ASQ, *Séminaire 12*, no. 41 (1874); Laval University Catalogues (SQ) 1933 onwards, no. 792.

Related work: No. 61.

Séminaire de Québec, Quebec

203 The Montmorency Falls
Oil on canvas, 51.0 x 64.3 cm

An examination of this work has revealed considerable repainting.

Private Collection

204 The Montmorency Falls
Oil on canvas, 69.8 x 94.5 cm

Provenance: Légaré's Quebec Gallery of Painting; Séminaire de Québec, Quebec, 1874; antique dealer Gilbert, Quebec, 1958; private collection, 1958.

Bibliography: ASQ, *Séminaire 12*, no. 41 (1874); Laval University Catalogues (SQ) 1933 onwards, no. 626; Harper

(1966), p. 82; Harper (1970), p. 194.

Private Collection

205 The Montmorency Falls in Winter c. 1839
Oil on paper, 21.0 x 15.9 cm

Inscription: recto, l.c. (in Jacques Viger's handwriting), *Montmorency en hiver* (Montmorency in winter); l.r. (in Jacques Viger's handwriting), *Jos. Légaré; verso,* bottom (in Légaré's handwriting), *Chûte de Momonrencie en Hiver* (Montmorency Falls in Winter).

Provenance: Acquired from the artist by Jacques Viger in 1840 for inclusion in an Album in the possession of the Montreal Public Library since 1944, and generally known as the Viger Album, p. 38.

Exhibition: 1952, Quebec, Musée du Québec, *Exposition rétrospective de l'art au Canada français,* no. 323 (Viger Album).

Bibliography: ASQ, Verreau Collection, Letter from Jacques Viger to Joseph Légaré, 23 Nov. 1839 (box 62, no. 227); Letter from Joseph Légaré to Jacques Viger, 6 Dec. 1839 (box 61, no. 4); Letter from Jacques Viger to Joseph Légaré, 13 Dec. 1839 (box 66, no. 5); Letter from Joseph Légaré to Jacques Viger, 22 Feb. 1840 (box 61, no. 6); IBC, Montreal (Bibliothèque municipale) file; Maurault (1944), p. 98; Vézina, *Théophile Hamel* (1975), pp. 143, 145.

Related work: No. 206.

Municipal Library, Montreal

206 Montmorency Falls in Winter 1850
Oil on canvas, 35.5 x 47.0 cm

Inscription: Signed and dated left of centre: *J. LÉGARÉ/ Quebec/1850.*

Provenance: Coverdale Collection (probably acquired in Montreal in 1948).

Bibliography: (?) ASQ, *Séminaire 12*, no. 41 (1874), p. 2, no. 55; Witt Library Collection (Courtauld Institute of Art), London, Joseph Légaré file.

Related work: No. 205.

We do not know the present whereabouts of this painting which might correspond with a work entitled *The Montmorency Falls Sugar-loaf,* listed as no. 55 when Légaré's collection of paintings was acquired by the Séminaire de Québec in 1874.

Whereabouts unknown

215

218

220

207 Niagara Falls c. 1839
Oil on paper, approx. 16.5 x 12.7 cm

Bibliography: ASQ, Verreau Collection, Letter from Joseph Légaré to Jacques Viger, 6 Dec. 1839 (box 61, no. 4).

Related works: Nos. 31, 32, and 208.

In a letter addressed to Jacques Viger on 6 December 1839, Légaré wrote as follows: "At the moment, I have some charming little sketches painted in oils on paper of a size for your album since the largest is no more than 6 or 7 inches by 5 inches. I have already made a similar set for a lady from Liverpool. They are as follows: ... Niagara Falls," We do not know what became of this work which Viger did not acquire.

Work now lost

208 Niagara Falls c. 1840
Oil on canvas, 45.7 x 61.4 cm

Provenance: Légaré's Quebec Gallery of Painting; Séminaire de Québec, Quebec, 1874; antique dealer Gilbert, Quebec, 1958; Musée du Québec, Quebec, 1960 (A 60 717 P).

Bibliography: ASQ, *Séminaire* 12, no. 41 (1874); Laval University Catalogues (SQ) after 1933, no. 627.

Related works: Nos 31, 32, and 207.

Musée du Québec, Quebec

209 Saint Anne River Falls c. 1839
Oil on paper, 24.0 x 17.1 cm

Inscription: recto, l.c. (in Jacques Viger's handwriting), *Chute de la Rivière Ste Anne* (Saint-Anne River Falls); *recto,* l.r. (in Jacques Viger's handwriting), *Jos. Légaré; verso* (in Légaré's handwriting), *VuChûte* [in one word, VU in a different ink] *de Ste Anne du mont* (View of the Falls of Saint-Anne du mont).

Provenance: Acquired from the artist by Jacques Viger in 1840 for inclusion in an album now in the Montreal Municipal Library since 1944, and generally known as the Viger Album, p. 136.

Exhibition: 1952, Quebec, Musée du Québec, *Exposition rétrospective de l'art au Canada français,* no. 323 (Viger Album).

Bibliography: See cat. no. 205.

Related work: No. 35.

Municipal Library, Montreal

210 The Sault-à-la-Puce Falls c. 1839
Oil on paper, 12.1 x 12.1 cm

Inscription: recto, l.r. (in Jacques Viger's handwriting), *Jos. Légaré.*

Provenance: Acquired from the artist by Jacques Viger in 1840 for inclusion in an album in the Montreal Municipal Library since 1944, and generally known as the Viger Album, p. 227.

Exhibition: 1952, Quebec, Musée du Québec, *Exposition rétrospective de l'art au Canada français,* no. 323 (Viger Album).

Bibliography: See cat. no. 205; Morisset, *La peinture traditionnelle* (1960), p. 100.

Related works: Nos. 36, 211, and 212.

Municipal Library, Montreal

211 The Sault-à-la-Puce Falls c. 1839
Oil on paper, approx. 16.5 x 12.7 cm

Bibliography: ASQ, Verreau Collection, Letter from Joseph Légaré to Jacques Viger, 6 Dec. 1839 (box 61, no. 4).

Related works: Nos 36, 210, and 212.

In a letter addressed to Jacques Viger on 6 December 1839, Légaré wrote as follows: "At the moment, I have some charming little sketches painted in oils on paper of a size for your album since the largest is no more than 6 or 7 inches by 5 inches. I have already made a similar set for a lady from Liverpool. They are as follows: two different views of the Sault-à-la-Puce" Viger acquired one of these views. We do not know what became of the other.

Work now lost

212 The Sault-à-la-Puce Falls
Oil on canvas, 42.7 x 54.0 cm

Provenance: antique dealer Gilbert; Musée du Québec, Quebec, 1955 (A 55 156 P).

Related works: Nos 36, 210, and 211.

Musée du Québec, Quebec

225

226

227

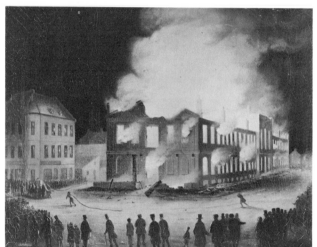

228

213 Two Figures on the Banks of a River
Charcoal and watercolour on paper, 44.0 x 57.5 cm

Provenance: Légaré's Quebec Gallery of Painting; Séminaire de Québec, Quebec (?) 1874 (Archives, Portfolio 159-G, p. 58).

This unfinished work may possibly be by Légaré. The two figures, a man and a woman, are perhaps sitting near the Saint Charles River crossed by a bridge, with Quebec City outlined in the distance to the right.

Séminaire de Québec, Quebec

214 The Garonne
Oil on canvas, 1.07 x 1.43 m

Provenance: Mrs Hector Painchaud (the artist's grand-daughter), Outremont; Paul Painchaud, Quebec; Musée du Québec, Quebec, 1972 (A 72 167 P).

Bibliography: Bellerive (1925), p. 14.

According to Bellerive, this is a copy of a work that was in Légaré's collection.

Musée du Québec, Quebec

215 Landscape
Oil on canvas, 25.3 x 32.9 cm

Provenance: Légaré's Quebec Gallery of Painting; Séminaire de Québec, Quebec, (?) 1874; antique dealer Gilbert, Quebec, 1958; Musée du Québec, Quebec, 1958 (A 58 539 P).

Bibliography: ASQ, *Séminaire* 12, no. 41, 1874?; Laval University Catalogues (SQ) after 1933, no. 574.

This small painting has been very much restored and its condition prevents us from attributing it with certainty to Légaré.

Musée du Québec, Quebec

216 Landscape (two paintings)

Bibliography: *L'Ami de la religion et de la patrie* (4 Oct. 1848), p. 655, nos 18 and 19, advertisement reprinted on 6, 9, and 13 Oct. 1948; *Le Canadien* (2 Oct. 1848), p. 3, nos 18 and 19, advertisement reprinted eleven times until 30 Oct., (13 Oct. 1848) p. 2; *The Quebec Mercury* (5 Oct. 1848), p. 3, nos 18 and 19, advertisement reprinted on 6 Oct. 1848.

In October 1848, Légaré exhibited some of his own works as well as certain paintings of his collection in one of the rooms of the Assembly Chamber in Quebec City for the purpose of a lottery to be held on the 23 of that same month. Nos 18 and 19 were entitled *A Landscape* (*Paysage* in French) and were both valued at £4. A correspondent from the newspaper *Le Canadien* wrote about them in the 13 October edition (trans.): "... two pretty landscapes, painted for the boudoir of some little lady, and which will delight the eyes during our days of mist and frost" These were perhaps works painted by Légaré. We do not know what has become of them.

Works now lost

217 Series of Landscapes
Oil on paper

Provenance: Painted for a lady from Liverpool before 1839.

Bibliography: ASQ, Verreau Collection, Letter from Joseph Légaré to Jacques Viger, 6 Dec. 1839 (box 61, no. 4).

Légaré tells us of the existence of this series of landscapes in a letter he addressed to Viger in December 1839: "At the moment, I have some charming little sketches in oil on paper of a size for your album since the largest is no more than 6 or 7 inches by 5 inches. I have already made a similar set for a lady from Liverpool. They are as follows: two different views of Sault-à-la-Puce, a view of Cape Torment from the La Puce River, a view of the falls of the Sainte-Anne du Mont River, a slipway where ships are repaired at Pointe-Lévis, Niagara Falls, Saint-Ferréol Falls, the Montmorency Falls in winter, a view of Quebec from Pointe-Lévis. The price of these little pieces is ten shillings each."

Whereabouts unknown

218 Landscape with Horsemen
Oil on canvas, 71. 7 x 91.9 cm

Inscription: At the bottom, towards the middle: *J. LÉGARÉ* (almost illegible).

Provenance: Mrs Charles Narcisse Hamel (née Céline Légaré); Marie-Thérèse Hamel; Mrs Edmire Painchaud; Louis Painchaud, Sherbrooke.

This landscape with the pierced rock is somewhat reminiscent of certain works by Salvator Rosa. As for the horsemen depicted under the natural arcade, they are almost identical to those painted by the artist in *First Ursuline Convent in Quebec City* in 1840 (See cat. no. 41).

Louis Painchaud, Sherbrooke

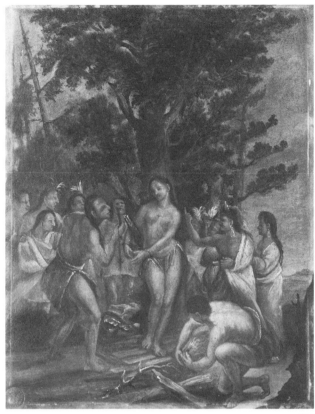

230

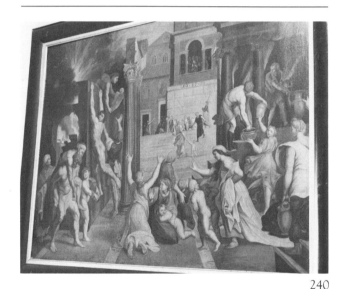

240

219 Bridge over the Jacques Cartier River

Bibliography: ASQ, *Séminaire 12*, no. 41, p. 3, no. 91.

This work, probably by Légaré, was acquired in 1874 by the Séminaire de Québec at the sale of Joseph Légaré's collection of pictures. Unless it corresponds (should its title be incorrect) with a painting belonging to the Séminaire and entitled *The Falls on the Jacques Cartier River* (see cat. no. 65), we do not know what has since become of it.

Work now lost

220 Seaport
Oil on canvas, 53.7 x 70.5 cm

Provenance: Mrs Charles Narcisse Hamel (née Célina Légaré), 1874; Victor Hamel; David Narcisse Hamel, Chicoutimi.

Exhibition: 1973, May, Chicoutimi, La Société des Arts de Chicoutimi, Dufour Auditorium, *Peintures anciennes.*

Bibliography: Catalogue of the Quebec Gallery of Paintings (1852), p. 4, no. 8.

Copy of a work by Claude Joseph Vernet painted in Rome in 1748. Vernet's picture belonged to Joseph Légaré before being acquired by the Musée du Séminaire de Québec (LU) (1933 Catalogue, no. 158).

David Narcisse Hamel, Chicoutimi

221 Quebec seen from Pointe-Lévis c. 1839
Oil on paper, approx. 16.5 x 12.7 cm

Bibliography: ASQ, Verreau Collection, Letter from Joseph Légaré to Jacques Viger, 6 Dec. 1839 (box 61, no. 4).

Related work: No. 26.

In a letter addressed to Jacques Viger on 6 December 1839, Légaré wrote as follows: "At the moment, I have some charming little sketches painted in oil on paper of a size for your album since the largest is no more than 6 or 7 inches by 5 inches. I have already made a similar set for a lady from Liverpool. They are as follows: ... a view of Quebec seen from Pointe-Lévis." We do not know what became of this work which Viger did not acquire.

Work now lost

222 Percé Rock

Provenance: Mrs Hector Painchaud (the artist's granddaughter), Outremont.

Bibliography: ASQ, *Séminaire 12*, no. 41 (1874), p. 7, no. 267; Bellerive (1925), p. 17; Colgate (1943), p. 109.

When Légaré's collection of paintings was acquired by the Séminaire de Québec in 1874, lot 269 was entitled *Percé Rock.* Perhaps there is a connection between this work and the painting mentioned by Bellerive.

Whereabouts unknown

C RECORDS, HISTORY, AND SCENES OF URBAN LIFE

223 The Old "Canadiens"

Provenance: Dr Cinq-Mars (the artist's grandson), Saint-Gédéon (Lac Saint-Jean).

Bibliography: Bellerive (1925), p. 16; Colgate (1943), p. 109; Morisset, *La peinture traditionnelle* (1960), p. 99.

This painting may possibly correspond with the work entitled *The Canadian* belonging to the Musée du Québec (see cat. no. 22).

Whereabouts unknown (?)

224 The Battle of the Plains of Abraham

Bibliography: AJQ, Register of Notary Public Jean-Baptiste Delâge, 6 Dec. 1872, no. 2921.

In the inventory of the joint possessions of Légaré and his widow, begun in December 1872, there is a mention of a painting depicting the Battle of the Plains of Abraham, a work that Mrs Légaré kept in her sitting room and which was valued at six piastres. In the document executed by the notary, the title has been crossed out. We do not know what became of this probable work by Légaré.

Work now lost

225 The Church of Notre-Dame-des-Victoires in Quebec City c. 1844
Oil on paper, 21.7 x 16.8 cm

Inscriptions: l.r., [illegible]; bottom, *Eglise de la Basse Ville, Québec* (Church in Lower Town, Quebec).

241

245

Provenance: Acquired from the artist by Jacques Viger about 1844 (through G.B. Faribault) for inclusion in an album in the possession of the Montreal Municipal Library since 1944 and generally known as the Viger Album (p. 141).

Exhibition: 1952, Quebec, Musée du Québec, *Exposition rétrospective de l'art au Canada français,* no. 323 (Album Viger).

Bibliography: ANQ-Q, Faribault Papers, Letter from Jacques Viger to G.B. Faribault, 19 Nov. 1844 (A.P.G. 6/1); IBC, Montreal (Bibliothèque municipale) file; Marault (1944), p. 98.

Municipal Library, Montreal

226 Stud Farm at Sainte-Pétronille
Oil on canvas pasted on material, 54.6 x 72.1 cm

Provenance: Légaré's Quebec Gallery of Painting; Séminaire de Québec, Quebec, 1874; antique dealer Gilbert, Quebec, 1957; Musée du Québec, Quebec, 1957 (A 57 202 P).

Bibliography: ASQ, *Séminaire 12,* no. 41 (1874); Laval University Catalogues (SQ) after 1933, no. 516; Morisset, *La peinture traditionnelle* (1960), p. 99.

The exact identification of the painting has not yet been established. Morisset saw it as "an attempt to reconstitute the Huron Fort on the Île d'Orléans," a theory contradicted by the presence of a steamer on the river. It is more likely to be a military camp which was not necessarily situated on the site of the present village of Sainte-Pétronille, on the Île d'Orléans.

Musée du Québec, Quebec

227 After the Fire in the Saint-Roch Quarter 1845
Oil on canvas, 81.3 x 111.2 cm

Provenance: Légaré's Quebec Gallery of Painting; Séminaire de Québec, Quebec, 1874; antique dealer Gilbert, Quebec, 1958; Musée du Québec, Quebec, 1958 (A 58 534 P).

Bibliography: Laval University Catalogues (SQ) after 1933, no. 624; see cat. no. 69.

Related work: No. 69.

Musée du Québec, Quebec

228 The Fire of the Parliament Buildings in Montreal
in 1849 1849
Oil on canvas, 35.6 x 48.2 cm

Provenance: McCord Museum, Montreal, 1930 (M 11588).

Bibliography: *L'Ami de la religion et de la patrie* (27 April 1849) p. 2, (9 May 1849) p. 2; *Le Canadien* (30 April 1849) p. 2, (2 May 1849) p. 2; *American Heritage* (December 1965), p. 27, repr.; Howard, *A New History of Canada* (1972), repr.; Roussan, *Le feu ne pardonne pas!* (1972), p. 8, repr.

Acquired from an English dealer in 1930, this painting is only attributed to Légaré. It is known that Légaré protested against the burning down of Parliament by strikers, and was a member of the delegation to Lord Elgin (see cat. no. 79) for that purpose. A lithograph depicting the fire on April 25 was published the following month.

McCord Museum, Montreal

229 Interior of Quebec Cathedral

Bibliography: AJQ, Register of Notary Public Jean-Baptiste Delâge, 6 Dec. 1872, no. 2921.

In the inventory of the joint possessions of Joseph Légaré and his wife, begun in December 1872 and resumed at the end of April 1874, following a notice published in the newspapers, there is mention of a painting entitled *Interior of Quebec Cathedral,* a work acquired by the Séminaire de Québec for the sum of "trente sous" (thirty cents). We do not know what became of this work probably painted by Légaré.

Work now lost

230 The Martyrdom of a young Huron
Oil on paper, 38.7 x 30.6 cm

Provenance: Mrs Charles Cinq-Mars (née Félicité Caroline Légaré); Dr Cinq-Mars, Saint-Gédéon (Lac Saint-Jean), 1925; private collection.

Bibliography: Bellerive (1925), p. 16; Morisset, *La peinture traditionnelle* (1960), p. 98.

This remarkable work still belongs to one of the artist's descendants. It may be compared with his production from 1840 to 1844, and especially with works such as *The Martyrdom of Fathers Brébeuf and Lalemant* (see cat. no. 53) and *The Martyrdom of a Jesuit Father* (see cat. 54). It contains one of the oldest female nudes in Canadian painting.

Private Collection

231 Temperance Monument at Beauport c. 1842

Bibliography: *Le Canadien* (18 March 1842) pp. 1-2; ASQ,

Séminaire 12, no. 41 (1874), p. 2, no. 47; University of Montreal, Émile Falardeau Collection, Portfolio 19, transcription of an article from the newspaper Le Fantasque, 7 April 1842.

This work was acquired by the Séminaire de Québec at the 1874 sale of Joseph Légaré's collection of pictures. It may possibly correspond with "a small painting [by Légaré] representing the Beauport column" which was presented, in the spring of 1842, to Abbé Chiniqui, the parish priest, "by a certain number of Saint-Roch citizens, to thank him for the good he has done through his sermons on temperance." Whatever the case may be, we do not know what became of this work after its acquisition by the Séminaire in 1874.

Work now lost

232 Temperance Monument at Saint-Joseph de Lévis

Bibliography: ASQ, Séminaire 12, no. 41 (1874), p. 4, no. 149.

This work probably painted by Légaré was acquired by the Séminaire de Québec at the 1874 sale of Joseph Légaré's collection of pictures. We do not know what has since become of it.

Work now lost

233 The Dumont Mill and Its Vicinity c. 1849

Bibliography: Le Canadien (20 Aug. 1849) p. 2; ASQ, Séminaire 12, no. 41 (1874), p. 3, no. 84.

Related work: No. 81.

Le Canadien gives the following report in the edition of 20 August 1849: "We are told that our artist, M. Légaré, is to paint a view of the Dumont Mill and its vicinity by replacing things as they were when M. Tourangeau acquired the property." We do not know whether Légaré carried out his plan, but we do know that À Sainte-Foy Landscape was acquired in 1874 by the Séminaire de Québec at the same time as Joseph Légaré's collection of pictures. This work may possibly correspond with the picture that Légaré was to paint in 1849. Whatever the case may be, we do not know what became of it.

Work now lost

234 Durham Place in Quebec City, before its Restoration

Bibliography: ASQ, Séminaire 12, no. 41 (1874), p. 3, no. 94.

This work probably painted by Légaré was acquired by the Séminaire de Québec at the 1874 sale of Joseph Légaré's collection of pictures. We do not know what has since become of it.

Work now lost

D GENRE SCENES AND VARIOUS SUBJECTS

235 The Storming of a Castle

Provenance: Notary Cyrille Tessier, the artist's nephew.

Bibliography: Bellerive (1925), p. 16.

According to Bellerive, this was a copy of a work in Légaré's collection.

Whereabouts unknown

236 Cupid (two paintings)

Bibliography: L'Ami de la religion et de la patrie (4 Oct. 1848), p. 655, nos 23 and 24, advertisement reprinted on 6, 9, and 13 Oct. 1948; Le Canadien (2 Oct 1848), p. 3, nos 23 and 24, advertisement reprinted eleven times until 30 Oct.; The Quebec Mercury (5 Oct. 1848), p. 3, nos 23 and 24, advertisement reprinted on 6 Oct. 1848.

In October 1848, Légaré exhibited some of his own works as well as certain paintings from his collection in one of the rooms of the Assembly Chamber in Quebec City, for the purpose of a lottery to be held on the 23 of that same month. Nos 23 and 24 were entitled Cupid (Cupidon) and valued at £1. 10 s. each. These were probably works painted by Légaré. We do not know what has become of them.

Works now lost

237 The Last Prayer

Bibliography: L'Ami de la religion et de la patrie (6 Oct. 1848), p. 655, no. 26, advertisement reprinted on 6, 9, and 13 Oct. 1848; Le Canadien (2 Oct. 1848), p. 3, no. 26, advertisement reprinted eleven times until 30 Oct.; The Quebec Mercury (5 Oct. 1848), p. 3, no. 26, advertisement reprinted on 6 Oct. 1848.

In October 1848, Légaré exhibited some of his own works as well as certain paintings from his collection in one of the rooms of the Assembly Chamber in Quebec City, for the purpose of a lottery to be held on the 23 of that month. No. 26 was entitled The Last Prayer (La dernière prière, in French) and was valued at £2. This was perhaps a work

250

253

painted by Légaré. We do not know what became of it.

Work now lost

238 A Family (Interior)

Bibliography: ANQ-Q, Register of Notary Public Alexandre-B. Sirois (25 July 1836), no. 377, cat. no. 121; *L'Ami de la religion et de la patrie* (4 Oct. 1848), p. 655, no. 8, advertisement reprinted on 6, 9, and 13 Oct. 1848; *Le Canadien* (2 Oct. 1848), p. 3, no. 8, advertisement reprinted eleven times until 30 Oct.; *The Quebec Mercury* (5 Oct. 1848), p. 3, no. 8, advertisement reprinted on 6 Oct. 1848; AJQ, Register of Notary Public Jean-Baptiste Delâge (6 Dec. 1872), no. 2921.

In October 1848, Légaré exhibited some of his own works as well as certain paintings from his collection in one of the rooms of the Assembly Chamber in Quebec City, for the purpose of a lottery to be held on the 23 of that month. No. 8 was entitled *A Family (Interior)* [*Une Famille (intérieur)*, in French] and valued at £3 - in 1836, a work entitled *An Interior with a Family Group* and valued at £16 was exhibited in Légaré's picture gallery. This was doubtless a work painted by Légaré. We do not know what became of it.

Work now lost

239 A Family in the Garden

Bibliography: ANQ-Q, Register of Notary Public Alexandre-B. Sirois (25 July 1836), no. 377, cat. no. 122; *L'Ami de la religion et de la patrie* (4 Oct. 1848), p. 655, no. 9, advertisement reprinted on 6, 9, and 13 Oct. 1848; *Le Canadien* (2 Oct. 1848), p. 3, no. 9, advertisement reprinted eleven times until 30 Oct.; *The Quebec Mercury* (5 Oct. 1848), p. 3, no. 9, advertisement reprinted on 6 Oct. 1848; Tremblay (1972), pp. 196-197.

In October 1848, Légaré exhibited some of his own works as well as certain paintings from his collection in one of the rooms of the Assembly Chamber in Quebec, for the purpose of a lottery to be held on the 23 of that month. No. 9 was entitled *A Family in the Garden* (*Une Famille dans le jardin*, in French) and valued at £3 - in 1836, a work entitled *Le Jardin avec Groupe d'une famil* and valued at £16 was hanging in Légaré's picture gallery. This was without doubt a work painted by Légaré. We do not know what became of it.

Work now lost

240 The Burning of the Town
Oil on canvas, 1.07 x 1.42 m

Provenance: Légaré's Quebec Gallery of Painting; Séminaire

de Québec, Quebec, 1874.

Bibliography: Catalogue of the Quebec Gallery of Paintings (1852), p. 13, no. 171, handwritten; AJQ, Register of Notary Public Jean-Baptiste Delâge (6 Dec. 1872), no. 2921; ASQ, *Séminaire 12*, no. 41 (1874), p. 6, no. 228; Laval University Catalogues (SQ) (1906) p. 43, no. 29, (1909) p. 49, no. 238, (1913) p. 63, no. 359, (1923) p. 73, no. 359, (1933) p. 82, no. 251.

This copy after Raphael's work in the Vatican Art Gallery was perhaps painted after an engraving. It belonged to Légaré before its acquisition by the Séminaire de Québec. It was perhaps a copy painted by the artist himself. In support of this theory, reference should be made to the earliest mention of the painting published in a catalogue of Laval University (SQ), in 1906: "Incendio del Borgo after Raphael, by Légaré."

Séminaire de Québec, Quebec

241 Peasants playing Cards
Oil on canvas, 36.4 x 36.3 cm

Provenance: Dr Cinq-Mars (the artist's grandson), Saint-Gédéon (Lac Saint-Jean); Mr Guy Bergeron (Dr Cinq-Mar's grandson), Chicoutimi-Nord.

Bibliography: Bellerive (1925), p. 14.

Bellerive thus describes this painting: "*The Card Game on the Grass*, also copied at the University, after a painting by Rosa Bonheur." It is, in fact, a copy of a picture entitled *Peasants playing Cards* and attributed to Salvator Rosa, a work that belonged to Légaré before its acquisition by the Séminaire de Québec (LU) (1933 Catalogue, no. 83).

Guy Bergeron, Chicoutimi-Nord

242 Travellers at Rest

Bibliography: *L'Ami de la religion et de la patrie* (4 Oct. 1848), p. 655, no. 22, advertisement reprinted 6, 9, and 13 Oct. 1848; *Le Canadien* (2 Oct. 1848), p. 3, no. 22, advertisement reprinted eleven times until 30 Oct.; *The Quebec Mercury* (5 Oct. 1848), p. 3, no. 22, advertisement reprinted 6 Oct. 1848.

In October 1848, Légaré exhibited some of his own works as well as certain paintings from his collection in one of the rooms of the Assembly Chamber in Quebec City, for the purpose of a lottery to be held on the 23 of that same month. No. 22 was entitled *Travellers at Rest* (*Repos de voyageurs*, in French) and valued at £12. It was perhaps a work painted by Légaré. We do not know what became of it.

Work now lost

243 Return from the Hunt

Provenance: Mr Philéas Joncas, Quebec.

Bibliography: ANQ-Q, Register of Notary Public Alexandre-B. Sirois (25 July 1836), no. 377, cat. no. 133; Bellerive (1925), p. 14.

Bellerive thus describes this painting: "*Return from the Hunt*, of Mr Philéas Joncas, of Quebec City, grandson of Jérôme, Légaré's brother" (*sic*). In his opinion, it was a copy of a work in Légaré's collection. The *Return from the Hunt* in Légaré's Gallery of Painting in 1836 was already considered "beyond repair."

Whereabouts unknown

244 Paintings (two)
Oils on canvas

Provenance: Michel and Charles Jourdain, Quebec.

Bibliography: Lemoine (1882), p. 158; Morin (1949), pp. 190-191.

Repeating statements made by Dr Hubert Larue in his *Voyage sentimental sur la rue Saint-Jean* and J.M. Lemoine in *Picturesque Quebec*, Victor Morin mentions the existence of two paintings by Légaré that once belonged to friends of the artist, Michel and Charles Jourdain, architects and contractors. The gentlemen were the owners of a house at 84 Saint-Jean Street where meetings of the Club des Anciens were held.

Whereabouts unknown

E STILL-LIFES

245 Flowers 1835
Oil on canvas, 26.5 x 41.5 cm

Inscription: Signed and dated, l.c.: *J.L. 35.*

Exhibition: 1961, Montreal, Montreal Museum of Fine Arts, *Flowers.*

Bibliography: *L'Aurore des Canadas* (20 Aug. 1842), p. 2; *Le Canadien* (13 Oct. 1848), p. 2; Tremblay (1972), p. 162.

This painting may possibly be one of Légaré's works and may have been mentioned in *L'Aurore des Canadas* in 1842 when Légaré held an exhibition of pictures at the residence of Mrs Saint-Julien, in Montreal. The signature of this still life is similar to that of certain portraits by Légaré now in the Musée du Québec (See cat. nos 39, 75).

Private Collection

246 Fruit (three paintings)

Bibliography: *L'Ami de la religion et de la patrie* (4 Oct. 1845), p. 655, nos 15, 16, and 17, advertisement reprinted 6, 9, and 13 Oct. 1848; *Le Canadien* (2 Oct. 1848), p. 3, nos 15, 16, and 17, advertisement reprinted eleven times until 30 Oct., (13 Oct 1848) p. 2; *The Quebec Mercury* (6 May 1845) p. 2, (5 Oct. 1848) p. 3, nos 15, 16, and 17, advertisement reprinted on 6 Oct. 1848.

Among the works shown by Légaré at the Mechanics' Institute of Quebec in May 1845 were three small still lifes depicting fruit. *The Quebec Mercury* published the list of paintings included in the exposition and mentions "3 Fruit pieces - natural - (small,) by Mr. Legare." In October 1848, Légaré exhibited some of his own works as well as certain paintings from his collection in one of the rooms of the Assembly Chamber in Quebec City, for the purpose of a lottery to be held on the 23 of that same month. Nos 15, 16, and 17 were entitled *Fruit* (*Fruits*, in French) and valued at £3 each. These were probably the same works but we do not know what became of them.

Works now lost

247 Game

Bibliography: ANQ-Q, Register of Notary Public Alexandre-B. Sirois (25 July 1836), no. 377, cat. no. 71; *L'Ami de la religion et de la patrie* (4 Oct. 1848), p. 655, no. 3, advertisement reprinted 6, 9, and 13 Oct. 1848; *Le Canadien* (2 Oct. 1848), p. 3, no. 3, advertisement reprinted eleven times until 30 Oct. (13 Oct. 1848) p. 2; *The Quebec Mercury* (6 May 1845) p. 2, (5 Oct. 1845) p. 3, no. 3, advertisement reprinted on 6 Oct. 1848.

In October 1848, Légaré exhibited some of his own works as well as certain paintings from his collection in one of the rooms of the Assembly Chamber in Quebec City, for the purpose of a lottery to be held on the 23 of that same month. No. 3 was entitled *Game* (*Gibiers*, in French) and valued at £12. This was probably a work painted by Légaré that he had shown at the Mechanics' Institute of Quebec in May 1845. We do not know what became of it.

Work now lost

248 Group of Game Birds

Bibliography: *L'Aurore des Canadas* (20 Aug. 1842), p. 2; Tremblay (1972), p. 162.

This work was shown at an exhibition of Légaré's paintings in Mrs Saint-Julien's salons in Montreal in 1842. A journalist from the *Aurore des Canadas* wrote (trans.):". . . his group of game birds especially shows all the artist's

versatility, variety of talent, and genius" We do not know what became of this work which could correspond to cat. no. 247 of this catalogue.

Work now lost

249 Still Life with Coffee Mill
Oil on canvas

Provenance: Mr Jean-Paul Légaré (the artist's great-grandson), Rimouski.

Bibliography: Letter from Jérôme Légaré of Chicoutimi to John R. Porter, 20 June 1975, in the National Gallery of Canada.

This painting was destroyed in the Rimouski fire on 6 May 1955. Mr Jérôme Légaré of Chicoutimi gave us the following information about it: "My brother, Jean-Paul, had received a superb painting by Joseph Légaré from my father representing a still life in a very good state of preservation having always been rolled up. There were fruit and vegetables on a table with an instrument for grinding coffee [an object that has remained in the family]. I always had the impression that this painting measured 40 x 40 inches, but my brothers think it was a little smaller."

Work destroyed

250 Still Life with the Portrait of Calvin
Oil on canvas, 66.2 x 80.7 cm

Inscriptions: recto, on the canvas: various inscriptions on a letter, on the engraving of Calvin, on the title page of Calvin's work and on the spines of the books; *verso,* on the mount, in ink: *Calvin Copie par Légaré - Original Pierson 1631-90* (Calvin copied by Légaré - Original Pierson 1631-1690) and *Nesbitt 78 Ste: Julie.*

Provenance: Jean-Paul Lemieux, Quebec; Musée du Québec, Quebec, 1967 (A 67 13 P).

Bibliography: Catalogue of the Quebec Gallery of Paintings (1852), p. 11, no. 114.

Copy of a work by Antoine Leemans (or Christoph Pierson) which belonged to Joseph Légaré before its acquisition by the Musée du Séminaire de Québec (LU) (1933 Catalogue onwards, no. 445).

Musée du Québec, Quebec

251 Vase and Fruit

Bibliography: *L'Ami de la religion et de la patrie* (4 Oct. 1848)

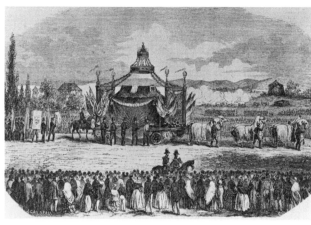

259

261

p. 655, no. 2, advertisement reprinted 6, 9, and 13 Oct. 1848; *Le Canadien* (2 Oct. 1848) p. 3, no. 2, advertisement reprinted eleven times until 30 Oct., (13 Oct. 1848) p. 2; *The Quebec Mercury* (6 May 1845) p. 2, (5 Oct. 1848) p. 3, no. 2, advertisement reprinted 6 Oct. 1848.

In October 1848, Légaré exhibited some of his own works as well as certain paintings from his collection in one of the rooms of the Assembly Chamber in Quebec City, for the purpose of a lottery to be held on the 23 of that same month. No. 2 was entitled *Vase of Fruit* (*Vase et fruits,* in French) and valued at £20. This was perhaps a work painted by Légaré that he had exhibited at the Mechanics' Institute of Quebec in May 1845. We do not know what became of it.

Work now lost

F ALLEGORIES AND WORKS FOR UTILITARIAN PURPOSES

252 *Decorations for the New Theatre Royal in Quebec City* 1832

Bibliography: *The Quebec Mercury* (14 Feb. 1832) p. 3, (16 Feb. 1832) p. 2; Lemoine (1882), pp. 115-116; Dufebvre (1955), p. 19; Morisset, *La peinture traditionnelle* (1960), p. 3; Harper (1966), pp. 81, 117; Harper (1970), pp. 338-339; Tremblay (1972), pp. 38, 39, 56, 57.

On 14 February 1832, *The Quebec Mercury* published the following passage concerning the new Theatre Royal in Quebec City on Saint-Stanislas Street:

> This Theatre has been rebuilt, and will be open on WEDNESDAY Evening, 15th FEBRUARY, 1832, with new Decorations and Scenery, designed and painted by Messrs. Légaré, Triaud, and Schinotti, and a new Drop Scene, representing the Temple of Dramatic Fame, designed by Mr. Woodley, and painted by Messrs. Triaud and Schinotti.

Two days later, the same newspaper devoted a long article to a description of the new theatre, in which more details were given concerning Légaré's contribution:

> Between the pilasters of the proscenium, is a crimson curtain painted in oil by Mr Légaré, with the King's Arms in the centre. A similar decoration we would have said before, is also placed over the centre box, appropriated for the Governor's accommodation and which is also decorated by a small neat drapery.

In an article published in 1955, Dufebvre quoted this description - repeated by Tremblay in 1972 - and mistakenly attributed it to the *Royal Circus* Theatre, an older building.

Work destroyed

253 *Design for the First Seal of Quebec City* 1833
Circular

Inscription: At the top of the periphery, *NATURA FORTIS. INDUSTRIA CRESCIT;* at the bottom, under the illustration, *CONDITA QUEBECENSE,/A.D. MDC-VIII/CIVITATIS REGIMINE/DONATA, A.D./MDC-CCXXXIII.*

Bibliography: AVQ, *Procès verbaux du Conseil de mai 1833 à octobre 1834,* Meetings of 24 May and 17 June 1833, and 23 May 1834; *Le Canadien* (19 June 1833), p. 2; Hawkins (1834), pp. 296-297; (anon.) *Le premier sceau de la ville de Québec* (1931), p. 162; Drolet (1967), p. 9; Tremblay (1972), pp. 65-67; Dahl *et al.* (1975), p. 207, plan no. 212.

Following the incorporation of Quebec City, Légaré was elected in 1833 to the town council as representative for the Palais ward, a post he would occupy from 1833 to 1836. At the meeting held on 24 May 1833, it was decided to adopt his design for the Corporation's future seal, the "said seal representing 1st, Cape Diamond and Lower Town, 2nd, the Goddess Sterna, Goddess of Activity and Work pointing with one hand to the Saint Lawrence River and holding corn cobs in the other, 3rd, a beehive and a beaver, lastly a Lion holding a key, showing Quebec as the key to Canada." While waiting for the Mayor to have the drawing engraved, a temporary seal was adopted bearing the letter L. The new seal was finally presented to the Council and officially adopted on 23 May 1834. It was subsequently reproduced on many occasions and particularly on money and maps of Quebec City. We thus find it on a map by Hawkins, engraved by William Smillie and dating from 1835 (see illustration). We have not been able to trace Légaré's original drawing.

Work now lost

254 *Main Banner for the Saint-Jean-Baptiste Society of Quebec* 1842
Oil on green and white silk, 1.98 x 1.37 m

Inscriptions: At the bottom, on a ribbon: *Société St. Jean Baptiste de Québec;* on a garland of maple leaves, *Nos institutions notre langue et nos lois* (Our institutions, our language, and our laws).

Provenance: Société Saint-Jean-Baptiste, Quebec.

Bibliography: *Le Canadien* (24 June 1842) p. 1, (27 June 1842) p. 2, (4 July 1842) p. 1, (17 Aug. 1842) p. 1, (9 June 1843) pp. 2-3, (26 June 1843) p. 3, (28 June 1843) p. 3, (5 July 1843) p. 3; *Le Fantasque* (30 June 1842) p. 1, (3 July 1843) p. 1; *The Quebec Mercury* (24 June 1843) p. 3; Chouinard (1881), vol. I, p. 28; Tremblay (1972), pp. 152-153.

Related works: Nos 255 to 257.

270

I

For several years, Joseph Légaré was an active member of the Saint-Jean-Baptiste Society in Quebec City which was actually founded in 1842. That year, the organization's board of directors decided to have a banner made and entrusted its execution to Légaré, "whose essentially Canadian taste, studies and talents were a guarantee of success." The best description of this banner that we have is taken from the newspaper *Le Canadien* of 5 July 1843, reprinted in *Le Fantasque* on July 8 (trans.):

> The main banner, which ... is green and white, bears as its principal emblem Saint John the Baptist, standing on the banks of the Jordan; in one hand, he holds the sign of the redemption and with the other points to heaven; the landscape is lighted by a rising sun, the promise of a better future; this small painting is surrounded by ornamental arabesques of great richness in the centre of which maple leaves and [branches of] fir predominate; on each side, and to give life to the elegant frame which encloses the main subject and to dissimulate the glaring colours of the original background, the painter has judiciously placed two jets of water sent up by wild ducks; at the bottom, for the same purpose, is a shell on which are shown two beavers playing, as a sign of fraternity; at the bottom of the design, a ribbon bears the inscription *Société St Jean Baptiste de Québec,* and on a garland of maple leaves, in a more luminous and tender green, is painted the national motto: *Nos institutions notre langue et nos lois* (Our institutions, our language, and our laws). This banner is bordered by gold braid and fringes, and hung from the pole by golden cords and tassels; the pole itself is surmounted by a medieval style copper lance and the cross piece to which the banner is attached is finished at each end by an axe blade of the same metal and similar style; these accessories, like those of the other banners and the separate lances, are of the severest yet simplest taste and of a perfect finish; they were made in the workshop of Mr. Lemoine, a mechanic of this town.

In 1843, Légaré was to make the banners of the Society's three sections. Like the main banner, they would appear at all the important events of the Society for many years to come. In spite of our research, we have not been able to find them.

Work now lost

255 *Banner of the First Section of the Saint-Jean-Baptiste Society of Quebec* 1843
Oil on green and white silk, 1.98 x 1.37 m (cut in the shape of a shield)

Provenance: Saint-Jean-Baptiste Society of Quebec.

Bibliography: Le Canadien (9 June 1843) pp. 2-3, (26 June 1843) p. 3, (28 June 1843) p. 3, (5 July 1843) p. 3; *Le Fantasque* (17 Dec. 1842) pp. 1-2, (29 April 1843) p. 2, (3

July 1843) p. 1; ANQ-Q, SSJB de Québec Collection, Quebec, Minutes of the SSJB (1842-1860), Registre des Procédés des différentes assemblées de la Seconde section, p. 5 (May 1843) (box 2, (cote) 100, file 100.1); Tremblay (1972), pp. 153-154.

Related works: Nos 254, 256, and 257.

In 1842, the board of directors of the Saint-Jean-Baptiste Society approved sketches for banners for the different sections of the society, and entrusted their execution to Légaré, not without having "offered to other *canadien* painters of [Quebec] the opportunity of devoting their brushes to a national organization." (trans.) Légaré made the most advantageous offer, asking 25 louis per banner. The artist was vice-president of the first section of the society, covering both the upper and lower towns of Quebec. *Le Canadien* of 28 June 1843 described the banner in the following terms (trans.):

> The banner of the first section is an allegorical representation of the Saint Lawrence. An Indian seated on the river bank, with a jug in one hand, and near him all his warrior's equipment, arrows, tomahawk, etc., presents the necklace and pipe to Saint Lawrence with the other, as a token of the alliance contracted by Canada with the Faith. The frame is surmounted by the crown of England, as a mark of its sovereignty over the country watered by the river. The Indian wears a medal on which the names of Cartier and Champlain can be read, one of whom discovered Canada and the other founded Quebec.

On 8 July 1843, *Le Fantasque* published the following details (trans.):

> The perspective is filled by an admirable view of Quebec, with its harbour, its forests of masts, and its pile of rock. The artist, by this charming composition, has successfully traced the allegory of our town's past and present; the landscape, though merely secondary, is finished in a manner not usually found in paintings of this type and size. It is framed by a shaded golden medallion resting on a field of acanthus leaves mixed with maple leaves and terminating in a royal crown of the finest work.

Work now lost

256 *Banner of the Second Section of the Saint-Jean-Baptiste Society of Quebec* 1843
Oil on green and white silk, 1.98 x 1.37 m (cut in the form of a shield)

Inscription: At the bottom, on a ribbon forming a garland: *Industrie, Economie* (Industry, Economy).

Provenance: Saint-Jean-Baptiste Society of Quebec.

Bibliography: ANQ-Q, SSJB de Québec Collection, Quebec,

III

Minutes of the SSJB (1842-1860), Registre des Procédés des différentes assemblées de la Seconde section, pp. 3, 4, 5, 8, 15 (1843-1844) (box 2, (cote) 100, file 100.1); see cat. no. 255.

Related works: Nos 254, 255, and 257.

In its edition of 28 June 1843 *Le Canadien* described the banner of the second section of the Society, covering the areas of Saint-Louis and Saint-Jean, as follows (trans.):

> It represents industry in the form of a woman resting her hand with a distaff on a spinning wheel, and holding a cornucopia in the other. Near her is a beehive, and through an opening, a view of the Saint-Jean quarter with one of the towers. The frame is decorated with tools of different trades, and on a ribbon cascading into a garland at the bottom can be read the words: *Industry, Economy.*

Work now lost

257 *Banner of the Third Section of the Saint-Jean-Baptiste Society of Quebec* 1843
Oil on green and white silk, 1.98 x 1.37 m (cut in the shape of a shield)

Inscription: At the top: *LABOR OMNIA VINCIT* (Work conquers all).

Provenance: Saint-Jean-Baptiste Society of Quebec.

Bibliography: See cat. no. 255.

Related works: Nos 254 to 256.

The following description is taken from *Le Canadien* of 28 June 1843 (trans.):

> On the banner of the third section (that includes the Saint-Roch and Saint-Vallier quarters), Saint-Roch can be seen on the clouds; in the foreground, a ship under construction; and in the background of the painting, a view of the Saint Charles River, ending with a view of Beauport and part of the Île d'Orléans. A timber raft towed by a steamship enters the Saint Charles. At the bottom of the frame is a beaver on a shell, nibbling a maple leaf. The shell is surrounded by naval objects, an anchor, a trident, a rudder, oars, and naval flags. On one side of the frame rises an oak branch, and on the other a branch of maple.

Le Fantasque of 3 July 1843 reported that the "members of the Saint-Jean-Baptiste Society had greeted with unanimous acclamations the four banners of one of their brothers, a Canadian artist, one of the most enthusiastic founders of the Society."

Work now lost

258 *Banner of the Frères des Écoles chrétiennes* 1849
Oil on silk

Provenance: Frères des Écoles chrétiennes, Quebec.

Bibliography: L'Abeille (14 June 1849) p. 2; *L'Ami de la religion et de la patrie* (13 June 1849) p. 2; *Le Canadien* (11 June 1849) p. 2, (13 June 1849) p. 2, (27 June 1849) p. 2; *Le Journal de Québec* (9 June 1849) p. 2; ANQ-Q, SSJB de Québec Collection, Quebec, Minutes of the SSJB (1842-1860), Registre des Procédés des différentes assemblées de la Seconde section (9 April 1849) p. 130, (21 May 1849) p. 136, (28 May 1849) p. 137, (4 June 1849) p. 138 (box 2, (cote) 100, file 100.1).

The following report appeared in *Le Canadien* of 11 June 1849 (trans.):

> Yesterday, after vespers, the Saint-Jean section of the Saint-Jean-Baptiste Society presented to the Frères des Écoles chrétiennes, for the use of their students, a superb silken banner worth £20, on which the founder of these schools is shown holding the Institute's rules in his hand. In the background of the picture, a group of young children can be seen playing on the grass, under the supervision of a Brother. The frame of the painting is very rich; and the whole effect is very fine. This banner will be a handsome ornament at the celebration of the Society's patronal festival. Its execution is the work of Mr Légaré, a well-known artist in this type of painting.

Work now lost

259 *Design for a Hearse* 1854

Bibliography: ANQ-Q, SSJB de Québec Collection, Quebec, Minutes of the SSJB (1842-1860), Registre des Procédés des différentes assemblées de la Second Section (10 April 1854) p. 219 (box 2, (cote) 100, file 100.1); Paulin, *Une page de l'histoire de France* (1854), pp. 79-80; Chouinard (1881), vol. I, p. 58 (by Olivier Robitaille); Tremblay (1972), pp. 213-214.

As part of his SSJB activities, Légaré designed a funeral carriage to transport the remains of the Heroes of 1760 to their last resting place, and he supervised its execution (see cat. no. 81). Légaré's sketch has not survived but the hearse itself was reproduced in *L'Illustration, journal universel* of Paris by the engraver J. Gaildrau, on 29 July 1854 (see illustration).

Work now lost

III VARIOUS TYPES OF WORK AND UNCOMPLETED WORKS

260 *Bronzing of two Plaster Busts* 1835

Provenance: Séminaire de Québec, Quebec.

Bibliography: ASQ, *Séminaire 128,* no. 228, Joseph Légaré's statement of expenditure (29 June 1833).

"*1835 bronzer 2 bustes en platre 1/8-0-3-4*" (1835, bronzing 2 plaster busts 1/8-0-3-4).

Séminaire de Québec, Quebec

261 Chapel-Reliquary c. 1851
Wood, gilt paper, stone statuettes, engravings touched up with painting, artificial flowers, glass, material, etc., 94.6 x 66.4 cm

Inscriptions: On an identification card, *Chapelle en miniature/Oeuvre de Mr. J. Légaré/premier artiste-peintre canadien/père de notre Soeur St. Léandre, une/des fondatrices de l'Hôtel-Dieu/de Chicoutimi/Don de Monseigneur Bouffard P.D.* Miniature chapel/Work of Mr J. Légaré/foremost Canadian artist-painter/father of our Sister St. Léandre, one of the founders of the Hôtel-Dieu/in Chicoutimi/Gift of Monseigneur Bouffard P.D.). Identification of the relics; On the back, at the level of the towers: newspaper cuttings dating from May and July 1848.

Provenance: Mgr. J.-H. Bouffard (1855-1934), parish priest of Saint-Malo, Quebec; Hôpital-Général de Québec, 1930; Hôtel-Dieu Saint-Vallier, Chicoutimi.

Bibliography: AHGQ, Journal (1923-1935), p. 449; Journal de la Dépense et de la Recette (1844-1866), 13 November 1851; *Journal du Musée,* vol. I (1938-1957), p. 7.

According to remarks of Mgr Bouffard reported by the archivist of the Hôpital-Général de Québec, this chapel-reliquary was supposedly made by Joseph Légaré with help from the nuns of the institution. The archives of the community mention a payment of £7 to J. Légaré in 1851.

Monastère des Augustines, Chicoutimi

262 Numbers for a Library 1833, 1835, & 1837

Provenance: Séminaire de Québec, Quebec.

Bibliography: ASQ, *Séminaire 128,* no. 228, Joseph Légaré's statement of expenditure (29 June 1835); *Séminaire 130,* no. 110, Joseph Légaré's statement (10 May 1838).

Translation:
"1833/Nov. 12 - 38 Numbers in the library at 6d-0.19.0.
"1833/Nov. 22 - 80 Numbers in the library 2d-0.13.4."
"1833/Nov 29 - 5 Numbers in the library at 6d-0.2.6.
"1835/Sept. 4 - 21 Nos. _____ 2d _____ 0.3.6.
"1835/June 29 - 20 Numbers _____ 0.3.4.
"1837/Sept. 26 - 122 Numbers at _____ 2d-1.0.4."

Séminaire de Québec, Quebec

263 Altar Frontals (2) 1833

Provenance: Church of Charlesbourg.

Bibliography: IBC, Charlesbourg and Joseph Légaré files.

In the third book of the parish accounts, for the year 1833, there is mention of payment "to the painter Légaré for two altar frontals 9.0.0." (IBC transcript.)

Works now lost

264 Altar Frontal c. 1834

Provenance: St. Patrick's Church, Quebec.

Bibliography: ASQ, Saberdache bleu, Letter from Jacques Viger to his wife (17 March 1834), pp. 288-289.

On March 17, 1834, Viger wrote to his wife (trans.): "I went this morning to . . . High Mass at St. Patrick's, in the fine new church of the Irish in the upper town of Quebec . . . The nave and the choir were hung with flags; . . . large collection; a new altar frontal, made and presented by Mr. Légaré, the painter; a really fine celebration."

Work now lost

265 Altar Frontals (3) 1837
Oil on canvas

Provenance: Church of Cap Santé.

Bibliography: IBC, Cap Santé and Joseph Légaré files; Harper (1970), p. 194; Tremblay (1972), pp. 79-80.

In the account books of the parish, there is an entry for the year 1837: "Paid to Mr Légaré, painter, for altar frontals painted on canvas, for the black £3 for the two others £6 each . . . £15.0.0" (IBC transcript).

Works now lost

266 Polychrome of Four Christs 1833 & 1837

Provenance: Séminaire de Québec, Quebec.

Bibliography: ASQ, *Séminaire 12,* no. 228, Joseph Légaré's statement of expenditure (29 June 1835); *Séminaire 130,* no. 110, Joseph Légaré's statement of expenditure (10 May 1838).

Translation:
"1833/Nov. 29/for painting 3 Christs at 3/6 _____ 0.10.6.
"1837/October 18 - for painting a Christ __ 0.10.0."

Séminaire de Québec, Quebec

267 Polychrome of Sculptures 1832, 1847, & 1850

Provenance: Hôtel-Dieu, Quebec.

Bibliography: Trésors des communautés religieuses de la ville de Québec (1973) pp. 35, 47, 49.

Translation:
"1832: Paid to Mr Légaré for painting the Large Christ . . . £3 for the small Calvary Christ . . . £1.
"1847: To Mr Légaré for painting the faces and hands of Jesus and Mary for the statue used for the procession £0.12.6.
"1850: To Mr Légaré for painting the statue of Saint Joseph which is placed in the garden wall £1.12."

Monastère des Augustines de l'Hôtel-Dieu de Québec, Quebec

268 Polychrome of a Madonna 1841

Provenance: Monastère des Ursulines de Québec, Quebec.

Bibliography: AMUQ, Desjardins Correspondence, Letters from Abbé Louis-Joseph Desjardins to Sister Saint-Henry (13, 20 December 1841); *Trésors des communautés religieuses de la ville de Québec* (1973), p. 97.

Translation:
13 December 1841: "The small Antique Madonna was meant for you as a gift, but Mr Légaré has betrayed my secret. In *honorable atonement,* he will have to paint the *said Virgin* himself, and give it to you within a week."
20 December 1841: "Would the Antique Bust of the Carved Madonna be acceptable? There are other small statues at Mr Légaré's, but very inferior."

Monastère des Ursulines de Québec, Quebec

269 Uncompleted Paintings (at least eleven)

Bibliography: AJQ, Register of Notary Public Jean-Baptiste Delâge (6 Dec. 1872), no. 2921.

In the inventory of the joint possessions of Joseph Légaré and his wife, begun in December 1872 and resumed at the end of April 1874, following a public notice published in the newspapers, there is mention of a total of at least eleven uncompleted paintings which the Séminaire acquired, but we do not know what has since become of them.

Works now lost

IV ADDENDUM

270 Wild Boar
Oil on board, 14.7 x 12.3 cm

Provenance: François-Xavier Légaré, grandson of the artist, Rimouski.

Though it has slightly deteriorated this work recalls other paintings of the artist by its coloration, its technique, and its background.

François-Xavier Légaré, Rimouski

271 Fruit and Flowers c. 1854
Oil on canvas

Bibliography: The Quebec Mercury (30 September 1854), p. 1

In September 1854 Légaré won two first prizes (see cat. no. 81) at the AGRICULTURAL AND INDUSTRIAL EXHIBITION OF LOWER CANADA held in Quebec City. He won £1.10s. for a still-life with the English title above. We do not know what became of this work.

Lost work

272 Saint Charles Borromeo giving Communion to the Plague Victims of Milan
Oil on canvas, approx. 3 x 2 m

Provenance: Église Saint-Charles, Charlesbourg.

Bibliography: IBC, Charlesbourg file; (Bellerive 1925), p. 13; Noppen and Porter (1972), pp. 53, 127, and 128, repr.

There are two traditions attached to this work. According to the first, it is a French painting acquired by Charlesbourg in 1700 and kept since then in the parish church. According to the second, related by Bellerive, the work is Légaré's, an assertion that seems more likely because the artist did some work for the Charlesbourg Church in about 1821, and in 1832 and 1833. What is certain is that this high-altar painting in Charlesbourg is a reversed version of a painting originally by Pierre Mignard now in the Musée de Narbonne in France.

Parish Church of Charlesbourg

V FALSE ATTRIBUTIONS

I Guardian Angel
Oil on canvas, approx. 1.5 x 1.15 m

Provenance: Church of Saint-Pierre de Montmagny.

Bibliography: IBC, Légaré and Saint-Pierre de Montmagny files.

This painting is a copy of a work in the Monastère des Ursulines de Québec (letter from Laurier Lacroix). Attri-buted to Légaré by Morisset, its treatment in no way resembles that of any of the painter's known works. The same may be said of another version (with slight variations) that came from the Church of Ancienne-Lorette and is now in the Musée du Québec. Bellerive (1925, p. 13) and Morisset ("Joseph Légaré copiste [à l'Ancienne-Lorette]", 1934, p. 2) both attribute the latter painting to Légaré - Morisset even seeing it as one of the artist's earliest works.

Parish Church of Saint-Pierre de Montmagny

II The Battle of Saint-Eustache
Engraving

Bibliography: ACSV, *Procès-verbaux des séances du Discrétoire particulier,* 1143rd session (15 November 1912), p. 7; "C.S. Viator," *Histoire du Canada* (intermediate course), Montreal: Les Clercs de Saint-Viateur, 1915, p. 192; Paiement, *La bataille de St-Eustache,* 1975, cover.

Paiement reproduces this engraving on the cover of a work he published in 1975. On page 2 he writes (trans.): "The illustration on the cover is from a drawing by Joseph Légaré (a political prisoner in 1837) and shows the resistance of the *Patriotes* a little before the final assault by English troops." In fact the engraving is based on a drawing by Jean-Baptiste Lagacé, a former pupil of Napoléon Bourassa. The original drawing, along with several others, was commissioned from Lagacé by the Clercs de Saint-Viateur in 1912 as an illustration for the *Histoire du Canada.*

III Saint John the Baptist
Oil on canvas, approx. 1.5 x 1.15 m

Provenance: Church of Saint-Pierre de Montmagny.

Bibliography: IBC, Légaré and Saint-Pierre de Montmagny files.

Attributed by Morisset to Légaré, its treatment in no way resembles that of any of the known works of the artist.

Parish Church of Saint-Pierre de Montmagny

IV Saint Joseph
Oil on canvas, 1.94 x 1.5 m

Inscription: in the centre, toward the bottom: *L. Dulongpré Pxit.*

Provenance: Church of Ancienne-Lorette; Musée du Québec, Quebec City, 1973 (A 73 227 P).

Bibliography: IBC, Légaré file; *Fêtes solonnelles à l'Ancienne-Lorette,* 1910, p. 8; Morisset, "Joseph Légaré copiste [à l'Ancienne-Lorette]," 1934, p. 2.

This painting was attributed to Dulongpré in a newspaper article published in 1910. In his article of 1934 Morisset pointed out that this attribution was incorrect and that it was rather Légaré's. However, the work is definitely by Dulongpré and, after all, bears his signature.

Musée du Québec, Quebec

V The Vision of Saint Roch 1777
Oil on canvas, 2.87 x 1.98 m

Inscription: l.r., *J.A. Créquy pter pxit 1777.*

Provenance: Church of Saint-Roch-des-Aulnaies.

Bibliography: IBC, Saint-Roch-des-Aulnaies file; Morisset, "Joseph Légaré, copiste à Saint-Roch-des-Aulnaies," 1935, p. 2.

Having attributed this work to Légaré in an article in 1935, Morisset then corrected himself in the IBC Légaré file, this time attributing it to Jean-Antoine Aide-Créquy (1749-1780).

Saint-Roch-des-Aulnaies, Parish Church

Bibliography

Author's Note

The various archival collections, newspapers, and printed matter listed below have been mentioned in the catalogue of Légaré's works and, except for the introduction, only refer to the catalogue.

_____ :indicates other works by same author

I. ARCHIVES AND MANUSCRIPT SOURCES

Archives des Clercs de Saint-Viateur, Montreal
Archives de l'évêché de Nicolet
Archives de l'Hôpital-Général de Québec (community)
Archives judiciaires de Québec
Archives du monastère des Ursulines de Québec
Archives du monastère des Ursulines de Trois-Rivières
Archives nationales du Québec, Quebec
Archives nationales du Québec, Trois-Rivières
Archives de la Société de Jésus, province du Canada français, Saint-Jérôme
Archives du Séminaire de Québec
Archives de la ville de Québec
Bibliothèque nationale, Paris
Émile Falardeau Collection, University of Montreal
Files, Musée du Québec
Files, Musée du Séminaire de Québec
Files, Valentine Museum, Richmond, Virginia
Inventaire des biens culturels du Québec (formerly: Inventaire des oeuvres d'art, Gérard Morisset Collection and provisional inventory), Quebec
Papers of the Légaré family
Parish Archives
 Notre-Dame, Quebec
 Saint-Gilles, Lotbinière
 Saint-Henri, Lévis
 St. Patrick's, Quebec
 Sainte-Foy
Private collections

II. NEWSPAPERS

L'Abeille, Quebec
L'Ami de la religion et de la patrie, Quebec
L'Aurore des Canadas, Montreal
La Bibliothèque canadienne, Montreal
Le Canadien, Quebec
Le Castor, Quebec
Le Fantasque, Quebec
The Illustrated London News, London
L'Illustration, Paris
Le Journal, Quebec
La Minerve, Montreal
The Quebec Gazette - La Gazette de Québec
The Quebec Mercury
The Quebec Spectator

III. CATALOGUES OF LAVAL UNIVERSITY (SÉMINAIRE DE QUÉBEC)

(in chronological order)
Laval University. 1880, 12 pages.
Peintures du Séminaire de Québec. n.d., I, 4 pages.
Université Laval. Pinacothèque. n.d., II, 4 pages.
Gallery of Paintings. n.d., III, 22 pages.
Université Laval. n.d., IV (? c. 1883), 32 pages.
Université Laval. n.d., V (? c. 1887), 32 pages.
Laval University. n.d., VI (? c. 1887), 32 pages.
Université Laval. 1889, 32 pages.
Université Laval. 1893, 32 pages.
Laval University. L. Brousseau, printer, 1893, 32 pages.
Laval University. Quebec: Léger Brousseau, 1894, 30 pages.
Université Laval. Quebec: Léger Brousseau, 1898, 32 pages.
Laval University. Quebec: Léger Brousseau, 1901, 31 pages.
Université Laval. Imp. Léger Brousseau, 1903, 45 pages.
Laval University. Quebec: La compagnie de l'Événement, 1905, 47 pages.
Université Laval. Quebec: Ed. Marcotte, 1906, 72 pages.
Carter, J. Purves. *Descriptive and Historical Catalogue of the Paintings in the Gallery of Laval University, Quebec*. Quebec: L'Événement Printing Co., 1908, 230 pages.
Laval University. Quebec: Telegraph Printing, 1909, 84 pages.
Carter, J. Purves. *Livret officiel de l'exposition spéciale de tableaux récemment restaurés. Musée de peintures, Université Laval, Quebec*. Quebec: Telegraph Printing, 1909, 22 pages.
Université Laval. Quebec: L'Action sociale, 1913, 91 pages.
Laval University. Quebec: L'Action sociale, 1923, 97 pages.
Université Laval. Quebec: L'Action catholique, 1933, 94 pages.
1933 Catalogue. Manuscript belonging to the Musée du Séminaire de Québec, n.p., catalogue nos 381-960.

IV. PRINTED SOURCES, BOOKS, AND ARTICLES CITED

Album-Souvenir de la Basilique de Notre-Dame de Québec. Quebec, July 1923, 87 pages.
Barbeau, Marius. "Trésor des anciens Jésuites." *Bulletin* no. 153, The National Gallery of Canada, Anthropology Series, no. 43 (1957), xv + 242 pages.
Beaudet, Louis. *Québec, ses monuments anciens et modernes* or *Vade mecum des citoyens et des touristes* (1890). Cahiers d'Histoire, no. 25. Quebec: La Société historique de Québec, 1973, viii + 200 pages.
Beaulieu, André, and Jean Hamelin. *Les journaux du Québec de 1764 à 1964*. Les Cahiers de l'Institut d'histoire, no. 6. Quebec and Paris: Les Presses de l'université Laval and Librairie Armand Colin, 1965. xxvi + 329 pages.
Béchard, A. *Histoire de la paroisse de Saint-Augustin (Portneuf)*. Quebec: Léger Brousseau, 1885, 395 pages.

Bellemare, Abbé Jos.-Elz. *Histoire de la Baie-Saint-Antoine dite Baie-du-Febvre 1683-1911*. Montreal: Imp. La Patrie, 1911, xxii + 664 pages.
_____ : *Histoire de Nicolet 1669-1924*. Arthabaska: L'Imp. d'Arthabaska, 1924, 410 pages.
Bellerive, Georges. *Artistes-peintres canadiens-français. Les Anciens*. 1st ed. Quebec: Librairie Garneau, 1925, 80 pages.
Biddle, Edward, and Mantle Fielding. *The Life and Works of Thomas Sully, 1783-1872*. Charleston, South Carolina: Garnier, 1969, viii + 411 pages.
Biographical Dictionary of Canada. 5 vols. (I, II, III, IX, X) published (1000-1770; 1861-1880). Toronto and Quebec: University of Toronto Press and Presses de l'université Laval, 1966-1976.
Bois, Abbé Louis-Édouard. *Étude biographique sur M. Jean Raimbault*. Quebec: Augustin Côté, 1869, 133 pages.
Boisclair, Marie-Nicole. *Catalogue des œuvres peintes conservées au monastère des Augustines de l'Hôtel-Dieu de Québec*. Direction générale du Patrimoine, Publication no. 24. Quebec: Ministère des Affaires culturelles, 1977, 195 pages, ill.
Boucher, Pierre. *Histoire véritable et naturelle des mœurs et productions du PAYS de la Nouvelle-France vulgairement dite le CANADA* (1664). Facsimile edition of the original with commentaries and studies by numerous contributors. Boucherville: Société historique de Boucherville, 1964, 415 pages.
Bouchette, Joseph. *Description topographique de la province du Bas Canada* London: W. Faden, 1815, 664 pages.
_____ : *The British Dominions in North America . . .* 2 vols. London: Longman, Rees, Orme, Brown, Green, and Longman, 1832.
_____ : *A Topographical Dictionary of the Province of Lower Canada*. London: Henry Colburn and Richard Bentley, 1831.
[Bourne, George]. *The Picture of Quebec*. Quebec: D. & J. Smillie, 1829, 134 pages.
Burger, Baudoin. *L'activité théâtrale au Québec (1765-1825)*. Montreal: Les Éditions Parti pris, 1974, 410 pages.
Cadieux, Lorenzo, S.J., ed. *Lettres des Nouvelles Missions du Canada 1843-1852*. Montreal: Les Éditions Bellarmin, 1973, 951 pages.
Cameron, Christina, and Jean Trudel. *Québec au temps de James Patterson Cockburn*. Quebec: Éditions Garneau, 1976, 176 pages.
Camesasca, Ettore. *Tutta la pittura di Raffaelo*. 2 vols. Milan: Biblioteca d'Arte Rizzoli, 1962.
Casgrain, P.B. *Les Batailles des Plaines d'Abraham et de Sainte-Foye*. Quebec: Daily Telegraph Printing Co., 1908, 93 pages.
Catalogue of the Quebec Gallery of Paintings, Engravings, etc.

the Property of Jos. Légaré, St. Angele Street, corner of St. Helen Street. Quebec: E.R. Fréchette, 1852, 16 pages.

Cauchon, Michel. "L'incendie du quartier Saint-Roch (28 mai 1845) vu par Joseph Légaré." Bulletin du Musée du Québec, no. 10 (October 1968), 4 pages.

————: Jean Baptiste Roy-Audy 1778-c. 1848. Civilisation du Québec Collection, no. 8. Quebec: Ministère des Affaires culturelles, 1971, 153 pages.

Charland, P.V. "Le tableau de l' 'Immaculée Conception' à la Basilique de Québec." Bulletin des recherches historiques, vol. XXII, no. 1 (January 1916), pp. 3-13.

Charlevoix, Pierre-François-Xavier de. Histoire et description générale de la Nouvelle France avec le Journal historique d'un Voyage fait par ordre du Roi dans l'Amérique Septentrionale. 3 vols. Paris: Didot, 1744.

Chouinard, H.-J.-J.-B. Fête nationale des Canadiens-Français célébrée à Québec en 1880. 2 vols. Quebec: A. Côté & Co., 1881.

Colgate, William G. Canadian Art: Its Origin and Development. Toronto: Ryerson, 1943, xvii + 278 pages.

Csatkai, A. "Beiträge zu den mitteleuropäishen darstellungen des todes des heiligen Franz Xaver im 17. und 18. jahrhundert." Budapest. Acta Historiæ Artium, vol. 15 (1969), pp. 293-301.

Dahl, Edward H.; Hélène Espesset; Marc Lafrance; and Thiery Ruddell. La ville de Québec, 1800-1850: un inventaire de cartes et plans. Dossier no. 13. Ottawa: National Museums of Canada, History Division, 1975, 413 pages.

De Roussan, Jacques. "Le feu ne pardonne pas." Perspectives (14 October 1972), pp. 8-9.

Douville, Abbé J.-A.-Ir. Histoire du collège-séminaire de Nicolet 1803-1903. 2 vols. Montreal: Librairie Beauchemin, 1903.

Drolet, Antonio. De l'incorporation à la Confédération (1833-1867). La Ville de Québec, histoire municipale, vol. III. Cahiers d'Histoire, no. 19. Quebec: La Société historique de Québec, 1967, 144 pages.

Dufebvre, B. "Ce soir à huit heures: Richard III (Québec en 1826)." Concorde, vol. VI, nos 7-8 (July-August 1955), pp. 19-22.

Duguay, Rodolphe. "Épaves de la révolution française." Opinions (Journal of L'Association des anciens étudiants d'Europe), vol. III, no. 4 (October 1932), pp. 11-14.

Dumouchel, Jacques, and Andrée Boileau. Musée de Vaudreuil. Catalogue (sélectif) 1975, n.p.

Duvernois, Louis. "Vestiges de plus de 300 ans d'histoire." Le Soleil (Quebec), 3 June 1967.

East, Charles. "Saint-Augustin de Portneuf." L'Action Catholique (Quebec), 8 September 1934, p. 5.

"Les Éboulements du Cap Diamant." Bulletin des recherches historiques, book 20, vol. II, no. 7 (July 1914), pp. 234-236.

"Fêtes solennelles à l'Ancienne-Lorette." L'Action sociale (catholique) (Quebec), vol. III, no. 851, (13 October 1910), pp. 1, 8.

"Le Frère Louis." Bulletin des recherches historiques, vol. 7, no. 7 (July 1901), p. 206; no. 9 (September 1901), p. 267.

Gagnon, Ernest. Le Fort et le Château Saint-Louis (Québec). Montreal: Beauchemin, 1912, 265 pages.

Garneau, François-Xavier. Histoire du Canada depuis sa découverte jusqu'à nos jours. 3 vols. 1st ed. Quebec: 1845-1848.

Gerson, Horst. Rembrandt Paintings. Amsterdam: Reynal & Co., 1968, 527 pages.

Giroux, Sylvia. "Le choléra à Québec: un tableau de Joseph Légaré." Bulletin no. 20, The National Gallery of Canada (1972), pp. 3-12.

Gluck, Gustav. Van Dyck. Des Masters Gemalde in 571 Abbildungen. Stuttgart and Berlin: Deutsche Verlags-Anstalt, 1931, 601 pages.

Godsell, Patricia. Enjoying Canadian Painting. Don Mills, Ont.: General Publishing, 1976, 275 pages.

Harper, John Russell. Early Painters and Engravers in Canada. Toronto: University of Toronto Press, 1970, xv + 376 pages.

————: Paul Kane's Frontier. Toronto: The University of Toronto Press, 1971, xviii + 350 pages.

————: La Peinture au Canada des origines à nos jours. Quebec: Les Presses de l'université Laval, 1966, 442 pages.

————: "Three Centuries of Canadian Painting." Canadian Art, vol. XIX, no. 6 (November-December 1962), pp. 405-452.

————: "Tour d'horizon de l'art canadien." Vie des Arts, no. 26 (spring 1962), pp. 28-37.

Hawkins, Alfred. Picture of Quebec with Historical Recollections. Quebec: Neilson and Cowan, 1834, 477 pages.

Highly Important Paintings and Sculpture of Great Masters of Canadian and European Art. Sale of 22, 23, and 24 October 1969. Jacoby's of Montreal, Catalogue no. 161, pp. 118-119.

Hopkins, J. Castell, ed. Canada, an Encyclopædia of the Country. 5 vols. Toronto: Linscott Publishing Co., 1898.

Hubbard, R.H. An Anthology of Canadian Art. Toronto: Oxford University Press, 1960, 187 pages.

————: Deux peintres de Québec. Antoine Plamondon/1802-1895. Théophile Hamel/1817-1870 (exhibition catalogue). Ottawa: The National Gallery of Canada, 1970, 176 pages.

————: The Development of Canadian Art. Ottawa: Queen's Printer, 1963, 137 pages.

————: L'évolution de l'art au Canada. Ottawa: Queen's Printer, 1964, 137 pages.

————: "Primitives with Character: a Quebec School of the Early Nineteenth Century." The Art Quarterly, vol. XX (1957), pp. 17-29.

————: ed. Canadian School. The National Gallery of Canada, Catalogue, Paintings and Sculpture, vol. III. Toronto: University of Toronto Press, 1960, 463 pages.

Jobin, André. "Le frère Louis Bonami." Le Soleil (Quebec), 23 December 1951, p. 21.

Journals of the Legislative Assembly of the Province of Canada. Session 1844-1845, vol. 4, pp. 243, 251 (Letter from Joseph Légaré to Sir Allan MacNab, 10 February 1845).

Lacroix, Laurier. "La collection Maurice et Andrée Corbeil." Vie des Arts, vol. XVIII, no. 72 (autumn 1973), pp. 24-31.

Lane, William Coolidge, and Nina E. Browne, eds. A.L.A. Portrait Index. Index to portraits contained in printed books and periodicals. New York: Burt Franklin, 1906, 1600 pages.

Le Jeune, L. Dictionnaire général de biographie, histoire, littérature, agriculture, commerce, industrie et des arts, sciences, mœurs, coutumes, institutions politiques et religieuses du Canada. 2 vols. Ottawa: Ottawa University, 1931.

Lemoine, J.M. L'album du touriste. Quebec: Augustin Côté & Co., 1872, 385 pages.

————: Maple Leaves. Canadian History and Quebec Scenery. Quebec: Hunter, Rose & Co., 1865, 137 pages.

————: Picturesque Quebec: a sequel to Quebec Past and Present. Montreal: Dawson Brothers, 1882, xiv + 535 pages.

————: Quebec Past and Present. A history of Quebec 1608-1876. Quebec: Augustin Côté & Co., 1876, xv + 466 pages.

Lord, Barry. The History of Painting in Canada. Towards a People's Art. Toronto: NC Press, 1974, 253 pages.

Lord, René. "Les peintures de Saint-Philippe: biens culturels." Le Nouvelliste (Trois-Rivières), 29 March 1975, p. 13.

Magnan, Hormidas. La paroisse de Saint-Nicolas - La Famille Pâquet et les Familles Alliées. Quebec: Imprimerie Laflamme, 1918, viii + 334 pages.

Malavoy, Anne-Marie. "Sur un tableau de Joseph Légaré." Unpublished manuscript, a copy of which is in the History of Art Department, Univeristy of Montreal, n.d., 30 pages.

Mâle, Émile. L'art religieux de la fin du XVIe siècle, du XVIIe et du XVIIIe siècle. Paris: Librairie Armand Colin, 1951, 532 pages.

Marteau de Langle de Cary, and G. Taburet-Misoffe. Dictionnaire des Saints. Paris: Le Livre de poche, 1963, 384 pages.

Maurault, Olivier. "Souvenirs canadiens. Album de Jacques Viger." Les Cahiers des Dix, no. 9 (1944), pp. 83-99.

Monseigneur de Saint-Vallier et l'Hôpital-Général de Québec. Quebec: C. Darveau, 1882, 743 pages.

Morin, Victor. "Clubs et Sociétés notoires d'autrefois." Part 2. Les Cahiers des Dix, no. 14 (1949), pp. 190-191.

Morisset, Gérard. "À l'église du Cap Santé." Le Canada (Montreal), 23 June 1936, p. 2.

————: "À l'églisse de Châteauguay." Technique (Montreal), vol. XVIII, no. 8 (October 1943), p. 570 ff. (transcript in the Châteauguay File of the Inventaire des biens culturels du Québec).

————: "Une belle peinture de Joseph Légaré." Le Canada (Mon-

treal), 23 July 1934, p. 2.

_____:

"Une belle peinture du frère Luc." *L'Événement* (Quebec), 17 October 1934, pp. 4, 10 (transcript in the Saint-Philippe de Trois-Rivières File of the *Inventaire des biens culturels du Québec*).

_____:

Le Cap-Santé. Ses églises et son trésor. Quebec: Medium, 1944, 68 pages.

_____:

La Collection Desjardins. Series of 15 articles published in *Le Canada français* (Quebec) from 1933 to 1936.
"La Collection Desjardins - Un brelan de tableaux." vol. XXI, no. 1 (September 1933), pp. 61-67.
"La peinture en Nouvelle-France. Sainte-Anne-de-Beaupré." vol. XXI, no. 3 (November 1933), pp. 209-226.
"La Collection Desjardins - Les tableaux de l'Ancienne Cathédrale de Québec." vol. XXI, no. 9 (May 1934), pp. 807-813.
"La Collection Desjardins et les peintures de l'école canadienne à Saint-Roch de Québec." vol. XXII, no. 2 (October 1934), pp. 115-126.
"La Collection Desjardins - Les tableaux de l'église Saint-Antoine de Tilly." vol. XXII, no. 3 (December 1934), pp. 206-214.
"La Collection Desjardins - À Saint-Henri-de-Lauzon." vol. XXII, no. 4 (December 1934), pp. 316-328.
"La Collection Desjardins à la Baie-du-Febvre." vol. XXII, no. 5 (January 1935), pp. 427-440.
"La Collection Desjardins à Saint-Michel-de-La-Durantaye et au Séminaire de Québec." vol. XXII, no. 6 (February 1935), pp. 552-561.
"La Collection Desjardins à l'Hôtel-Dieu et à l'Hôpital-Général." vol. XXII, no. 7 (March 1935), pp. 620-625.
"La Collection Desjardins à l'église de Sillery et ailleurs." vol. XXII, no. 8 (April 1935), pp. 734-746.
"La Collection Desjardins au couvent des Ursulines de Québec" (I). vol. XXII, no. 9 (May 1935), pp. 855-868.
"La Collection Desjardins chez les Dames Ursulines de Quebec" (II). vol. XXIII, no. 1 (September 1935), pp. 37-48.
"La Collection Desjardins à Verchères et à Saint-Denis-sur-Richelieu." vol. XXIII, no. 3 (November 1935), pp. 226-234.
"La Collection Desjardins au musée de l'université Laval" (I). vol. XXIII, no. 5 (January 1936), pp. 448-456.
"La Collection Desjardins au musée de l'université Laval" (II). vol. XXIV, no. 2 (October 1936), pp. 107-118.

_____:

Coup d'œil sur les arts en Nouvelle-France. Quebec: Charrier et Dugal, 1941, 170 pages.

_____:

"Joseph Légaré copiste [à Trois-Rivières]." *Le Canada* (Montreal), 12 September 1934, p. 2.

_____:

"Joseph Légaré copiste (à l'Ancienne-Lorette)." *Le Canada* (Montreal), 25 September 1934, p. 2.

"Joseph Légaré copiste à l'église de Bécancour." *Le Canada* (Montreal), 12 December, 1935, p. 2.

_____:

"Joseph Légaré, copiste à l'Hôpital-Général de Québec." *Le Canada* (Montreal), 18 June 1935, p. 2.

_____:

"Joseph Légaré, copiste à Saint-Roch-des-Aulnaies." *Le Canada* (Montreal), 4 July 1935, p. 2.

_____:

Peintres et tableaux. 2 vols. Quebec: Les éditions du chevalet, 1936-37.

_____:

"La peinture au Canada français." Paper presented to l'école du Louvre, 8 March 1934 (Archives du Louvre F8/1934).

_____:

La peinture traditionnelle au Canada français. Montreal: Le Cercle du Livre de France, 1960, 216 pages.

Noppen, Luc. *Notre-Dame-des-Victoires à la Place royale de Québec.* Civilisation du Québec Collection, no. 15. [Quebec], Ministère des Affaires culturelles, 1974, 118 pages.

Noppen, Luc, and John R. Porter. *Les églises de Charlesbourg et l'architecture religieuses du Québec.* Civilisation du Québec Collection, no. 9. Quebec: Ministère des Affaires culturelles, 1972, 132 pages.

O'Gallagher, Marianna. "Saint Patrick's, Quebec, The Building of a Church and of a Parish." Thesis presented to the History Department, Ottawa University, April 1976.

O'Leary, James. *History of the Irish Catholics of Quebec, St. Patrick's Church to the Death of Reverend P. McMahon.* Quebec: Daily Telegraph Printers, 1895, page 7.

Ostiguy, Jean-René. "Les arts plastiques." *Visages de la civilisation au Canada français,* edited by Léopold Lamontagne. Royal Society of Canada. Toronto and Quebec: University of Toronto Press and Les Presses de l'université Laval, c. 1965, pp. 100-118.

Paiement, Raymond. *La bataille de St. Eustache.* L'histoire de ce pays Collection. Montreal: Les éditions Albert St-Martin, 1975, 41 pages.

Park, Julian, ed. *The Culture of Contemporary Canada.* Toronto and Ithaca, N.Y.: Ryerson and Cornell University Press, 1957, xiii + 404 pages.

Paulin. "Une page de l'histoire de France, commemoration, à Québec (Canada), de la bataille gagnée sous les murs de cette ville le 28 avril 1760." *L'Illustration, journal universel* (Paris), vol. XXIV, no. 596, 29 July 1854, pp. 79-80.

"Les peintures de Légaré sur Québec." *Bulletin des recherches,* vol. XXXII, no. 7 (July 1926), p. 432.

Playfair, Giles. *Kean. The Life and Paradox of the Great Actor.* London: Reinhardt & Evans, 1950, 336 pages.

Plesses, Joseph-Octave. "Les dénombrements de Québec faits en 1792, 1795, 1798 and 1805." *Rapport de l'archiviste de la province de Québec,* 1948-1949.

Porter, John R. *Antoine Plamondon. Sœur Saint-Alphonse.* Masterpieces of the National Gallery of Canada, no. 4. Ottawa: The National Gallery of Canada, 1975, 32 pages.

_____:

"L'Hôpital-Général de Québec et le soin des aliénés (1717-1845)." *Session d'étude 1977,* Société canadienne d'histoire de l'Église catholique (forthcoming).

_____:

"Un projet de musée national à Québec à l'époque du peintre Joseph Légaré (1833-1853)." *RHAF,* vol. 31, no. 1 (June 1977), pp. 75-82.

_____:

"La société québécoise et l'encouragement aux artistes de 1825 à 1850." *Annales d'histoires de l'art canadien,* vol. IV, no. 1 (spring 1977), pp. 13-24.

Porter, John R., and Léopold Désy. *Les Annonciations dans la sculpture au Québec* followed by *Les statuaires et modeleurs Carli et Petrucci. Esquisse historique.* Quebec: Les Presses de l'université Laval, 1978.

_____:

Calvaires et croix de chemins du Québec. Ethnologie québécoise Collection. Montreal: Hurtubise HMH, 1973, 145 pages.

"Le premier sceau de la ville de Québec." *Bulletin des recherches historiques,* vol. XXXVII, no. 3 (March 1931), p. 162.

Réau, Louis, *Iconographie de l'art chrétien.* Book II, *Iconographie de la Bible,* 2 vols., 1956-1957. Book III, *Iconographie des saints,* 3 vols., 1958. Paris: Presses universitaires de France.

"Recent Acquisitions by Canadian Museums and Galleries." *Canadian Art,* vol. XIII, no. 3 (spring 1956), pp. 292-295.

Reid, Dennis. *A Concise History of Canadian Painting.* Toronto: Oxford University Press, 1973, 319 pages.

Robson, Albert H. *Canadian Landscape Painters.* Toronto: Ryerson, 1932, 227 pages.

Rosenberg, Pierre, and Antoine Schnapper. *Jean Restout (1692-1768)* (exhibition catalogue). Rouen: Musée des Beaux-Arts, 1970, 231 pages.

Roy, J.-Edmond. *Histoire de la seigneurie de Lauzon.* 5 vols. Lévis, P.Q.: Mercier & Co., 1897-1904.

Roy, Pierre-Georges. *Toutes petites choses du régime anglais.* 2 vols. Quebec: Éditions Garneau, 1946.

_____:

Le vieux Québec. 2nd ed. Lévis, P.Q.: 1931, 300 pages.

Scott, H.-A. "Paroisse de Sainte-Foy." *Almanach de L'Action Sociale Catholique,* vol. III, (1919), pp. 62-64.

Selected Canadian Paintings, Drawings, Watercolours, Prints and Sculpture of the 19th and 20th Centuries from the Collection of Mr and Mrs Jules Loeb of Lucerne, Quebec. Sale of 8 April 1970. Sotheby & Co. (Canada) Ltd., Catalogue no. 41, p. 57.

Signay, Joseph. *Recencement de la ville de Québec en 1818.* Cahiers d'Histoire, no. 29. Quebec: La Société historique de Québec, 1976, xi + 323 pages.

"Le testament de Pierre-Joseph-Olivier Chauveau." *Rapport des archives du Québec,* vol. 41 (1963), pp. 169-174.

Tremblay, Claire. "L'œuvre profane de Joseph Légaré." M.A. thesis presented to the History of Art Department, University of Montreal, August 1972, v + 275 pages.

Tremblay, Jean-Noël, pref. *Collection des musées d'état du Québec.* Quebec: Gouvernement du Québec, 1967, 108 pages.

Trudel, Jean. "À propos de la statue de Wolfe." *Vie des Arts*, no 59 (summer 1970), pp. 34-37.

———:

Un chef-d'œuvre de l'art ancien du Québec. La chapelle des Ursulines. Quebec: Presses de l'université Laval, 1972, 115 pages.

———:

"Étude sur une statue en argent de Salomon Marion." *Bulletin* no. 21, The National Gallery of Canada (1973), pp. 3-19.

———:

"Joseph Légaré et la bataille de Sainte-Foy." Unpublished manuscript, 1977.

———:

L'Orfèvrerie en Nouvelle-France (exhibition catalogue). Ottawa: The National Gallery of Canada, 1974, 239 pages.

Trudelle, Charles. *Le frère Louis.* Pierre-Georges Roy, ed. Lévis, P.Q.: 1898, 74 pages.

Les Ursulines de Québec depuis leur établissement jusqu'à nos jours, vol. IV. Quebec: Darveau, 1866.

Les Ursulines des Trois-Rivières depuis leur établissement jusqu'à nos jours, vol. III. Montreal: A.P. Pigeon, 1898, 436 pages.

Vézina, Raymond. "Attitude esthétique de Cornelius Krieghoff au sein de la tradition picturale canadienne-française." *Racar*, vol. 1, no. 1 (1974), pp. 47-59.

———:

Review of Barry Lord, *The History of Painting in Canada.* *Racar*, vol. 2, no. 1 (1975), pp. 51-55.

———:

Théophile Hamel, Peintre national (1817-1870), vol. I, Montreal: Éditions Élysée, 1975, 301 pages.

Wade, Mason. *Les Canadiens français de 1760 à nos jours*, vol. I, 1760-1914. Montreal: Le Cercle du Livre de France, 1966 (c. 1955), 685 pages.

Wallace, W. Stewart, ed. *The Macmillan Dictionary Biography.* Toronto: Macmillan, 1963, 822 pages.

Wildenstein, Daniel. "Les œuvres de Charles Le Brun d'après les gravures de son temps." *Gazette des Beaux-Arts*, Series 6, vol. LXVI (July-August 1969). pp. 1-58.

V. CATALOGUES OF EXHIBITONS IN WHICH WORKS BY LÉGARÉ HAVE APPEARED

(in chronological order)

Numismatic and Antiquarian Society of Montreal. *Descriptive Catalogue of a Loan Exhibition of Canadian Historical Portraits and other objects relating to Canadian Archæology.* Montreal: Gazette Printing Co., 1887, 80 pages.

Macdonald, A.C. de Léry. *A Record of Canadian Historical Portraits and Antiquities exhibited by the Numismatic and Antiquarian Society of Montreal 15th September 1892.* [Montreal: 1892], 56 pages.

Painting in Canada. A Selective Historical Survey (exhibition catalogue). Albany, N.Y.: Albany Institute of History and Art, 1946, 46 pages, 69 plates.

The Arts in French Canada. Exposition rétrospective de l'art au Canada français. (exhibition catalogue). Quebec: 1952, 118 pages.

The Arts in French Canada. Les Arts au Canada français (exhibition catalogue). Vancouver: The Vancouver Art Gallery, 1959, 96 pages.

Morisset, Gérard. *Canadian Portraits of the 18th and 19th Centuries. Portraits canadiens du 18ᵉ et 19ᵉ siècles* (exhibition catalogue). Ottawa and Quebec: The National Gallery of Canada and Musée de la province de Québec, 1959, 48 pages.

Martin-Méry, Gilberte. *L'art au Canada* (exhibition catalogue). Bordeaux: 1962, xxxi + 176 pages.

Harper, J. Russell. *Treasure from Quebec. Trésors de Québec* (exhibition catalogue). Ottawa and Quebec: The National Gallery of Canada and Musée du Québec, 1965, 63 pages.

Shadbolt, Doris. *Images for a Canadian Heritage* (exhibition catalogue). Vancouver: The Vancouver Art Gallery, 1966, n.p.

Carter, David G. *The Painter and the New World. Le Peintre et le Nouveau Monde* (exhibition catalogue). Montreal: Montreal Museum of Fine Arts, 1967, n.p.

Hubbard, R.H., and Jean-René Ostiguy. *Three Hundred Years of Canadian Art. Trois cents ans d'art canadien* (exhibition catalogue). Ottawa: The National Gallery of Canada, 1967, 254 pages.

Trudel, Jean. *Peinture traditionnelle du Québec* (exhibition catalogue). Quebec: Musée du Québec, 1967, 125 pages.

Hubbard, R.H. *Peintres du Québec. Collection Maurice et Andrée Corbeil.* (exhibition catalogue). Ottawa: The National Gallery of Canada, 1973, 212 pages.

Hubbard, R.H., and Northrop Frye. *Canadian Landscape Painting 1670-1930* (exhibition catalogue). Madison, Wisconsin: Elvehjem Art Center, University of Wisconsin, 1973, 198 pages.

Thibault, Claude. *Trésors des communautés religieuses de la ville de Québec* (exhibition catalogue). Quebec: Musée du Quebec, 1973, 199 pages.

Harper, J. Russell. *People's Art: Naive Art in Canada/L'art populaire: l'art naif au Canada* (exhibition catalogue). Ottawa: The National Gallery of Canada, 1973-1974, 165 pages.

Thibault, Claude. *Le diocèse de Québec 1674-1974* (exhibition catalogue). Quebec: Musée du Québec, 1974, 59 pages.

Indexes

Photograph Credits
Patrick Altman, Québec: 124.
Archives de l'Hôtel-Dieu de Québec, Quebec: 190.
Archives nationales du Québec, Quebec: fig. 4, 5; 101.
Art Gallery of Ontario, Toronto: 71, 73.
Bibliothèque nationale du Québec, Montreal: 259.
Sally Chappell, London: 39, 61.
Courtauld Institute of Art, London: 206.
Robert Derome, Gatineau: 52a, 139, 181, 203.
John Evans, Ottawa: 78.
Inventaire des biens culturels du Québec, Quebec: 86, 88,
 133, 135, 138, 140, 142, 143, 144, 145, 158, 160, 164,
 167, 171, 175, 185, 188, 189, I, III.
A. Kilbertus, Montreal: 245.
Laurier Lacroix, Montreal: 116, 162.
Jérôme Légaré, Chicoutimi: 94.
McCord Museum, Montreal: 228.
Brian Merrett, Montreal: 1a, 2a, 3a, 13, 23, 24, 25, 31, 32,
 40, 44, 45, 46, 51, 54, 55, 64, 65, 66, 67a, 69, 70, 80,
 81a, 202, 205, 209, 210, 225.
Montreal Museum of Fine Arts: 11.
Musée du Québec, Quebec: 12, 14, 22, 26, 30, 42, 43, 49,
 59, 60, 67, 67b, 72, 75, 76, 111, 119, 131, 134, 136, 147,
 153, 166, 170, 173, 179, 182, 191, 196, 208, 212, 214,
 215, 226, 227, 250.
National Gallery of Canada, Ottawa: 1, 2, 2b, 3, 4, 7, 8,
 9, 10, 16, 17, 18, 19, 20, 21, 27, 28, 29, 33, 35, 36, 37,
 38, 40a, 47, 48, 50, 52, 53, 56, 57, 58, 62, 63, 68, 74, 77,
 81, 184.
National Library of Canada, Ottawa: 22a, 52b.
John R. Porter, Quebec: 4a, 5, 5a, 6, 15, 19a, 34, 36a, 41,
 41a, 41b, 42a, 79, 83, 84, 85, 87, 89, 90, 93, 95, 96, 97,
 99, 100, 102, 106, 107, 108, 109, 112, 113, 114, 117,
 118, 120, 123, 132, 137, 141, 146, 150, 151, 152, 154,
 156, 157, 163, 165, 168, 172, 176, 177, 193, 194, 195,
 199, 204, 213, 218, 220, 230, 240, 261, 270.
Public Archives of Canada, Ottawa: figs. 1, 2, 3; 44a, 53a,
 73a, 73b, 253.
Royal Academy of Arts, London: 13a.
Pauline Séguin, Valleyfield: 125, 155, 159.
Réal Tremblay, Chicoutimi: 241.
Jean Trudel, Montreal: 42b.

Credits
Design: John Grant
Printing: Thorn Press Limited